Jean

very happy Birthday
and love Peter Diane
November '87

THE GLORY OF
WATERCOLOUR

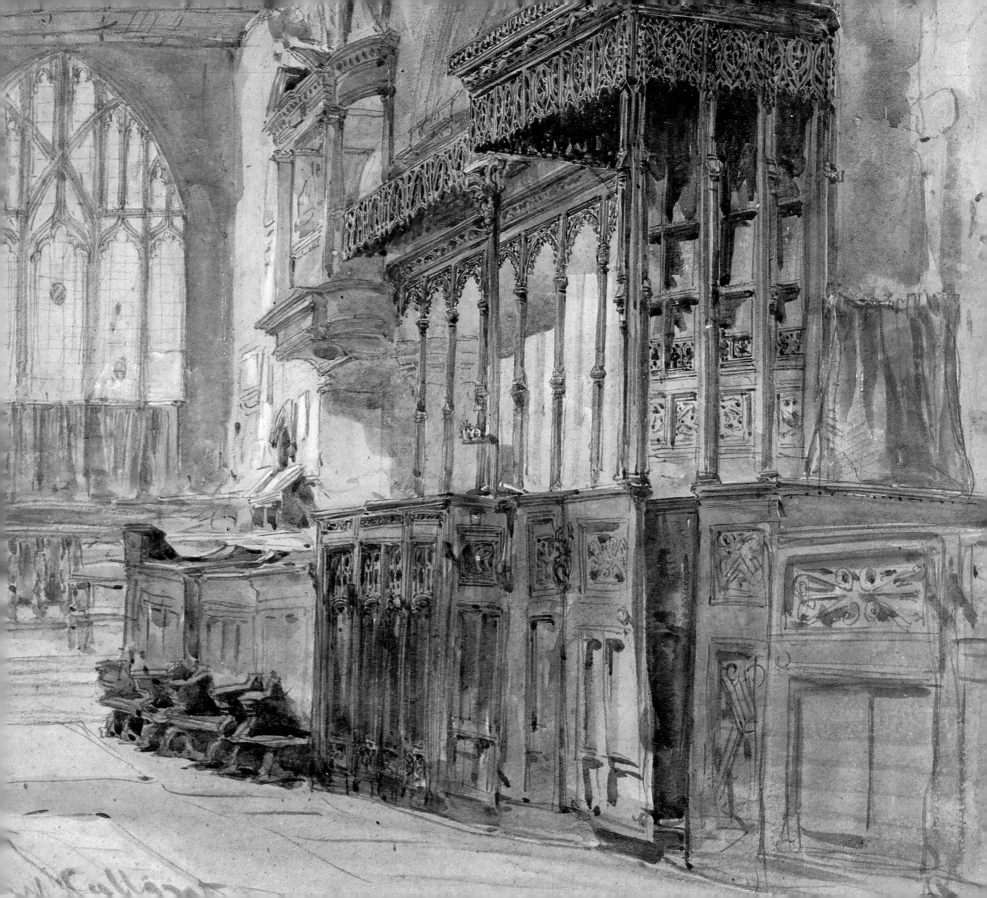

MICHAEL SPENDER

THE GLORY OF
WATERCOLOUR

THE ROYAL WATERCOLOUR SOCIETY
DIPLOMA COLLECTION

DAVID & CHARLES
Newton Abbot London

For My Parents

FRONTISPIECE
Detail from St Mary's Church,
Richmond, Yorks, Before its Restoration
WILLIAM CALLOW RWS

British Library Cataloguing in Publication Data

Spender, Michael
 The glory of watercolour.
 1. Watercolor painting, British
 2. Watercolour painting — 18th century
 — Great Britain 3. Watercolour painting
 — 19th century — Great Britain
 4. Watercolour painting — 20th century —
 Great Britain
 I. Title
 759.2 ND1928

ISBN 0–7153–8932–7

Typeset by ABM Typographics Ltd, Hull
and printed in The Netherlands
by Royal Smeets Offset Weert
for David & Charles Publishers plc
Brunel House Newton Abbot Devon

Published in the United States of America
by David & Charles Inc
North Pomfret Vermont 05053 USA

ACKNOWLEDGEMENTS

A society like the Royal Watercolour Society touches on the lives of many people and a considerable number of these have in some way or other been involved in the Diploma Collection conservation, exhibition and publication programmes of which this book is part. It would be impossible to name here all those friends – members, scholars and curators among them – whose help and advice have been gratefully received, but they know who they are and I thank them most warmly.

I should like to use the limited space available to record my particular appreciation of the following few: Lord Thorneycroft, Chairman of the Friends of the RWS, who has taken such an interest in the project and written the foreword; Eric Clark, Vice Chairman, who was involved in the book's conception; Maurice Sheppard, under whose Presidency the Diploma Collection project was started and who has been a constant help; David Porteous, whose efforts on behalf of the publishers were I hope lightened by his enthusiasm for watercolour; Dr Steve Ellis, whose support and comments on the text were invaluable; and Helen Snow, who word-processed my scribbled manuscript and gave most excellent and apt advice about its content.

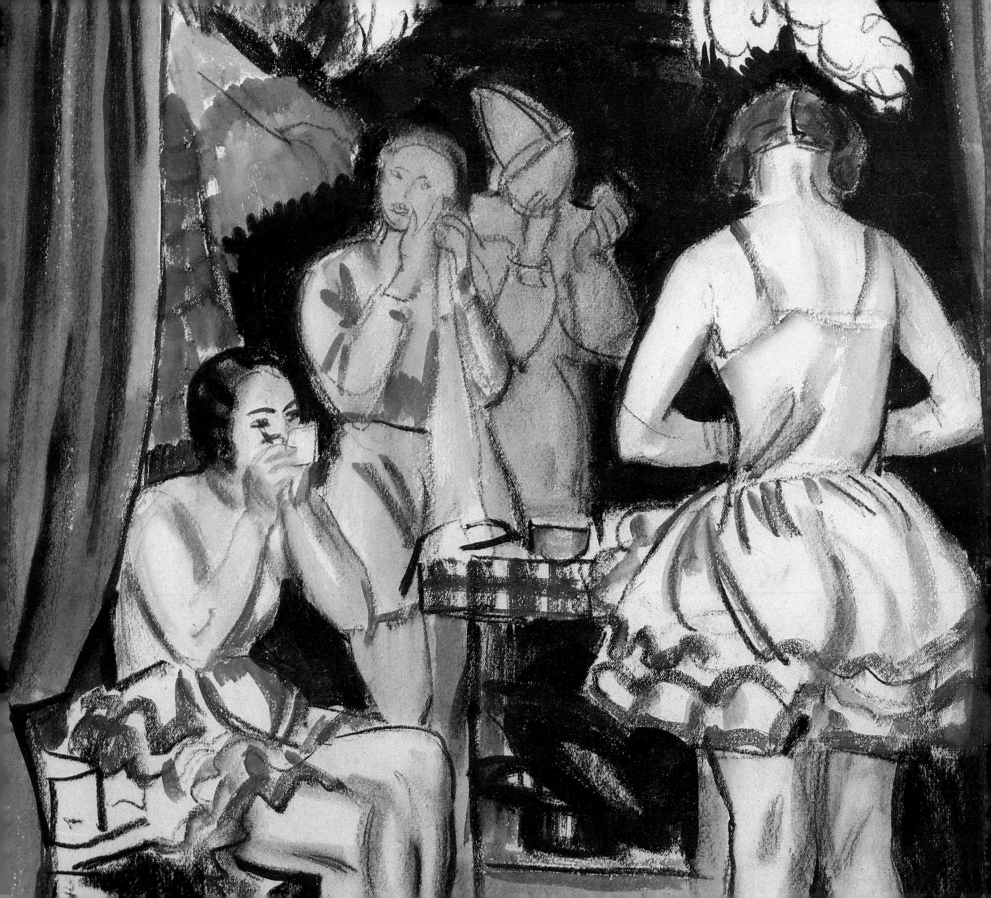

CONTENTS

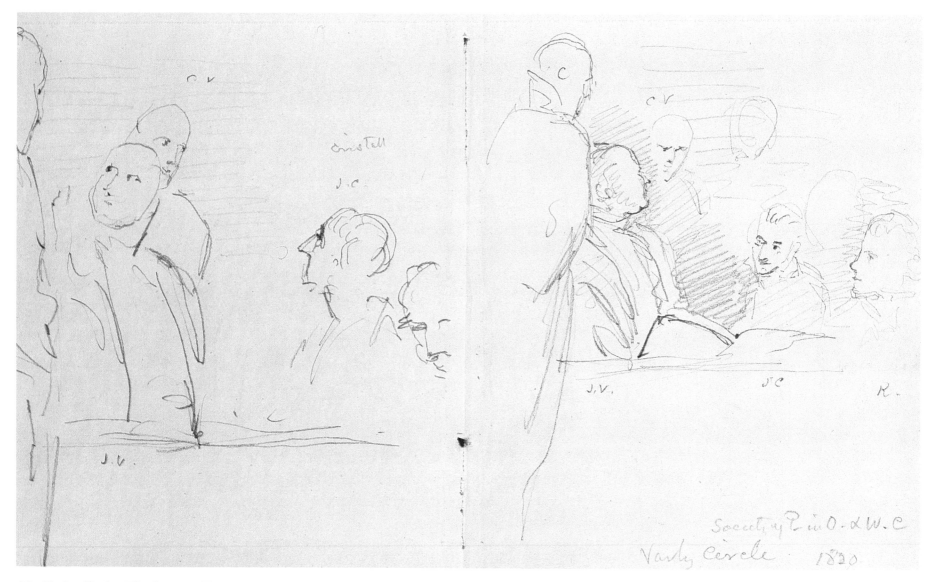

The Varley Circle – The Society of Painters in Oil and Water Colours, 1820
JOHN LINNELL OWS (1792-1882)
Graphite
4⅞ × 7¾ ins

These brief pencil studies of Varley's colleagues in the early Society reflect the companionship of the members. Throughout the Society's history, its members have come together not only to conduct business but to enjoy social and professional dialogue befitting what might be described as an 'artists' co-operative'. In the year of these sketches the Society was about to undergo the second major transformation in its history and return to its original purpose as a watercolour society only (see text). Among the members depicted are Joshua Cristall and Cornelius and John Varley.

FOREWORD

This book is the story of a great collection of British watercolours – the paintings given to the Royal Society of Painters in Water-Colours by the artists on the receipt of their Diploma. It is also a fascinating account of the methods adopted by British water-colourists over a period extending for more than a century and a half. It will be compulsive reading not only for the professional practitioners of that Art but also for amateurs, for collectors and, indeed, for the ever widening audience that has grown to admire the national achievements in this field.

The British have over the years made a notable contribution to the Arts, not least, for example, in the field of literature, but the one art form in which we are judged to be pre-eminent is perhaps in the painting of watercolour. We established that reputation over the years which spanned the end of the eighteenth century, and it was at this very time, 1804, that the Royal Watercolour Society was formed. Michael Spender in his admirable account recalls the excitement and the achievements of those early years. But this book is something more than a history of the RWS. It takes as its base the paintings which were from 1860 onwards presented by the Member artists to the Society on the award of its Diploma. These paintings, together with some others in the possession of the Society, provide the backcloth to a commentary upon the British achievement in watercolour.

The interest, the strength and the importance of Michael Spender's account lie, I think, in its objectivity. Watercolour is a many-splendoured thing. Inevitably over this period since the formation of the RWS one finds a huge variation both in method and in subject matter. The methods are analysed and even more importantly illustrated in some detail. The various types of subject matter here and abroad are separated out for study. The approach to painting watercolours of, say, Birket Foster or Helen Allingham and that of David Cox, William Callow or John Sargent have little perhaps in common but Michael deals with each with a degree of knowledge and insight and sensitivity which will, I believe, enrapture his audience as they read this book.

In the main British watercolourists would fall into the class of painters known as representational. Their inspiration in other words is drawn from the world observed about them. And yet all painting and certainly many of these paintings are in a real sense abstractive. The painter's eye takes from the scene before him or so arranges it that his own vision of the things he sees is presented to the viewer. The painter finds beauty in places where other men would fail to observe it. The rotten banks and slimy posts beloved by Constable; the decaying walls of Camden as seen by Ginner; the shapes, the shadows, the foregrounds and the distances, the landscapes, and above all, perhaps, the skies, present the painter with endless opportunities for creating a construction of his own and presenting us with something which cannot be described in words but only in the brush-strokes which are peculiarly his personal handwriting.

The illustrations in this book, and particularly perhaps the illustrations of details of the paintings backed by Michael Spender's text, provide us with an unrivalled opportunity to study for ourselves the mysterious combination of factors, of line and colour and construction that help to create a watercolour by a master of that art. It is an opportunity that no lover of watercolours should allow himself to miss.

For those who would wish to keep in close touch with the RWS and its activities there is also the opportunity to become a Friend of the RWS. All that is necessary is to apply to the Bankside Gallery for an enrolment form by telephoning 01 928 7521.

Lord Thorneycroft CH, Hon RWS

Norman Janes at Hoorn
ROLAND BATCHELOR RWS (b 1889)
Pen and ink and watercolour.
6¾ × 5 ins

Over the years it has often been the practice of artists to
make sketching tours and painting trips together. Here,
Roland Batchelor's keen wit creates an affectionate
portrayal of a fellow RWS member going about his work.

INTRODUCTION

Watercolour drawing and painting has for over two centuries been a substantive element within the development of British art. Only during the past decade, however, has the importance of artists' contributions in the medium become fully appreciated by a wide audience beyond those connoisseurs and collectors who in past decades of relative neglect have helped keep alive interest in this major aspect of our cultural heritage. Recent high saleroom prices, not only for the eighteenth- and early nineteenth-century greats, but notably for modern figurative watercolourists, have given a recognition to the medium proportionate to that accorded to oil painting. The opening out of the market has brought to our attention the seemingly inexhaustible range and quality of the watercolour tradition.

This book is intended to unveil and illustrate various aspects of this tradition. The watercolours chosen for the purpose are a cross-section of works from the permanent collection of the Royal Society of Painters in Water-Colours – better known as the Royal Watercolour Society, or simply the RWS – whose own history mirrors the development of the art over the period in which it has played a significant role in the visual arts.

We shall unfold stories of the way watercolour painters have depicted various elements of our national life and environment over two hundred years, and share with them the pleasures and trials involved in making these depictions. We shall consider how the artist's approach to his or her subject has changed over this time and how the particular characteristics of the medium have been exploited to convey personal visions of the world around us. These visions belong to many of the great names of the British watercolour school, including John Varley, Peter DeWint, David Cox, Samuel Palmer, Birket Foster, Helen Allingham, John Singer Sargent, Arthur Rackham, Russell Flint, Laura Knight, Vivian Pitchforth and Stanley Roy Badmin.

We will also attempt to unveil some of the mysteries of the watercolour techniques of the masters. At its simplest, a watercolour painting may be described as a sheet of paper on which water-based paint has been applied. This fact makes the watercolour particularly suitable for fine colour reproduction in the pages of a book. We have taken advantage of this suitability by presenting numerous large illustrations that allow the

reader to explore in fine detail the artists' painting methods. Notable among the reproductions are several details taken from works that are also illustrated in their entirety. The aim here has been to put the reader in the privileged position enjoyed by a visitor to the watercolour department of a museum. The ability to study important passages in close-up detail and then to relate the chosen portion to the complete work is one of the great joys of handling watercolours. A number of these details are seen here in life-size, and some are even enlarged to show particular items of technique, texture or subject that are of special interest.

This introduction will briefly outline the tradition of watercolour painting in Britain as it is reflected by the inception and development of the Royal Watercolour Society.

It has not always, however, been a Royal Society and has had to prove its worth over the years to attain such status. The Society of Painters in Water Colours was founded in 1804 to provide an emerging band of painters in this newly-popular medium with a proper exhibiting forum for their art. On 30 November of that year a group of ten mainly young artists met to discuss proposals to present an exhibition of their watercolours in London. The event would be held under the banner of the Society and it was hoped that if it proved sufficiently successful a series of annual exhibitions would follow.

The ten watercolourists were W. S. Gilpin, Robert Hills, J. C. Nattes, Francis Nicholson, W. H. Pyne, Nicholas Pocock, Samuel Shelley, John Varley, Cornelius Varley and W. F. Wells – the latter a close associate of J. M. W. Turner and a guiding light in the foundation of the Society. If Turner had wished to join in the project, he would have been prevented by his membership of the Royal Academy, which guarded jealously its artists' exclusive membership. Only much later in the century were Academicians permitted to be members of other art societies, and in 1870 W. C. T. Dobson ARA became the first associate of both institutions when he was elected ARWS.

Turner's own letters reveal that Wells had been contemplating the idea of creating such an exhibiting association of watercolourists since 1802, the year in which Turner's great contemporary and colleague,

Thomas Girtin, prematurely died. Also departed before the inception of the Society were such influential early masters of the medium as Alexander and John Robert Cozens. Paul Sandby and Francis Towne were perhaps too old to become involved in what was essentially a young man's enterprise.

At a time when the country was beleaguered by events in the war with France, any new opportunity to enjoy the beauties of its native land through the medium of art had a good chance of being enthusiastically received by London society. Unable to travel overseas, the watercolourists were exploring the beauties of the British countryside and discovering the grandeur of Wales, Yorkshire and the Lake District. The range of landscape and marine subjects represented in the Society's first exhibition in 1805 offered many comforting vistas of a countryside unaffected by war, and in most cases taken far away from the burgeoning industrial centres, whose rapid growth saw urban grimness encroach more and more upon the life of the land. The founder members undoubtedly recognised a need of their potential urban patrons to escape for a while into the visual delights of landscape watercolour.

The recently rediscovered minute books of the early Society show that the November 1804 meeting was a constructive one and record that Officers were appointed, among them Gilpin as first President and Hills as Secretary. Laws for the Society's members were prepared and it was decided to add six further artists to the ranks before the first exhibition in 1805: George Barrett, Joshua Cristall, John Glover, William Havell, James Holworthy and Stephen Rigaud.

We might ask why there was a need for a new exhibiting association, when watercolours were regularly shown in the annual exhibitions of the country's most prestigious art institution, The Royal Academy. There existed among many exponents of watercolour the feeling that insufficient attention was being paid it by the mandarins of the Academy. It certainly was true that in terms of the hierarchy of art acknowledged by Academicians in accordance with the Discourses of their first President, Sir Joshua Reynolds, the art of watercolour did not figure highly. Neither was it seen as a suitable mode of expression for the portrayal of elevated subject matter or the conveyance of serious considerations. In the canon of art, oil painting was

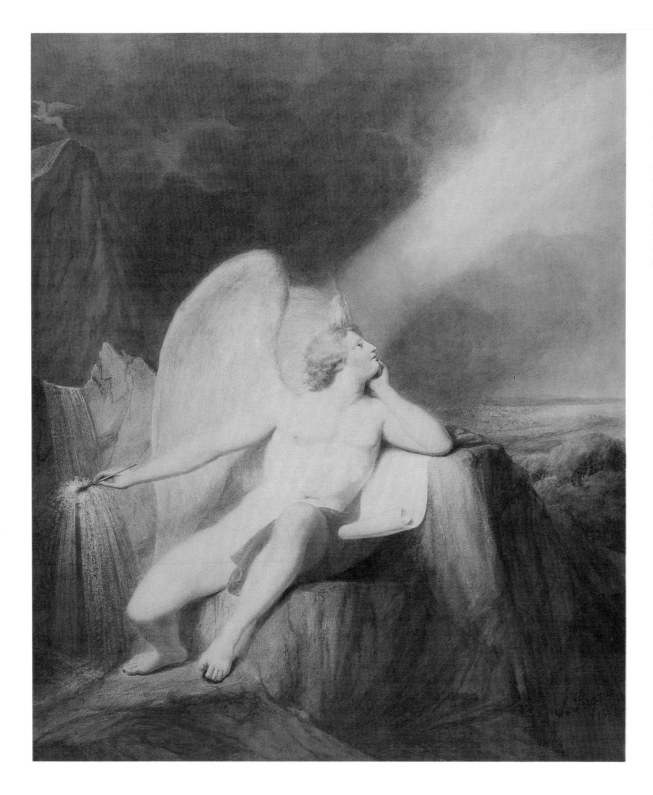

**The Genius of Painting Contemplating the Rainbow
1807**
STEPHEN FRANCIS DUTILH RIGAUD OWS
(1777-1861)
Watercolour
23½ × 19⅝ ins (sight)

This work depicts the Genius of Painting dipping his sable
brush into the stream flowing from Mount Helicon's
Spring of Hippocrene, itself created by Pegasus striking
the mountainside with his hoof. The Genius is of course a
watercolourist and he gazes at the choice of colours
available to him in a now sadly faded rainbow. In recent
years the range of readily available colours had been
considerably expanded and was an important factor in the
growing confidence and popularity of watercolour,
symbolised in this work, painted as it was by Rigaud to
commemorate the foundation of the Society.

better suited as a vehicle for the production of important works of art or expression for lofty ideas. Even the greatest of watercolour painters of the last decade of the eighteenth century could not stand on their reputations as producers of grand, exhibition-intended watercolours alone. Both Turner, successfully and Girtin, unsuccessfully recognised the need to submit substantial oils instead of their watercolours to establish any chance of election to the RA.

There also existed practical problems of exhibiting watercolours with the Academy at its rooms in Somerset House. These problems were graphically described by Ephraim Hardcastle in the *Somerset House Gazette* of 6 December 1823. Having berated the placing of watercolours among certain oil paintings of dubious quality, which he describes as 'inferior performances as were not deemed worthy of a place in the upper and principal apartment', Hardcastle goes on to relate:

'These disadvantages were not all; the light in the apartment devoted to the water-colour department was ill calculated to display the merits of such delicate and high-finished works, being admitted through common sashes and frequently glaring on the subjects on one side of the room, whilst those on the other side were exhibited on the piers and spaces between the windows, with the light from behind. Hence many works of merit appeared not as pictures, but merely as so many pier-glasses.'

Because of their fragility as works on paper and particularly as a result of their vulnerability when on public exhibition, watercolours have traditionally been glazed when placed in frames. The Society of Painters in Water Colours appears to have been one of the first exhibiting institutions which recognised the need to ensure suitable overhead lighting for glazed pictures to prevent them from becoming so many mirrors. Large watercolours are particularly prone to picking up reflections from a wide area of light sources. This was a problem to which the Society had to address itself when choosing venues for the early exhibitions, for its members were out to produce large and important watercolours to cover the walls in the annual exhibition.

Following the example of Turner and Girtin, the watercolourists of the first decade of the nineteenth century were producing 'performances' on a grand scale in their chosen medium. If this was not an attempt to emulate oil painting, it was certainly indicative of a wish to compete with the 'superior' medium. In its early years the Society evolved a system of paying a special premium to those members who exhibited watercolour paintings measuring 39 inches or over. These 'premium' works, together with commissioned set-pieces, which we find from time to time proudly featured in the catalogues of exhibitions, were intended as major artistic statements about the importance of watercolour and of the Society's own position in the hierarchy of art institutions.

In the early years of the Society, the members were positively encouraged to send as many works as possible to the annual exhibitions. The Society's accounting procedures meant that any profits resulting from the exhibitions were shared out among the members in proportion to the number of watercolours sent in. John Varley was regularly in the habit of submitting over thirty pieces, and accordingly receiving a substantial dividend. In 1809 he sent sixty watercolours! Like most of his colleagues, not only in the early Society but among today's membership, Varley was in the habit of sending a combination of largish set-pieces and those smaller, more intimate works which are so treasured by collectors. Peter DeWint was another artist who found the Society's exhibitions an ideal setting for the public display of a wide range of his watercolour production, from stately views of Lincoln to freely painted landscape studies.

But why did watercolour require the new status afforded it by the Society's exhibitions and why was it to become the most novel and successful art of the first decade of the century? The medium had in the eighteenth century been generally regarded only as a suitable vehicle for the topographical depiction of architectural subjects by artists described as draughtsmen. Watercolour was characteristically used to colour in graphite drawings of buildings, which were often commissioned by their owners as 'house portraits'.

Because coloured drawings were not exhibited or sold on the open market and were usually produced for the precise purpose of recording subject matter, it was both natural and necessary for their practitioners to seek the employment of a patron. Those artists who produced country house views might also be contracted to accompany their patrons on those travels abroad that were obligatory to the education of the English gentleman. Until Napoleon's armies closed Europe's borders, it was the fashion for the gentry to undertake the Grand Tour in the company of a draughtsman, who would make a visual record of the journey with his readily transportable materials – pencil, pen, paper, brush and pigments. In a pre-photographic age, the eyes of major artists like John Robert Cozens or Francis Towne were most acceptable cameras for their employers that could provide beautiful and nostalgic recollections of visits to the great sites of Italy. Another opportunity for employment for the draughtsman existed in colleges and military academies. The teaching work done both in academies and privately by drawing masters such as Sandby provided much of the groundwork for a development of public interest in watercolour. Later on, the amateurs and cognoscenti who had received tuition from the eighteenth-century teachers would provide a ready audience for the exhibitions of the Society of Painters in Water Colours. Sandby was well received in Royal and society circles, and as Chief Drawing Master at the Woolwich Military Academy he was able to influence the taste of a new generation of potential patrons.

In the early decades of the nineteenth century, the role of the drawing master became largely superseded by that of the independent teacher to both professional and amateur watercolourists. It became fashionable for artists to publish books containing prints after their drawings for the further enlightenment of amateurs. John Varley was perhaps the most influential teacher of his generation and his 'how-to-do-it' books for the emerging amateurs of the nineteenth century were the precedent for a tradition of instruction for the amateur which survives to the present day.

The late eighteenth-century stigma that watercolour was useful only for the production of topographical 'tinted drawings' was hard to shake off, and it proved so, in their early years, for even Turner and Girtin. By the turn of the century, however, a new-found confidence in the medium was emerging. The Society's ambitious founder members represented a growing body of practitioners of watercolour painting, who had profited from chemical developments in the production of paints, which had extended the range of ready-made pigments available to the artist. Such technical progress gave watercolourists greater ability to paint in rich, dense colour than had the limited range of pigments previously available.

A generally growing interest in watercolour coincided with and perhaps encouraged these technical developments. The new colours most certainly assisted Thomas Girtin in his evolution from the maligned manner of the 'tinted drawing' to a richer, more expressive use of the medium. From colouring in pencil drawings he progressed to actually drawing with the brush, using layers of wash and gum arabic to build up the density of colour. Some of his watercolours, like the monumental *Bridgnorth*, were painted

on an impressively grand scale. This powerful new use of the medium went hand in hand with Girtin's development of Romantic subject matter – wild and sublime scenery, often unaffected by or associated with man, let alone with a particular commissioning patron. With Girtin, the watercolour achieved independent status as a work of art. The watercolourist was no longer to be dependent for his subject on his patron and neither would he continue to be as financially dependent on commissions. The artist needed to earn a living and in this new climate, steps to create a forum for the art would soon have to be made. It is worth pausing here to consider the language we use in the description of works of art employing watercolour. The traditional appellation of 'drawing' is still used today, but in conception dates from the era of the topographical draughtsman. While Girtin drew with the brush, there can be no substantive argument against the claim that in his mature work he was a painter through and through. On the other hand, many of his successors over the years, however greatly they learned from his example, produced works that for their reliance on preparatory linear marks could really only be described as drawings. For the purpose of description of the art works, the writer of the present text has chosen to use what seems to him to be an appropriately pragmatic variety of words, according to the technical characteristics of the given example.

Thomas Girtin died in 1802, his twenty-eighth year. Given the brevity of his career, his achievements were remarkable, and were to have a great bearing on the progress of watercolour and the watercolourist's status in the first decades of the new century. The artists who joined together to found the Society were certainly ambitious to follow his example. They were producing forceful works in the medium, which were frequently large exhibition pieces known as 'machines' intended to express major ideas. They also followed in Girtin's footsteps to the wilder parts of Britain to gather subject matter which accorded with the contemporary passion for the Sublime. While the characteristic topographical drawing would normally have been commissioned as a record of the subject depicted, the new watercolours had to, and were intended to, stand up as paintings in their own right. They would also have to be sold on the open market.

At this time the Academy's prestige relied on portraiture and history painting, produced principally by artists working in the grand style. Its exhibitions were shop windows for the Academicians to display their wares, rather than shops at which the purchasing of pictures from the walls was the order of the day.

During their preparations for the Society's first exhibition, the Committee clearly recognised the natural potential of the watercolour as a portable and eminently collectable artefact. In the minutes of a meeting held on 23 March 1805, Robert Hills records 'that the Members be particularly requested to mark with a Star such of their Works as are to be disposed of, in order that the Prices of such Paintings may be inserted in a Book left in the care of one of the Door and Room Keepers to satisfy the enquiries of such Visitors of the Exhibition as may wish to become purchasers.'

Recalling this exhibition some eighteen years later, Hardcastle writes 'Hitherto, very few instances could be named of the pictures of living artists being disposed of at a public exhibition; whilst here, the room at once became an excellent mart for sale'. The outstanding commercial success of the exhibition proved the shrewdness of the Committee's request and the purchase of watercolours from exhibitions became one of the fashions of the decade.

On 22 April 1805, the inaugural exhibition of 275 watercolours was opened to the public at the Rooms in Lower Brook Street, off Grosvenor Square. Hardcastle describes how, 'No sooner was this novel exhibition announced, than the members had reason to rejoice at the experiment. The room was crowded by the first personages, who appeared emulous to become purchasers of the works for sale . . .' By the close of the exhibition on 8 June, 11,542 visitors had filed through the Rooms. The last week had proved especially busy after the closing date had been announced in the press and London society had flocked to get a glimpse of this display of the watercolourists' art. Sales had been most satisfactory. Under the curious arrangement referred to earlier, once overheads had been met, all proceeds from admissions and the sales of catalogues were proportionately shared out among the members according to the number of works exhibited.

Unlike the Academy, the Society has always restricted its exhibitions to the work of members or invited artists. Exercising both aesthetic and commercial judgement, the members recognised the desirability of expanding the Society. In 1806 we find fellow exhibitors being added to the ranks. The next year these were described as associate exhibitors. Associates did not benefit from the share out after the close of the exhibition, but this category has remained to the present day as the first stage of admission to membership of the Society. Today's associates have a much greater involvement in the affairs of the RWS

than their predecessors and they enjoy nearly all the rights and privileges of full membership.

Among the 1806 fellow exhibitors was Anne Frances Byrne, who is chiefly known for her still-life watercolours. Miss Byrne was elected a member in 1809 and her membership continued until 1834. Anne Byrne was the first of a long and distinguished line of professional women members of the Society. In the nineteenth century, watercolour painting was considered a most suitable recreation for gentlewomen, but the Society has long provided a serious exhibiting forum for those women who were able to make a professional commitment to the art, such as Helen Allingham and Dame Laura Knight.

As the numbers of exhibitors grew in these early years, so did the popularity of the exhibitions. In 1807, 14,366 people paid the one shilling admission fee, while in 1809 the Society achieved an apogee of 22,967 visitors to the annual exhibitions. The system noted above of sharing out exhibition proceeds did, however, mean there was no capital to fall back on if hard times were to arise – such was the climate of optimism for the fashionable watercolour art.

When, after 1809, this fashion did begin to wane, the Society was ill-prepared to cope with diminished returns. As early as 1812, we find the Society being wound up at the Anniversary General Meeting as a result of debts of £11 11s 9d. Much debate had been entered into as to the advisability of widening the Society's appeal to the public by introducing oil paintings to the exhibitions. Such a move was so contrary to the original purposes, that when a meeting was held to form a Society of Painters in Oil and Water Colours, several of the original members washed their hands of the development and refused to participate.

The new experiment proved successful enough for the reshaped Society to be able to continue holding annual exhibitions of works in oil and watercolour until 1820. While the old Society's run of exhibitions was thus added to, its original ambitions and purposes were temporarily lost during what turned out to be an interregnum. Other institutions already existed to present works in both media, and even taking into account the reformed Society's emphasis on watercolour painting, its exhibitions could only have been a pale reflection of those of the RA. By the end of the 1810s it became apparent that the London art world would be better served by a return to the original plan and that the need still existed for a Society whose interest was exclusively in watercolour.

In times of trouble, the Society has over nearly two centuries proved its fortitude and ability to change as

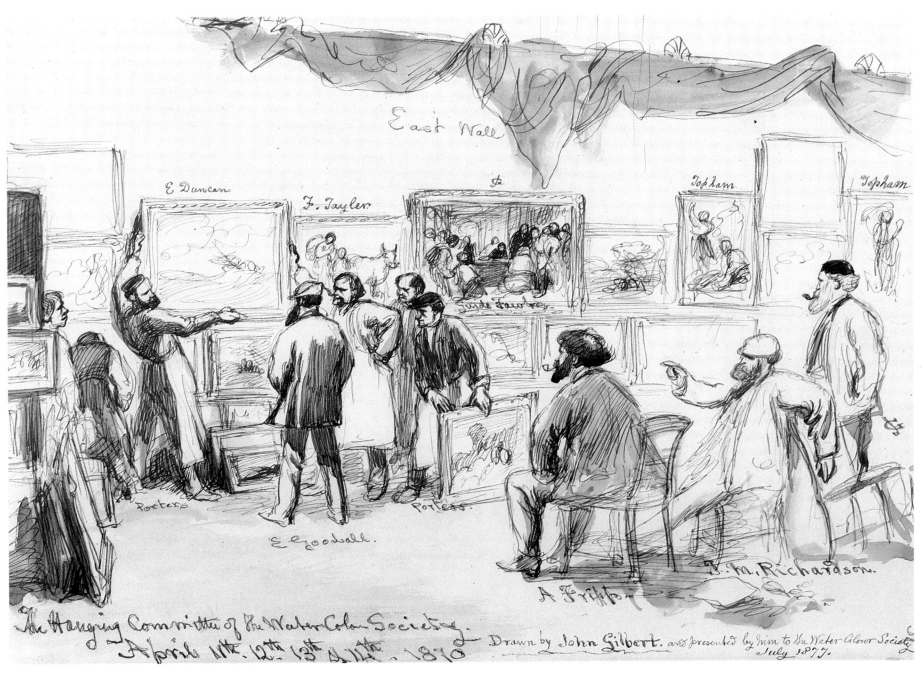

Within the drawing, handwritten labels:

East Wall

E. Duncan F. Tayler. Topham Topham

Porters Porters.

E. Goodall.

A. Fripp. T. M. Richardson.

The Hanging Committee of the Water Colour Society.
April 11th. 12th. 13th & 14th. 1870

Drawn by John Gilbert. and presented by him to the Water Colour Society July 1877.

The Hanging Committee of the Water Colour Society 1870
SIR JOHN GILBERT RA PRWS (1817-97)
Pen and ink and graphite
9¼ × 12¾ ins

The Hanging Committee are instructing porters on the placement of pictures in the annual exhibition. The committee members and a number of the pictures are recorded by Gilbert, who stands to the far right of the scene. Note the crowding of the works and the drapes which hang from the walls beneath the skylight in the Pall Mall East gallery.

circumstances have required. When the experiment with oil painting was rescinded at a General Meeting held on 5 June 1820, the renascent Society of Painters in Water-Colours had not only retained distinguished names, such as the Varleys, from the early years, but had also gained younger masters, such as David Cox and Samuel Prout.

The nobility had always bought watercolours from the Society's exhibitions, but the seed of future Royal status was no doubt sown in 1834 when the fifteen-year-old Princess Victoria paid the first of her many visits. Although her broader interest in the visual arts was nurtured by her Consort, Prince Albert, Victoria's interest in watercolour existed from an early age. Under the direction of professional drawing masters, among them members of the Society, Queen Victoria became a proficient watercolourist in her own right.

At the General Meeting of the Society held on 18 July 1834, it was reported that the Duchess of Kent had expressed her wish to visit that year's exhibition with the Princess Victoria 'on the Monday after its close'. In 1835 the sending-in date was amended to allow such a visit on the Friday before the private view on Saturday 25 April. The Society has since this time held aside a special day for visits by members of the Royal Family as so required. Queen Victoria proved to be a most consistent visitor and her purchases of works by such members as Callow and Lundgren can only have encouraged her appetite for watercolour and her own wish to practice in the medium.

At the Anniversary General Meeting held on 30 November 1871, the minute book tells us that the newly elected President reported that he and the Society's Committee had had the honour of receiving the Princess of Prussia who 'expressed her gratification at visiting the Society's Gallery; having a pleasing remembrance of the works of its past and many of its present members, when she was a frequent visitor in former years with her father the Prince Consort.' Gilbert went on to announce 'that he had received a letter from Mr Gladstone the Prime Minister acquainting him that he had received Her Majesty's permission to offer him the honour of Knighthood as President of the Society of Painters in Water Colours, which he had accepted, and congratulated the Society upon its receiving for the first time State recognition, which undoubtedly placed it in its true position among Art Societies and before the public.'

Such was the growing status and official recognition of the Society that on 24 June 1881, in response to a petition from the members, it was granted the title of Royal by the Queen.

Shortly after, another watercolour society, which had established itself in 1831 as a kind of breakaway body called the New Water Colour Society, was also given a Royal Charter. The New Society had in 1863 retitled itself the Institute of Painters in Water Colours, to which it was now able to add the word Royal. The Royal Institute may not have quite the prestigious history or longevity of the RWS, but it has flourished over the years and now holds its annual shows at the Mall Galleries, near Trafalgar Square. Following the formation of the New Society, the Society of Painters in Water Colours was to gain the colloquial appellation of 'The Old Watercolour Society'. The initials OWS placed after an artist's name refer to his membership of the Society prior to Queen Victoria's granting of the initials 'RWS'. The Royal status meant that the Society accepted official responsibility for the promotion and enhancement of all aspects of watercolour, together with the task of educating the public at large as to its worth as an art form. This latter duty was the foundation of the charitable status the RWS was later to enjoy.

Until the 1820s the Society had been in the habit of hiring gallery space for its exhibitions, notably the Great Room in Spring Gardens, near Trafalgar Square. In 1823, however, the annual exhibition opened in what was to be the Society's home for some 115 years of continual occupation, No 6, later 5a, Pall Mall East, close to the National Gallery.

Mindful that fine work in watercolour was being practiced outside its membership, the Society also in this year staged a loan exhibition of a 'Selection of Drawings by British Artists' at their new gallery. This provided the opportunity to not only show works by Academicians normally barred from exhibiting with the members, such as J. M. W. Turner, William Westall and R. R. Reinagle, but also to acknowledge and assess the works of some masters of the recent past, hanging side by side with the members' own works. To this end a fine group of watercolours by Girtin was assembled, with works by Thomas Hearne, Henry Edridge and the yet to be elected John Sell Cotman.

From the prestigious and much loved Pall Mall Gallery, the Society moved closer to the venue of its first exhibition and in 1938 installed itself in the RWS Galleries, 26 Conduit Street, off Bond Street. Exhibitions were held throughout World War II and their continuity from 1805 to the present day is something of which the RWS is justifiably proud.

In the 1970s, with the imminent expiry of the lease of the RWS Galleries, the Society took a far-sighted decision to seek a new home. It was decided to establish a gallery outside the high-rated and commercial West End area, at which it could present a continuous series of exhibitions that fulfilled its charitable object. The RWS was joined in this plan by another charitable art society, the Royal Society of Painter-Etchers and Engravers (RE). The latter Society had habitually held its exhibitions at the galleries of the RWS since the last years of the nineteenth century.

Under the guiding hand of the then Secretary, Malcolm Fry, the RWS left Conduit Street in 1980 to establish itself in its newly built Bankside Gallery, on the Southwark shore of the Thames, opposite St Paul's Cathedral. Sir Christopher Wren had stayed in a house on a site near the new gallery, from which he watched his Cathedral being built. With its close connections also with Shakespeare, whose Globe Theatre was situated nearby, Bankside seemed an appropriately historic and cultural area for the Society to find a home. This courageous and successful move was made possible by an appeal to a wide community to help find the project. The members of the Society themselves raised a substantial contributions, notably the late Keith Henderson, whose donation is acknowledged by the naming of one of the gallery's rooms after this long-serving member.

The Bankside Gallery was opened on 11 November 1980 by Her Majesty the Queen, whose Patronage of the RWS is shared by Her Majesty the Queen Mother. Both the Society's Patrons are keen collectors of watercolours and His Royal Highness the Prince of Wales, an Honorary member of the Society, follows in the family tradition and is an accomplished watercolourist who exhibits with the RWS.

It will be informative to examine now the policy of today's RWS towards the many definitions of watercolour that exist. Readers will doubtless also wish to know what criteria the Society follows in its procedures to elect new associate members to its ranks.

To this day the Society has shown only watercolours and sketches in its exhibitions. A liberal interpretation of the word 'watercolour' has, however, predominated. In the 1980s this interpretation can mean the acceptance of acrylic and other water-based media applied to paper. In the nineteenth century this liberality enabled members such as Cotman, Cox and Palmer to exhibit works which incorporated a wide range of often personally invented opaque media, evolved for creative effect. The employment of body-colour, or gouache, was as common then as it is now and J. M. W. Turner was perhaps its greatest exponent. While 'purists' may frown upon a watercolourist

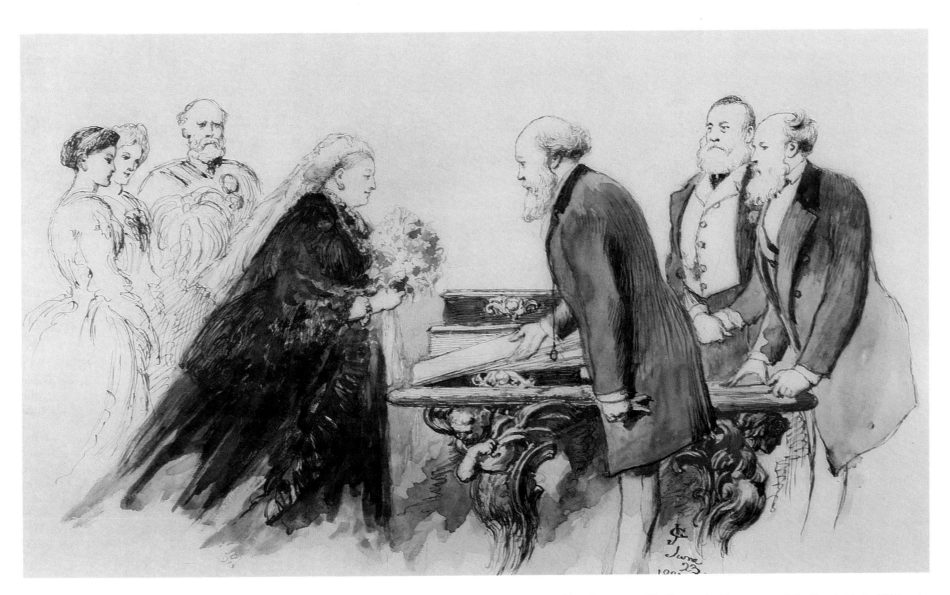

The Presentation of an Album Containing Sketches by Members of the R W Society Accepted by Her Majesty as a Souvenir on the Occasion of her Golden Jubilee 1887.
SIR JOHN GILBERT RA PRWS (1817-97)
Pen and ink, wash, bodycolour and graphite
8 × 13 ins (sight)

The Society had been granted the Royal title in 1881 and the album presented to mark Queen Victoria's Jubilee is still held in the Collection of Her Majesty the Queen at the Royal Library, Windsor Castle. In this drawing Gilbert himself features as prominently as the Queen, as perhaps is to be expected of a man who refused to sell pictures in the later years of his life in order to make a grand, but largely forgotten bequest to the nation.

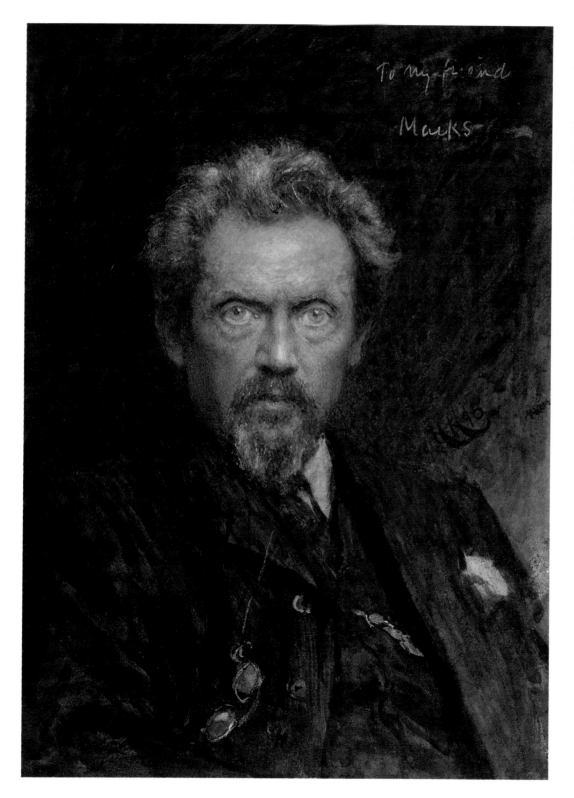

Portrait of Henry Stacey Marks
SIR HUBERT VON HERKOMER RA RWS
(1849-1914)
Watercolour and gum, with scratching out
7 × 4⅞ ins (sight)

A penetrating and superbly wrought portrait of a fellow member by a distinguished artist and teacher. The Society has recently instituted a policy of encouraging members to present to the RWS Diploma Collection both self portraits and images of their colleagues. Incisive, personal portraits such as this, presented initially to Marks and then by him to the Society, accurately reflect the supportive and warm spirit amongst the membership, as well as their admiration for the institution itself. Herkomer has scratched out with a knife, or other sharp implement some of the highlights in this watercolour, such as his sitter's hair and eyes.

using bodycolour to produce mere highlights, they may forget that many of Turner's most beautiful Continental watercolours were painted in this medium alone.

But the one essential contribution watercolourists have made to art in this country must be understood in terms of their ability to *draw*. Whether it be Thomas Girtin drawing with the brush or Francis Towne adding colour to his pencil and pen outline, the message of the early masters is that draughtmanship is the key to the successful execution of any work on paper. Picasso and David Hockney, to take two random examples, give ample evidence of this in their work. The ability of artists such as these to tie down to an underlying drawn structure any flights of fancy in their chosen mediums gives strength to their watercolours. In other words, there is no successful painting unless there is successful drawing, either preparatory to, or simultaneous with, the final application of brush to paper.

Watercolour is not a restrictive medium for the painter. In accordance with the ambitions of the Society's founder members, it should be remembered by today's practitioners of the art that the wide variety of materials available provides an extraordinary fund of potential for the creation of great works of art via the simple concept of applying stained and enriched water to a piece of paper. For too long has a jaundiced view prevailed that the word 'watercolour' meant *per se* certain kinds of approach to certain kinds of, usually landscape, subjects. But to be a watercolourist, you don't have to be DeWint, Edward Seago or Charles Knight.

Many prominent painters of the 1980s use the medium to create significant works of art as well as studies for pictures in other media. Painters such as Hockney, Patrick Procktor and Howard Hodgkin should be seen as practitioners of watercolour, in addition to other art forms. So should numerous great European and American masters over the ages, such as Durer, Van Dyck, Delacroix, Winslow Homer, Picasso and Jasper Johns.

The RWS is not a fixed or static entity. It is by its constitution an ever growing body – an 'artists' co-operative', which changes its style and face with the times and as members come and go. But this is not a matter of casual to-ing and fro-ing, as members are elected for life when they join the ranks of the Society. It is not the honour and exhibiting opportunities alone which attract painters to the RWS, but also the feeling of belonging, for as long as one's natural life allows, to such an association of like-minded painters, that

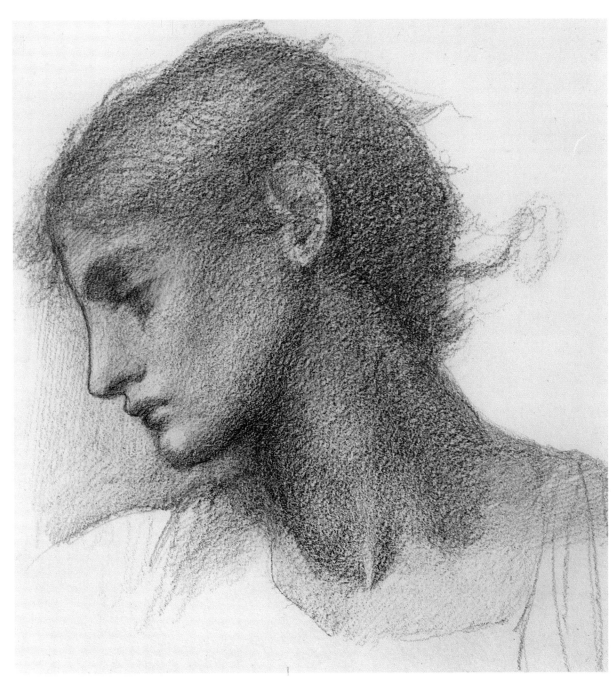

Study of a Head for 'The Mill'
SIR EDWARD COLEY BURNE JONES ARA RWS
(1833-98)
Graphite and wash
7¼ × 6½ ins (sight)

This beautiful study for a major oil painting by Burne Jones is an excellent example of the fine draughtmanship which underlies much good watercolour painting and certainly a great proportion of that produced during its history by the Society's members. The romantic, poignant image is emphasised by the deep and tonally superb shading.

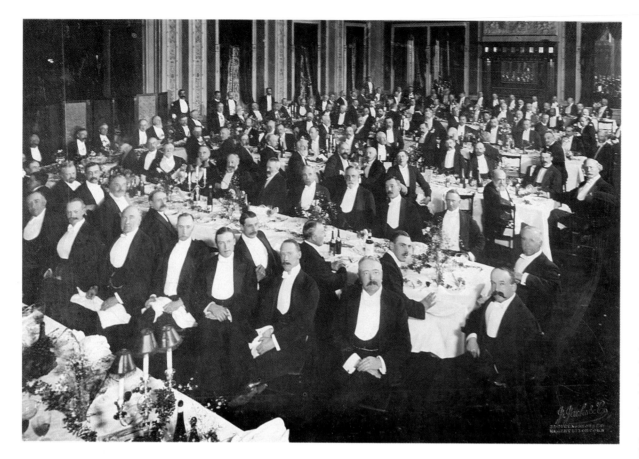

Centenary Dinner of the Royal Society of Painters in Water-Colours
Photograph

A photographic record of the 146 guests present for the Dinner held on Wednesday 27 April 1904 at the Trocadero in Shaftesbury Avenue, London. This was considered an anniversary of considerable note and was commemorated by a number of publications, including a special issue of *The Studio* magazine.

draws artists to wish to stand as candidates for election. The system historically used to elect new associate members is tortuous. It is, in practical terms, difficult for the members to elect more than five new associates annually from the hundred who apply and two or three is the usual number of successful candidates. The system is however a very fair one.

The candidates' watercolours are hung as an exhibition for the members to peruse. A complicated but extremely democratic balloting procedure is used and the election of one new associate will take some 40 minutes of voting. This apparently laborious method of seeking new colleagues allows the members every opportunity to exercise their judgement, and prevents any over-zealous electioneering from holding sway. When the confirmatory ballot shows that a new associate has been elected, the applause that follows echoes the sincerity of the commitment made to the selected artist by the Society for the rest of his or her career.

In 1984 the RWS elected two new associates whose vivid watercolours will grace the walls of the Society's

Bankside Gallery for many years to come. On election Gregory Alexander was twenty three and Jenny Wheatley twenty four. Whatever the make-up of the RWS will be in the early decades of the twenty-first century, our successors as appreciators of watercolour will undoubtedly revere the great contribution to the Society's history of Alexander and Wheatley.

The true contribution of the RWS itself to the development of watercolour painting in Britain is represented by the accumulation over the years of a series of exhibitions by its members, now numbering over 305 in total. These exhibitions have always been important because they have represented the concerted creative product of the membership. But the exhibitions are in one sense ephemeral – once finished they are dispersed, either to new owners or back to their creators. Only the catalogue and the memory remain. However, the Society does possess one most tangible record of its members' creativity.

In 1860, the Council of the Society decided that its achievements should be enshrined in a 'Diploma Gallery', which would contain examples of the finest work of members. The President of the time, Frederick Tayler, was a great supporter of the scheme, which had a precedent in the Academy's Diploma Collection, but its implementation was probably due largely to the Secretary, Joseph John Jenkins.

Jenkins was later a great benefactor of the Society, and his donations of watercolours and a fine library of books by or concerning members have enriched its collections. A distinguished watercolourist in his own right, Jenkins is, however, best remembered for his accumulation of correspondence and archive material concerning the Society's history, which formed the main primary source of J. L. Roget's *History of the Old Water-Colour Society,* the seminal work on nineteenth-century watercolour painting.

The uniqueness of the Jenkins papers lies in the fact that they largely consist of letters from or concerning artists of his acquaintance or of the earlier decades of the Society's history. Much of this correspondence resulted from the Secretary's initiative of circulating an appeal for information which would form the source material for a publication on the Society within the overall context of the establishment of the British watercolour school. Jenkins fell ill before he was able to complete his task, but with characteristic dedication and generosity he handed his valuable papers over to Roget to expand upon and, in 1891, to publish.

The Jenkins papers were lost for decades, but happily re-discovered on the Society's move from

Pandora
SIR LAWRENCE ALMA TADEMA RA RWS
(1836-1912)
Watercolour and bodycolour, with scratching out
$10^3/_8 \times 9^5/_8$ ins

A mythological figure subject by one of the leading
classicising painters of the late nineteenth century. The
essentially topographical chapter themes in this book do
not allow for subject pieces such as this, but they were
popular among the watercolourists of the time. This is a
particularly pleasing example of the genre.

 This work was originally designed as an oval and on the
paper underneath where the mount would have been
placed we can observe Alma Tadema's test brush-strokes,
with which he settled on the desired colour mixes.
Applying these to the paper sheet itself gave the artist a
precise indication of the final effect.

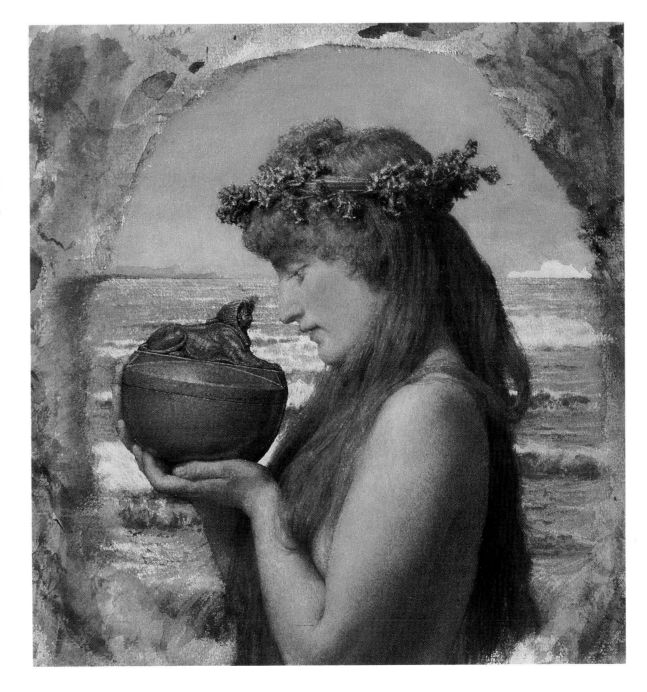

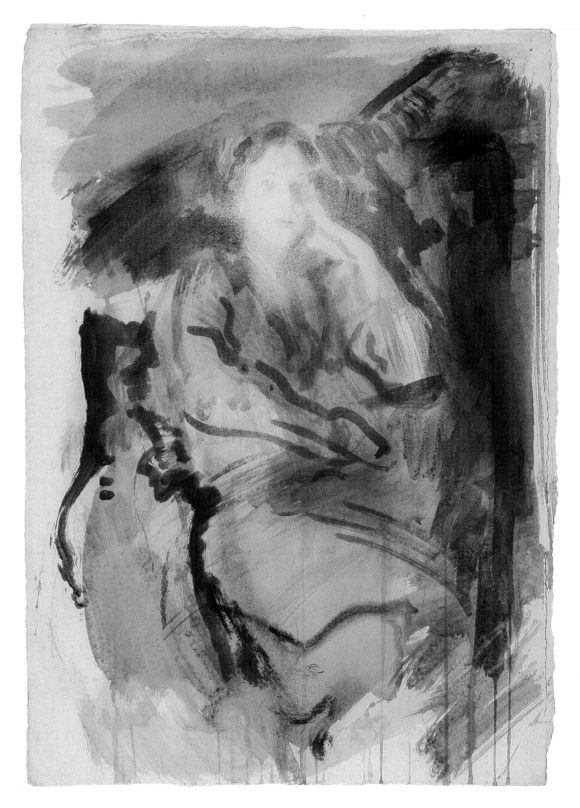

Beatrice
ARTHUR AMBROSE MCEVOY ARA RWS
(1878-1927)
Watercolour, ink and chalk
18 × 12¼ ins

Although for some time in the twentieth century portraits were barred from RWS exhibitions, studies of the figure such as this have always been accepted and admired. The no-portrait law has recently been revoked and the Society positively encourages figure painting in watercolour.

There is extraordinary breadth and freedom in this late work by McEvoy, who only joined the Society in the year before his death. The artist has attacked the paper surface, not in the manner of, but with the voracity of Turner.

Conduit Street to Bankside. Their importance for the scholarly documentation of the history of the art form is great and the enormous task of cataloguing the papers is currently being initiated. Of those who played a part in the establishment of a major collection of pictures and archive material for the Society, Jenkins played perhaps the foremost role.

The RWS Collection of watercolour paintings that has been thus accumulated is one of the most important holdings of work in the medium. Upon election, each new associate member is required to submit to the RWS a Diploma work in return for the Society's Diploma. Since 1882, when Queen Victoria acceded to a request from the Society, this Diploma has been signed by the Sovereign.

The RWS Diploma Collection is unique in its historical perspective on the contemporary judgement of artists of their own work. It may be, for instance, that Sir Hubert von Herkomer's conception of a representative example of his art for posterity does not accord with our conception in the 1980s of his most impressive aesthetic achievements. Another intriguing factor is that it is, unusually, a collection formed by artists and not by museum curators.

The Society has been fortunate to receive a number of important bequests of watercolours to augment the 'Diploma Gallery'. Notable among these has been the Jenkins Bequest in 1885 and the 1979 Parsons Bequest, which added eighty eight works to the Collection. Such gifts have enriched the Collection, but the principal growth of this holding of watercolours takes place through the giving of Diploma works. Each time this presentation is made, the RWS steps a little further into the future. This future is a commitment to the art shared by artists and by all those who have an

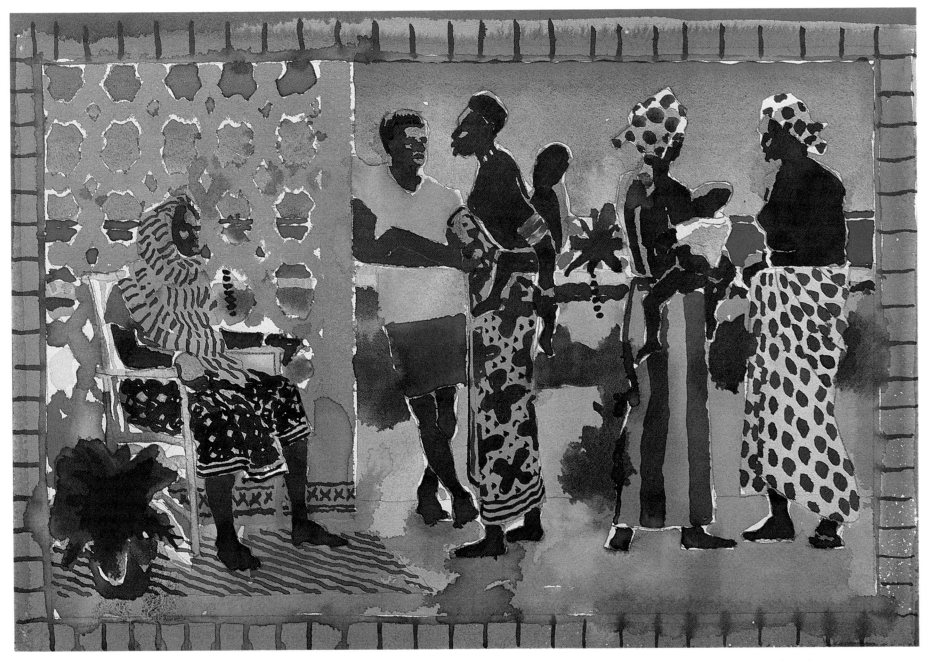

African Variation
GREGORY ALEXANDER RWS (b 1960)
Procion and watercolour
11¾ × 5¾ ins

A young artist using a new medium for new purposes. Alexander finds the vivid colours of the dye procion suit his exotic subject matter, in this case figures in a Kenyan setting. The newness of his medium, however, does not mean that the artist has not assimilated and made use of the technical example of his predecessors.

interest in the furtherance of watercolour painting.

Watercolours, like all works on paper, require special attention and care, for their state can easily be impaired by the existence of harmful acidic mounts or adverse environmental conditions, such as high humidity or an excess of light. Since 1984 the RWS has been engaged on a major conservation programme for its 500 watercolours, each of which must be preserved for posterity according to the most advanced methods of expert treatment. To implement such a programme, the Society has called on outside help. It has invited interested individuals and companies to 'Adopt a Picture', thus ensuring a particular watercolour's safety for the future. Those who adopt works receive in exchange for their financial contribution, a long-term association with their chosen painting. The 'Adopt a Picture' Campaign has enabled the Society to prepare an important travelling exhibition of newly conserved watercolours from the RWS Collection, entitled 'The Glory of Watercolour'.

The present book accompanies the exhibition, but its function is more far-reaching as a permanent record of some 100 watercolours from the Collection, both in colour illustration and supporting text. Because of the wealth of subject matter depicted in the Collection, the author has decided to embark on a representation of its holdings by subject theme. The chapter headings have been selected to provide an insight into how, over two centuries of great change in patterns of British life, the watercolourist has seen and depicted such changes.

The themes chosen are both reflections of the development of our environment and lifestyles over the period and of the particular concerns of the watercolour painters who have depicted them. On occasions we will find that the artist has, in the spirit of eighteenth-century topography, simply recorded his surroundings.

While this taste for topography has continued over the centuries, on other occasions we find that the subject matter is chosen to express a personal view of life. Girtin's achievements helped to free artists from the slavish depiction of commissioned views and to enable his successors to choose for themselves their attitude towards both watercolour and subject matter. The effects of such liberating influence mean that the watercolours we shall discuss are as varied in their message and image as they are in their technique. As we will see, great artists have used the medium as a method of expression of significant values and ideas. They have also conveyed sensations of sublimity, beauty, and sadness and joy. As technique is so often integral with the meaning of the watercolours chosen, the methods employed by the artists are described as fully as possible.

Those of us who are lucky enough to spend our working lives in the world of watercolours gain much satisfaction from the sympathetic and harmonious qualities of the art. It is a privilege and a pleasure to have this chance of sharing some treasured masterpieces in the medium with a wider audience, through this personal view of the RWS Diploma Collection.

THE BRITISH LANDSCAPE

Since the eighteenth century, the portrayal of the British countryside has been a primary concern of painters working in both watercolour and oil. The still flourishing tradition of landscape art in Britain is perhaps only rivalled in its longevity and diversity by the Dutch and French schools. It was upon the achievements of the painters of the Low Countries and those French artists working in Italy in the seventeenth century that the foundations of the British School were laid.

Dutch painters, such as Jacob van Ruisdael and Aelbert Cuyp, rendered the moods and atmosphere of their northern climate, although the serene countryside of Cuyp is tinged with a southern light. Maintaining the while a concept of naturalism in their approach to their surroundings, that was to have such an impact on the British School, they would also bring their landscape scenes to life with local colour and active human involvement. The Dutch had a feeling for the particular, the very detail of landscape and rural life, as in the skating scenes of Avercamp or the river subjects of Van Goyen.

For generations of British artists, from the early eighteenth century onwards, these precedents were a liberating influence. As they strove to break away from the formal conventions of post-Reformation art, which essentially constricted their production to portraiture, allegory and topography, British painters revelled in the earthy naturalism of the Dutch. But it was the great Flemish painter Rubens who brought the landscape painting of the Low Countries to these shores. A number of Rubens' most ambitious views of his native countryside entered English collections and their breadth, freshness and descriptive weather effects were to make a particularly profound impression on, among others, John Constable.

The more formal approach to landscape represented by those French seventeenth-century painters whose works are bathed in the light of Italy, such as Claude, Poussin and Gaspar Dughet, was also of great appeal to British taste. These artists were deeply affected by what they felt to be a classical conception of art and they brought to their pictures a formal compositional ordering of the landscape that was readily comprehended and imitated.

The guiding lights of the Picturesque in the late eighteenth century required landscape paintings to be constructed in an approved manner and the more they reminded them of the compositional style of Claude, the better. The landscape gardener, 'Capability' Brown would create a seemingly natural order from wild and unorganised nature in designing country estates. Similarly the theoretician and amateur painter, the Reverend William Gilpin, organised his imagined sepia landscapes to accord with compositional dictates, rather than any concern for naturalism. The strictly defined canons of the Picturesque espoused by such influential writers of the time as Richard Payne Knight played an integral part in the development of painters like Richard Wilson and J. R. Cozens, and the young Girtin and Turner. And Claude, Dughet and Poussin also brought to British artists and collectors a pleasing and fashionable glimpse of the arcadian light of the Mediterranean.

The great collections formed by the landed gentry in the late eighteenth and early nineteenth centuries confirm the esteem in which the Italianate-French and Dutch landscape Schools were held in Britain. Before the formation of public collections of paintings by 'old masters' like that at the Dulwich Picture Gallery in South London, which opened in 1814, it was in the houses of their patrons that British artists would principally have had the chance to see the products of these Schools.

The pictures had largely been collected abroad, at a time when the 'Grand Tour' was an essential part of the cultural training of a gentleman. The Tour took travellers through Europe to the envied golden light of Claude's Italy. Like the later productions of Canaletto, Claude's paintings of classical and mythological subjects set in an arcadian Italy were among the most prized souvenirs of the Tour. Paintings by artists of the Low Countries were also entering British collections, partly due to the ever increasing flow of commerce across the North Sea.

Thus, in the late eighteenth and early nineteenth century, British landscape painters had considerable opportunity and reason to see and be affected by the works of their Dutch and French forebears. This great age of collecting in Britain also gave artists and connoisseurs opportunities to study the works of painters of other nations. Notably they could observe the approach to landscape of Italian painters of the Venetian Renaissance and of the seventeenth century.

The wealth of foreign landscape painting in British country house collections like those built up at Petworth and Chatsworth helped artists to look afresh at their native landscape and remained a touchstone for the British landscape School well into the nineteenth century.

The freedom of later Romantic values did not prevent Turner, for example, from continuing to model his compositional structures on Claudian principals, even in some of his most 'abstract' late oils and watercolours of the 1840s. The use of classicising *repoussoirs*, a compositional device of receding projections of trees, hills or buildings, usually towards the sides of the picture area, often gave Picturesque form to the most dissolved of Turner's motifs. That he was using these structural keys for his most freely handled and daring forays beyond the boundaries of artistic convention is evidence of the painter's debt to his spiritual master, Claude.

On the other hand we should acknowledge Turner's ability to absorb and weld together, for his own purposes, influences from many sources. Throughout his career, Turner continually animated his paintings with everyday human activity. This injection of life into the countryside can ultimately be traced back to the seventeenth-century Dutch. Turner was the presiding genius of such eclecticism in British art, but his ability to develop a style through the assimilation of varied precedents echoes the development of the whole British landscape School.

Yet the impression should not be given that the School originated and flourished solely in a spirit of imitation. British artists have had a great deal to contribute to the development of the art of landscape and crucial to this individual contribution has been a close observation of the moods and vicissitudes of the climate. Our preoccupation with the weather is by no means a modern obsession and suitably reflects the exceptional range of climatic conditions which affect our surroundings and our lives.

The way a minute variation of light or atmosphere can change the mood of a vista of Suffolk countryside and sky provided John Constable with an unquenchable fund of subjects, conveyed both in oil and watercolour. His celebrated series of cloud studies describe with great subtlety an almost infinite range of natural phenomena. Climatic effects in Britain vary to an

Shady Quiet
SAMUEL PALMER RWS (1805-81)
Watercolour and gum, bodycolour and graphite with
traces of gold leaf
7⅞ × 16¼ ins

This life-size reproduction well conveys the wide vistas of
this beautiful mid-career work by Palmer. Particularly to
be appreciated are the half-concealed views over the
distant landscape and the intriguing tunnel through the
trees to the right. The richness and intense working of the
dominant foreground only serves to emphasise the
openness of the panorama.

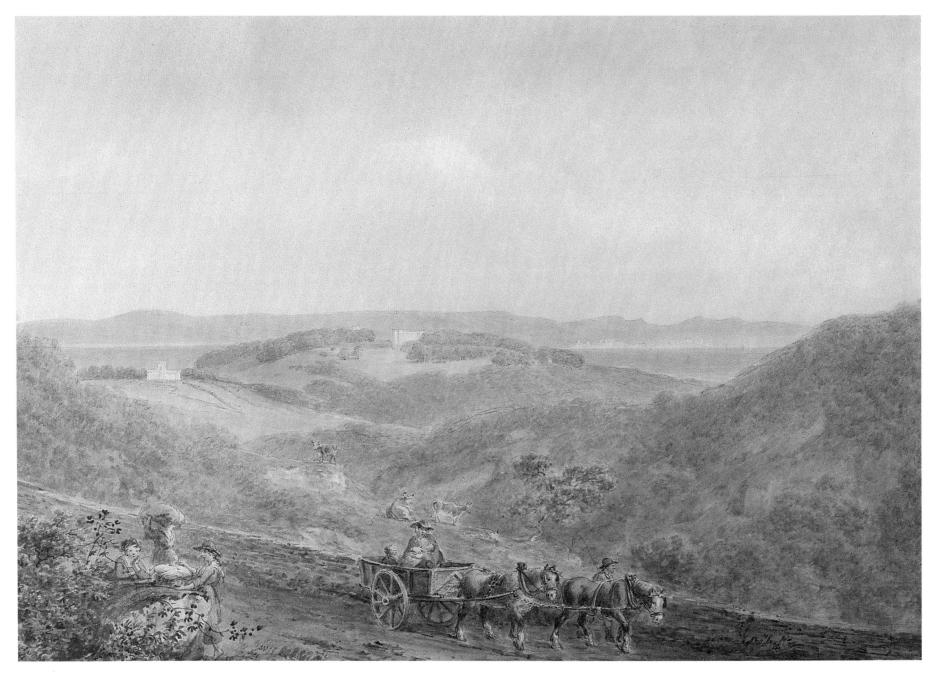

View of the Menai Straits from outside Bangor
NICHOLAS POCOCK OWS (1740-1821)
Watercolour over graphite
16½ × 23⅛ ins

Slightly faded over the years, this piece still retains a bright
and pleasing palette, as seen in this reproduction.

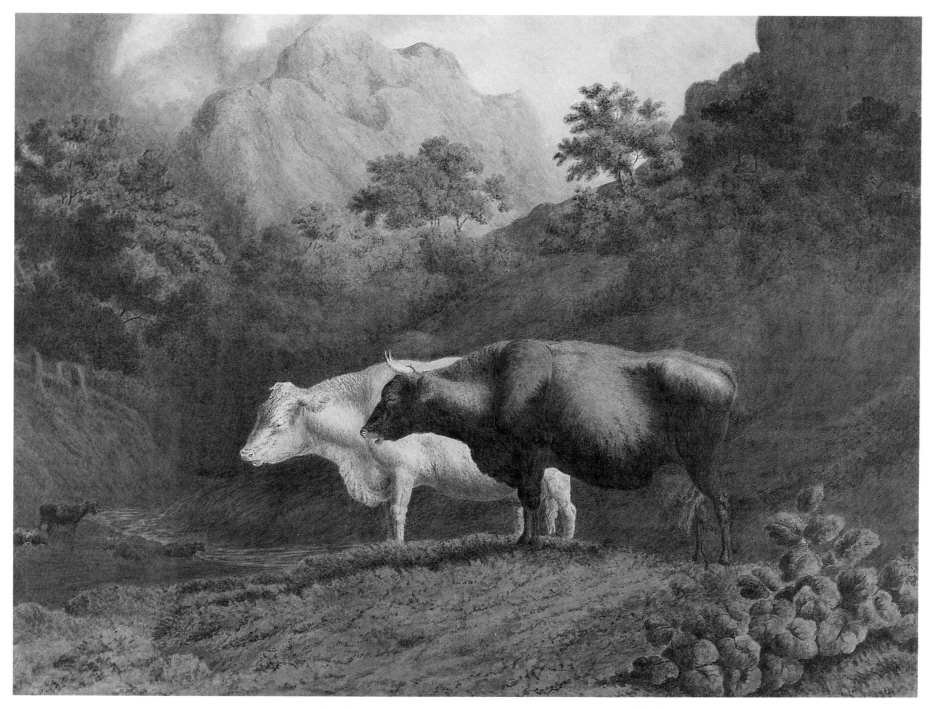

Cattle
ROBERT HILLS OWS (1769-1844)
Watercolour and gum over graphite with scratching out
14⅝ × 19⅜ ins

This illustration reveals the intricately wrought brushwork characteristic of Hills' tightest manner. He achieves a monumentality in this exhibition watercolour not sought for in many of the fine, but more freely handled, animal studies also in the Society's Collection.

extent not experienced, for example, by the inhabitants of Mediterranean lands, and their ephemeral nature has been felt by many artists to be captured best in watercolour.

The artist with his sketchbook, his portable set of watercolour paints and brushes and his water pot, is free to search the countryside for the most telling scene and there to record fleeting aspects of weather and light. Their ability to catch moments of natural effects is one reason why Constable and David Cox are sometimes described as precursors of the French Impressionists, those open-eyed portrayers of the phenomena of nature. Constable's followers and admirers in France were, in general, concerned with painting in oils *en plein air*, and the faithfulness with which they were able to record the most subtle effects of atmosphere is remarkable.

In the first decade of the nineteenth century there was in Britain a definite movement into the open air of artists using both watercolour and oil. This preference to paint before the motif was exemplified by Turner, who in 1806 to 1807 was in the habit of taking a boat onto the Thames and its tributaries. From the boat he made not only a fine series of watercolours, but also several large oil sketches of the river and its banks. In the same decade, many artists were making sketching tours of the more remote areas of Britain and returning not only with a fund of material for future work, but also with finished watercolours and studies of impressive scenery, usually executed before the subject.

It was not just the portability of watercolour materials that made the medium so appropriate to the recording of the British landscape. The very speed with which the accomplished painter may capture in watercolour the most fleeting atmospheric conditions makes the medium for many artists unparalleled in its suitability for this purpose. It is also true that the watery climate we endure and from which our painters have derived boundless effects, is very appropriately conveyed via this watery medium.

This chapter is about those painters who have taken their watercolour materials to the hills, mountains and valleys of Britain in the quest for scenery and motifs which might enhance our appreciation and understanding of the countryside.

They have found, as we shall see, great tracts of wild scenery devoid of man's presence. They have

Cader Idris, North Wales (*Detail*)
JOHN VARLEY OWS

This detail, slightly over life size, concentrates on the beautifully controlled and minute washes with which Varley has captured the horizontal expanses of the unruffled lake. We are able to examine the delicate depiction of the mountain of Cader Idris. The artist has used aerial perspective to convey the distant scene.

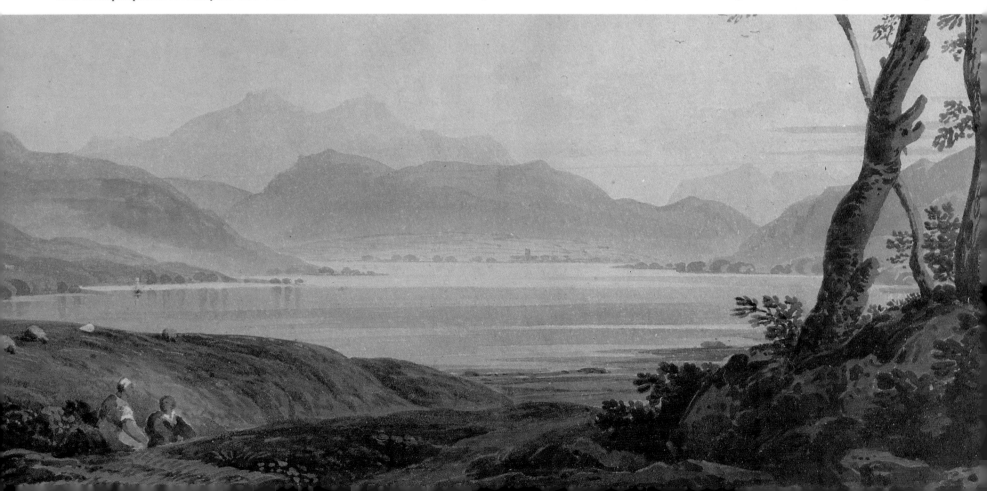

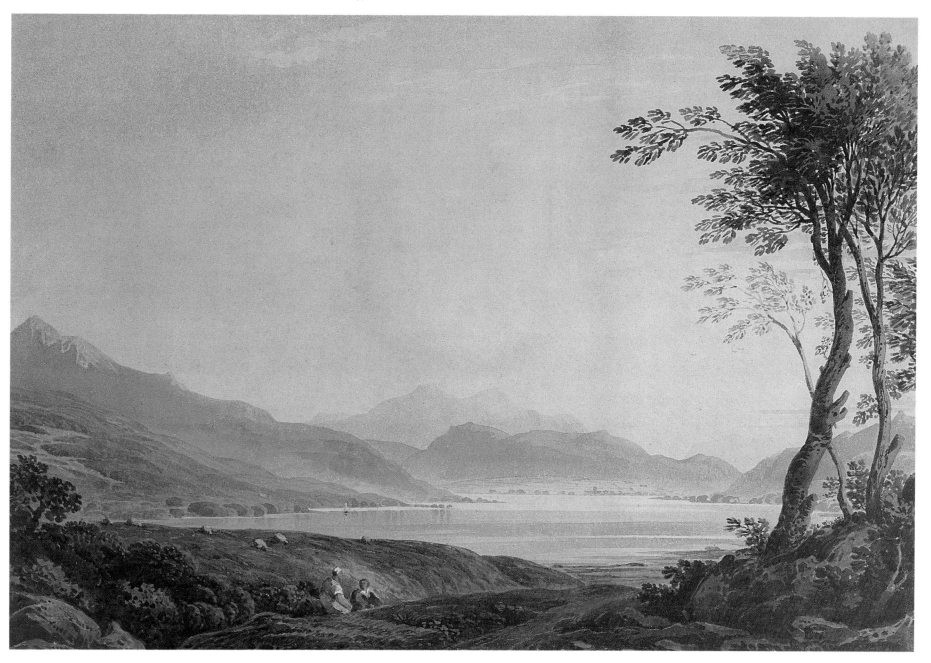

Cader Idris, North Wales
JOHN VARLEY OWS (1778-1842)
Watercolour over graphite
9½ × 13¾ ins

This lyrical Snowdonia panorama is reproduced here just under its full size. We may note the foreground *repoussoir*, with the Claudian trees set to the right of the composition, which relieves and enhances the broad expanse of water. The sharply defined foreground also contrasts with the subtle, misty tones of the distant mountains.

also chosen to paint rural scenes, where the signs of man's influence on the land are evident, be it through the growth of farming, transport or industry. Generally, however, we will be led to conclude that the effects of the Industrial Revolution and increasing urbanisation have led painters to seek a Britain untouched by the cotton mills or the car factories and to represent nature unaffected by the encroachments of the modern age.

One of the earliest watercolours in the RWS Collection, *View of the Menai Straits from outside Bangor*, by Nicholas Pocock, is a pertinent example of the portrayal of a rural way of life at a time when the Industrial Revolution was at its height. This scene, suitably tranquil and happy for an age when both rustic charm and grand but inhabitable landscape were valued for their picturesque qualities, shows the island of Anglesey in the distance, its coastline receding to the right, northwards towards Puffin Island. Later we shall see John 'Warwick' Smith painting a less rustic and picturesque watercolour of the island itself.

In the foreground, farmworkers, or villagers, trail along a rough track before a horse and cart. A young boy turns his eyes towards us and leads us, not only into the picture, but possibly to wonder about his working life in this scene. Pocock was not, however, noted as a social commentator. Picturesque subjects such as this were stock in trade for artists of the late eighteenth century who were providing anecdotal watercolour landscapes for, perhaps, local landowners. The interest in rustic life, a passion in eighteenth-century France but deriving also from the Dutch, had already been well established in Britain by men like George Morland and Paul Sandby. We shall see in a later chapter that the tradition remained popular right through the nineteenth century.

Pocock is better known as a marine artist than for his admittedly numerous landscape watercolours. He was born in Bristol in 1740 and worked at sea for the first half of his life. At about forty, he took up art and in 1709 he moved to London to expand his practice as a painter of naval engagements. The oldest of the founder members of the Society of Painters in Water Colours, Pocock withdrew upon the reconstitution of 1812. He died in 1821. Although in essence a coloured drawing, the view of Anglesey contains some well-wrought washes and is a good example of the artist's ability with the brush. Its colour range is relatively limited, but is nevertheless quite advanced in its description of the distant hills and sky.

Pocock's picture gives a taste of the kind of pic-turesque landscape predominent in the age of Sandby, but this chapter is mainly about the later exploration of the wilder corners of the British Isles made by a younger generation of watercolourists and their successors. The first Secretary of the Society, Robert Hills, was another artist rooted in eighteenth-century traditions of subject matter. In a nation which values highly its history of sporting art and enjoys the portrayal of domesticated animals, Hills' particular forte was the depiction of horses, deer or cattle in landscape settings. The publication of George Stubbs' *Anatomy of the Horse* provided a model for many equestrian painters. But the anatomical studies by Hills, including the beautiful series of wash drawings in an album given to the RWS through the good offices of J. J. Jenkins, reveal an original scientific and creative mind at work. Hills was also a landscape watercolourist of note and his studies made on the field of Waterloo, soon after the Battle, are spontaneous and apparently faithful renditions of the scene.

In his watercolour, shown here, of cattle in a mountainous landscape, Hills combines his ability to depict these statuesque animals with a dramatically rendered backcloth of stream, hills and rocky pinnacles. Much earlier, Stubbs and James Ward had produced important oil paintings of horses and cattle in sublime and imposing rocky scenery. Hills' grandiose and rather touching picture undoubtedly owes a debt to those two artists, but it is important to our theme because the subject is treated with great confidence and monumentality, and a rich Romantic manner, in the medium of *watercolour*.

The method Hills employed to achieve his monumental effect was an elaborate massing of a multitude of tiny brushstrokes of strong colour, which give density and substance to his painting. This handling also has the advantage of being able to convey the smallest variations of light and texture. It was a technique used to even greater effect by Turner in his watercolours produced for engraving. This picture, however, exemplifies Hills' singular style and his ability to draw with the brush in a manner dissimilar to, but showing knowledge of, that of Girtin.

Hills, born in 1769, apparently received his early training from John Gresse, a drawing master and a collector. He went on to study at the Academy Schools in 1788. Besides being a prolific exhibitor with the Society, in whose inception he was one of the driving forces, Hills was also an accomplished etcher. He retired from the Society during the interregnum of the second decade of the nineteenth century, but returned in 1823. Later he was one of the artists who gathered around William Blake and that future alumnus of the Society, Samuel Palmer, in the Shoreham Valley. Having exhibited some 600 watercolours at the Society's exhibitions, he died in 1844, his seventy-fifth year.

Another much younger founder member, whose debt to Girtin was immense, was John Varley. While watercolourists growing up in the last decade of the eighteenth century might have been able to study old-master oils in the houses of the aristocracy, they would less commonly have seen in such houses the watercolour drawings of their immediate predecessors. Being less expensive and generally smaller works of art, the collection and commissioning of drawings in the eighteenth century could be undertaken by the middle classes. It was in the collection of the leading psychiatric doctor, Thomas Monro, that Girtin and Turner found and were encouraged to copy the works of J. R. Cozens and other founders of the British watercolour School. From about 1794 to 1797, the two young men spent many evenings at Monro's 'Academy', imitating by lamp-light the masterpieces of Cozens in line and wash.

Varley too came under the influence of Monro and his works of the 1800s owe much to the watercolours by Girtin that he saw in Monro's collection. Even into his later years, Varley's art reflects this influence, as well as his appreciation of the concepts of the Picturesque and the work of eighteenth-century painters such as Richard Wilson. The formulaic approach to even the most sublime Romantic scenery, which an acceptance of Picturesque principles encouraged, led Varley to develop a sometimes unhappy capability to mass-produce his watercolour subjects. He was one of the earliest and most notorious of a distinguished line of painters of such 'pot-boilers' and, in his successful practice as a teacher, he must have encouraged others. Varley had every reason to work in this way, for the large number of watercolours he habitually sent to the exhibitions of the Society not only earned him a decent share of profits, as we saw earlier, but also sold well.

By the year 1822, when he painted the watercolour of Cader Idris, reproduced here, Varley was however experiencing leaner times. With an unhappy marriage and eight children to support, he fell heavily into debt. He had only relatively recently emerged from a period in gaol for bankruptcy when he painted the serene watercolour before us now. Varley's surprising capacity, despite his circumstances, to serve up an acceptably convincing view of a well-worn subject is brilliantly shown here. It would be unfair to describe

The Copper Works on the Parys Mountain, Anglesey
JOHN 'WARWICK' SMITH POWS (1749-1831)
Watercolour and gum
5 × 8½ ins

This full-size illustration of Smith's interesting record of
the once prosperous copper mines reveals his traditional
use of outline and wash for the distant hills, contrasting
with the more 'fashionable' gum-laden richness of the
foreground.

In the Highlands (*Detail*)
ANTHONY VANDYKE COPLEY FIELDING POWS

This detail is shown nearly twice life size and reveals even better the subtle tonal changes and counterpoints of the picture. Note how the cattle closer to us are set darker against a lighter stretch of water than the more distant and peripheral cow. Still further away a boat's sail seems to melt into the golden haze created by the low sun. Fielding has used the reverse end of his brush to scrape out the boat's form as well as some of the foreground highlights.

as a 'pot-boiler' this watercolour of the most delicate touch and feeling for its subject.

Varley may not in fact have visited North Wales since 1802, when he travelled in the company of his brother Cornelius. But his good visual memory, aided by sketchbook information and enhanced with Claudian principles of composition, meant that he could produce a formalised but enchanting watercolour of great integrity some twenty years later. The *repoussoir* created by the dark trees is a characteristic Claudian device.

As well as physically following the footsteps of Girtin to Snowdonia, Varley also followed the master closely in his use of watercolour. The wide watercolour washes used to represent the lake emulate the subtlety with which Girtin also washed in stretches of water. The detail illustrated here follows the artist's brush across the panorama of the lake. We also see in the middle foreground two figures, perhaps engaged in conversation about the captivating scene before them. While their communication with each other means we cannot strictly describe them as onlookers on our behalf, this is the function they serve for us. Such onlookers are to be found in numerous paintings

of the early nineteenth century and they serve as intermediaries for the viewer, whose acceptance of the reality of the landscape depicted is encouraged by this human presence in otherwise humanly uninhabited scenery. The figures and the distant cattle, a Girtinesque touch, also give perspective to the landscape and a sense of scale. This human presence in nature is redolent of the pantheism inherent in the verse of Wordsworth. The intellectual conception of Picturesque and Romantic landscape expressed by English poets was in advance of the efforts of painters, but it can be argued that artists such as Girtin, DeWint and Palmer gave visual form to the preoccupations of, respectively, Wordsworth, Clare and Blake.

Some important aspects of John Varley's career have already been outlined, but let us fill it out with a little more detail. Born in Hackney, East London, in 1778, he went on to study with two topographical draughtsmen before joining the Monro circle. About 1818 he made Blake's acquaintance through an introduction by John Linnell. The poet's influence was profound and Varley became deeply interested in astrology and physiognomy, publishing a treatise on

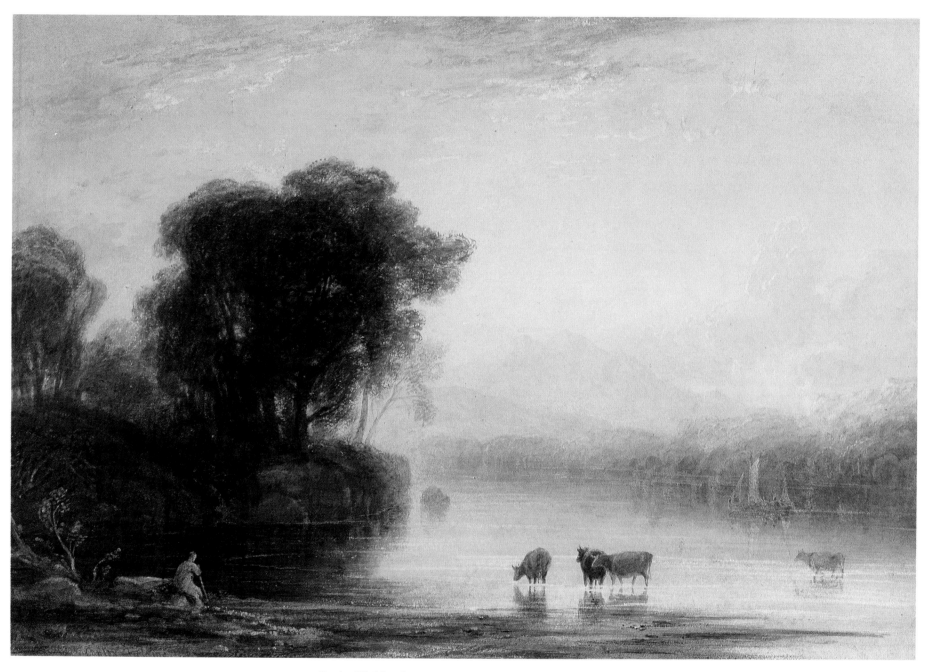

In the Highlands
ANTHONY VANDYKE COPLEY FIELDING POWS
(1787-1855)
Watercolour and gum, with scraping out
9⅝ × 13¾ ins

Reproduced slightly under life size, the radiant, overall golden light of the scene may still be appreciated. This is essentially a tonal painting and it is well worth examining the careful tonal variations made by Fielding throughout this Claudian composition.

the latter subject in 1828. Despite his prolific work and fame as a teacher, he died destitute in 1842.

For a contrasting view of the presence of humanity in the mountainous regions of North Wales we turn to John 'Warwick' Smith's slightly earlier view of the *Copper Works on Parys Mountain*, in which we see the encroachment of industry into a remote area of Anglesey. While this watercolour is undated, it is known that Smith visited Wales on a number of occasions between 1784 and 1806. As we shall see later, there are, however, reasons for believing that Smith painted the *Copper Works* after 1815. A near contemporary of Hills and some twenty-five years older than Girtin, he was one of the artists whose long career spanned and to some extent assimilated the development of the watercolour from the tinted drawing to the independent painted art work. The present example contains elements of both types.

Born in 1749, and going on to study under Sawrey Gilpin, Smith was one of the fellow exhibitors invited in 1805 and was elected a member in 1806. Having been Secretary and Treasurer, Smith was made President for the years 1814, 1817 and 1818. He left the Society in 1823, eight years before his death. His two appellations of 'Warwick' and 'Italian' Smith refer to his period of employment as topographical draughtsman to the Earl of Warwick, whom he accompanied to Italy. It was common practice to differentiate in this manner between artists bearing similar names and we will later come across William Turner 'of Oxford', who was not to be confused with William (or as he went on to call himself, J. M. W.) Turner RA, and William Evans 'of Bristol', whose namesake was a drawing master at Eton.

While Smith's watercolour of the *Copper Works* depicts the introduction of industry into a barren and previously undisturbed scene, the very nature of the mining and processing work involved is quintessential to the geology of this particular landscape. Like the other minerals becoming important to industrialised Britain, copper had to be excavated where it was available. Also the ruggedness of the scenery is echoed by that of the fort-like works. There is, for all this, a stillness about the scene, which, together with the apparent lack of human or mechanical activity, gives to this watercolour the air of an industrial archaeology record. The dilapidated state of the roof of the small building in the foreground seems to emphasise this sense of quietude, as does the serene summery weather and the obviously low sun.

Parys Mountain is an upland of some 500 feet, a few miles south of Amlwch, a coastal town in the north of Anglesey. The mountain's rich copper deposits were mined by the Romans, but the heyday of its productivity was between 1768 and 1815, when it became the largest copper mine in Europe, employing some 1,500 people. The immense volume of ore extracted from the mountain meant that this one mine was responsible for controlling world copper prices. As a result of the works' importance, Amlwch developed over this period from a hamlet to a prosperous harbour town.

The subject of quarries and mining works was popular with painters of the period and in 1805 the watercolourist Louis Francia depicted the Parys works as a scene of flourishing industry. But by 1815 the best of the copper ore was exhausted and the prices of foreign copper had come to undercut those of the Anglesey mine. The works closed down, leaving decaying buildings and a great crater at the summit of the mountain. It is apparently this recently deserted site which Smith depicts – the crater filled with water and the green, copper rich rocks being clearly visible.

The artist has used the low angle of the sun's rays to create a large area of shadow on the rocks in the foreground. This is principally a technical device successfully employed to give recession to the sunlit middle distance, where the dramatically shaded buildings stand out against the far panorama of hills. Smith's method of outlining in graphite and then washing in the hills is, like his generally linear technique, redolent of the approach of an eighteenth-century topographical draughtsman. The density of colour drawn with the brush into the foreground rocks is, however, evidence of newly established confidence in the medium as a vehicle for painterly expression.

Another long-serving and prolific member of the early Society who sought many of his subjects in the more remote corners of Britain was Copley Fielding. He was born in Halifax in 1787 and having been brought up in the dramatic scenery of the Lake District, Fielding went to London in 1809, joining the Monro 'Academy' and taking lessons from the by now established John Varley. Made an associate in 1810 and a member in 1812, he stayed on during the years of the Oil and Water Colour Society, was its Treasurer in 1813 and became Secretary in 1815. His twenty-four years as President, from 1831 until his death in 1855 make his tenure of office the third longest in the Society's history, after Sir John Gilbert and Robert Austin. Under Fielding's direction the Society consolidated its position as the leading exhibiting forum for watercolourists.

The democratic processes of the Society have never been interfered with by Presidents, who have always been subject to annual re-election. But the stability of Fielding's Presidency, following as it did a ten-year stint by Joshua Cristall, must have helped relieve the Society of the tensions inevitable with the annual musical chairs of changing officers that had been the habit in its more uncertain, nascent years. The Society of Painters in Water Colours had clearly found its feet. Since Fielding's election to the office only twelve members have presided over its affairs and this fact is undoubtedly testimony to consistent planning and certainty of purpose.

Like Michael Angelo Rooker, a fine watercolourist of the late eighteenth century, Anthony Vandyke Copley Fielding was blessed with forenames which anticipated his choice of career and encourage writers to repeat his name in its full grandeur. To his credit, he usually wished to be known simply as Copley Fielding. If Turner was a genius at marrying a variety of absorbed styles in his own work, Fielding, as if his name was his birthright, was an unashamed eclectic. He was in the habit of accumulating other artists' manners and styles as they suited his needs. But for all this he was never purely an impersonator and the original talent represented by his finest watercolours, such as the Highland scene from the Parsons Bequest illustrated here, is one of the unrecognised successes of nineteenth-century watercolour painting.

The Turneresque treatment of this sublime scenery is most convincing in its handling. As in Varley's *Cader Idris* we are led into the picture by an onlooker, who gazes upon the tranquil water, wonderfully lit by a setting sun. The technique of scraping out with the reverse end of the brush, learnt from Turner, is effectively used in passages defining the boats and water to the right of the scene. But this area reveals much more intricate and subtle manipulation of the medium. The building up of layers of washes and the masterly handling of the 'right' end of the brush to create a receding perspective of light effects owe much to Turner, but have an atmospheric beauty which may justifiably be ascribed to Fielding alone.

Martin Hardie's description of Fielding's art in his seminal three-volume history of *Water-Colour Painting in Britain* seems apposite when considering the present picture. Hardie characterises the artist's style as bearing '. . . a certain timelessness, as if the hot stillness had hung for centuries over the scene.' Slight fading may here have warmed up the reds, yellows and browns, but Hardie's evaluation is still pertinent to *In the Highlands*.

The Claudian group of foreground trees on the left are not so well handled as the passages discussed

Welsh Flood
ALFRED WILLIAM HUNT RWS (1830-96)
Watercolour with scraping out
14½ × 21⅛ ins (sight)

This moody watercolour is reproduced slightly less than one quarter life size, but still retains much of its power. The subject and vigorous technique are reminiscent of David Cox, while the intensity of the working of the sheet and the fearsome grandeur of the conception say much about Hunt's debt to Turner.

Landscape with Goats (*Detail*)
ROBERT THORNE WAITE RWS

Slightly under life size, this detail reveals fully the deftness of Thorne Waite's brushwork and picks out the central features of the composition, with the goats being led into the inviting middle distance. This is a picture simply to be enjoyed.

above. In this area, Fielding has used a considerable amount of gum arabic. This gelatinous substance, which binds the pigments in watercolour paints, was employed by nineteenth-century artists, from Girtin onwards, to give greater substance and density to parts of their works. Oil painters of the late eighteenth century had used bitumen for not dissimilar purposes, a practice that proved disastrous because with age this substance congeals and distorts the paint surface. Unless used too heavy-handedly, gum arabic is more permanent and, if so desired, is capable of providing on paper a consistency resembling that of oil paints. Sparingly used, gum can give variety and relief, especially to those foreground areas the watercolourist wishes to stand out from the distant scene. In this case, Fielding's somewhat indiscriminate use of gum for the trees has left us with a bland and indistinctly modelled foreground *repoussoir*. None the less, this picture is a remarkable and resonant view of the untouched British hinterlands, comfortingly seen with the aid of an onlooker.

Possibly one of the greatest treasures of the RWS Collection is an intricately constructed watercolour by the visionary painter, Samuel Palmer. Reproduced in its full size at the beginning of this chapter, the luxuriant and intense quality of this work is made manifest. Recent research has revealed it to be that sent to the Society's 1852 exhibition under the title *Shady Quiet*. No 251 in the exhibition, the picture was bought for ten guineas (plus one guinea for the frame and glass) by Palmer's fellow exhibitor, J. J. Jenkins, the Society's Secretary. A close friend and supporter of the often impoverished and sickly artist, Jenkins later returned this watercolour to the Society's Collection in his Bequest, which provided several of the masterpieces of the early and mid-nineteenth-century that the RWS now holds.

Born in Newington, South London, in 1805, Palmer was a precocious artist and first exhibited at the RA at the age of fourteen. A close associate of John Varley and William Blake, he is one of the mystical

Landscape with Goats
ROBERT THORNE WAITE RWS (1842-1935)
Watercolour over graphite with scratching out
14⅛ × 21⅛ ins

This reproduction conveys the breezy airiness of the original. The bright, open sky is economically and attractively handled, as is the rolling landscape.

eccentrics of British art. The highly imaginative and spiritual drawings of his younger life, produced in and around the village of Shoreham in Kent, became a major inspiration for the Romantic landscape painters of the 1930s and 1940s, such as Sutherland, Piper, and Minton. Palmer, whose achievements went relatively unrecognised during his lifetime, presented to these artists of the modern age a vision of landscape which eschewed the unselective naturalism and apparent mundanity of much nineteenth-century art in favour of a more profound analysis of man's relationship with nature. Palmer seemed to be in contact with the elemental and sublime driving force of the natural world and the youthfully intense work of his Shoreham period was informed by a deep Christian commitment.

It was Martin Hardie who reintroduced the early Palmer to a twentieth-century audience in an exhibition at the Victoria and Albert Museum. Following the interest in the young Palmer thus created, developed a view that after the Italian period, while on honeymoon with Hannah, John Linnell's sister, his artistic powers declined. Fortunately, a reappraisal of these years and particularly of the late etchings now allows us to appreciate the majesty of the full career of this remarkable artist.

Shady Quiet, a mid-career work, bears many of the qualities and much of the pastoral vision of the Palmer of the Shoreham period. The sheep are depicted with the 'blobby' technique so characteristic of that used for the flocks which played a central role in his early work. The pastoral idyll, though not seen with such intensity as in the monochrome drawings of the 1820s and 1830s, is entirely convincing in its sentiment.

In this work Palmer can be seen to have grown up as a picture-maker. The flatness of the naively but compulsively composed early works has given way to a more conventionally mid-Victorian composition of considerable sophistication.

The two vistas – to the left over the distant valley and to the right, down through the tree-covered lane – open up the scene in an unusual and, for the eye, pleasingly distracting way. But our view of the subject is not dislocated by this compositional exercise, as the picture is tied together by the placement of figures, sheep and trees. The woman emerging along the lane stops the eye wandering too far along that track and brings us back to the central subject of the leisurely shepherd, providing a young child with a drink from a glass which has been outlined by the artist in gold leaf. The man's hat is also edged with gold, a little of which has been applied to the foliage of the trees, and the

intensity and preciousness of the whole conception reveals Palmer at his best.

Samuel Palmer's letters to Jenkins, now held in the archives of the RWS, sadly describe his poor financial state and his low morale. One saving grace was the companionship and ability to exhibit, that his membership of the Society afforded him. Its exhibitions were the principal forum for the display of this great painter's art and his letters make clear that the comradeship of his fellow artists was very dear to Palmer.

Elected an associate in 1845, he was brought into the membership in 1856 and continued to exhibit regularly until the Society was made Royal in the year of his death, 1881.

Alfred William Hunt chose a less idyllic scene for his Diploma work, finding, like John 'Warwick' Smith, a source of inspiration in the Welsh hills. Hunt's picture of a *Welsh Flood* is a resoundingly forceful record of an incident he must have come upon during his travels. By comparison with Smith's tranquil watercolour of the Parys Mountain, it shows nature in its most awe-inspiring and potentially destructive mood. We feel that both artists have stumbled upon a subject that has captivated their attention and provided the impulsion, even if in the confines of the studio, to make a visual record of the scene. Taking into account that Hunt's watercolour is an elaborate one, destined for exhibition, it nevertheless bears a freshness and strength that implies recent contact with the dramatic subject. The immediacy of the act of watercolour painting lends credibility to these notions and while Hunt and Smith are 'picture-making' in these works, they are also utilising the spontaneous and intimate qualities of the medium.

Hunt, born in Liverpool in 1830, was inspired in his early work by his father's friend David Cox, whose style and enjoyment of terrifying scenery are echoed in this watercolour of 1870. Elected an associate in 1862 and a member in 1864, Hunt gave the *Welsh Flood* to the Society some years into its project to form a 'Diploma Gallery'. He was elected Vice-President in 1888, eight years before his death.

The influence of Turner and of the Pre-Raphaelites, with whom he was associated from the 1850s, enabled Hunt to move beyond the style of Cox. The high finish of the Pre-Raphaelites and the all-embracing vision of Turner's exhibition watercolours both had a significant effect on the young painter. No British artist before Turner could have conceived such an abstract rendition of his surroundings as features in this apparently formless painting. While we

can observe the broadly dark, encompassing landscape towards the sides of the picture, we are essentially looking at a painting of a torrent of water, which is not relieved by any comforting picturesque reference points. The flood is the total picture and confronts us in a most uncompromising manner.

In *Modern Painters*, his major series of publications intended to demonstrate the achievement of Turner and of the Pre-Raphaelites, John Ruskin called for an honest and all-embracing depiction of the elements of nature. Although he regarded Turner as the fulcrum of his argument, inheritors of the great painter's vision, such as Hunt and Albert Goodwin, carried Ruskin's theories into the latter half of the nineteenth century. Ruskin himself was a great advocate of the importance of the Society and a regular purchaser of works from its exhibitions. He was proud of the Honorary membership granted him in 1873, when this class was first established. With Gladstone, Ruskin was one of five men honoured by the Society, whose minute book for the 24 March General Meeting records his formal acceptance to the Secretary, A. D. Fripp.

'No honour that I ever yet received has given me so much pleasure as the quite unexpected one which your favour of the 18th announces to me. The first works of art I ever cared for, (and I care for them still) were those of your old member – the quiet and tender, mountain-lover – George Robson – my first real master was Copley Fielding, and in your room I still spend the happiest hours that modern art can bestow on one. I beg of you to express very earnestly to the members of the Society my sense of the honour done me by their courtesy and to the President and to Mr A. Hunt my more especially personal thanks for their favour on the occasion.'

Singled out in this letter of acceptance, Hunt, in his *Welsh Flood*, accords with Ruskinian principles in his open-eyed and unsentimental rendering of the forces of nature. The intense working with both ends of the brush that the artist has employed activates the picture in a way that is comparable with the most feverish conjurings of Turner.

Whereas Hunt recorded the drama, darkness and terrible power of the elements, Robert Thorne Waite shows a much more refreshing and hospitable aspect of our climate in his Diploma watercolour of a pastoral southern English landscape, probably in Sussex. A herdsman leads his goats away on a breezy summer's day and the flickering light created by the scudding clouds serves only to enhance the beauties of a richly abundant countryside. We can almost feel the warm,

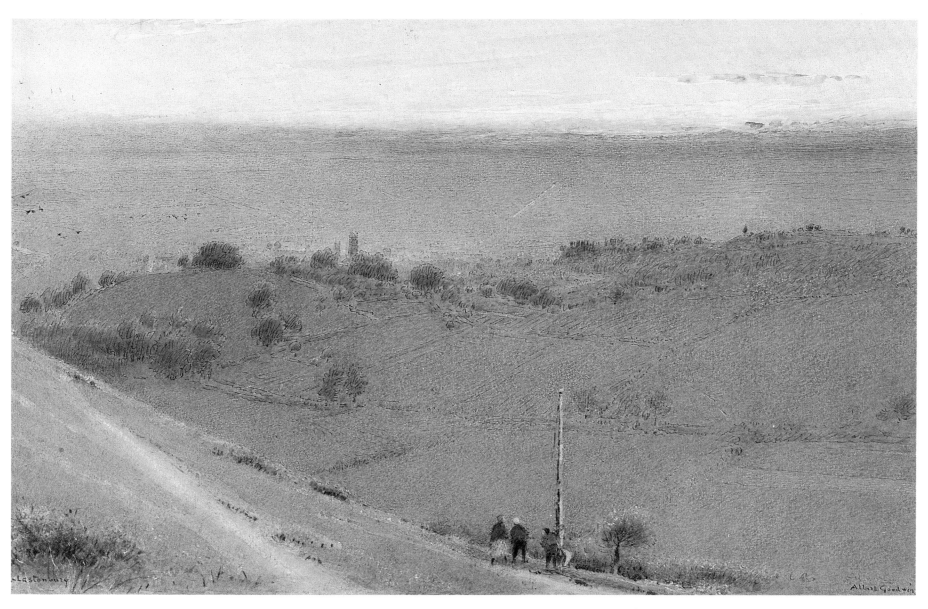

Glastonbury
ALBERT GOODWIN RWS (1845-1932)
Watercolour, bodycolour and pen and ink
12 × 19½ ins (sight)

About one quarter of its full size, as illustrated here, this work's subtle tonal ranges may possibly be better understood than in any larger scale reproduction. The extensive, near abstract passages of paint are welded together with the later application of a superstructure in ink.

41

but fresh air and the freedom and directional brushwork of Thorne Waite's handling accentuate the movement of the trees and clouds and, consequently, the wind. This painting is a simple celebration of the British countryside and its own appeal and worth lie in the artist's own joy in his environment.

Robert Thorne Waite was elected an associate of the Society in 1876 and, following the grant of the Royal title, he became RWS in 1884, when his election to membership obliged him to present this Diploma work. His watercolour style was initially influenced by Copley Fielding and he studied at the South Kensington Schools, London. Born in 1842, Thorne Waite was of a generation for whom it was becoming *de rigueur* to study at one of the newly established colleges of art. The Royal Academy Schools had long been constituted as a vital element of that institution's educational purpose and, together with less formal academies such as Sass's, Monro's and the Sketching Society, the Academy Schools had been able to provide for watercolourists a valuable training ground.

It was, however, in the latter half of the nineteenth century that watercolour, as a medium for major works of art, received sufficient acknowledgement to be treated as a discipline in its own right at such educational establishments. Whereas watercolourists of an earlier generation were trained under the watchful eyes of private teachers such as Varley, a budding artist in the medium like Thorne Waite was able to undergo training in the environment of a fully-fledged art school. While such training lays the artist open to the vagaries of attitudes of a number of teachers, it does of course enable a freedom of choice for the student who is initially unsure of his direction. It is sad to relate that watercolour is no longer taught as a specific medium in art colleges and we will discuss this present lack of formal tuition later.

Thorne Waite lived until 1935, but his watercolour technique is deeply rooted in the tradition of Fielding, Cox and DeWint. For the purist, his use of the medium is exemplary, and the execution of the *Landscape with Goats* is achieved with great economy. The artist has only touched the paper where the needs of the picture have so dictated. There is no uncertainty in the handling and no evident reworking of any passages of the picture. It is of course the nature of the pure application of watercolour that every brushstroke counts and may not, without difficulty, be deleted. For all the majesterial qualities of Turner's most complex works in this medium, the very simplicity of touch of painters like DeWint and Thorne Waite

at their best is peculiarly breath-taking and impressive for its assurance of purpose. There is no going back on any single brushstroke applied to the paper. Whatever superseding washes may influence a passage of a watercolour, artists using the medium in its purest form stand or fall on their technical and artistic ability at every moment of the creative process.

In his picture, Thorne Waite makes use of some scraping out for highlights and has based his watercolour on a loose pencil drawing. Despite these technical aids, this is a most spontaneous work, in which the power of the accomplished artist to draw with the brush is well demonstrated.

Albert Goodwin's process of arriving at a finished watercolour was immensely more complicated and the techniques of his mature works derive from the most intricate works of Turner's later years. Painted in 1924-5, *Glastonbury* is a wistful and typical example of Goodwin's late style. He has characteristically selected an unconventional view of a celebrated landmark and turned a potentially topographical scene into a subtle rendering of the light and atmosphere of the Somerset levels. But Goodwin was only able to develop the Turnerian approach that proved such an appropriate vehicle for his own mature vision through the patronage of John Ruskin.

Taking into account the unconventional view away from, and not towards, Glastonbury Tor, Goodwin was nevertheless a painter of places. He was a topographical artist with a poetic feeling for the world around him. In suitably Turnerian fashion, his world was extensive and the gorgeous colours of his watercolours painted on the other side of the Atlantic have their basis in his study of the light and colour of Venice. It was Ruskin who introduced him to Venice and to the watercolours of Turner.

The first time Goodwin came under the influence of the great critic was in 1872, when Ruskin took his young protégé to Italy. Goodwin was already moving in Pre-Raphaelite circles and the intensity of his handling of watercolour throughout his life is an echo of the Pre-Raphaelite obsession with the detail of life and landscape. Nevertheless, Turner's influence was probably the stronger and Ruskin's description of the master's work as 'imaginative topography' is a label which fits Albert Goodwin just as well.

Goodwin's idiosyncratic watercolour technique is illustrated in the painting shown here. The misty light of the Glastonbury plain is caught by a careful manipulation of watercolour with the opaque white of bodycolour. In the distance, the setting sun catches one of the drainage ditches which criss-cross the

levels and this minute, but pictorially important note is achieved with a sliver of bodycolour.

Goodwin's process typically involved painting directly onto the paper with watercolour and chinese white. On this often opaque foundation he would wash transparent colour, thus imparting a translucent glow to substantially painted passages. On top of all this, we can see him drawing outlines and emphasising details with an ink pen. We find this technique employed to great effect in the watercolour of Glastonbury. There is also in his *oeuvre* much evidence of Turner's scraping-out process, intended to bring highlights out of newly painted dark or strongly coloured passages of the picture. In the present watercolour, however, Goodwin's procedure has been remarkably single-minded. The artist's complex technique does not impede our simple enjoyment of his celebratory treatment of the subject. It is with small touches, like the onlookers, those nineteenth-century participants who now reappear in a twentieth-century painting, and the delicate strip of water, that Goodwin enlivens the scene and sets off his broad approach to the mood and colour of landscape.

Born in 1845, Goodwin was elected an associate of the Society in 1871 and a member in 1881. Although he lived until 1932 he remained a nineteenth-century artist in spirit and his later portrayal of the British countryside is of a land untouched by troubles at home and abroad. In the war year of 1915, when he was elected a member of the RWS, a much younger painter, Sir Herbert Hughes Stanton, painted the view of *Hindhead, looking towards Haslemere*. This portrayal of one of the most spectacular views in the south of England is dramatic and laden with deep, menacing colour. For those who today drive south of Guildford on the A3, this view is a welcome respite from the monotony of travel. When Hughes Stanton depicted the scene, the highway would not have been humming with the noise of motorised traffic, but it must be true that the distant rumblings of war were becoming apparent to even the least affected of the population. The heavy sky of his watercolour may reflect a feeling of gloom, but Hughes Stanton's panorama is still a glorious depiction of the beauty of the Surrey countryside, far away from the ravaged fields of Flanders.

The scene is full of natural incident and human presence is indicated only by two plumes of smoke, ultimately a Girtinesque device, which swirl in the blustery conditions. Shafts of sunlight pierce the clouds and create a changing pattern of light and shade over the scene. In a work of pure watercolour,

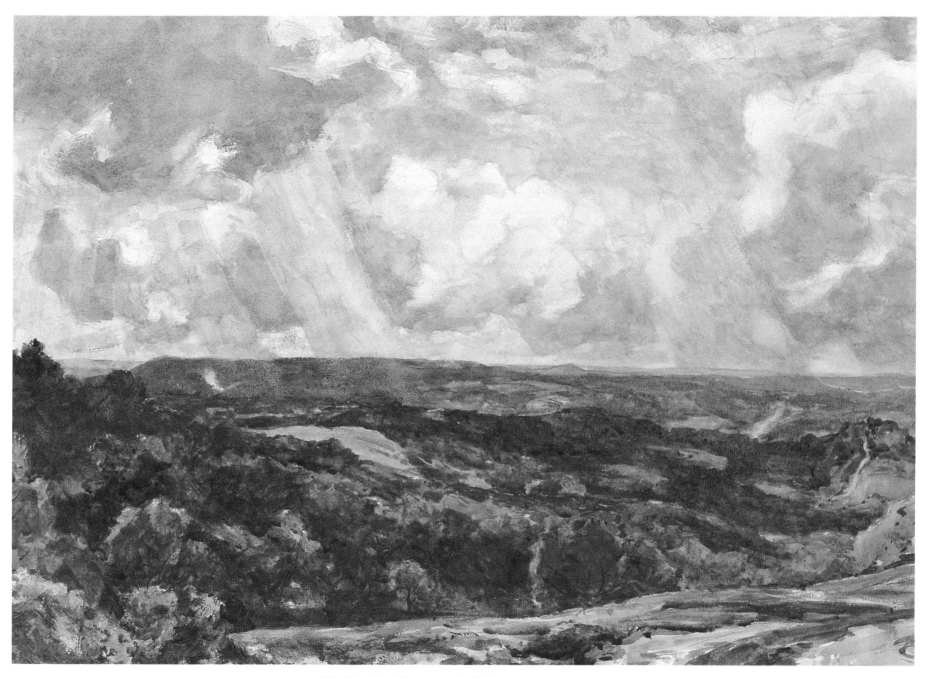

Hindhead, looking towards Haslemere
SIR HERBERT HUGHES STANTON PRWS
(1870-1937)
Watercolour over graphite
14⅛ × 19⅞ ins (sight)

The strong, deep tones and colours of this view taken in the North Downs are, if anything, intensified in this illustration in which we may experience the full majesty of the scene.

Hughes Stanton has briefly washed in these shafts with a water-laden brush, dissipating the already present pigment and thus creating a paler area of light. In the shaded passages, gum-laden watercolour gives density to the foliage, effectively contrasting with the thin medium with which the sky has been vigorously worked.

First joining the RWS as an associate in 1909, his thirty-ninth year, Hughes Stanton, who was essentially self-taught, reached the Presidency in 1920. The previous year he had been elected a Royal Academician. The time had long lapsed when any enmity between the RA and the Society prevented membership of both. From the late nineteenth century until after the World War II, it was the tradition for Presidents of the Society also to be Academicians. Following Gilbert's knighthood, three Presidents were similarly honoured by the Sovereign for their services to art during this period. Hughes Stanton's investiture came in 1923. He stood down from the Presidency in 1936, the year before his death.

Hughes Stanton's handling of the Surrey watercolour is, for all its breadth, intense and contorted when set beside the relaxed felicity of a scene in Norfolk by Edward Seago. *Green's Farm*, Seago's Diploma work, is as fresh and broad in its technique as the open, breezy fenland countryside the artist depicts. Seago was a master of the watercolour wash, inherited from another painter of the fenlands, Peter DeWint. Whereas some of Seago's work may be fairly criticised for suffering from a superficial reliance on his technical ability, the very simplicity of the washes in this delightful watercolour belie any sense of technical trickery.

This is a typical DeWintian subject, unashamedly composed in the manner of that great watercolourist. The dark silhouette of the shadowed farm buildings, gate and middle-distance foliage, form a counter-tone to the bright, though cloudy East Anglian sky. The flat landscape, interrupted for interest's and the composition's sake by the buildings, serves to emphasise the vastness of the sky, which takes up over two thirds of the sheet. The dark clouds looming to the right of the scene stabilise the composition and help to give recession to the view. These are all methods of tackling the depiction of flat countryside that, through DeWint, Seago owes in their origins to the Dutch painters of three centuries before.

Using a technique also conceivably learnt from DeWint, Seago has dragged a dry brush across the raised points of a sheet of rough hand-made paper, thus creating a grainy effect where appropriate, for example in the earthy right foreground. This dry brush technique is also effective when applied over a wash which has been allowed to dry. In the middle to lower-right passages of the sky, we see ample evidence of his mastery of these methods, which have endeared the artist to hosts of amateur watercolourists.

Here Seago has dragged a brush loaded with grey pigment across an already moist, but lighter coloured wash. The darker pigment has run downwards in tiny rivulets, fragmented by the roughness of the paper, and gives the effect of distant rain immediately over the horizon. This technique is known as wet-in-wet. Above this band of wet weather, some pale blotches to the right show where Seago has flicked water, again while the coloured wash was still wet. And then, after the paper has dried, the dark cloud has then been laid in to the left to finish the sky. Edward Seago was born in 1910. His election to associate membership of the Society did not come until 1957, two years before he was made a full member. He died in 1974.

Stanley Roy Badmin is, like Seago, one of the best-loved post-war painters of the English scene. Both artists delight in animating the countryside with human activity. While Seago's Norfolk farm is devoid of human presence, he was just as much at home at the race-track or the boating regatta. In his contrastingly painstaking style, Badmin shows us the skaters in St James's Park, or Master Fox cocking a snook at his pursuers as he evades the Leconfield Hunt in the snow of a Sussex village. But Badmin's art is more characteristically one of nostalgia for the sunny summer days fondly remembered from childhood.

It is through his watercolour illustrations to books such as Puffin's *Village and Town*, Odham's *British Countryside in Colour* and the *Shell Guide to Trees and Shrubs* that many of today's adults first learnt the rich variety of our native countryside. Although never a sentimental artist, Badmin's sincere love for every detail of his surroundings is immensely pleasing and memorable in an age when the pace of life affords us little time properly to see and contemplate the intimate beauty of nature. Badmin performs this labour of love for us and reveals the beauty of every element of his chosen subject on unexpectedly small sheets of paper.

Bolton Abbey, Wharfedale is a distant view of the ruins of this fine gothic priory, so superbly set by the River Wharfe in the most southerly of the Yorkshire dales. In this watercolour Badmin animates the scene with changing weather effects and active human and animal life. He shows how the land is occupied in harmony by the working shepherd with his flock and the playful swimmers in the Wharfe. One may not immediately think of Turner when considering S. R. Badmin's art, but here the comparison is inevitable. A well-known Turnerian subject is animated with a zest for life in the countryside which is so characteristic of Turner's vision of the Yorkshire landscape in his finished watercolours intended for engraving for illustrated books.

Turner's topographical watercolours of this type often contain a narrative element – a human-interest storyline, which usually arises from some particular local characteristics. This element could be the bustle of townspeople in his view of the streets of Louth, Lincolnshire, the elegant deportment of fine ladies having a day out by Richmond Bridge, or the heavy work of loading coal onto ships in Shields Harbour. This relation of narrative interest to land or townscape subject matter is characteristic of many of the watercolours discussed in this book and is notably present in S. R. Badmin's lively *Bolton Abbey*.

There is further comparison to be made with Turner and this is in the technical manner in which Badmin expresses his vision of the world. Both artists seem able to see and capture on paper the whole of the scene. Within the great panorama of this Wharfedale view, every detail appears to us to have been revealed. We have a similar sensation when looking at many of Turner's finished watercolours of the hills and dales of northern England, for example in the superbly broad vista of the *Crook of Lune*, in the collection of the Courtauld Institute of Art. Not only is the detailed working of *Bolton Abbey* intense, but so is the colour, its heightened freshness increasing the liveliness of the scene and belying the effort of Badmin's painstaking and traditional building up of the washes, layer upon layer. Seeing Roy Badmin's half finished works in his Sussex studio is a revelation in itself. One realises how slowly the washes develop from broad areas of colour to the many layered and most subtle modulations of tone and colour. On top of these layers then emerges, as if by magic, the fine detail for which the artist is so well known. As in Turner's most apparently intricate watercolours, the whole structure of the applied brushwork finally adds up to this impression of detail. There are, however, no tricks, but a lot of hard work and the talent to pull the picture together at the right moment – a hallmark of a fine painter in any medium.

Badmin's all-seeing style is most suited to the hilly countryside so often the subject of his art – the Yorkshire Dales, the Cotswolds and the Sussex Downs, for instance. In such settings, a distant hillside, being

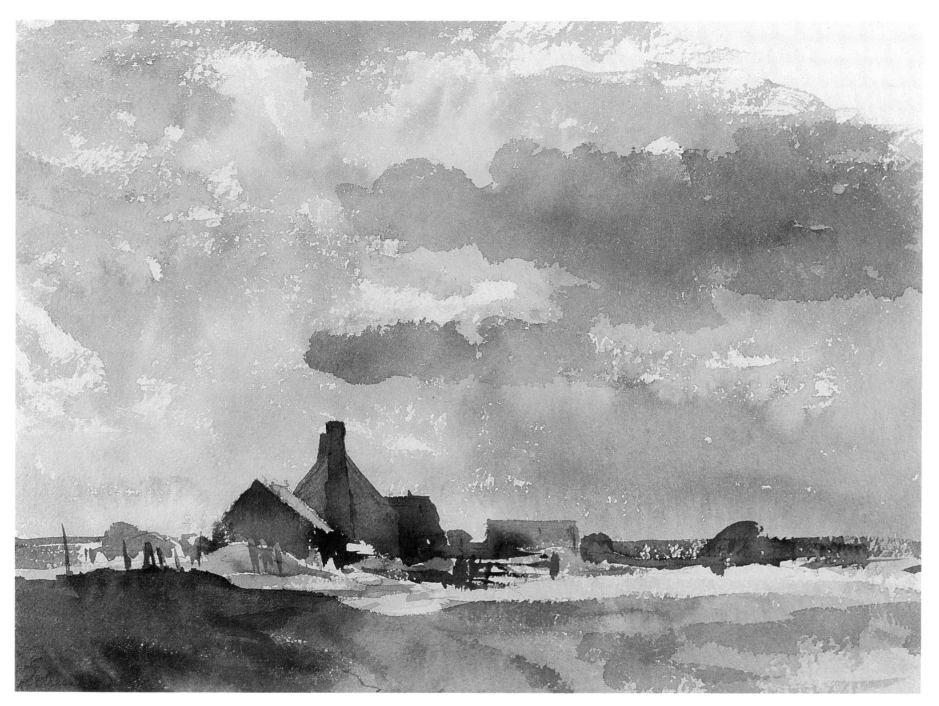

Green's Farm
EDWARD SEAGO RWS (1910-74)
Watercolour
11 × 15 ins

The apparent ease of execution and breadth of Seago's washes are the envy of many amateur and professional watercolourists today and this illustration enables us to take pleasure in these qualities. This is a happily uncomplicated and disarmingly straightforward example of the artist's work.

closer in angle to the picture plane than in a less undulating landscape, can provide greater areas of interest for the artist's detailed examination of the subject.

Roy Badmin was born in 1906 in Sydenham, South London, the son of a schoolmaster. He trained at Camberwell School of Arts and Crafts and then at the Royal College. His contributions to the exhibitions of the RWS over the years, since his election at the age of twenty-six to associateship and to membership in 1939, make Badmin one of the longest-serving and most respected participants in the Society's affairs. His Diploma work is an extremely fine and tranquil view of a watermill at Westerham, but nevertheless *Bolton Abbey* represents, in addition to its pictorial qualities, an aspect of modern collecting which is admirable. Bought by Miss Mary Parsons from the 1967 Autumn Exhibition of the RWS and kept with many treasures by nineteenth-century watercolourists in a much-loved portfolio of drawings, this work suitably returned to the Society for good in the 1979 Parsons Bequest. To restore such a recently exhibited watercolour to this Collection is surely bringing it back to its rightful home.

A near contemporary of Badmin, Roland Vivian Pitchforth, could not take a more different approach to painting the landscape and his broad and atmospheric washes are admirably suited to the depiction of open countryside, dominated by the sky and full of light effects. Such a picture is *Kent Marshes*, illustrated here. The two men also differ in that Badmin remains essentially a topographical artist in the great tradition, whereas Pitchforth, evokes, rather than describes, a sense of place. *Kent Marshes* could be Romney Marsh, but we do not necessarily know this from the watercolour itself, as few visual reference points are given. The generalised title also suggests the painter's relative lack of concern for topography or any narrative element in his picture.

Pitchforth was born in 1895 and studied at Wakefield and Leeds Art Schools. After war service he taught at Leeds and then at the Royal College of Art. In World War II he was appointed by the War Artists Advisory Committee to record Civil Defence, the War Industries and events in Africa, India, Burma and Ceylon.

Already a distinguished Royal Academician, he was elected ARWS in 1957 and a full member in 1958. He has been one of the most loved and critically appreciated landscape painters of the century, whose following among amateur watercolourists was, and still is, some years after his death, immense.

Bolton Abbey, Wharfedale (*Detail*)
STANLEY ROY BADMIN RWS

In this detail, considerably enlarged, we are able to study the intricacy of the artist's technique and to observe the principal scene of human and animal activity within the landscape. Note also the bold colour changes over a small area of paper, that are such a feature of Badmin's work.

An ebullient Yorkshireman who suffered deafness resulting from his experiences as an artilleryman in World War I, Pitch, as he was known by his friends and students, was one of the great characters of art teaching in this century. Be it in his elevated teaching position at the Royal College, or at evening classes for amateurs, he always had time for and much to give to his students. Lord Thorneycroft, the Chairman of the Friends of the RWS, an Honorary member of the Society and a watercolourist of some distinction, was one of his many enthralled pupils. Another clear reason for Pitchforth's popularity is his great facility with the pure watercolour method and his ability to create the most free, yet atmospherically descriptive watercolour washes, as we see here in *Kent Marshes*.

Rapidly painted, as the wet-in-wet technique demands, this apparently leisurely work conceals the great skill required to hold together moving areas of water and pigment from the beginning to the end of the artistic process.

It is possible to be sufficiently skilful with this kind of broad watercolour technique to concentrate on the potential marvels of effect alone. But content is also important and Pitchforth is not simply conducting an exercise in bravura. Although not essentially a topographical painter, he nevertheless has a feeling for form, subject and the truth of these. In this case, it is the quiet agricultural marshland of Kent and its seaborne weather that in terms of content, were the artist's concern. Pitchforth was not restricted only to the art of watercolour landscapes and his creative talents led him to produce a varied *oeuvre* in other media.

The only time the author visited Pitchforth in his studio was shortly before his death in 1982. He was reworking a complex crucifixion painting that he had started some thirty years earlier. Because of his inability to hear, we communicated through scribbled notes and his Yorkshire drawl. He explained how interested he had become again in this particular work. Like many artists, he was turning, in his old age, to a subject that reflected his own mortality.

A more narrative approach to the British landscape than Pitchforth's characteristic watercolours is represented by the Diploma work of Maurice Sheppard, who served as President of the RWS from 1984 to 1987. Sheppard's work is informed by the watercolours of his great predecessors in the Society, such as DeWint, Cox and the great French painter and Honorary member, André Dunoyer De Segonzac. He has also been influenced by Palmer, whose perhaps most creative period of expression was during his period at Shoreham, a few miles away from Sheppard's

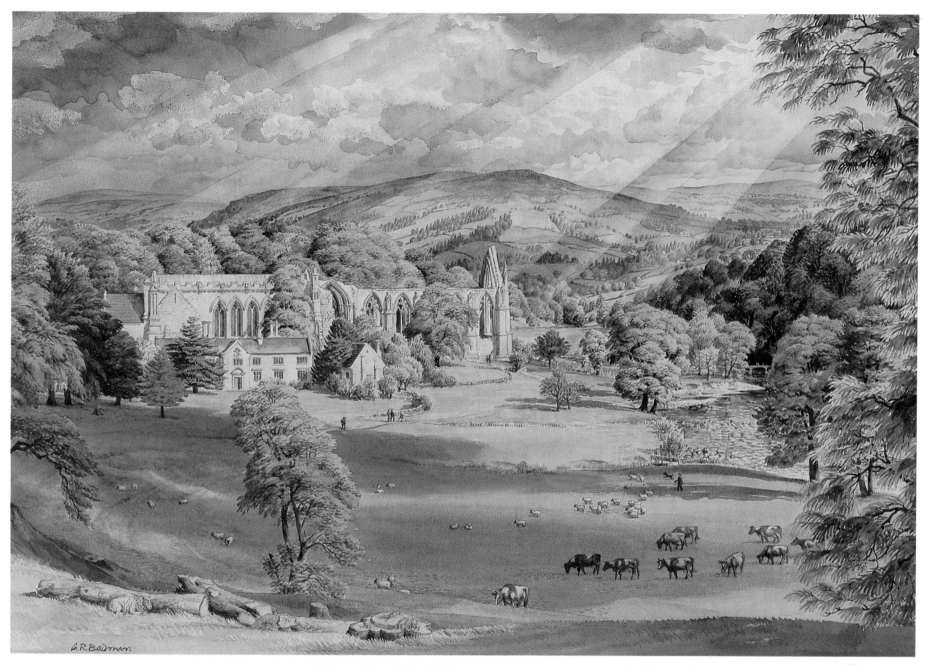

Bolton Abbey, Wharfedale
STANLEY ROY BADMIN RWS (b 1906)
Watercolour and bodycolour over graphite
9¼ × 13⅜ ins

In this reproduction we can discover the characteristic miniaturist's detail with which Badmin has painted this scene. We are also able to take in the full drama and life with which he has imbued the Turnerian subject. The master himself could hardly have animated the subject with greater liveliness.

Kent Marshes
ROLAND VIVIAN PITCHFORTH RA RWS
(1895-1982)
Watercolour and chalk
16⅞ × 23 ins

The washes here are as broad and watery as one could imagine in a watercolour landscape, and are entirely fitting to the damp, atmospheric and flat scene that Pitchforth has chosen. The full breadth of his technique is apparent in this illustration.

In th
colou
ety o
to loc
and
lishec
have
paint
appe:
Othe
come
scene
they I
at a I
the F
but c
pictu

As
eight
possil
for ai
count
live a
was t
Britai

A r
of the
media
genre
seven
dered
tists.
the o
being
of the
folk w
subjec
superl
Georg
rated
fully s
partici
and u
the id
pastor
appea
that th

Chislehurst home. The concentric and calligraphic marks that we see drawn with the brush in the foreground of his Diploma work echo similar marks found in the works of Palmer and in pictures by some of Palmer's early twentieth-century admirers. The modern British Romantic landscape painters have in their turn had considerable effect on Sheppard's art. He is particularly drawn to the haunting and ultimately tragic vision of Christopher Wood.

But Maurice Sheppard's own vision is idiosyncratic and original. A conservative painter by preference, his personal communication with the scenery of his native Pembrokeshire, where his family home is, and his Kentish surroundings, provides the fundamentally serious and emotional character of his art. Sheppard could be described as conservative in that his style and subject matter make one think of the nineteenth-century tradition, but there is a tautness and disquietude in his watercolours and oil paintings which is every bit the product of an artist of the second half of the twentieth century. This modern feel is partly created by the tension between deliberately conflicting elements of his compositions. The anxious feeling sometimes engendered is enhanced by the often dry and spiky brushwork.

Whereas Pitchforth successfully evades any sense of the facile in his easy washes, Sheppard makes every little mark tell. *Rest; Going Home from Work, Prescelly*, his Diploma work, is a most appropriate marriage of the artist's concern for his native Wales and the life of

Rest; Going Home from Work, Prescelly
MAURICE RAYMOND SHEPPARD PPRWS (b 1947)
Watercolour
12¾ × 22¼ ins

This work's uncompromising composition binds together extremely well in this illustration. We might take note of the almost calligraphic marks which, for example, describe the foreground stones. Such literal drawing with the brush is reminiscent of Samuel Palmer as well as being typical of the intuitive draughtmanship that underpins Sheppard's exhibition watercolours.

their creativity and started to choose their subject matter accordingly. It is with this knowledge that we are able to recognise, not only that Cristall's classicism was never likely to bring commercial success, but also that, as an eighteenth-century artist working in a nineteenth-century environment, he was a man of great integrity and personal vision.

He was certainly highly regarded by his fellow members in the Society of Painters in Water Colours, of which he was one of the first exhibitors in 1805, and he was elected President for 1816, 1819, 1821 and 1831. Joshua Cristall's one self-portrait, in oils, has for many years enjoyed pride of place on the walls of the Secretary's office and his central role in the early history of the RWS is assured.

Another distinguished early member, whose portrait, this time in marble by Alexander Munro, is in the possession of the RWS, is William Henry Hunt. From birth Hunt was disabled, and had rather a wild facial appearance. The necessity for him as a painter to be in public places in search of subjects could be a cause of great unhappiness for him, and he once recorded how unpleasant was the tormenting of small boys on Hastings beach. The portrait bust slightly softens his facial looks, but gives us a fair impression of the power of the man's features. Hunt's career has been described as falling into three distinct phases. He was born in 1790 in London and the first phase runs from his youth, confined to painting at home, to around the year 1830. This period is marked by apprenticeship to John Varley, an association with Dr Monro and Hunt's first participation in one of the Society's exhibitions in 1814. In this, some consider his best phase, his subjects were principally topographical and were epitomised by his drawing of Monro's parish churchyard at Bushey, in which the graves of the topographical watercolourists, Henry Edridge and Thomas Hearne, feature prominently.

The second phase, starting around four years after his 1826 election to membership of the Society, sees the development of a more intricate style and the production of numerous figure subjects. The start of the third period in about 1845 is signified by the use of an even more complex technique, with much use of bodycolour, and by the appearance of the subject which was to give him his nickname – the birds nest. W. H. Hunt was apparently the first British artist to take up this subject, but the enormous appeal for collectors his still lifes seem to have had meant that he left behind a useful legacy for a considerable number of imitative Victorian painters. The Parsons Bequest picture reproduced here of a *Jug with Rose and other*

Flowers and Chaffinch Nest, is a relatively early and most pleasing example of the genre. This watercolour is appropriate to the theme of this chapter, being an exercise in combining nature and the domestic. Hunt makes no attempt to disguise the contrivance of the arrangement of natural and artificial objects in the composition, but the way he has handled the jug, positioned as it is before the mossy bank, does enough to make us believe that the work might have been executed directly from the subject in the open air.

In terms of technique, this still life is a *tour de force*, as the enlarged detail reproduced here shows. At first sight, we might think the intricacy of the brushwork means it could only be painted in bodycolour with a tiny brush, allowing the artist to build up a complicated massing of minute changes in tone and colour. Hunt has used bodycolour, but only to overlay the detail of the mosses, to heighten with chinese white the flowers and nest, and to describe the porcelainous quality of the jug. The complex background is mostly painted in pure watercolour and is a considerable feat of painstaking dry brushwork. On top of this brushwork small marks of green bodycolour have been placed, which create the illusion that he has accurately rendered every blade and leaf. This particular method of suggesting precise detail in watercolours was taken up later in the century by many painters. Birket Foster and some of the Pre-Raphaelites, for example, were much affected by Hunt's technique as well as by his interest in the minutiae of natural life.

W. H. Hunt's technical mastery of the medium, his intense passion for conveying natural detail and the vividness of his colour endeared him to John Ruskin, who became an avid collector of the artist's work. His preoccupations undoubtedly place Hunt in history as one of the precursors of Pre-Raphaelitism and this fact brought him towards the forefront of Ruskin's writings. In one lecture, the critic favourably compared Hunt's colouristic abilities with those of his bright, but 'morbid', young successors and even goes so far as to compare him with the great sixteenth-century Venetians, 'so far as he goes'. While such a claim is imbued with Ruskinian over-enthusiasm, its hyperbole should not blind us to Hunt's sensitivity to colour – so evident in the best of his still lifes. Since Caravaggio in the early seventeenth century, the painters of the major national schools had been concerned with bringing light out of large areas of darkness. After two centuries of predominantly gloomy paintings, including the watercolours of some of Hunt's immediate predecessors, the heightened hues of his later and Turner's work would have been

The Basket Girl
JOSHUA CRISTALL POWS (1767-1847)
Watercolour over graphite
9⅛ × 10⅜ ins

This watercolour by one of the Society's most popular early Presidents is illustrated just below life size. A modest and unassuming work, it befits a man whose ambitions to paint classical scenes never had the effect of making his art pretentious or unattractive.

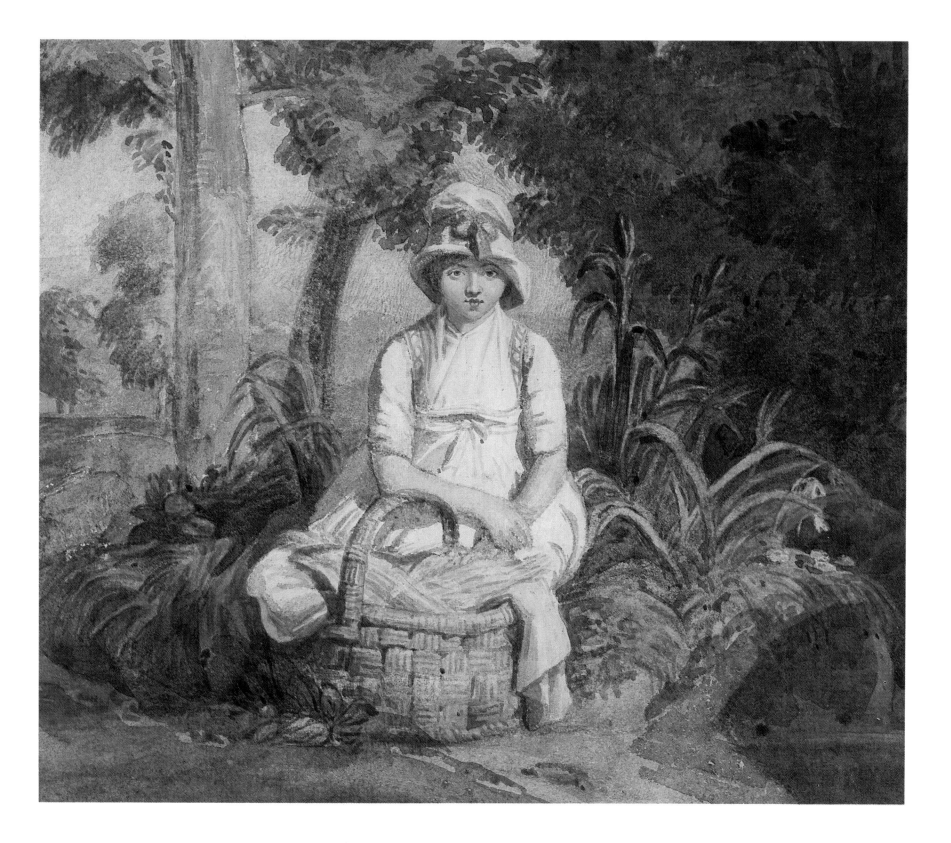

refreshing and revelatory for their contemporaries.

Hunt was not in the mainstream of European art, but he was, with the exalted company of Turner, Constable and Delacroix, one of those who showed the generations to come that all of nature is colour. As we may see here, Hunt was aware that objects cast coloured shadows on their surroundings. The jug appears to be tinged with blue from the reflection of the nest, and there is also a suggestion of a pink cast on it reflecting from the rose in the left foreground. This is not to suggest that he had himself developed the complex theories of local colour that influenced Delacroix and later the Impressionists, but we can at least say that Hunt was one of the painters who moved away from a long-held belief that each individual object in a composition had its own particular colour and shading, unaffected by the colours of nearby objects and light-sources.

William Henry Hunt was dedicated to the Society and it is fitting that the last positive action of his life was to view candidates' work and record his votes in the 1864 annual election of associates. But the effort of attending the viewing was too much for his health and led to the stroke which resulted in his death.

Myles Birket Foster's *The Green Lane* is an excellent example of Hunt's influence on one of his most successful later followers' mature watercolour technique. Born in 1825 Foster practised as a wood-engraver and illustrator in his early career, but taught himself watercolour painting in his thirties and from 1859 concentrated on the medium. This new departure led to quick recognition by the Society, who elected him an associate the next year. Foster's development since his conversion to watercolour was considered sufficiently impressive for him to be made a full member two years later.

At first his watercolours were of a lyrical, but topographical nature. The country cottage subjects, for which he is today so well known, appear somewhat later in his career and *The Green Lane*, given to the RWS under the terms of the Nettlefold Bequest, is a fine result of his practice of this genre, which Foster made his own. As we shall shortly see, it was however only his own for a while. Like Hunt, Foster had many followers and admirers, who wished to imitate and expand upon his often sentimental depiction of English rural life and thus to enjoy the financial bounty afforded artists propounding this genre by the nouveau-riche barons of an increasingly industrialised late nineteenth-century Britain.

The present work was probably inspired by a scene observed in the north Surrey woods, and another version of this subject is entitled *Lane near Dorking*. At the time Foster was living at Witley, one of Surrey's most attractive villages. By comparison with his first topographical watercolours, there is no sense here of accuracy in the rendering of place and the subject was probably conceived by the artist in the studio, rather than before nature. Topography does not come into it and the central theme of the picture is the anecdotal human and animal interest in an appealing rural setting.

The Green Lane amply displays the extraordinary facility and accomplishment which Birket Foster achieved in his new-found medium. He does not resort to extensive use of bodycolour to weave this intricate surface and uses chinese-white heightening sparingly. White is most noticeable in the detail of the figures' costumes and the overpainted plume of smoke, which creates an area of interest as well as aerial perspective in the middle distance. In a composition ultimately owing much to Dutch art, Foster uses the lane itself to lead the eye through the landscape, much as did Constable and Gainsborough in their early landscape work. The actual description of the lane is a piece of technical virtuosity. By dragging a dry brush of darker hue over a sandy-coloured wash, Foster has managed to convey a three-dimensional effect that is entirely right for the rutted track, and which on close examination surprises us by not being the product of built-up patches of bodycolour.

Another artist working near Witley was George Price Boyce. This was where Foster built a house in 1863 and, with Helen Allingham coming to the area later, a tradition of country cottage painting developed in this still beautiful corner of Surrey. Boyce is, however, one of the most interesting and unusual watercolour artists of the late nineteenth century. He was born in London in 1826 and originally trained to be an architect. After meeting David Cox in Wales in 1849, he turned to landscape painting. First influenced in his style by Cox, Boyce came into contact with the Pre-Raphaelite circle. He became closely associated with, among others, Dante Gabriel Rossetti and his published diaries covering the period 1851 to 1875 are among the most fascinating and immediate accounts of the comings and goings of the Pre-Raphaelite Brethren as well as of the Watercolour Society of the time. Pre-Raphaelite influence on his manner is evident in the heightened colour range and precise brushwork of the tightly constructed farm-house portrait that represents him in the Diploma Collection. The painting is of *Brook Farm*, a substantial half-timbered building in the heart of the village of Brook. Boyce was elected an associate in 1864, not long after

Jug with Rose and other Flowers and Chaffinch Nest
WILLIAM HENRY HUNT OWS (1790-1864)
Watercolour and bodycolour
9¼ × 11¼ ins

Seen here just under life size, Hunt's still life is an apparent fusion of an evenly applied web of minute brushstrokes. It is only in the enlarged detail that follows over the page that we will be able to appreciate the cleverness and relative economy of his technique.

OVERLEAF
Jug with Rose and other Flowers and Chaffinch Nest
(*Detail*)
WILLIAM HENRY HUNT OWS

This reproduction of the lower half of the picture, approximately four times actual size, shows that Hunt has built up various areas only so far as his conception of the final result requires. For example, the foreground earth is essentially watercolour with a few dragged strokes of chinese white for highlighting. In contrast, the chaffinch nest is structured upon this initial watercolour underlay with painstaking applications of bodycolour with a small brush. Observing the treatment of this nest, it is no wonder that Hunt's later phase is seen to be an influence on some of the Pre-Raphaelites.

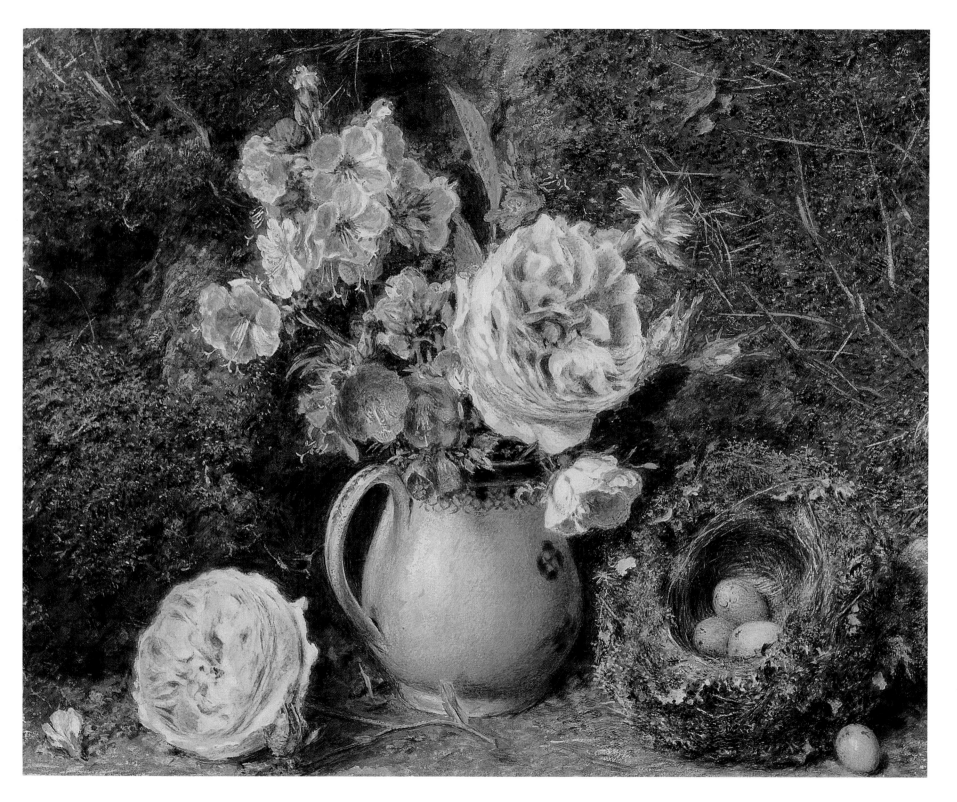

The Green Lane
MYLES BIRKET FOSTER RWS (1825-99)
Watercolour and bodycolour
17⅝ × 13⅝ ins

Foster's rustic Surrey landscape looks as pretty as the author of any picture-book could wish. We can appreciate the consummate pictorial skills which made him one of the foremost illustrators of his age. This is, in fact, one of Foster's most poetic watercolours and a shining example of his self-taught watercolour technique.

the foundation of the 'Diploma Gallery', and his talents were finally given full recognition by the Society in 1877, when he was granted full membership.

In this Diploma piece the farm's vegetable garden is faithfully seen and the simple composition suggests a truth about the subject absent from Foster's watercolour. Boyce's interest in the essential tranquillity and earthiness of the scene, on a pleasantly sunny autumn afternoon, would make the inclusion of self-consciously composed rustic furniture and romantically attired folk irrelevant to his purpose. His concern for realism reminds us of the truth to nature sought in much Pre-Raphaelite landscape work and is refreshing in an age in which rustic subject matter was much exploited for reasons of sentiment and commercial viability.

There is some lovely descriptive brushwork in this piece, ranging from the faintly dry-brushed branches of the tree at the far right, to the typically Boyceian mingling of wet dabs of green and yellow in the tree to the left. On a similarly bright autumnal afternoon in 1986, the atmosphere and colours of the scene were little changed. In the late nineteenth century a harmonious L-shaped and gabled wing with a new chimney stack were built onto the near left corner of the farmhouse and at some stage the chimney at the far right was removed. The walled garden is no longer a vegetable plot, but otherwise the picturesque scene is as close to Boyce's depiction as to convince the visitor of the faithfulness of his portrayal.

Boyce's description of country cottage and farm life is less anecdotal and prone to sentiment than the art of one of the most currently popular members of the RWS, Helen Allingham. While Boyce's Diploma work is a watercolour of considerable beauty, *Feeding the Fowls, Pinner*, her Diploma work, is something of a masterpiece, in a career of outstanding technical consistency.

Brook Farm, Witley, Surrey
GEORGE PRICE BOYCE RWS (1826-97)
Watercolour
11½ × 15½ ins (sight)

Although it may have faded a little over the course of time, Boyce's Brook Farm is still a faithful rendition of the waning light catching this solid, homely building in the heart of the Surrey hills.

Feeding the Fowls, Pinner (*Detail*)
HELEN ALLINGHAM RWS

Here, slightly larger than life size, we examine the superbly handled foreground of the work. Looking at the whole picture initially, it is possible to conclude that the whole is painted with a diligent evenness of attention to detail. Such treatment would have been dull by comparison with the freedom of handling we are now able to study. The fluid brushwork representing the hedge is a particular joy. Also note the clear delineation of the fowls, gouged out of the initial foreground washes.

Allingham was born in 1848 near Burton on Trent. Her precocious early talent led to her attendance at Birmingham School of Design, followed in 1867 by her acceptance at the Royal Academy Schools. She was elected an associate member of the Society of Painters in Water Colours in 1875, her twenty-seventh year. Already by this time a most accomplished painter, she had married the Pre-Raphaelite poet William Allingham and became one of the fashionable Cheyne Walk set, of which Boyce was also a member.

Helen Allingham began her series of cottage paintings in the late 1870s and in 1881 the Allinghams moved to Witley in Surrey. Here Allingham was close to Birket Foster and the countryside that inspired him. Both Foster and his colleague in the Society, Frederick Walker, had considerable influence on her art. But while her characteristic subject matter may have been intended for the new suburban art-buying public and thus shared a purpose with Foster's rustic scenes, she manages to pass on an intimacy with her subjects that is occasionally missing in the blander and sometimes over-indulgent works of her mentor. Yet nostalgia is still an obvious factor in this Diploma work. It should be borne in mind that this building, dating from the sixteenth or seventeenth century, was already a structure of historical quaintness and picturesque charm to the Victorian imagination.

In *Feeding the Fowls* Allingham's technical accomplishment serves only to intensify the affection which the artist appears to invest in every sunflower or patch of grass. These foreground passages are treated with a steady and precise hand. However, the backcloth of tall trees is seen and painted with a much broader brush, although it is no less understood and faithfully depicted. Unlike some of her contemporaries, Allingham recognised that this kind of rustic art could be over-fussy and sickly if overladen with picturesque detail.

On moving from the full view of the picture to studying it in close-up, we may be surprised to discover what a difference in handling there is between these areas. By effecting such variations, Allingham has managed to throw the foreground incident into relief and give it prominence over the broad foliage background. Her technical skill, nonetheless, enables the whole piece to retain a visual cohesion, allowing the spectator's eye effortlessly to bind the different elements of the composition.

Feeding the Fowls, Pinner
HELEN ALLINGHAM RWS (1848-1926)
Watercolour with scratching out
13½ × 20 ins

This illustration gives us the opportunity to survey the overall composition of this remarkable picture, before examining it in detail. This is a typical Allingham subject, but treated on the grand scale, as befits a Diploma work.

Feeding the Fowls, Pinner (*Detail*)
HELEN ALLINGHAM RWS

This detail shows the central elements of Allingham's watercolour, slightly under its full scale. It allows us to enjoy the sumptuously rich textures of the mossy roof tiles as well as the knowledgeable depiction of the flora; notably the splendid sunflowers, their blooms again scratched out of the paper. The breadth of her handling of the trees is also worth noting.

Through the precision of fine colour reproduction, we can explore Helen Allingham's technique by comparing the full illustration with two details. The full picture, as reproduced, about half life size, represents the watercolour as our eyes would survey it in an exhibition, or on the wall of a collector's town house. The near life-size details represent closer scrutiny of the work and reveal, for example, that what might previously have been accepted as finely detailed handling of the hedge is in fact a passage of quite free brushwork. The abundant foliage is indeed worked up with a succession of broad washes and dabs of watercolour, mixed in parts with a little chinese white. At a distance the eye reads into this area a precise delineation of branches and leaves which in reality is only suggested. The infinite painterly variety of the brushwork, of tone and colour, makes the eye convey to the imagination a message that relies simply on our previously perceived knowledge of what hedges look like. It is on this accepted preconception of the visual character of a subject that the Impressionists founded their technique of broken brushwork, which, seen at a distance, is bound together in the mind's eye into the correct pictorial image. We have already noted Foster achieving similar effects and the sheer technical virtuosity of these mid to late nineteenth-century watercolourists is breathtaking.

As stated before, this is not mere technical trickery. It is an artist's understanding of how we really perceive the world around us. In Allingham's case, the argument is made in the picture, not in terms of theory, and this argument is that the eye searches the subject of central interest and takes in a general impression of peripheral surroundings. Although *Feeding the Fowls* could only have been painted in an age which had already absorbed the lessons of the Pre-Raphaelites, it can certainly be said that when looking at a landscape vista, we do not do so with such studious and all-encompassing attention as their

paintings often imply. The eye is selective and focusses on a tiny area of our vision. This watercolour suggests that Allingham recognised this fact as did Joshua Cristall and W. H. Hunt before her.

It is worthwhile to pause further over the details of Allingham's picture. Let us look at the finely drawn ducks, chicken and pigeons, and the equally well observed sunflower heads. In these we find, and not for the first time, that fine draughtsmanship does not have exclusively as its vehicle the drawn graphite or brushed outline. Some of the most descriptively rendered fowl are drawn by scraping the paper surface away beneath the green washes.

When *Feeding the Fowls* was being conserved at the studio of the Area Museums Service for South Eastern England at the Fitzwilliam Museum, Cambridge, it was noticed that Allingham had dug the shapes of the sunflowers out of the paper and then infused them with bright yellow watercolour, afterwards adding brown for the seeds. This had allowed her to proceed quickly and uniformly with the wash describing the cottage wall without muddying the future brilliance of the flowers.

This brilliance becomes an intoxicating shimmer of colour in Helen Allingham's smaller and bejewelled *A Bit of Autumn Border*. This herbaceous border was just possibly painted in the open air on a pleasantly warm evening. The sun no longer shines on the subject and, in the twilight, the colours of the rich array of flowers glow with an intensity we have all seen in life. This is a glow which is stronger than the detail and delineation of petal or stamen, and the painter acknowledges this particular phenomenon of colour by giving the blooms an almost abstract presence.

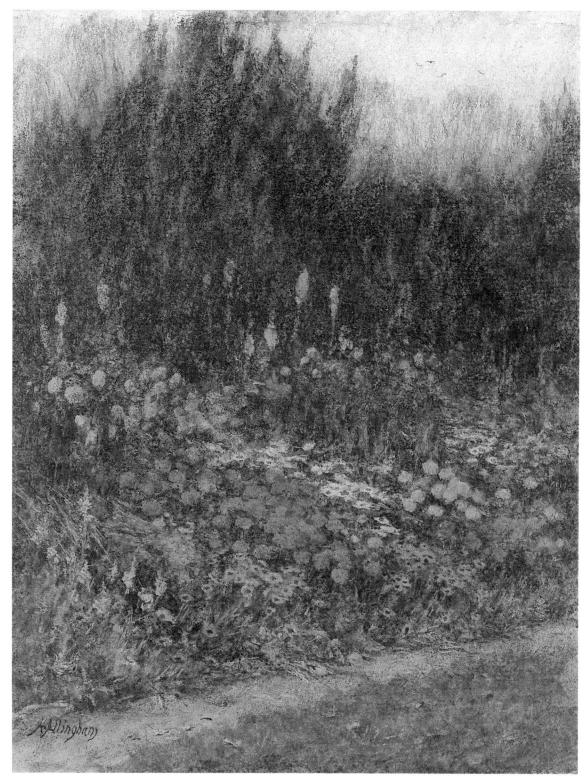

A Bit of Autumn Border
HELEN ALLINGHAM RWS (1848-1926)
Watercolour and bodycolour, with scratching out
8⅛ × 6⅛ ins

Reproduced on its full scale, this diminutive study is rich with colour patterns and an abundance of floral detail. This detail is not handled in a slavish or 'botanical' manner and the freedom of the brushwork is testimony to the artist's understanding of her subject as well as her consistent technical ability to create an accurate impression of both the general and the particular in the gentle, insular world her art inhabits.

If we think what a grey and dull overall cast a black and white photograph of this particular subject would have, we can appreciate how she has accepted its inherent tonal uniformity and accurately enlivened the almost formless composition with colour alone. It is a time of the evening when the recession provided by daylight disappears and the flat picture plane is in keeping with the way we would in reality view the border. The red spikes are the flowers closest in tone to the surrounding green foliage and yet glow the greatest. It is an interesting fact that colour reproduction finds such reds very difficult to re-create. For the human eye, as readers will have experienced, the gorgeous intensity of the red geranium or rose on a summer evening is an unparalleled and even somewhat unreal sight. Allingham's subject could be one of the borders designed on 'the graduate doctrine' as practised by Mrs Jekyll at Minstead near Godalming, which are depicted by the artist in Marcus B. Huish's book *Happy England*.

Helen Allingham was not elected from associateship to full membership of the RWS until her forty-second year. This was not due to any lack of recognition of her abilities on the part of the Society's members, but because it took them until 1890, and probably with Allingham's particular talent in mind, to make membership available to women. At this time, the Royal Academy, of which Angelica Kauffman had been one of the founder members in 1768, no longer allowed full membership to women. It was not until the twentieth century that the Academy reverted to its previously more enlightened attitude.

Within the Society, associateship had been available to female artists from the beginning, with Anne Frances Byrne being one of the earliest fellow exhibitors. It needs to be emphasised, however, that associateship of the Society did not until this century allow full participation in the affairs of the RWS. Indeed it is only with the revision of the Society's laws in 1985 that the distinction in anything but honour between the two categories of membership has been eliminated. Now an associate has equal right with a member to affect the governing of the Society, but in Allingham's day no such powers were afforded those who were still, essentially, invited exhibitors. So her admission to membership was a noteworthy event in the history of the RWS. After a long and productive career, Allingham died in 1926, her seventy-eighth year.

The Irish artist Rose Barton did not enjoy Helen Allingham's professional training. Largely self-taught, Barton developed a most accomplished and relaxed watercolour style, which is shown to excellent advantage in her Diploma work, a delightful study of a *Child with a White Cap*. Barton was probably best known in her own day for the atmospheric city views with which she illustrated *Familiar London* for A & C Black in 1904. She was also very fond of domestic subject matter and this Diploma piece is characteristic of her tender, but not over-sentimental approach to the painting of children – always a difficult task, particularly, it would seem, for artists of the late Victorian age.

The simple, uncluttered composition allows us to concentrate on the sensitively observed posture of the child, whose cap is placed right at the centre of this single-planed picture. We follow her unseen, but, we are made to believe, curious gaze down to the hand which clasps some interesting and newly found piece of brick or stone. The position of her left arm aids her balance, both physically and in terms of the composition, and the open fingers of the left hand give away as much of a feeling of childish discovery as any more direct eye contact or facial expression might. Subtly hiding her face, the artist allows the poise of body and limbs to reveal her subject's sense of wonder at this new experience. This is narrative art in the true Victorian tradition, but the painting has no obvious storyline, and is free of those other associational trammels of Foster's and Allingham's cottage pictures.

Despite the passage of years between Joshua Cristall's *Basket Girl* and this Diploma work of circa 1911 – the year of her election to full membership of the Royal Watercolour Society – the similarity between the two works, each with their unaffectedly straightforward presentation and emotional discretion, is quite clear. Of the two watercolours the Barton probably carries a more luscious painterly quality, and her interest in the texture of stone, brick and moss is marvellously supported by broad use of the brush. The stone wall is loosely conveyed with a mixture of wet-in-wet and dry brushwork. Some bodycolour has been employed to reinforce the passages of moss; graphite has been used, mainly as a guide for the figure painting, but the girl's surroundings are worked up from the beginning with the sable brush.

In this work, we are reminded of the appropriateness of pure watercolour on paper for the description of roughened, matt textures. The four bricks to the top left could not have so well retained their natural texture if depicted in any other technique. In *Feeding the Fowls*, Helen Allingham gave similar descriptive qualities to her wonderful rendering of the cottage roof-tiles. The very quality of the portrayals of the

Child with a White Cap
ROSE BARTON RWS (1856-1929)
Watercolour and bodycolour over graphite
$10\frac{1}{4} \times 12\frac{1}{4}$ ins

This affectionate watercolour displays the painterly virtuosity and ability to represent a variety of textures, that were qualities the essentially self-taught Barton shared with many of her professionally trained, as well as some amateur, contemporaries. This is a work that satisfies the eye, if not perhaps to such a degree the intellect.

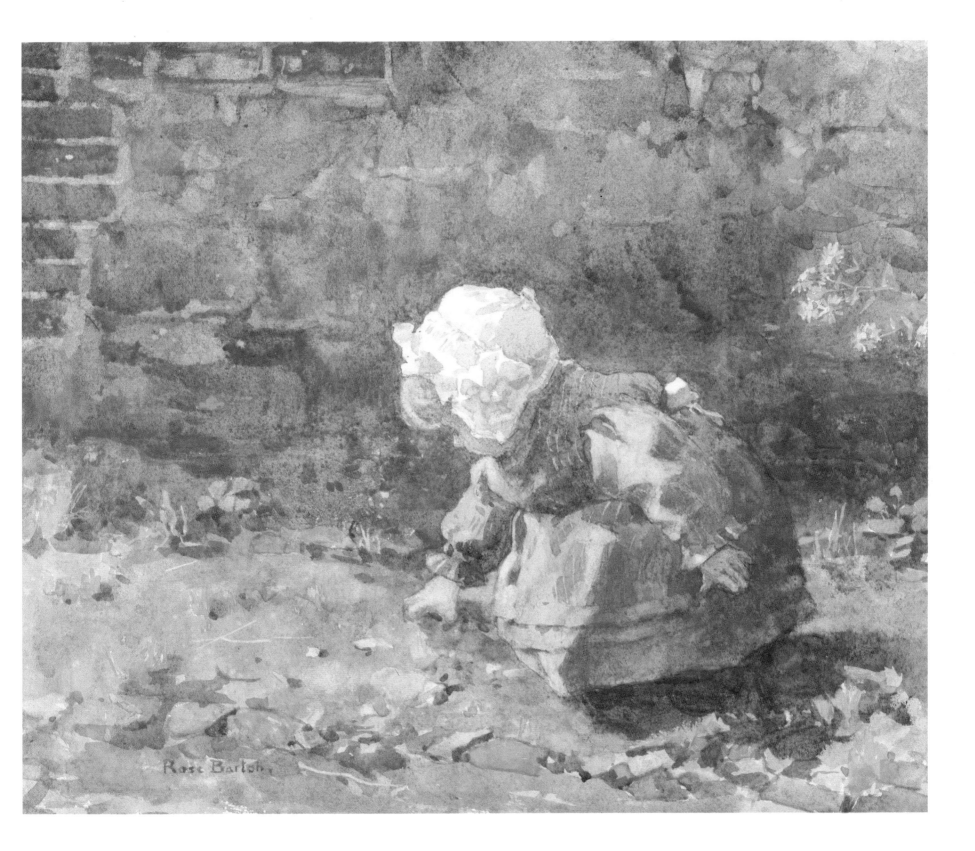

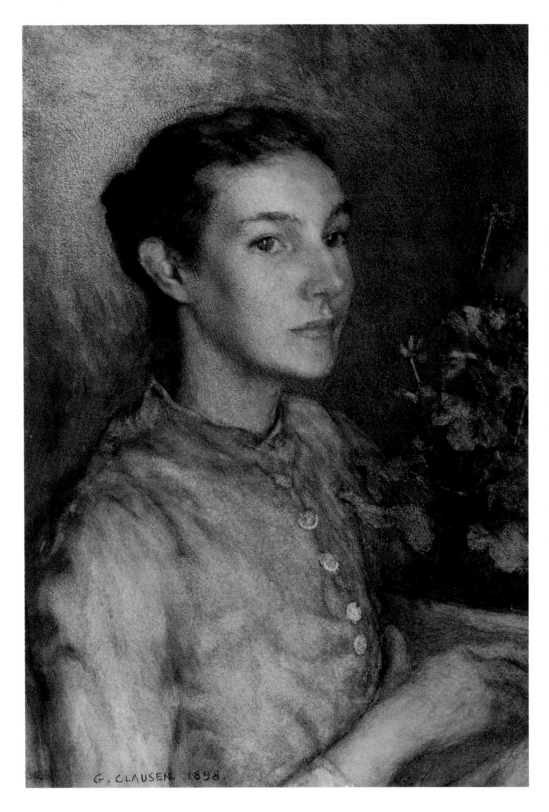

G. CLAUSEN. 1898.

Girl and Flowerpot
SIR GEORGE CLAUSEN RA RWS (1852-1944)
Watercolour and bodycolour
13¾ × 9¼ ins (sight)

We are not able to see in this illustration how the artist has stuck his watercolour paper to a larger piece of card and thus increased his picture area. The fact he felt the need to do this suggests that Clausen had not fully thought out the composition before putting brush to paper. But this is how he finally wished us to view the work.

everyday furniture of domestic country life revealed in this chapter is one of the great pleasures of such art.

Elected a member of the RWS in 1911, Rose Barton had been an associate since 1893. She was born in 1856, the daughter of an Irish solicitor and lived in both Dublin and London. A number of exhibitions of her town scenes were held in London galleries, including a show at the Japanese Gallery in the year of her election as associate. She died in her seventy-fourth year, in 1929, after a fruitful artistic career. The record book of membership recalls that she was partial to horse racing and backed two winners on the day of her death.

Helen Allingham's depiction of the country garden is echoed in Sir George Clausen's radiant portrait of a *Girl and Flowerpot*. In this work, taken in subdued light, we see that resonant red of the geranium, alluded to above, subtly enriching the picture in the area of deepest tone. Allingham's works portray a concept of harmony with nature, of moral accord between humans and domesticated country life. She achieves this idyll by the association of tranquil figures with unthreatening, controlled natural surroundings. Clausen does the same but he goes deeper into the character of the participants in the cycle of rural and farming life that was his favourite subject matter. Some of his major compositions in oil are of earthy, but noble scenes of farm labour, recollecting Stubbs' *Reapers* and *Gleaners*, and the dignity of the agricultural subjects of the great French artists, his antecedents, Millet and Courbet. Clausen's ennoblement of agricultural life conveys both Courbet's realistic portrayal of the work-ethic and the spiritual labour of Millet's peasants. But despite the influence on Clausen of these and later French painters, his art is quintessentially English in its reticent, but deeply felt, sentiment. The *Girl and Flower Pot* is the artist's Diploma work, painted in the year of his election to membership of the RWS, 1898.

Clausen was born in London in 1852, his father a Danish sculptor, and educated at the South Kensington Schools and later in Paris. In 1876 he travelled to the Netherlands, where he came under the influence of the flourishing Hague School of painters. His appearance in the Society as associate was in 1889 and he was later elected to the RA in 1908. He lived until 1944, his ninety-second year, but was, for all his later development of atmospheric effects, an essentially late nineteenth-century naturalist and painter, both stylistically and in his choice of rustic subjects. It is rarely possible to accuse Clausen of sentimentality, however, and his factual post-impressionist approach to the broken colours and contours of an orchard in another work in the RWS Collection is mirrored by the honest vision of the young woman in *Girl and Flowerpot*. Her bearing is dignified and at the same time that of a most sensitive and warm individual. The distant look in her eyes does not disassociate her from the integral simplicity of her image and neither is her attention distracted from the geranium pot she so carefully holds.

This is yet another technical *tour de force:* the face superbly painted with a multitude of overlapping washes and dry, stippled brushstrokes; the rest a tentative building up of flecks of the watercolour-laden brush. The work is painted on a sheet of paper stuck down onto a piece of card, on which Clausen has further developed the composition. This card is of poor quality and, with age, has affected the paint colour. It is also implicit from the original mounting of his Diploma work that it was the area of the paper sheet itself which Clausen intended us to see.

It has always been the prerogative of artists to change their compositions as their paintings have progressed. Watercolours generally being framed in overlay mounts, it is often the choice of the painter or

Girl and Flowerpot (*Detail*)
SIR GEORGE CLAUSEN RA RWS

The detail chosen is reproduced nearly twice life size and concentrates on the radiant head of the woman. It had long been a tradition of portrait painters in watercolour and oil that the face should be treated in greater detail than the rest of the composition and Clausen's study is no exception. Intricate brushstrokes are used to build up a beautifully warm and serene head.

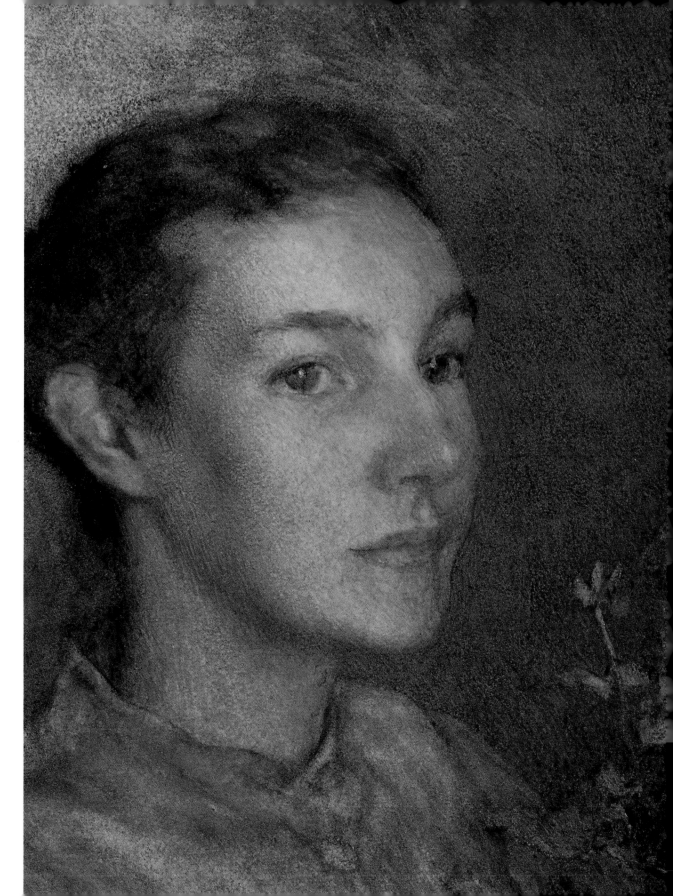

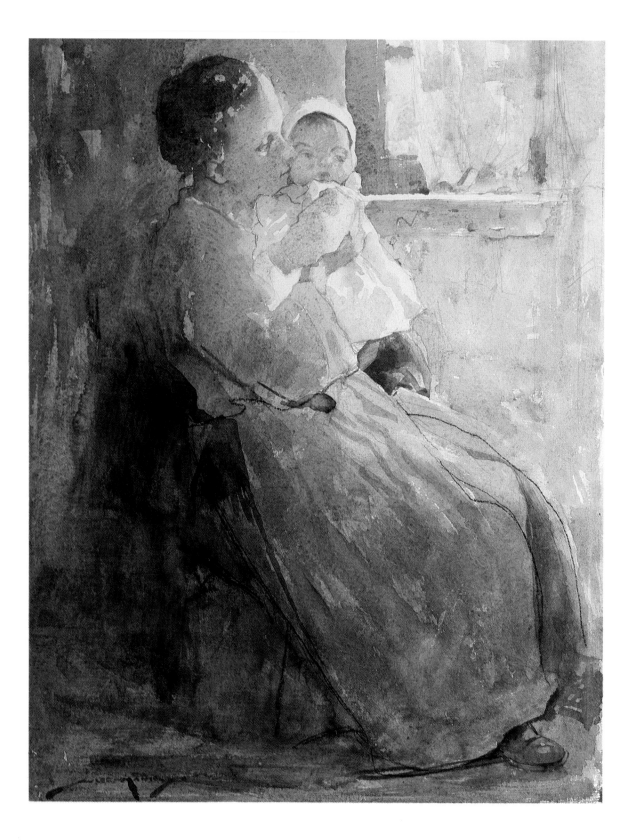

Julie et Louise
WILLIAM LEE HANKEY RWS (1869-1952)
Watercolour, black chalk and graphite
14 × 10¾ ins

The free execution of this watercolour is quite apparent in this reproduction. A pleasing image well handled, this is another example of the technical accomplishment of watercolourists trained in the late nineteenth century. It also provides one more example of the suitability of the medium to homely, domestic subject matter.

even sometimes the framer as to which part of the work is to be revealed for general inspection. This facility allows the watercolourist a freedom the painter in oils only enjoys if he is prepared to cut down his canvas. Like the photographer enlarging sections of a negative, the watercolour artist is able to paint first and ask questions of presentation and the final composition afterwards.

Another RWS member who introduced a child into one of his domestic pieces was William Lee Hankey, in his Diploma work, *Julie et Louise*. The almost pugnacious expression on the little girl's features is touching, as again is the lack of fuss about the composition and setting. Lee Hankey was a master of many mediums, being an oil painter and etcher of note, and this work is a typically graphic mixture of watercolour, black chalk and pencil. The latter two linear processes, are used here on top of the watercolour brushwork to define and hold together the forms, as much as to provide an earlier drawn underlay for his washes. The artist also reveals much of the paper surface for the lights, notably in the passages where the mother and child are bathed in the daylight filtering through a loosely curtained window. In the compositionally opposite area, where garments hang on the chair, some bodycolour is used to add density to the shadows. To give crispness and definition to the light areas of the baby's clothing the shadow-defining brush is applied directly to dry paper.

Many watercolourists seeking an overall wet-in-wet effect, will first soak their paper, often in a bath or sink. But to achieve his desired contrasts, Lee Hankey painted onto dry paper in this area, leaving clearly defined lines between the passages of shade and light. On the other hand he heavily washed the right and lower right sections of the painting, infusing layer upon layer of dense watercolour and bodycolour, thereby enriching the colour and depth of this shadowy area.

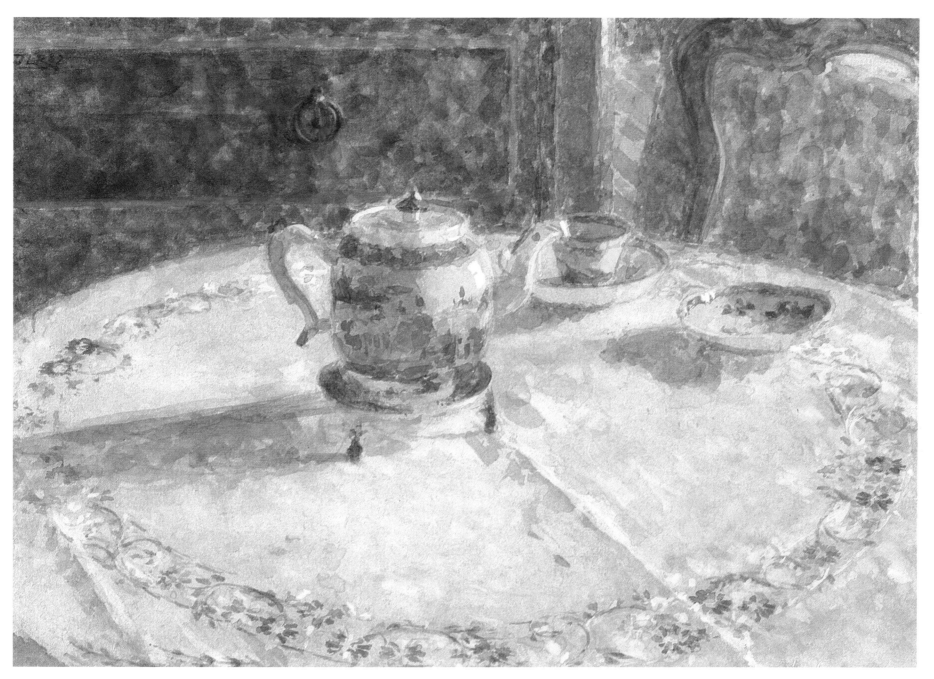

Still Life with Porcelain on a White Cloth
JACQUELINE RIZVI RWS (b 1944)
Watercolour and bodycolour on buff paper
8⅝ × 11⅞ ins

Shown here just under its full size, this work is at first sight a simple conception. In fact the sophistication of the composition and the brilliant, but never overstated complexity of the technique are paramount to our appreciation of Rizvi's concentration upon her subject.

The intuitive building of the picture's structure of bodycolour brushwork is a pleasure for the observer and a lesson to the amateur painter brought up on the principle that the purer the wash, the better the resulting image.

There exists in this work an empathy with the subject that implies some affection for this woman and child relationship. This may just be a result of the professional abilities of an artist whose principal concern was people, but yet again the apparent caring intimacy of the scene is felt by the viewer.

Born in 1869, Lee Hankey was a considerable contributor to the Society's exhibitions and activities following his election to associate membership in 1925. He became an RWS in 1936 when he was sixty-seven years of age. Following this late arrival in the Society he was Vice-President in 1947. He had trained at the Royal College of Art and in Paris. Lee Hankey's interest in scenes of social and domestic life may reflect his French training, as does the title and free handling of his Diploma work.

Watercolour is an inimitably suited medium to the subjects of home life, and the Royal Watercolour Society's living members are no less interested in their domestic surroundings than were their forebears. A fine example is the work of Jacqueline Rizvi, whose still lifes and portrayals of figures in the studio of her North London house are her most popular subjects. Rizvi is an ambitious painter and her large allegorical and portrait compositions would look well in the company of the major premium watercolours of the founder members of the Society. For Rizvi, watercolour is not a minor method of expression and her unrelenting ideals are admirable. In this medium she creates the sort of grand image considered by many of her contemporaries to be worthy only of paintings in oils.

Jacqueline Rizvi was born in Yorkshire in 1944 and studied art and later art history at Chelsea School of Art, London. She was elected ARWS in 1983 and was soon to be made a full member in 1986. This elevation may have been in recognition of her personal and sincere watercolour art, although her active participation in the Society's affairs has been notable. In its role as an educational charity, the RWS is developing a teaching programme which incorporates not only the demonstration orientated 'Art Event Days' but also short training courses for students of the art, who as a rule find such tuition unavailable through more conventional institutional channels. Rizvi is a propounder of this pedagogic role for the Society and her knowledge of the history of watercolour as well as her own particular working of the medium are evidence of her feeling for the exceptional power and import of the art.

Rizvi's Diploma work *Still Life with Porcelain on a White Cloth* concerns itself with, but is not only about domestic objects. It also reveals how the simple beauty of such pieces can crystallise a painter's interest in picture-making, and the relation of form with colour. Rose Barton chose a centrally focussed composition, and Rizvi's contemplative approach is equally uncomplicated by artifice. It would be pleasing to believe that the porcelain we see is placed on the artist's own dining table. But, to find such elegant vehicles for her art, Rizvi has painted this work in the apartment of a friend, who is a collector of fine ceramics.

This is an understated work – the porcelainous quality is there, but is hinted at, with the application of dabs of chinese white. The intimate reconstruction of the subject is not disturbed by any exercise in technical bravura, of which the artist would be well capable if she so wished. Rizvi uses here a brown tinted paper, a neutral colour, from which she works up the lights – often with bodycolour – and works down the darks with an ever developing succession of brushmarks on dry paper. The picture is formulated by an always changing counterpoint of brushstroke with brushstroke, one moment bringing a passage down in tone and the next enhancing it with a juxtaposed mark of brighter tone.

In some senses, this might be seen as an oil-painter's technique, but Jacqueline Rizvi makes it her individual way of tackling the watercolour process. There are no washes, no tricks, no slight of the watercolourist's technical abilities. Her style is far removed from that of De Wint or Russell Flint, but it is nevertheless that of a powerful and effective watercolourist.

Jacqueline Rizvi's recent Diploma work brings this chapter to a close. The chapter has carried a fairly loose theme of rural home life. Rizvi's work was executed in a flat in central London, but the domestic intimacy of her still life is a fitting summation of the qualities of many of the watercolours we have discussed.

RIVERS AND WATERWAYS

The affection of British watercolourists for their native landscape over some two centuries has been chronicled in Chapter One. We have seen that the arrival of Romanticism and the consequent freedom of artists in their choice of subject by no means eradicated their interest in the depiction of the particularity of places. In a sense the topographical tradition has formed and still represents the backbone of British landscape art. Within the great array of topographical landscape watercolours in Britain's museums and private collections, it is possible to pick out a number of recurrent themes. These themes reflect the character of our immediate world and also popular interest in the subject matter concerned. There are several such themes and particular subjects which have held a fascination for artists – castles, ruined abbeys, country houses, rustic cottages and coastal scenes are but a few of them. Another preoccupation has been the rivers and waterways which provide some of the most attractive scenery in the British countryside.

In the next chapter, we shall discuss and illustrate British involvement with the sea, but this island is also blessed with some of the finest inland waterways in Europe. The lushness of our countryside is at its richest on the banks of wide rivers, tumbling mountain streams and busy canals. In an often quoted passage of a letter to his friend John Fisher, John Constable records his passion for the dank and fecund qualities of riverbanks. He remarks '. . . the sound of water escaping from Milldams . . . Willows, Old rotten Banks, slimy posts & brickwork. I love such things . . . As long as I do paint I shall never cease to paint such places . . . Painting is but another word for feeling. I associated my "careless boyhood" to all that lies on the banks of the *Stour*. They made me a painter (& I am gratefull [sic]).'

This remarkable declaration serves as the keynote for the present chapter and for many of the watercolours that illustrate its theme.

The intimacy Constable epitomises with the flora of riverbanks arises in great part from the abundance of natural life with which our waterways are endowed by our temperate climate. The British do not enjoy the sun that Claude and even the French Impressionists bathed in, but nor do we suffer the scorched riverbeds and coarse foliage of the Mediterranean lands. We have benefited to such an extent from the cool tranquillity of our native rivers that a very individual culture of water-based activity has been a popular aspect of national life. Be it fishing from a rowing boat, nestled into an Essex creek, or making fools of ourselves in a punt on the Cam, or watching an Eight expending their efforts on the Thames at Henley, we enjoy our days on the water, even if they are on occasions rather chilly ones.

The canals and rivers of south Suffolk provided the settings for many of Constable's finest drawings and watercolours. But independently of this great and influential artist, several major watercolour painters of the early nineteenth century were finding such subjects sympathetic to their fluid painterly techniques. William Havell, Peter DeWint and William Evans 'of Bristol', whose picture of *The Old Bridge* that we see here so well evokes Constable's quoted statements, each in his own way exploited the capacities of watercolour to depict abundant foliage, damp atmosphere and water. Their pictures are topographical, in that they represent specific places, but in the case of each of these artists' work reproduced in this chapter, it is the atmosphere and delight in the river life which seem to interest them most. While in these works they capture the general characteristics of British waterways, rather than any particularity of their individual settings, these painters still use topographical reference points in a manner befitting the landscape tradition discussed in the first chapter.

Today, rivers, lakes and canals are crowded with pleasure trippers and sportsmen, and it is still possible to acknowledge an important role for inland waterways in contemporary life. In the early years of the Industrial Revolution and in the centuries before, rivers were, however, a principal means of traffic for goods. Long before the canals were built in the eighteenth and nineteenth centuries, barges and other boats and ships would ply the British rivers, transporting loads from the great ports to inland destinations and vice versa. Long before the railways established a unified alternative transport network across the country, the canals were being built to link major rivers and to carry freight around the industrial quarters of our growing cities.

In the 1820s, J. M. W. Turner produced a series of seventeen watercolours for a series of engravings issued by W. B. & George Cooke, entitled *The Rivers of England*. Four plates after Thomas Girtin were also included in the publication. Of Turner's watercolours, at least half show scenes in which the rivers are being used for private trade or corporate industry – from coals being unloaded on the Tyne at Shields, to fishing on the River Tweed. Turner himself was a keen fisherman, who kept a copy of Isaac Walton's *The Compleat Angler* in his travelling library. The currently great interest in angling, which has been described as the country's most popular participatory sport, is an example of our continued dependence on rivers for relaxation, in an era which has seen a decline in the industrial use of waterways, that Turner records in *The Rivers of England*.

In William Havell's *Distant View of Eton*, we may enjoy both the equivalent of a pleasant walk by the luxuriant riverbank as well as take interest in a man hard at work in these agreeable surroundings. This man's activity we shall consider in a later chapter, devoted to the theme of work, but let us now delight in the tranquil qualities of this watercolour. The view is, in fact, of Winchester Tower, Windsor Castle. In a more truly topographical watercolour, the castle might have been given more prominence, and Havell's mistake in describing the view as Eton in an inscription on the reverse of the sheet is possibly indicative, in this instance, of his relative lack of concern for topographical precision. His central subjects are concentrated in the foreground and middle distance, with the strolling pair of figures providing a contrast with the man labouring by the quay. The overall feeling of relaxation on a warm day by a cool Thames is predominant.

Havell stuck his thin sheet of watercolour paper to a board, on which he lined and washed a border for the picture. Unfortunately he did not make a sound job of the sticking down, and the picture is wrinkled and thus rubbed with age. Nevertheless, we are still able to enjoy the lucidity of his washes and dabs of watercolour, together with discreet and effective scraping away of the paper, to create lights which go towards making this such an attractive work of art.

Havell was very much an artist of the early nineteenth-century generation, who painted and drew, rather than coloured in, with watercolour. He also was prepared to use chinese white as one of his weapons and was quite capable of exploiting the

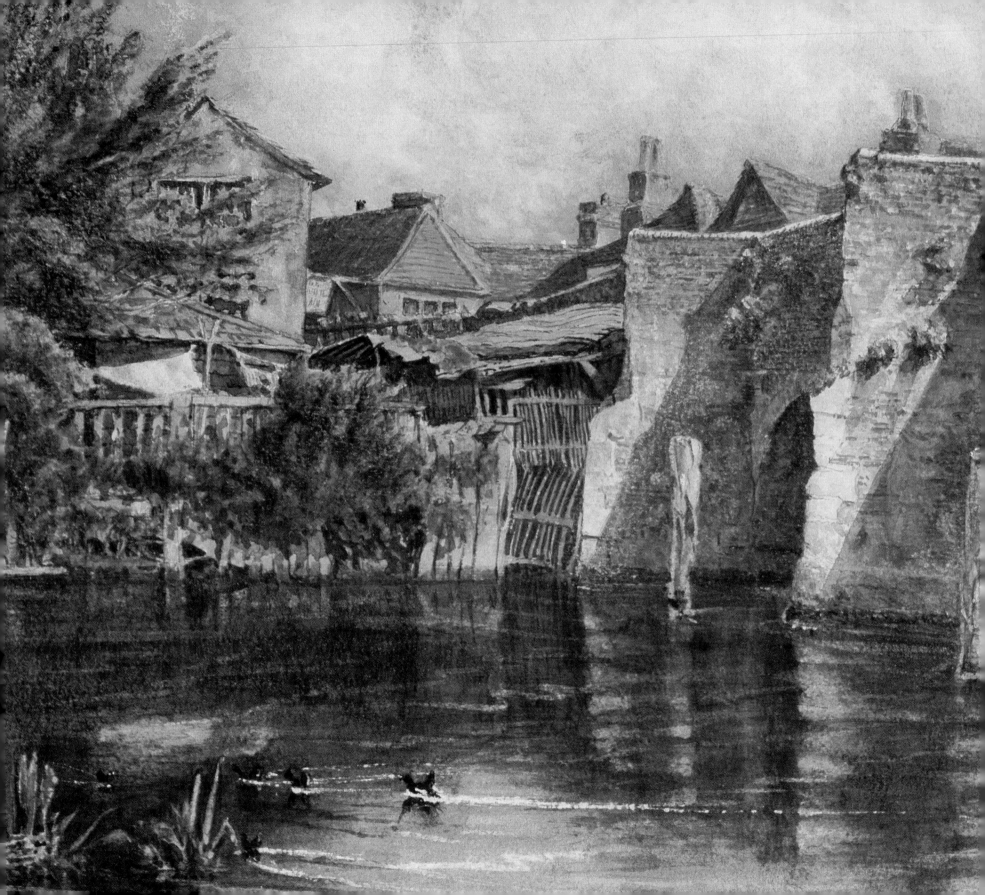

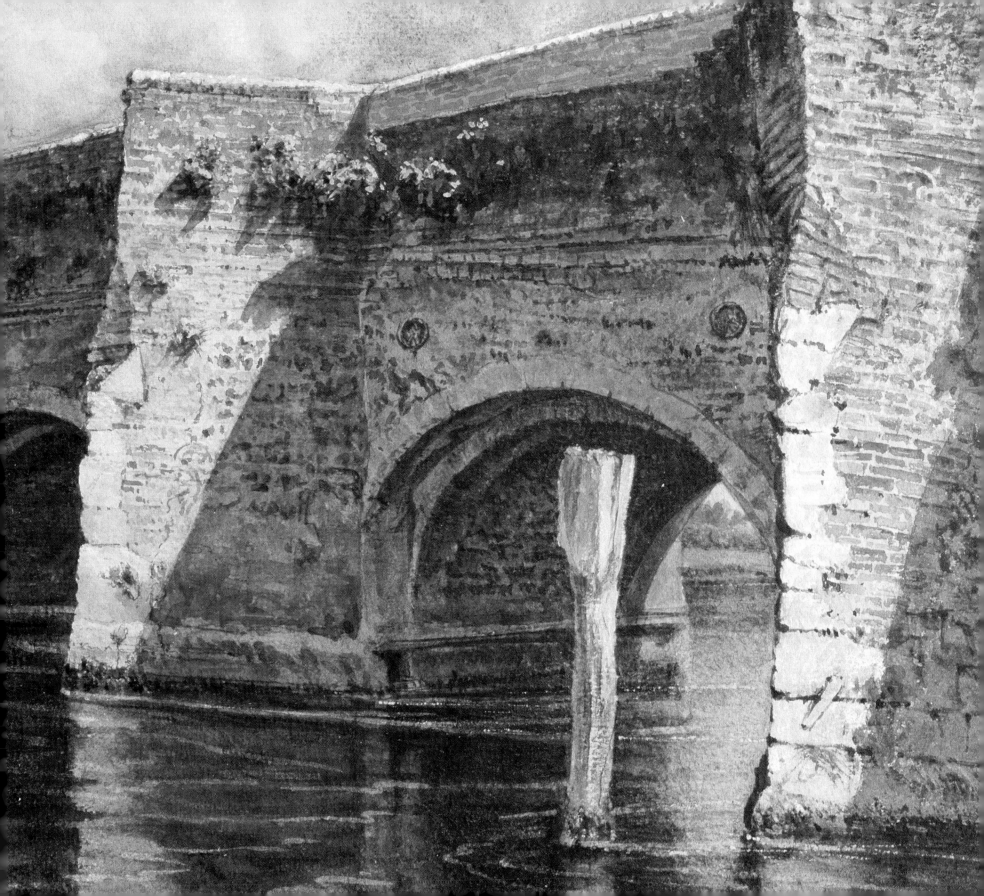

PREVIOUS PAGE
The Old Bridge (*Detail*)
WILLIAM EVANS 'OF BRISTOL' OWS

This over life size double-page detail shows almost the full width of Evans's superb watercolour, described later in this chapter. Here we get an ideal opportunity to study 'at close quarters' the artist's intensive technique. The stone and brickwork of the picturesque mediaeval bridge, the cool, slightly ruffled river, the greenery of the riverbank – all these are beautifully and remarkably depicted.

OPPOSITE PAGE
'Distant View of Eton' (Winchester Tower, Windsor Castle)
WILLIAM HAVELL OWS (1782-1857)
Watercolour and bodycolour with scratching out
10⅜ × 13⅜ ins (sight)

Like Evans, Havell depicts a cool, calm river with economy and apparently effortless technique. The scratching out as highlights of the ripples in the water made by the river fowl is a classic and effective device for establishing the location and angle of plane of the water surface, which itself can scarcely be painted as it is purely made up of reflections.

watercolour medium to the full in the search for the appropriate effects. Thus, we see both scratching out and opaque white used in this river scene, without either appearing uncongenial to the other. Havell has used both methods, for example, to convey the lights on the deep green water, and found scraping of the paper most suitable to depict the waterfowl and their wake, and chinese white preferable for the broader reflections of sunlight. This is the primary language of the great age of nineteenth-century watercolour painting, and while Turner was the greatest visual linguist of the time, Havell was a most competent and richly creative exponent of these methods of expression.

William Havell was born in Reading in 1782. In 1802 he made his first Welsh sketching tour and three years later he was to be one of the exhibitors in the inaugural exhibition of the Society of Painters in Water Colours. In 1812 he chaired the meeting at Robert Hills' house at which the original Society was wound up, although he continued to exhibit with the Oil and Water Colour Society. He later travelled with Lord Amherst's embassy to China, going on to visit Ceylon and India, in which latter country he remained for six years as a fashionable portrait painter. Havell later was to travel to Italy, but most of his life from 1826 to his death in 1857 was spent in Britain.

In *The Thames at Windsor* Peter DeWint shows us a similar view of Windsor Castle as that in Havell's watercolour, though taken from slightly further upstream. This lyrical watercolour bears all the hallmarks of DeWint's intuitive and broad watercolour manner. His breadth of technique in all but the largest exhibition pieces is one of the greatest revelations of the watercolourist's descriptive powers that comes down to us and which continues to entrance painters and collectors to this day.

That DeWint's large machines, which are to be seen to great advantage in the Usher Gallery at Lincoln, are among his finest works, should go without saying. But the current and very twentieth-century 'modernist' appreciation of his more sketchy, more apparently private watercolours is not, however, a misrepresentation of the artist. Even such loosely handled watercolours as *The Thames at Windsor* would have been displayed in public exhibitions, notably those of the Society. Peter DeWint may be regarded as an artist who, in the public arena of his time, took the painterly potential of watercolour to its extremes of expression.

DeWint is one of the central figures of British Romantic art. He was born in 1784 in the suburbs of what is now Stoke-on-Trent, the son of a doctor of Dutch ancestry. It may be mere coincidence, but his love of the flat countryside and open skies of Lincolnshire and the Trent Valley, for example, seems to hark back to his Low Country forebears. DeWint painted many watercolours of English river valleys. A number of these were centred around Windsor, a popular centre for artists of the period, among them J. M. W. Turner. In 1806 or 1807, Turner produced a series of oil sketches and watercolour studies of scenes on the Thames and its tributaries west of London. As noted earlier, a number of these at least may have been started from the vantage point of a hired boat, and then worked up to a 'finish' in the studio. While working on the spot entailed practical difficulties, such as the restricted size and amount of equipment which could be carried, and the fickleness of weather and atmospheric conditions, spontaneous confrontation with nature and natural forces was central to the motivation of the Romantic artist.

Nevertheless Turner and the other watercolourists continued to make pencil sketches from nature to be redesigned and enlarged in studio conditions to create exhibition pictures. They also began to blur the previously distinct dividing line between the watercolour sketch and the finished work. In Turner's case, this particular activity resulted in the beautiful and naturalistic series of watercolours in the 'Thames, from Reading to Walton' sketchbook now in the Turner Collection at the Tate Gallery, in which distant views of Windsor's Royal Castle are prominent. For DeWint, the landscape 'sketch' in watercolour was a perfectly acceptable form of 'finished' work, and he would have seen no reason why pictures of this type should not be included in the annual exhibitions of the Society.

Despite the efforts of scholars, it remains largely conjecture as to which oils and watercolours of this most fruitful period of British landscape art were painted entirely before the subject. A similar puzzle exists in dating DeWint's *oeuvre*. The consistency of vision and technique over his mature career presents as yet unresolved problems of chronology. One would imagine that the watercolour reproduced here is of the 1820s or 1830s. Its breadth of handling and keenly observed rendering of the damp, green riverbanks and foliage are characteristic of the artist's work at this time. It would, however, be speculation alone to suggest *The Thames at Windsor* was painted on site.

We do know that the work was presented to the Society by J. J. Jenkins, and was certainly hung at the Pall Mall gallery for some time. This exposure to light caused some fading, for any colour that there might

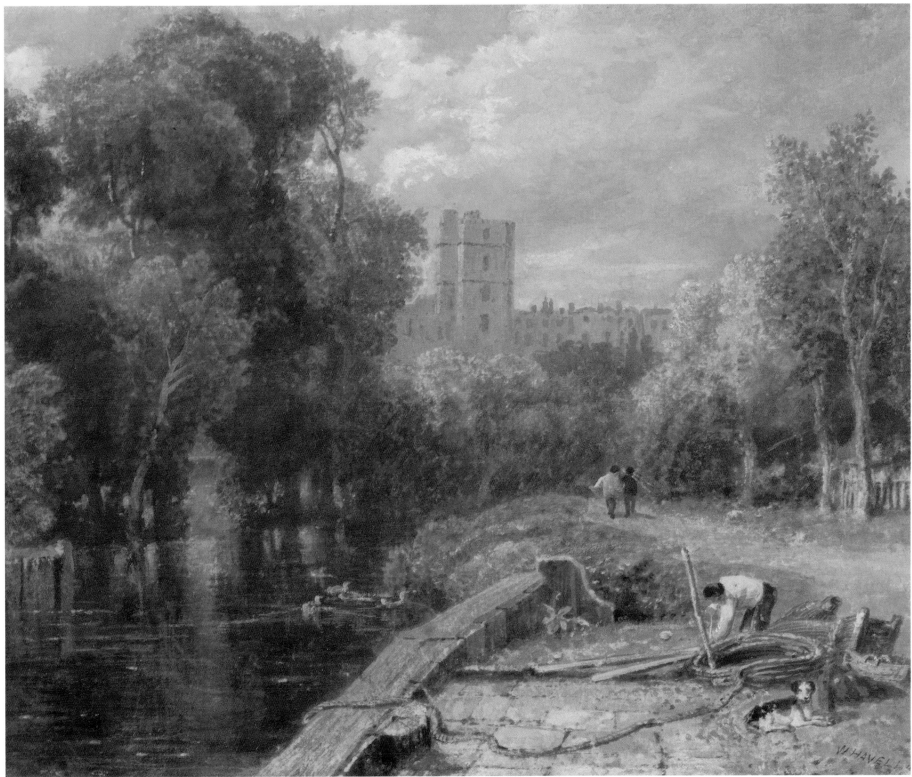

The Thames at Windsor (*Detail*)
PETER DEWINT OWS

In this enlarged detail we see the central section of DeWint's splendid Thames scene and can examine more closely the breadth of his brushwork. The ability to describe so much with so few marks on the paper is an achievement born out of years of experience, a particularly acute vision of the world and considerable natural talent.

have been in the sky has disappeared, a characteristic misfortune of many of DeWint's exhibited watercolours, the blues he employed being extremely fugitive. However, little of the lush colour and rich tonal washes of the foreground have been lost. The free brushwork is exemplary of his masterly technique, from the wet brush drawn across the right foreground and the economically brushed trees above – their wet-in-wet method contrasting with the wet brush on dry paper at their edges, suggesting the filtering of light through foliage – to the utterly DeWintian broken-brush stippling of the leaves of the dominant tree on the left. The necessary dryness of the paper behind these upper reaches of foliage, in what seems to be a quickly painted watercolour, gives credence to the possibility that there may never have been any wet, and therefore coloured, sky in the first place. In any case, this fresh picture is a good example of the combination of what Hammond Smith has described as the artist's 'dry brush' and 'wetter, blottesque methods' of depicting foliage. This combination may place the work as late as 1840, by which time De-Wint's palette appears to have developed a richness quite unique in the annals of watercolour painting.

Peter DeWint was a member of Dr Monro's circle and thus came under the influence of Girtin, whose creative force and new approach to watercolour expression was to exert a life-long effect on him. He became a leading member of the Society in 1810, resigning on the formation of the Oil and Water Colour Society, but rejoining in 1825. Rooted in tradition as a painter and although a man who was unadventurous in his travels, DeWint is nonetheless one of the most refreshingly radical artists of his period. Above all else DeWint was absorbed by the realities of the English landscape and it is perhaps appropriate that it was the 'plough-boy' poet John Clare who wrote in a letter to the artist that 'nothing would appear so valuable to me as one of those rough sketches, taken in the fields, that breathe the living freshness of open air and sunshine'.

The Thames at Windsor
PETER DEWINT OWS (1784-1849)
Watercolour over graphite
$11\frac{1}{8} \times 17\frac{5}{8}$ ins

This strong DeWint is shown here slightly beneath actual size and its strong, broad brushwork is clearly to be seen. A view close to that taken by Havell, the subject has been very differently treated, as befits the variance between DeWint's sketching technique and Havell's manner for finished watercolours.

Another major figure of the early nineteenth-century watercolour school was William Turner 'of Oxford'. He was 'of Oxford' in a literal sense, in that he spent most of an apparently uneventful life in and around his native city. But, as was mentioned earlier, he was given this appellation to distinguish him from the other William Turner, known at first as W. Turner, and later as Turner RA, or Joseph Mallord William Turner. Even if it is fair to describe 'of Oxford's' career as uneventful, this is to a great degree mitigated by the passion and political concern which inform many of his more substantial watercolours and oils over a lifetime of creative work.

In 1809, this twenty-year-old painted a startlingly advanced and impressively large watercolour of *Whichwood Forest, Oxfordshire*, now in the Victoria and Albert Museum, which besides being a major statement of the watercolourist's power, is a symbolic protest against the closure of the forest by the Duke of Marlborough. Turner was also unsympathetic to industrial development changing the natural countryside. As late as 1849, when *Cherwell Waterlilies* was painted, we may assume that Turner had not lost his interest in conservation and that the rich, rain-forest-like abundance of the scene is intended to be a statement about the crude, modern industrial canal which earlier had been dug in the vicinity, thus making the Cherwell a backwater.

Born in 1789, Turner was to become one of John Varley's most distinguished pupils, and he went on to develop a highly personal and emotive approach to landscape which, for its sincerity, is unlike that of some of his more commercially minded pot-boiler-producing contemporaries. Of all the works in the Collection of the Royal Watercolour Society, *Cherwell Waterlilies* may be understood as having one of the most distinct places in history. Painted in 1849, it represents a landmark in Turner's career.

1849 was the year in which Pre-Raphaelitism appeared upon the London scene, with a number of confident paintings being shown at the Royal Academy by the young members of the Brotherhood. Whatever Turner's knowledge of the Pre-Raphaelites, this very large and intricately handled piece of body-colour painting is unusual, if not unique in his *oeuvre*. In no other work of this time do we come upon such clarity of conception, such overall precision of handling, nor such a Ruskinian breadth of revelation of the

Cherwell Waterlilies
WILLIAM TURNER 'OF OXFORD' OWS (1789-1862)
Watercolour and bodycolour
21⅝ × 27 ins

This illustration shows the almost Amazonian richness of handling and colour which makes this something of a unique work in the *oeuvre* of the artist. The impression that Turner has picked out virtually every leaf in bodycolour is not an illusion and this picture emphasises how far, by 1849, his career had come from the early topographical watercolours.

BELOW
Cherwell Waterlilies (*Detail*)
WILLIAM TURNER 'OF OXFORD' OWS

This half-size detail allows us to study in greater depth Turner's handling. For example, it is worth observing the flecks of bodycolour which build up the bark of the tree to the right of the composition. These convey the effects of texture, volume and light. The waterlilies are painted with a more straightforward use of watercolour and of necessity were carefully planned in advance.

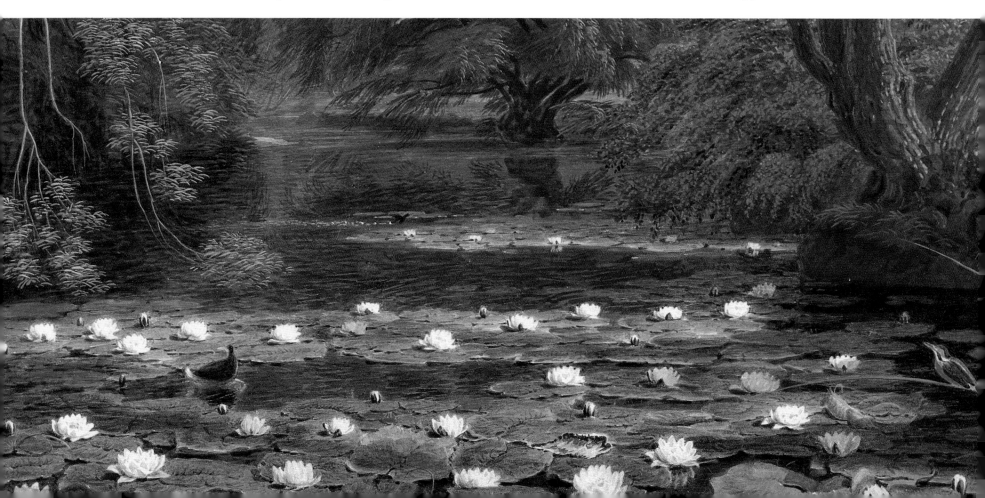

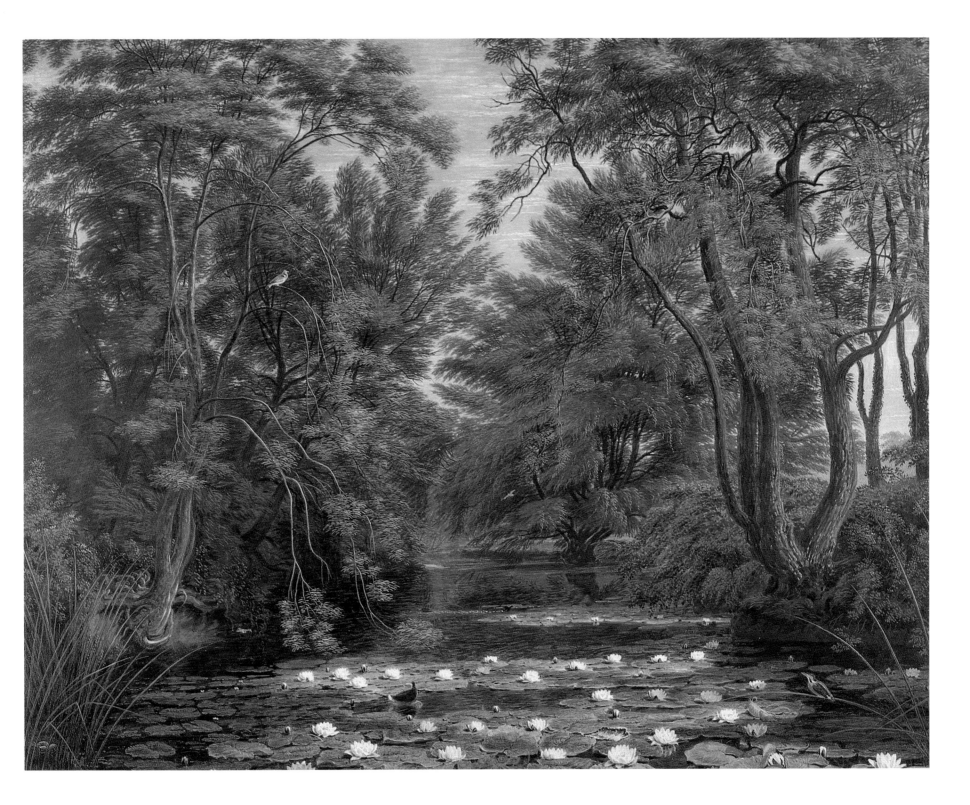

intricate glories of what is a much loved and studied subject. The Cherwell, before being bypassed by the canal, was Turner's local river thoroughfare and passing as it did near his uncle's manor house at Shipton, it was also a principal element of his spiritual home.

In this picture we see the Cherwell has now become a backwater, unfrequented by river craft, but populated by an abundance of natural river-life: waterlily, kingfisher and coot prosper in its tranquillity. Of the several versions of *Cherwell Waterlilies* he produced between the late 1830s and the 1850s, this is the only dated one, and probably the grandest. On the reverse are inscribed lines which read:

'Cherwell Water Lilies,
Stilly and lightly their vases rest
On the quivering sleep of the water's breast
Catching the sunshine, thro' leaves that throw
To their scented bosoms an emerald glow.
– Mrs Hemans'

It was characteristic for artists of the period to enhance major exhibition pieces with lines of poetry in the catalogue, and Turner's namesake, the Academician, often attached his own lines to important works in this way. The comforting mood of Mrs Hemans' verse is well-suited to the artist's vision of the scene.

Turner was elected to the Society in 1808 and, as a member most involved in its affairs, he went on to exhibit over 400 watercolours at the annual exhibitions. The project to form a Diploma Collection was conceived two years before his death in 1862. While he never contributed a Diploma work, we should be grateful that his interest in the Society resulted in the presentation of this major watercolour by Turner's executors, soon after his death.

Both William Turner and Peter DeWint were prolific artists. William Evans 'of Bristol' is a far rarer painter, and such highly finished exhibition works as *The Old Bridge* are much sought after. This is a precious and most rewarding topographical watercolour, that despite its sense of place has yet to yield the identity of its subject. This may be a town or village in the artist's native Westcountry, but as observers we may simply share with Evans his delight in the texture of the bridge and the river, and the superbly evoked effects of midday sunlight. The painter revels in the deep tones of the water, setting these off against the crisp handling of the brick and stonework. There is a profound tranquillity about the scene, emphasised by the gentleness of the disturbance of the water and by

the timelessness of this peaceful English summer's day, captured with an easy naturalism. This is a river seemingly made for beauty, far from the active life of industrial waterways. But this tranquillity is not quite shared by the manner of Evans's active painting technique.

In his *Dictionary of British Watercolour Artists*, Huon Mallalieu describes this fine technician's skill as a matter of 'soaking, pumping, scraping and scratching his paper, and using its texture to aid his compositions'.

This could have been an appraisal of *The Old Bridge* in which we observe, for example, the use of Rough paper to create texture in the principal area of blue sky. Here, the tiny pits which naturally form in Rough-surfaced deckle-made paper gather particles of washed blue pigment whereas the higher bumps of the well-sized sheet reject them. Thus an intricately patterned paper surface is exploited to animate and break up the flatness of the wash and produce a variety of tone and colour. This effect would of course be less easily achieved on smooth, Not or Hot Pressed paper. Many watercolourists of today, particularly amateurs who have been misleadingly indoctrinated, employ Rough paper which is over-mechanical in its surface; exaggeratedly patterned by its humps and hollows. With mould-made paper especially, where the machine's pre-designed surface provides a mechanical-looking and repeated pattern of texture, we often see that the individual quality of the artist's handling has been dominated by the relentless imposition of the paper's own structure. Hand-made papers tend to have a less rigorously repetitive surface character, largely because each sheet is individually made by craftsmen. A good Whatman sheet of the nineteenth century or modern Arches or Saunders (having an excellently variegated surface despite being mould-made) or the RWS paper of Barcham Green & Co allow the painter to be in control of his materials and not the other way around.

In *The Old Bridge*, we may also enjoy Evans's accomplished use of scratching-out – for example in the sunlit parapet of the bridge and in the delicately placed wake of the swimming moorhen or coot. Some chinese white is to be found on the parapet, but most of the ripple effects in the water have been achieved through stopping out – the application of a later removed resistance before the general watercolour wash – or gentle scraping with the reverse end of the brush. Essentially, however, this is a 'pure' watercolour, and we can only marvel at the artist's inventiveness and accomplishment. William Evans was elected to as-

sociateship of the Society in 1845, his thirty-sixth year. He continued to exhibit until his death, having taken up residence in London after his election and later spending some years in Italy.

The industrial use of waterways is portrayed in Thomas Miles Richardson Jr's *Lock at Windsor*. The Thames Valley provided the subject matter of much of this Tyneside artist's most attractive work. Born in 1813, and growing up in Newcastle in the second and third decades of the nineteenth century, Richardson, whose father was an accomplished watercolourist working in the tradition of David Cox, experienced the growth of this bustling north-eastern industrial centre. From the city's river set sail the ships which left Newcastle and Shields with precious cargoes of coal, destined for commercial and domestic use in many regions of England.

Richardson moved to London in 1846, three years after his election to associate membership of the Society of Painters in Water Colours, of which his membership was granted in 1851. He travelled extensively in Britain and Europe and returned to Newcastle in his last years, dying there in 1890. The industrial surroundings of his native city were never his predominant choice of subject matter, but industrial use of water must always have been in his mind.

Lock at Windsor, painted one year after his arrival in the capital, does allude to commercial use of waterways, as two men struggle to open the lock gates for a barge. Adding to the impression of human activity in the scene, a woman and a child walk away from us along the towpath, itself a visual aid to the recession of the composition. Recession is also conveyed through the use of aerial perspective. This technical device is the product of the realisation that forms become paler and less distinct under most atmospheric and light conditions as they recede from the viewer. Look, for example and comparison, at the sharply defined tree to the left and the slightly less distinct first tree on the right hand bank. Immediately beyond the latter is a tree of much lighter tone. Behind the horses, distant trees stand in hazy, silvery light, fading gradually as they recede towards the right – thus indicating the direction of the river.

The distant woods are painted with great delicacy and a most sensitive tonal palette of pure watercolour. Elsewhere, Richardson has made use of added gum arabic, giving density to the foreground bushes, and bodycolour, which picks out the sunlight on the brick of the building to the right. Immediately below this, the horizontal scratching of the water surface gives a twinkling light where it meets the bank.

The Old Bridge
WILLIAM EVANS 'OF BRISTOL' OWS (1809-58)
Watercolour and bodycolour over graphite with stopping,
scraping and scratching out
12³⁄₈ × 19⁷⁄₈ ins

We are now able to look at Evans's beautiful watercolour
from, as it were, a greater distance. Not only does this help
us to take in the composition, but also to see how his
technical mastery binds the whole range of marks on the
paper to create his representation of the subject.

Lock at Windsor (*Detail*)
THOMAS MILES RICHARDSON JR RWS

With a near actual size detail we enter a little further into the picture and pay closer attention to the aerial perspective of the composition. The gradations of tone along the line of trees in the distance are extremely subtle and are necessary to suggest the continuous curve of the river, as well as avoiding too flat a backdrop. Note the scratching out in the Thames, to the right of the detail.

Richardson never gave the Society a Diploma work. This fine piece, one of four works by the artist in the Parsons Bequest, may justly be regarded as a substitute Diploma watercolour, being both in date and quality a fitting representation of the painter on his move to London to further the career which his election to the Society had made possible.

A setting geographically much closer to Richardson's north-eastern roots is to be found in one of a pair of small watercolours of Norham Castle, on the River Tweed, also from the Parsons Bequest. This famous Turnerian subject is handled in a way that surely indicates the master's influence on Richardson's conception. The picture's companion piece in the Parsons Bequest is a midday scene, taken from a different and higher viewpoint over the castle. In the present work Richardson positions himself by the Tweed and shows the castle at sunset, producing a most effective rendering of evening light and atmosphere.

Turner's favourite composition of this scene was usually taken at sunset, but he normally looked westward towards the castle, silhouetting its ruins against the light. Richardson has gone upstream to catch the last rays of the sun striking the top of the castle hill and the blue depths of the advancing twilight. It is worth recording also that both artists have typically animated the river scene by recording its continual use into the summer evening by both rivercraft and animals drinking at the edge.

The depiction of ruined castles beside rivers held much appeal for nineteenth-century watercolourists and publishers of illustrated books. Much of Turner's work in this genre was intended for engraving for topographical publications. If anything, the Richardson *Norham* is less topographically orientated than, for instance, Turner's watercolour for the *Rivers of England* series, which is itself also a remarkable excursion into complex theories of chromatic evaluations of shape and form. The colour schemes of Turner's picture partly existed to help the engraver in his monochromatic translation of the intricacies of the work. Richardson's work was not produced for reproduction by an engraver and, with greater breadth of colour washes, he was really using the subject as a

Lock at Windsor
THOMAS MILES RICHARDSON JR RWS
(1813-90)
Watercolour, gum and bodycolour over graphite, with
scratching out
9⅝ × 15 ins

In this illustration the attractive colouring of Richardson's
picture may be appreciated, as can the change in execution
from, for example, the foreground foliage to the gentle and
complex washes of the misty background.

vehicle for effects of light and atmosphere that are ends in themselves.

With Thomas Charles Leeson Rowbotham's exquisite little watercolour of *Cliveden*, we return to the Thames Valley. In an inscription to the lower left of this work, Rowbotham tells us that he sketched his subject, which he describes as Cliefden, on 24 August 1865. This lazy summer scene is most beautifully painted, probably in front of the view, with a suitably relaxed and happy technique, and without any suggestion of artifice or the complications of picture making. The composition appears entirely natural, exactly as it was that sunny day, when Rowbotham sat down on the river bank to record this pleasant stretch of the Thames to the west of London.

The punt, lying moored, and for the moment unused, to the fore of the artist's vision, is symbolic of the aesthetic pleasures of the river and the recreation it still affords those boating on these reaches of the Thames that are as relatively unindustrialised now as they were in 1865. The balmy vista is most pleasingly painted in pure watercolour with a freedom which is often missing in Rowbotham's rather more mechanically constructed set-pieces. His large studio-created exhibition works can be somewhat dull by comparison and often include extensive and sometimes heavy-handed use of bodycolour and gum. These he would probably not have had available in his portable painting kit.

Born in Dublin in 1823, and one of a family of watercolour artists, Rowbotham joined the New Society of Painters in Water Colours in 1848. He became drawing master at the Royal Naval School, Greenwich, in succession to his father, and in the tradition of such institutional tutors as Paul Sandby and John Sell Cotman. The RWS is grateful for the inclusion in its Collection of this charming watercolour by a non-member, due to the generosity of Mary Parsons.

In the work of Wilmot Pilsbury, we come upon a watercolourist continuing the approach and style to rustic subject matter forged by Birket Foster and Helen Allingham, both of whom featured in the previous chapter. Principally he was a painter of country cottages and idyllically comforting landscapes. The charming Diploma work which goes under the anecdotal and typically late Victorian title *The Never Failing Brook, the Busy Mill* is indicative of the artist's predelictions.

In this painting, Pilsbury depicts with nostalgia a late summer evening. The last failing rays of the sun catch the trees on the hill behind the watermill, and an air of quietude and lack of human presence, belying the industry of those who may be behind the scenes and within the building's walls, creates the dominant mood. But any point Pilsbury wishes to convey is indicated by the title, which emphasises that it is the millstream which is doing the lion's share of the work to provide energy for a country industry. Man-made machinery harnesses natural forces and it is upon the 'never failing' power of this unspoilt stream that man relies for his industrial processes.

Therefore this apparently happy co-operation between man and nature in agreeable surroundings is to be seen as a microcosm of the ever-resourceful abundance of natural energy. In our own day, as debates proliferate about the relative advantages of energy production from natural forces: be these wind or water, as opposed to nuclear or fossil fuel generation, Pilsbury's particular admiration for the harmonious coupling of industry and nature does not seem in the least archaic. One might consider it idealistic, given the squalor of the industrial landscape we have inherited from the naturally-powered Victorian age, but sincere and worthy in concept his opinion certainly is. Whatever we may feel about its apparent message, this picture plays an integral part in the theme of this chapter, and shows the beneficial use of a river for mankind's material ends.

Pilsbury's evocation of atmosphere and light is most successful, and he employs extensive use of bodycolour to enhance what is in essence a pure watercolour. The sky, in particular, is covered in chinese white, probably to give it the palpable texture and presence it requires properly to be set against the complex manner of the rest of the picture, which leaving of the raw paper surface alone might not have achieved. There are passages of drawing, however, which do not convince us so readily. Note, for instance, the awkward perspective of the gate on the lane by the mill. His occasional clumsiness has its own charm and the picture works well as a composition and is most evocative in mood. Pilsbury was a Birmingham artist, born in 1840, who trained at the city's art school and later at South Kensington. He went on to a successful career as a teacher and to run the Leicester School of Art. Elected ARWS in 1881, his elevation to full membership in 1898 is commemorated by this fine Diploma work of the same year.

In his watercolours, largely painted for his own pleasure, when not involved with commissions for portraits in oils, Pilsbury's near contemporary John Singer Sargent was a less *recherché* and more formidably powerful practitioner of the art. Produced some ten or fifteen years later than *The Never Failing Brook* Sargent's Diploma work of a *River Bed* is a tour de force of painterly virtuosity that stylistically accords with the current developments in mainstream European art.

Through his contact with, among others, Claude Monet, Sargent was aware of the work of the French Impressionists and their influence is to be seen on this picture. By the later years of the twentieth century's first decade when he executed this work, Impressionism was no longer a contemporary phenomenon. But few watercolourists working in Britain at this time had such a close initiation into the recent advances made by artists in France and this fact is reflected in the character of much of the work of the British school at this time. Many watercolourists were still painting in Victorian methods and styles. Wilmot Pilsbury, who lived until 1908, is a good example of this retrospective attitude. Impressionism represents the transition from previously long-held attitudes of the visual representation of the world to a modern formal language for, and attitude towards, nature. Those painters who are, often erroneously, described as Post-Impressionists asked questions which attempted to tackle the central issue of the formal and symbolic role of art. In an age enlivened by the descriptive potential of photography, loosely linked painters like Cézanne and Seurat sought ways to find and portray the essence of nature, rather than its superficial face. While RWS members such as Thomas Hennell and A. S. Hartrick worked with Gauguin and other Post-Impressionists at Pont-Aven in Brittany, it took the American Sargent to display convincingly and popularly to a London audience the bravura and formal considerations of modern French art in his watercolours.

Sargent lived until 1925 and although his bread-and-butter work of society portraiture is a key-note of the Edwardian era, it had precedence in the successful portrait practices of such respected late Victorian painters as Sir John Everett Millais and Sir Francis Grant, both Presidents of the Royal Academy. In his watercolours, though, Sargent broke free from the constraints of commissioned art, rather as Gainsborough had done with his landscapes in watercolour and oil.

One of our first impressions of Sargent's dry and stony river-bed, with the blur of a mountain stream beyond, is that it seems relatively formless and without any considered sense of composition. This absence of traditional picture structuring, recollecting as it does Monet's late paintings of waterlilies, is one of the

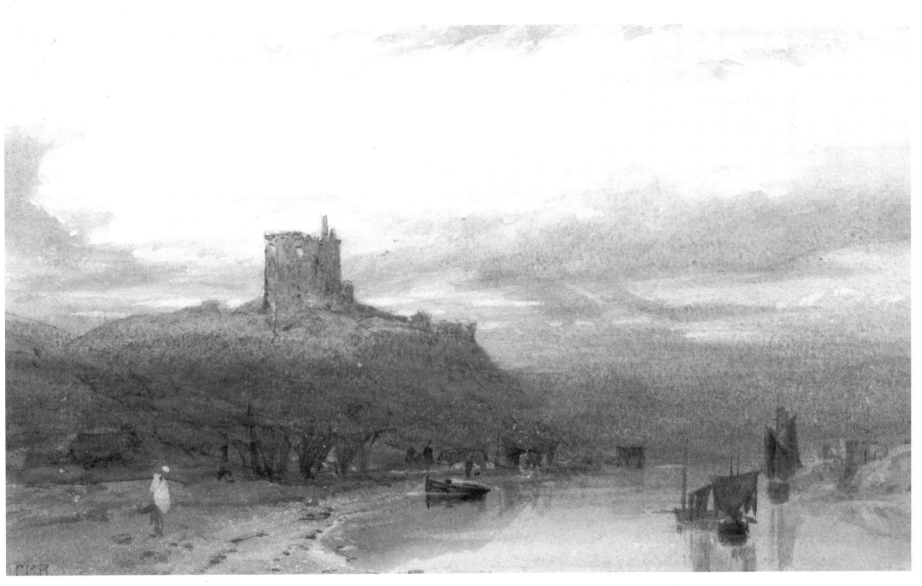

Norham Castle, Evening
THOMAS MILES RICHARDSON JR RWS (1813-90)
Watercolour and bodycolour over graphite
6 × 9 ins

Richardson has probably done some sponging out to help create the misty effects above the line of shadow, which is presumably creeping up the hill on which the castle stands. This life-size reproduction allows us to examine the artist's varied brushwork and enjoy the Turnerian breadth of his colour range.

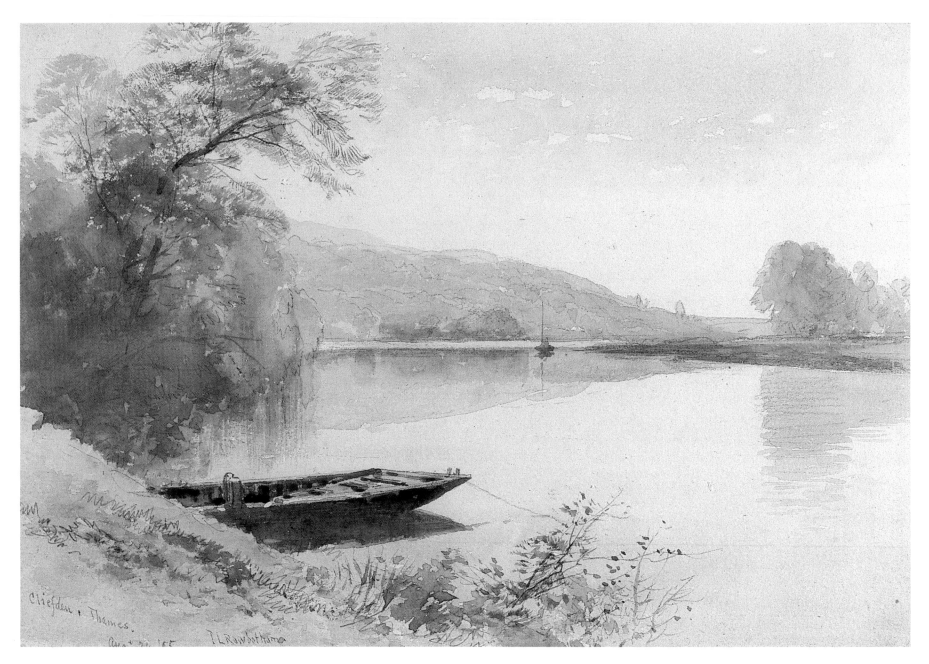

Cliveden Reach, Thames
THOMAS CHARLES LEESON ROWBOTHAM
(1823-75)
Watercolour and bodycolour over graphite
6¾ × 9¾ ins

Shown here at its full size, this delightful and understated little watercolour captures all the airiness and light of a calm Thames-side afternoon. Rowbotham's sparse application of the dry and wet brush and his simple clear washes are an example to today's amateur watercolourists. Indeed this has the feeling of a very modern piece of watercolour painting.

work's great joys and allows the artist to convey admirably with broken colours and textures his apparently mundane subject.

The heightened colours of the lights and shadows not only reveal the influence of the Impressionists, but also reflect the fact that this is a stream-bed basking in the clear light of the Alpine slopes of the Val D'Aosta, which plunges down to the North Italian Plain. Although not of a British scene, this watercolour has been included in this chapter because it so interestingly shows yet another way of considering natural waterways and is to be contrasted in its treatment with a similar subject by Charles Knight, which we shall consider shortly.

Sargent paid several visits to the village of Courmayeur, situated at the head of the valley, and there are many extant watercolours which record the details of his surroundings there. Often these are of mountain streams, sometimes populated by his travelling companions, bathing or lounging around on warm summer days. Like Constable, Havell or Evans, Sargent was particularly concerned with the intimate richness of river, or in this case, river-bed life. His technical bravura consummately conveys not every detail, but the way each particular element of the scene is affected by the interplay of light and shadow. The rich juxtaposition of vibrant colours is made with immense fluency, with watercolour and bodycolour being pushed to the extremes of their potential.

The life-size detail reproduced here vividly reveals Sargent's bold virtuoso style. Painting rapidly, and unconcerned to conceal or merge his marks on the paper, Sargent has left ample evidence of his working technique. First of all, a brief pencil outline has been washed over with a wet brush. In the painting of the bank at the top of the picture, he has let the roughness of the paper create texture and allowed the fluid wet-in-wet pigment to form its own 'accidental' paths and patterns.

Bodycolour has been used for some of the highlights, such as many of the stones on the dry bed, while in other areas the original white of the paper shows through, further enlivening the broken quality of the painted surface. To describe some twigs within the sienna patches to the right foreground of this illustration, Sargent has lightly flicked the brush point, loaded with an umber pigment, and then scratched over these, probably with the reverse end of the brush, to throw the twigs into relief.

This work is a remarkable example of the artist's technical adroitness and is a classic instance of a watercolourist employing a wide range of techniques and materials to achieve his chosen effects. It may disturb the purist, but this work also shows that a deliciously liquid overall effect can be achieved other than with simple watercolour washes.

Born in Florence in 1856, the son of an American doctor, Sargent travelled extensively in Europe before setting up his portrait practice in London. He made frequent journeys to the United States, where he was equally fashionable as a painter of the wealthy and famous. Watercolour became the principal medium for his expression of interest in landscape and, having been elected an RA in 1897, he joined the RWS as associate in 1904, becoming a member in 1908, from which year his Diploma piece may date.

Sargent once described his watercolours as 'mere snapshots'. By comparison with his more formal *oeuvre* in oil, this comment is understandable. It is also a true reflection of the concern he shared with the Impressionists to capture a moment, an instant of natural light and colour. In his well known series of paintings on the themes of haystacks, the façade of Rouen Cathedral and the Houses of Parliament, made under varying weather conditions, Monet exemplified the

River Bed
JOHN SINGER SARGENT RA RWS (1856-1925)
Watercolour and bodycolour over graphite, with scraping out
14 × 20 ins

In this illustration of the whole work we are able to get sufficient impression of the overall composition of what is in essence a somewhat uncomposed study. Better still can be appreciated how the broad, vigorous brushwork fuses together into a recognisable image. Even so, it is only just possible to say that water is flowing in the background.

River Bed (*Detail*)
JOHN SINGER SARGENT RA RWS

This almost life-size double-page detail reveals the full force and vitality of Sargent's free use of watercolour and bodycolour. While the larger portion of the river bed may be dry, we can bathe in the splendid lushness of the picture and enjoy the varied use of techniques and mediums, that are the artist's hallmark.

belief of the Impressionists that as light differs, effects differ, so the character of the subject being painted also differs. This is a recognition that we only perceive the world around us through the light reflected off objects and into our retinas. Without light there is no visual substance to the world, and as the light changes, so does the nature of the subject before the artist. In a watercolour like his *River Bed*, Sargent shows how he too conceived of the painting of landscape in a similar way.

Sargent's watercolours have, over the years, been avidly acquired by American museums and collectors and appear rarely on the market in Britain, his adopted country. These inspired works are among the major achievements of American art.

Samuel John 'Lamorna' Birch was an artist almost equally indebted to the example of the Impressionists, and, with a reputation which has been recently revived and is rapidly growing, should now be seen as one of the major figures of British 'Post-Impressionism'. He adopted the name 'Lamorna' from the Cornish village in which he spent much of his life, in order to differentiate himself from Lionel 'Newlyn' Birch, whose native village was the centre for a new and now much appreciated group of English painters, one of whose number was his namesake. Without quite the accomplishment of Sargent, Birch successfully adapted the principles of recent French painting to a very English approach to landscape. His period of training in Paris in the 1890s, when he was deeply affected by the works of Monet and Camille Pissarro, must in part be accountable for the breadth of style he brought to his Cornish and Scottish landscapes.

Birch's Diploma work of 1903 was made far away from his adopted county and shows *The Old Brig O'Dee*. The bridge spans the River Dee to the west of Castle Douglas in south-west Scotland, and in the clear Scottish light the scene is painted with a vivid but cool palette. This all suggests the chill in the air of a sunny spring day, before the snows have cleared from the Kirkudbrightshire hills. The broken brushwork of the river is reminiscent of Monet, as is the luminous colour and the artist's refusal to allow anything but reflected colours into the shadows – under the arches of the bridge for instance.

His palette is here less subtle than Sargent's, but the vigorous brushstrokes are uniformly enough structured, giving the viewer a recognisably comprehensible impression of the scene when the picture is seen from a distance. The Sargent is so sensuously and texturally pleasing as well as essentially abstract that it survives critical examination from any view-point, but it too knits together properly when observed *in toto* from a distance, as the illustration of the full work shows.

Lamorna Birch was born in 1869 and spent his early years in Manchester, where he worked for a time in a mill. From 1892 he turned what had been dabbling in watercolour painting into full time occupation, and also developed an interest in oil-painting. After his time in Paris, Birch returned in 1902 to settle permanently at Lamorna. His associate membership of the RWS was granted in 1912, and full membership came in 1913. He died in 1955, his eighty-sixth year. A favourite pastime of the artist was to fish for trout and one can imagine that his Diploma work was not the only reward from his time by the Dee.

David Jones, who was made an Honorary member of the RWS in 1960, was another watercolourist inspired by artistic developments on the Continent. As much as any other British artist of this century, he successfully translated the 'abstract' concerns for colour and shape of oil painters such as Matisse and Kandinsky into a pure watercolourist's language. But Jones was not fundamentally a formalist painter – his interest was in a perceived spiritual reality beneath the everyday surface of objects. He wanted his art to express more than could be appreciated by 'the eye of the flesh'.

Born in Kent in 1895, Jones studied at Camberwell before war service with the Royal Welsh Fusiliers. He then came into contact with the artist Eric Gill from whom he learned the craft of wood engraving. In the early twenties he and Gill moved to Capel-y-Ffin, set in the Honddu valley, in the Black Mountains of South Wales. In this secluded valley and its surroundings, Jones painted some of his most profoundly felt and abstract works. It was a time of great intensity, both artistic and emotional – after his engagement to Gill's daughter was called off Jones never married. His long life was afflicted by mental illness, but the strength of his artistic vision shone through. After the Capel-y-Ffin period, his subject matter became increasingly entwined in the myths of Celtic folklore.

This watercolour of that early Welsh period shows the Afon Honddu tumbling down the wooded upper slopes of the river valley. In this secluded place, an animated private drama is taking place. It is a drama in which every shape and brush-stroke plays a part. Each mark the artist has made on the paper has a vigour of its own and a visual effect on every other shape and passage of paint, in addition to its contribution to the overall look of the picture. The whole scene is living: every rock, every dancing tree is imbued with what

The Never Failing Brook, the Busy Mill
WILMOT PILSBURY RWS (1840-1908)
Watercolour and bodycolour.
14½ × 21¼ ins

This illustration of Pilsbury's active millstream gives us the opportunity to enjoy the pleasing rendition of the summer evening light. This is a watercolour for the senses and is not one to be analysed.

The Old Brig O'Dee
SAMUEL JOHN 'LAMORNA' BIRCH RA RWS
(1869-1955)
Watercolour and bodycolour over graphite
14¾ × 21⅞ ins

Birch's picture, like Sargent's, benefits from being seen here on a scale which binds together the brushmarks to form the complete image, as if we were looking at it from some distance. We can also appreciate the clear, bright light of this colourful scene.

Afon Honddu Fach, above Capel-y-Ffin
DAVID JONES HON RWS (1895-1974)
Watercolour and graphite
21⅞ × 15⅞ ins

In this illustration the full picture of Jones's subject becomes quite clear and we are able to see how the blocks and serpentine shapes of colour interrelate and set one another off, almost in the manner of Kandinsky's great compositions in oils.

David Jones himself described as 'the intimate creatureliness of livings'. The picture and its creator are seemingly possessed of an inner fire. The leaping brush marks of the plunging water could as easily be flames.

The painting is very flat and without recession – the whole scene is brought right to the surface of the picture plane. Suiting the steepness of the hillside, this device also enables Jones to explore the patterns of natural shapes, which he simplifies at will. But this apparent lack of naturalism is only an absence of superficial recording of natural detail, for the artist's total commitment to and love of his subject is made plain by the intensity of feeling which emanates from each carefully placed brush-stroke. Looking at *Afon Honddu Fach*, it is difficult not to recall the great 'compositions' that the Russian painter Wassily Kandinsky was producing in the previous decade. Besides a surprising visual resemblance between the two artists' work, the common concern to express an inner life via the simplification and arrangement of coloured shapes based on natural phenomena, is quite striking.

Undoubtedly one of the finest modern British painters at the height of his powers, Jones did not sadly come within the orbit of the RWS until 1960, fourteen years before his death. There does not exist a Diploma work from his hand – for this is not a requirement of Honorary members – and the RWS was, in 1980, most grateful to receive from the Trustees of the David Jones Estate this magnificent early piece.

A few years Jones's junior, Charles Knight also sought tranquillity and remote scenery in the Welsh landscape. His Diploma work *Rhaidr Ogwen, North Wales* of 1933 also affords intriguing comparisons in the artists' handling of a mountain stream. The varying shapes of rocks which cause the water to switch and fall this way and that have fascinated both painters. In their very different ways they were at this period equally interested in the patterns of natural form and the inner structure, or substance, of the

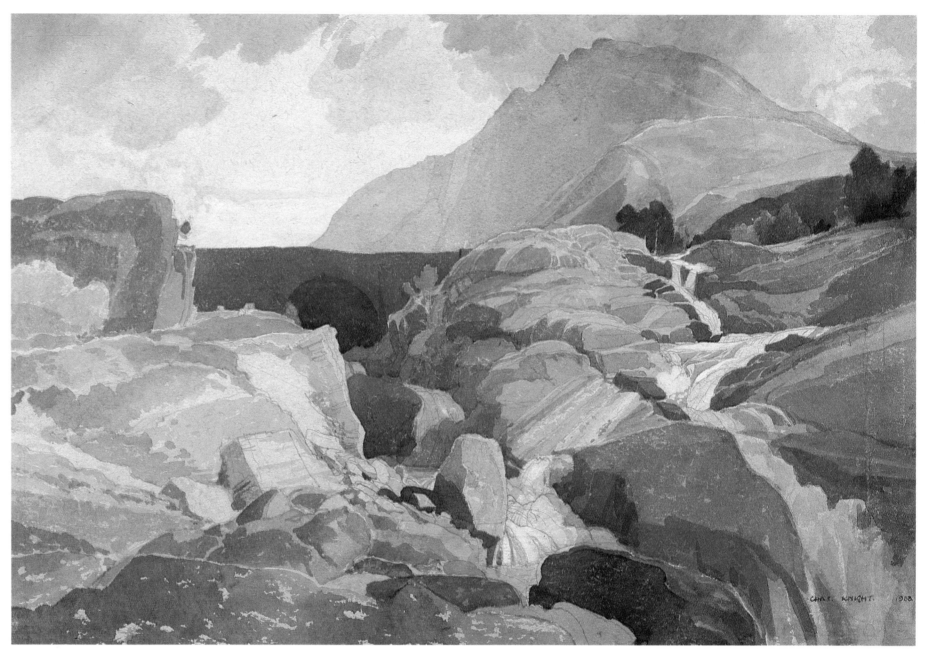

Rhaidr Ogwen, North Wales
CHARLES KNIGHT RWS (b 1901)
Watercolour and bodycolour over graphite
10⅜ × 13¾ ins

Knight's Diploma work is a monumental design that
deserves to be studied 'at a reasonable distance'. The
patterns and the tonal structure of the depiction of the
mountain are to be admired.

forms whose surfaces their brushes described.

In Knight's case, direct inspiration for his approach to landscape came from way back in the watercolour tradition – from the early years of John Sell Cotman. His style also looks back past Cotman to the first painter of monumentally structured landscape compositions, Titian.

Although his manner owes a great debt to his eminent predecessor in the Society, Knight's grandeur of vision and sense of shape and colour reveal the profound influence of the Venetian master, whose landscape backgrounds to his religious and allegorical subjects were the classic basis for the art of Claude and Poussin. In turning to Titian, Knight was going back to a principal source of the English landscape school. Stylistically he was perhaps always a traditionalist, but Knight's considerations for the formal values of shape and colour, his monumental re-creations of the grandeur of natural compositions give his art a high sense of purpose and achievement. The integrity of his art will ensure its survival long after the demise of respect for more ephemeral and fashionable styles. These considerations of Knight's are also characteristically twentieth century. Maybe it was Cotman who was born a century too early, and not Knight one too late.

At least two other versions of this imposing Diploma work exist: a common enough practice of this and many other artists has been to produce duplicates of successful pictures. In Knight's case, such reinterpretations – for they are never repetitions – result in no falling off in quality. The harmonious tonal values of his unified palette and the precise and careful rendering of patterns of tone and colour are always a delight.

The work is painted, with the aid of a few pencil notes, direct onto his favourite absorbent buff paper, named as it is after one of his most respected forebears, David Cox. Dry, dense passages of pure watercolour build up, one next to the other, over the paper surface and call for little reworking. Just a hint of chinese white heightens the mountain stream above the neutral tone of the paper, which itself is left uncovered in many areas. The paper colour, whether exposed or covered, helps to tie together into a harmonious unity the distinct and angular blocks of colour spread over its surface. On white paper, these would have appeared disjointed and, for example, the left foreground would have been a meaningless assembly of blotches of pale watercolour. When he did aim for a more radiant colour scheme in one of the other versions of this subject, he employed whiter paper for the purpose of giving luminosity to the washes, much as Sargent had done in his *River Bed* Diploma work. The Sargent can be compared with the present watercolour too, for the interest it reveals in the bold shapes and colour variations of a closely observed mountain stream bed.

Charles Knight's absorption with nature and the country life, away from the modern industrial world, is the guiding force of his life's work. Born in 1901, he trained at Brighton and at the RA Schools under W. R. Sickert. He has spent most of his life living and working in the Sussex Downs, north of Brighton, where he taught at the Art School. He was elected an associate of the RWS in 1933 and a member in 1935, going on to show regularly at the Society's exhibitions for over fifty years.

With Knight's Diploma work, which closes this chapter, we have travelled far from the wide rivers of the lowland valleys depicted by DeWint and Havell, and arrived at the river's source; at a stream, not unlike the one in which Stephen Rigaud's *Genius of Painting* dips his sable brush, in the 1807 watercolour illustrated in the early pages of this book. In the North Wales mountains, Knight sought and found inspiration and simple dignity. In an age when Britain's inland waterways had been increasingly polluted by effluence from industry, a situation considerably rectified, thankfully, in recent years, the artist has returned to where the pure waters spring.

SEA AND COAST

That the peoples of the British Isles have for centuries been dependent on their maritime capabilities goes without saying. In the age of air travel and satellite communications we are less reliant on the hazards of seafaring, but as an island race surrounded by thousands of miles of varied coastline, the British still have a deep fascination for the sea and coast. And it is at the coast where some of the richest natural life and most interesting human activity may be found. For an artist like John Varley, working in the early nineteenth century, the much greater activity then to be found on the beach and in the harbour provided prime material for topographical watercolours.

We only have to glimpse a few drawings of busy beach scenes by such as Varley, Samuel Prout and Joshua Cristall, to appreciate what rich, picturesque subjects could be found at the time. The uncertainties of the sea, and the knowledge that storms could break with little warning, that lives might be lost and everyone from sailors to net-menders affected in some way by the awesome power of natural forces, meant that our shores were a fertile source of Romantic and often tragic themes for the artist.

In Varley's day, coastal scenery was often more accessible than the inland wildernesses. There was more industry on the coast than today and therefore relatively more transportation available. Indeed, painters journeying to distant areas of Britain would on occasion go by sea rather than risk the hazards of overland travel, from poor roads to bandits.

For two thousand years the coast has represented our first line of defence against a series of invaders from overseas, and from the Romans onwards great sea defences and castles have been constructed in an attempt to keep the foe at bay. Of the castles built by William the Conqueror, Bamburgh, on the Northumberland coast, must be one of the most strategically well placed and dramatically situated. On a cliff which rises like a natural motte, or castle mound, from the surrounding countryside, the great Norman keep dominates every view of this part of the coast, as it did in Varley's day. In the eighteenth century, Bamburgh became well known as a picturesque and historically interesting site and several engravings of the castle were produced. So what better subject for Varley – a building of considerable topographical and antiquarian interest, perched on a cliff which overlooks a sea shore which is brimming with activity.

John Varley took a number of views of Bamburgh, at least one of them from out at sea. In a prolific *oeuvre* of up to ten thousand watercolours, he was hardly likely to let slip such a good opportunity. He had visited the Northumbrian coast castles in 1808, making a number of sketchbook studies which, in the manner of Turner, he continued to use for finished watercolours for over thirty years.

This work, made in 1831, is slightly faded, as the deeper colour of the margin strip, previously concealed from daylight by an overthrow mount, shows. The patches of blue sky may be a restorer's attempt to replace Varley's own fugitive blue, which we see in a bit of sky on the extreme left, just above the horizon. The latter colour is more in harmony with the now rather lightened and warm overall colouring that has resulted from the fading.

Taking this misfortune into account, *Bamburgh Castle, Northumberland* is still a coherently composed and carefully executed little watercolour. It also has some most attractive passages. The enlarged detail reproduced here particularly reveals the beautiful and deftly handled horizontal brush-strokes with which Varley describes the water. This ability of the artist was noted when we discussed his view of Cader Idris in Chapter One.

Varley could hardly be described as a marine artist. Even the maritime view of Bamburgh mentioned above was looking forward to and dominated by the watercolour's central subject, the distant castle. Many nineteenth-century artists who one would normally classify as, say, landscapists, would on occasion produce maritime pictures. Such works were part of the general landscape tradition. However there is a more specialist vein of nautical painting, drawing and engraving running through British art, that has been concerned with recording over five centuries of shipping activity. Elizabethan portraits of naval battles, diagrammatically reporting the manoeuvres of men-of-war gave way to the more dramatically conceived pictures of eighteenth- and nineteenth-century artists, including Turner, the greatest of all painters of the sea. The native maritime tradition was brought into the post-Renaissance world of naturalism by the influence of painters of the sea-trading nations of Flanders and Holland, and major Dutch marine artists like Van de Velde were employed by English patrons. These patrons admired this particular branch of seventeenth-century Dutch art as much as landscape and genre subjects. It was also considered desirable for royalty, naval commanders and institutions to commission oil paintings of sea battles and of favoured and victorious fighting ships to adorn the rooms of palaces, mansions and naval academies.

If the tradition of marine painting in oils of the seventeenth, eighteenth and early nineteenth centuries was orientated towards military subjects, it may be said that watercolourists of the period were more generally concerned with commercial and domestic shipping and boating and with voyages of discovery. These strains of maritime art were also practiced by the seventeenth-century Dutch, great traders and explorers as they were. While the oil painter was well equipped to make grand portrayals of historic naval scenes, the artist working with pencil, watercolour and a small sheet of paper was better able to travel on the oceans with his materials and more inclined to the intimate depiction of less heroic views of life at sea. It was important for explorers such as Raleigh to have a visual portrayal of their discoveries, and John White's on-board records of Raleigh's voyages are works of great historical interest. It is, however, the commercial and domestic life of the sea around the coast of Britain which above all concerned the watercolourists of the first half of the nineteenth century.

The art of William Joy is undemonstrative and accurate in its nautical detail. His work was undoubtedly influenced by Dutch precedents and his upbringing in Great Yarmouth may have encouraged his rapport and contact with Dutch painting. The flat East Anglian coastline bears an affinity with that of the Netherlands, and many immigrants from over the North Sea settled here. Even today, the influence of Dutch architecture is to be seen in towns and villages in Norfolk and Suffolk, and, further north, Lincolnshire.

William, who at times collaborated on pictures with his brother, John Cantiloe Joy, trained as a marine artist and the faithful rendition of the sailing boats in the watercolour from the Parsons Bequest illustrated here, reflects this training. His art depicts nautical life of all shapes and forms, and he travelled far in search of subject matter, working in Portsmouth and Chichester, as well as in London. Unlike Varley, Joy

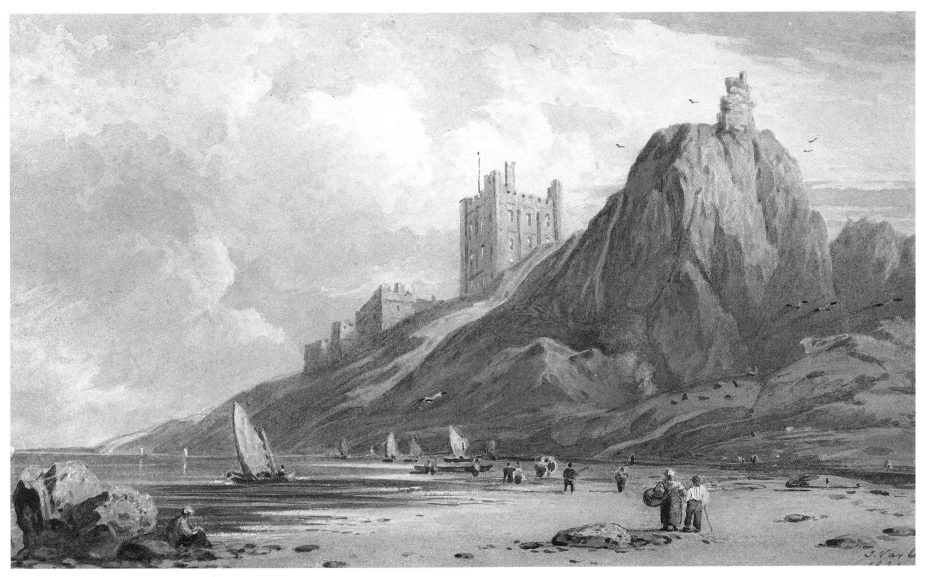

Bamburgh Castle
JOHN VARLEY OWS (1778-1842)
Watercolour and bodycolour over graphite
5⅞ × 9⅝ ins

Varley's Bamburgh is reproduced a shade under full size
and we can appreciate the characteristically fine washes of
the calm sea, similar to those in the Cader Idris
watercolour discussed earlier, as well as the dense building
up of the brush-strokes describing the dramatic cliffs.
Note also the possibly later patches of blue sky referred to
earlier in the text.

here takes a view out to sea, and he encourages the viewer to join the fisherman standing with his basket and net beside him, who looks towards the becalmed boats. Joy beautifully captures the peace of the early evening, as the sunlight fades over the sea, and in the stillness he takes the opportunity to show every detail of rigging and the activity of the sailors on the nearest boat and dinghy.

Born in Yarmouth in 1803, William was educated with his brother at Wright's Academy in the town. They started to paint maritime subjects and moved south in the early 1830s to further their careers, working at first as naval draughtsmen at Portsmouth. John Cantiloe died in 1866 and his brother one year after.

A setting sun is central to William Callow's beautiful small watercolour of boats in choppy waters. This work of the early 1830s reveals the influence of the brilliant English watercolourist Richard Parkes Bonington, whose work Callow had recently encountered in Paris. Bonington's death at twenty-six, along with the early demise of Girtin, was one of the greatest ever losses to English art. Bonington was a central figure in the French Romantic movement and the influence of his prodigious technical ability was felt by such colleagues as Eugène Delacroix. Although he never quite had Bonington's deliciously sensitive and effective touch, Callow's watercolour *oeuvre* was among the most consistently successful of his century.

It was as a studio sharer with Thomas Shotter Boys in Paris in 1831 that Callow would have first come across Bonington's lucid and unpretentious art. The latter had been dead some three years, and Boys and his companion were greatly inspired by his work. Callow's natural talent enabled him to absorb much of Bonington's lessons of fine draughtsmanship combined with fresh application of colour.

It can be argued that the ease of execution and picture making he developed over a long career sometimes subjugated Callow's inherent powers of observation. Some of the later works have been described as pot-boilers, but this charming watercolour from the Parsons Bequest has a freshness, verve and feeling for its subject which ranks it close to the finest marines of J. M. W. Turner. As Turner would scratch and scrape the paper surface to pick out white horses and the highlights of reflections on waves, so here has Callow. He evocatively depicts the rough sea on which the populous sailing boats rise and fall. Turner once had himself tied to a ship's mast in order to be able to paint the eye of a storm. Although this view is set in rather more benign circumstances, we do neverthe-

less believe that Callow has directly experienced this particular scene.

The watercolours by Varley and Joy are products of artists drawing with the brush, but here we encounter a real *painting* in the medium. Layers of dense brush-work, using considerable gum arabic, build up the most tangible areas of water, wood and sail-cloth, while an expertly handled wash describes the luminous sky. On a sheet of paper measuring some seven by ten inches, the painter conveys a grandeur of vision and design that would adequately serve a yard-wide canvas. One of the most enjoyable aspects of the best watercolours is the achievement of artists who are accomplished enough to say much in a small area. An economy of scale need not lead to meanness of conception and there are many collectors of art who would happily forgo the grandeur of painting on a large scale for the jewel-like qualities of a work such as this.

In the annals of the RWS, William Callow holds a very special place. Born the son of a Greenwich builder in 1812, he joined the Society as an associate in 1838, becoming a member ten years later. His acceptance encouraged him to return from Paris in 1841 and he set up practice as a drawing master in London. In 1855, he moved to Great Missenden, where he died in 1908, having earlier participated actively in the Society's affairs as Secretary and Trustee. Despite his several trips abroad, Callow exhibited regularly at the Society for a period of nearly seven decades, and thus ranks as its longest serving member. It is a remarkable thought that an artist born during the Napoleonic Wars, when Goya and Napoleon's court painter Jacques Louis David were at the height of their powers, was still creative in the years when Picasso was redirecting the course of art for our century.

The Diploma work of Edward Duncan, another watercolourist whose career spanned most of the nineteenth century, is dated 1857, eight years after his election to membership of the Society, and was presumably presented after the founding of the Diploma Collection. *The Approaching Wreck* is certainly a grand and representative piece, full of incident and the noise and colour of its subject. We can almost feel the strength of the gale at the height of the storm, we can almost hear the roar of the waves and that strange rushing sound that occurs as the sea water is sucked back down the beach, as the next wave crashes in.

This dramatic work puts one in mind of the sea pieces of Turner, not only for the panoramic breadth of its keenly observed storm effects, spread over a wide area of paper, but also for its technical dexterity

and the palette that Duncan has used. The life-size illustration reveals the Turnerian majesty of the work as well as its complexity – with minute flecks of colour he has woven an intricate tapestry of varying shades and tints of blue and green to enrich his depiction of the water. There is extensive scratching out, sometimes on the wave crests, which have generally been lightened by dragging a moist brush over a recently applied colour wash, and Duncan has also sparingly employed this technique and a number of translucent washes to give a remarkable effect of wetness to the beach. In these methods, together with the generally blue and yellow ochre colouring, Duncan undoubtedly owes a debt to Turner's marine art.

This is not to suggest, however, that in painting *The Approaching Wreck* Duncan has been slavishly imitative of the master. Indeed, there is here a vitality and understanding of the sea which are entirely Duncan's own, and these are virtues that could only have been accumulated and expressed by one whose experience of maritime life was as full as his knowledge of marine painting.

His career did not start in this way, however, and Duncan was not himself a sailor. His first contact with the sea came through his labour of engraving prints after marine paintings by William Huggins, whose daughter he married. From the 1830s onwards he began to gain real experience of life at sea, going on sketching trips on the southern coast of England, and later sailing to Holland and the Channel Islands, and visiting Italy. While Duncan also executed more tranquil landscape watercolours, perhaps his best known and most successful works are the storm scenes at sea, characteristically featuring shipwrecks and dramatic rescues. In an age of sail and not having the benefit of radio shipping forecasts, the dangers of the sea were a very real and constant threat. The rough waters around the British Isles were regularly the scene of tragedy for the vastly greater number of people who used them than do today. It was understandably common practice, therefore, for marine artists to produce prints, watercolours and oil paintings of shipping disasters, not simply for the drama and possibly ghoulishness of such subjects but because they were a constant factor of nineteenth-century coastal life.

In *The Approaching Wreck* Duncan portrays drama and impending human tragedy as a narrative element in the scene. The crowd assembled on the shore are unable to prevent the impending wreck and they spectate helplessly as the ship is tossed on the angry sea. On the ship itself, no sign of life is visible, but we may assume that a crew is aboard, fighting to save the

vessel and their lives. The driftwood being hauled ashore, and the skeleton of a hull 'in the water are presumably unrelated to the principal drama and are simply intended to emphasise the power of the storm and the approaching tragedy. Although this is a picture with a definite and rather gruesome story line, it is indeed the awesome effect of the violent, natural forces which is the true theme of Duncan's Diploma work.

Edward Duncan was made a member of the New Society of Painters in Water Colours in 1834, but resigned in 1847 to apply to the older Society, which elected him an associate the following year. He was elevated to membership in 1849 and became a constant and prolific exhibitor.

Another master of rough seas, George Chambers, is seen in more tranquil mood in the delightful little watercolour of *Shipping by a Quay*. It is not known when this poetic drawing entered the RWS Collection, but it cannot be a Diploma work as Chambers died in 1840, his thirty-seventh year. Only in the last seven or eight years of his life did he turn from oil painting to watercolour and the surviving *oeuvre* in the latter medium reveals Chambers to be one of the finest exponents of the art in the early Society, to which he was elected associate in 1834 and member the year after.

In its undemonstrative subtlety and controlled washes, this work helps to represent Chambers as a major figure, ranking in his best work alongside better known men like Cox and DeWint. The jewel-like qualities of Bonington's shipping subjects in watercolour were perhaps never repeated by another artist, but in this piece, Chambers goes some way towards emulating his near contemporary. Whereas Duncan's technique is rich in its industry and energy, Chambers here applies his brush with great economy and care. Duncan would work and rework the paint layers and almost attack the paper surface. This approach means that the artist may continually amend areas of the picture as he builds up the final image. In Chambers' simple use of pure watercolour over a sketch in graphite, every brush-stroke applied throughout the execution counts and is visible in the finished work. In classic style, he allows the paper to shine through transparent washes and give a gentle overall effect of light. In some passages, the paper shows through apparently untouched by the brush, particularly in the sky where the clouds are barely though effectively suggested. The seeming ease of application of pigment and water we see here is the hallmark of a fine watercolourist and masks the inherent difficulties the medium presents. In an all-revealing watercolour like

Bamburgh Castle (*Detail*)
JOHN VARLEY OWS

This small detail of the central foreground and middle distance is almost twice life size. We are made fully aware in this vignette of the painterly attractiveness of Varley's technique at its best. Although he is not particularly noted to be a painterly artist, the brush marks have genuine visual appeal and describe the observed human activity extremely well.

this, one cannot afford to make mistakes.

In a straightforward and essentially symmetrical composition, the open sky is well countered by the density of the huddle of boats at the quayside. These are rendered with deeper colouring and a denser array of broken brush-strokes, befitting the central point of interest. The slightly looser treatment of the steps, figures, nets, and the boat to the right is a delight.

Unlike Duncan, Chambers was inculcated with maritime life from birth. He was the son of a sailor living in Whitby and was sent to sea when he was ten years old. He later trained as a painter, producing oils on panels of houses and ships in Whitby. He went on to receive the patronage of Christopher Crawford, a Whitby man who purchased the Waterman's Arms in Wapping Wall, London. It is recorded that Chambers painted his first canvas for Crawford and this *Prospect of Whitby* led to commissions for ship portraits from other eager patrons, including William IV, the 'Sailor King'. His intimate knowledge of naval detail and the accuracy with which he was able to depict it made Chambers one of the more sought-after practitioners of his profession.

It is said that a period as a scene painter, during which he used water-based paints, led Chambers to take up the fashionable art of watercolour. Only for a few years was he to work in the medium and his health broke down in the last two years of his life, during which, at the suggestion of Crawford, he went to Madeira for the climate. He died, however, on his return to England. Chambers had also travelled twice to Holland, whose great marine painters of the seventeenth century had much influenced his art. Our watercolour of *Shipping by a Quay* could well depict a Dutch harbour, and its evocation of a northern light certainly indicates a debt to Van de Velde and his compatriots.

Of the 'greats' of the British watercolour School, David Cox has long enjoyed one of the highest and most popular reputations. It is perhaps the broad atmospheric works of his last phase – the twenty years or so before his death in 1859 – which have led to Cox being prized in recent years as an artist of the mainstream. This is because his watercolours and oils of this period are seen to be forerunners of French Impressionism, as much as those of his near contemporaries in England, Constable and Turner, and Delacroix for example in France. There is much less direct evidence of Cox's influence on this movement than the recorded impact of Constable's *Hay Wain* on the young Monet and Pissarro. But Cox's concern in his later years freely to capture on paper and canvas

Seascape with Shipping (*Detail*)
WILLIAM CALLOW RWS

Reproduced considerably larger than life, this detail of Callow's exquisite watercolour reveals qualities of painterliness superior even to those exhibited by Varley in his *Bamburgh*. These qualities are not simply achieved through the application of paint and gum, but can be as much the product of the artist's manipulation of the paper itself, with considerable scratching and scraping out.

the effects of light and weather are definitely close in spirit to the paintings of Monet's mentor, Eugène Boudin.

Boudin's best known works are his many oil sketches made on the beaches of Normandy, in which society ladies are captured with the spontaneous use of a brush which also renders effects of light and wind in what has become known as the 'impressionistic' manner of *plein-air* painting. Some of David Cox's late beach scenes are quite close in manner and spirit to those of Boudin, although painted some decades previously.

The little watercolour of *Figures on Horseback Crossing the Sands* from the Parsons Bequest is an earlier work and more traditional in manner, which nevertheless relies for its main interest on the portrayal of light and atmosphere. Although he started as a topographical draughtsman in the tradition of his time, washing in what were basically monochrome drawings, Cox's mature art is not harnessed merely to concepts of the portrayal of place. In a considerable number of his late works, references to the particularity of topography seem to have had little interest for him. This does not mean he had not travelled widely in Britain and on the Continent in search of subject matter – his watercolours of Haddon Hall, Derbyshire, are for example among his most poetic works – but that his interests in picture-making, human life and natural effects were at this stage dominant over any need to record details of particular buildings or places. In this, Cox was up to date with his period and reflected the Romantic preoccupation with freedom for the artist in his choice of what he wanted to paint as a vehicle for ideas. Sometimes his late manner took his art so far from topography that, in response to criticism, Cox felt moved to declare that he created works of the mind, not mere portraits of places. While in his career he by no means eschewed topography, he was given the opportunity to be free of it by the example of artists like Girtin and Turner. For all his brilliance and creative pictorial advances, Turner has to be seen as a more instinctively topographical artist than Cox, especially in the finished watercolours.

There is perhaps less distinction in David Cox's work than in Turner's between the sketch and the exhibition piece. Many of his watercolours were painted on a small scale and embody the fluidity of application of a study, while having the largeness of conception of a finished work. He also sketched prolifically in pencil and wash but Cox, like DeWint, was one of the first nineteenth-century watercolourists who blurred the boundaries between the private and public drawing. There was a developing open market to be satisfied, and small 'finished' watercolours of this type would not necessarily appear at exhibitions. At the Society's exhibitions they would, in the order of things, be hung on free-standing screens rather than with the grand machines – among them some of Cox's own works – stacked on the main walls. But they could equally as well be channelled through the new picture dealers, for whom the size and popular appeal of such watercolours made them an attractive commercial proposition.

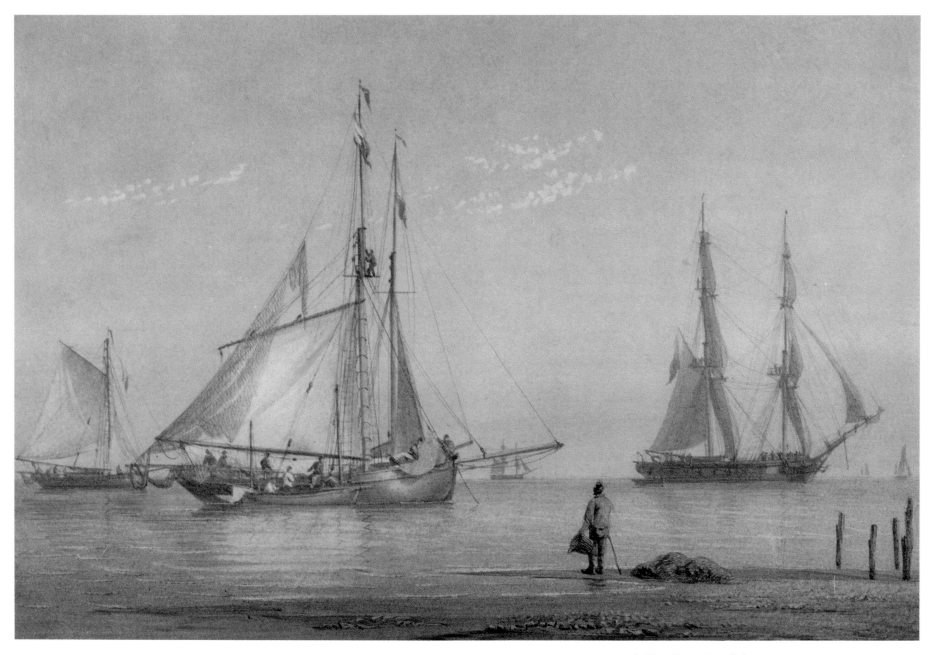

Sailing Boats in a Calm
WILLIAM JOY (1803-67)
Watercolour over graphite, with scratching out
8⅜ × 12⅛ ins

In this illustration the observer is able to take in Joy's pleasing and somewhat diffident use of the medium, together with his knowledgeable depiction of nautical detail.

Several of David Cox's coastal subjects were set on the vast, flat sands of Morecambe Bay, Lancashire. There, at low tide, he found a pleasing combination of natural elements and human life – the overpowering and changing sky, distant sea and hills, and figures on horseback taking the opportunity to make a short cut across the sands of the encircled bay. The present watercolour would appear to be a view from near Morecambe looking north towards the Cumbrian Hills. But it is evidence of Cox's attitude towards topography that the sense of place is suggested by the fact that riders are crossing a spacious beach, rather than through recognition of any particular feature of the landscape.

This pleasing twilight scene is painted with dense pigments and the artist has employed scratching out to highlight the posts on the right, the low-flying gull on the left and some passages of the central group. Despite the even light effect, there are some extremely subtle touches, like the exquisitely rendered tinges of sunlight on the high clouds and the fading light of the middle-ground beach and the rivulet to the left of the scene. Cox had an eye for the humorous and the vignette of a little dog and pony being dwarfed by their human companions has an amusing quality. This is by no means a major work of the artist, but it admirably reveals Cox's mastery of the medium and his ability to make a convincing composition on a small scale.

David Cox was born in Birmingham in 1783, the son of a blacksmith. After a time working for his father, he took lessons in drawing and went on like Chambers to be a scene painter, in the Birmingham Theatre. He moved to London in 1804 and although soon becoming himself a drawing master, Cox took lessons from John Varley and continued to wish to be taught by distinguished artists well into his middle age. Varley, the most successful teacher of the time, had a considerable influence on Cox's landscape style. Having already been President of the Associated Artists in Water Colours, Cox was made an associate of the Society in 1812, the last year before its reconstitution as the Oil and Watercolour Society. On its revision to its previous purpose, in 1820, he became a full member. In 1814, Cox had served as drawing master at the Farnham Military College, but much of his time from then on was spent travelling in search of subject matter. In 1841, having lived and taught for a time in Hereford, he returned to the Birmingham suburb of Harborne and died there eighteen years later.

Thomas Charles Leeson Rowbotham's watercolour of *Dunstanborough Castle* is, in scale at least, an altogether grander affair. One of Cox's greatest

Seascape with Shipping (*Detail*)
WILLIAM CALLOW RWS

This detail of the left side of the work is reproduced about twice life size. The speeding boat seen from behind is a marvellous image and the sail, absorbing the light as it does, is extremely well handled. Beyond we see a tiny and pleasing vista of distant sailing activity.

achievements was to create substantial form on a small area of paper. Here, on a sheet some six times larger, Rowbotham also imbues his forms with a weighty substance which might, however, be described as ponderous and certainly lacks the sparkle of the older artist's handling. Despite this, we have in an earlier chapter noted the freshness of Rowbotham's sketching technique in his view of the Thames at Cliveden. The solid shapes of the beach scene in the Dunstanborough picture are nonetheless relieved by the vast and freely washed tract of early evening sky.

Rowbotham's picture is undated, but Dunstanborough Castle was already a ruin when he painted it around the middle of the nineteenth century. Here, the castle, another Norman defence on the spectacular Northumberland coast, some ten miles south-east of Varley's Bamburgh, appears in much the same state as we can see it today. Set on a promontory above the North Sea, the castle ruins present a dramatic and romantic attraction for today's visitors. For Rowbotham and his contemporaries, it was an eminently suitable subject for recording in visual form.

Topographical recording of the castle is not however the driving force behind the conception of this picture. It really just provides a picturesque setting for Rowbotham's study of beach folk and vessels, seen in the slightly misty light of the lowering western sun.

This is a fine example of aerial perspective and the backdrop of cliffs and castle is given considerable recession through the rendering of the haze which exists between it and the middle ground. This the artist in part achieves by applying dabs and streaks of pale purply-blue bodycolour over washes of ochre-based watercolour. The density of the twilit gloom of the middle ground, obtained with layers of green and brown watercolour washes, contrasts with the airy distant scene and enhances the sense of recession. A group of three figures is placed before this middle ground and their richly coloured garments pull them out from the darkness of the foreshore. They seem to be discussing the day's catch, and beyond them fishing nets hang to dry. Rowbotham was the son of a marine painter and succeeded his father as drawing master at the Greenwich Royal Naval School. Many of his earlier watercolours were of marine subjects and the Dunstanborough picture conveys an empathy with coastal life and a knowledge of, and enjoyment in drawing, seagoing vessels.

There is a technical curiosity about this accomplished watercolour, which was discovered by a conservator during recent work undertaken at the Fitzwilliam Museum. Someone – perhaps the artist,

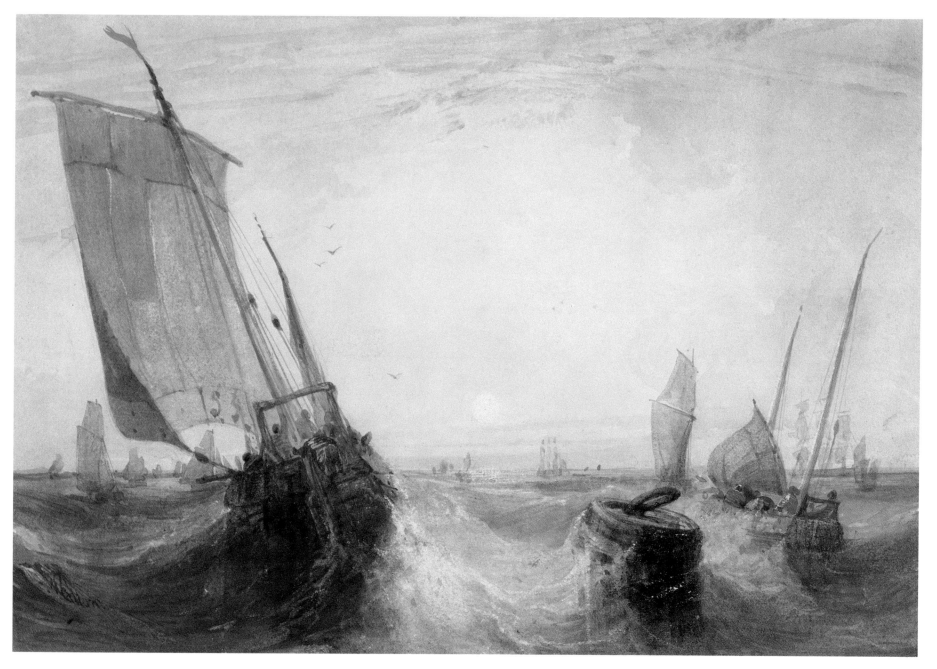

Seascape with Shipping
WILLIAM CALLOW RWS (1812-1908)
Watercolour and gum over graphite, with scratching and scraping out
6⅞ × 10 ins

Despite the technical facility of Callow's manner throughout his career, he was rarely to make such a virtuoso performance as in the early watercolours, of which this is a compelling and fine example.

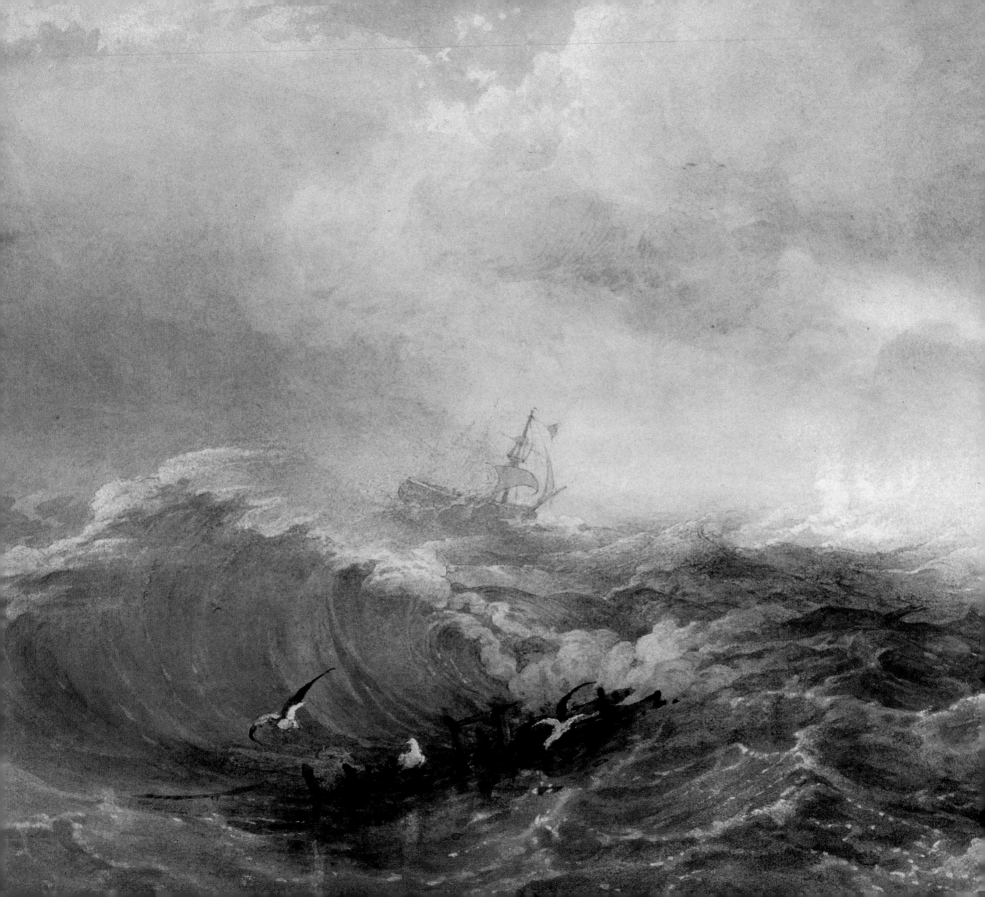

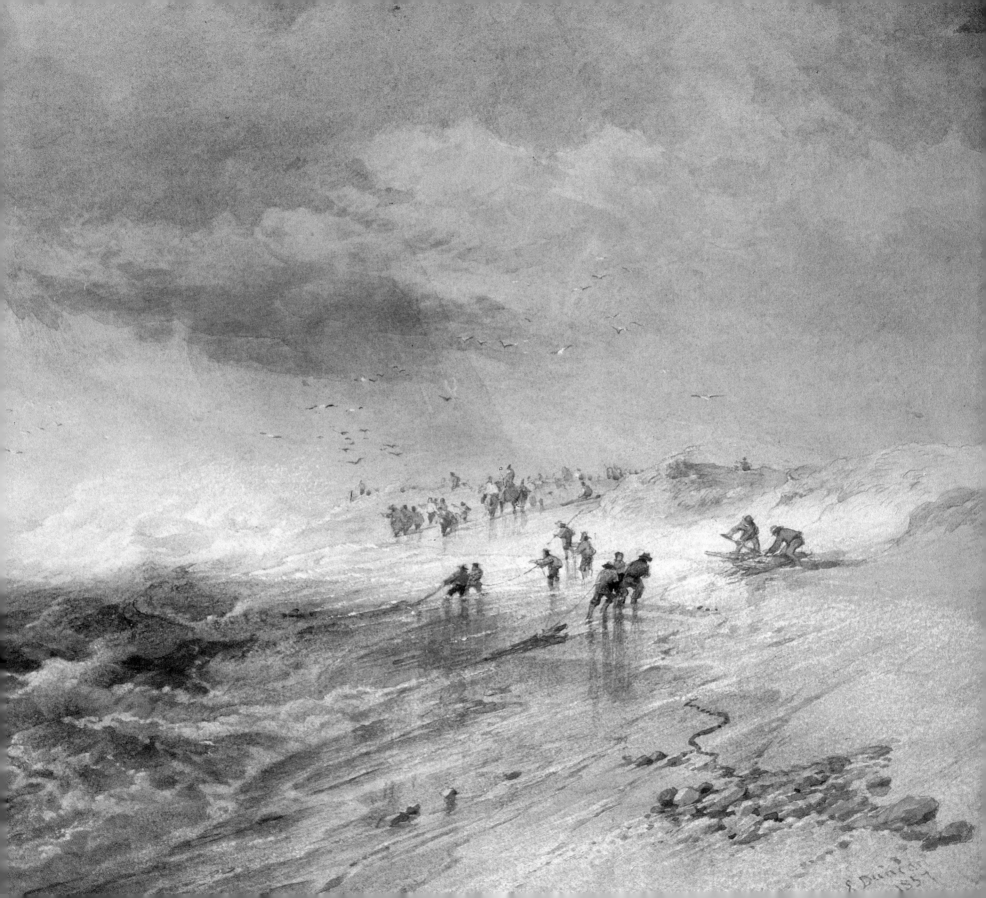

E. Duncan
1857

The Approaching Wreck
EDWARD DUNCAN RWS (1803-82)
Watercolour over graphite, with scraping out
11¼ × 23 ins.

The Turnerian majesty of this dramatic watercolour is
revealed in this near life-size illustration. We are also able
to examine its technical intricacy – an intricacy which
animates the scene and creates a rich tapestry of storm
effects as the gale whips up the waves. The crests seem to
have been lightened by dragging a moist brush over a
newly applied deep colour, thus removing the new colour
along the tops of the waves. Later, when the watercolour
was dryer, the artist used the reverse end of his brush or
some sharper implement to scrape out the white horses.

Shipping by a Quay (*Detail*)
GEORGE CHAMBERS OWS

About twice its true dimensions, this detail picks out
the fine painting of the clutter of boats and the figures at
rest and at work on the quay of a small port. The technical
qualities seen here are further evidence of the loss to
British watercolour painting when Chambers died.

but one can only guess – has started to cut with a knife
along the line of the horizon, being particularly
painstaking around the castle ruins. This fact was re-
vealed as the conservator, methodically scraping away
the acidic board from the back of the work, arrived at
the watercolour sheet to find it almost in two pieces.
The purpose of this unfinished act is a mystery. It
would be comprehensible if something had gone
drastically wrong with the painting of the sky – say
some heavy-handed brush-strokes that Rowbotham

had been unable to wash out of the paper. He might
have decided to literally cut his losses and attach the
landscape onto another piece of paper. But there was
no reason for him to do this and the incisions remain a
minor, yet interesting puzzle.

Our next coastal scene was painted around half a
century later, in 1897. This is Charles Napier Hemy's
Diploma work, executed in the year of his election to
membership of the RWS. *A Coastguard Watch House* is
almost certainly set hundreds of miles further round

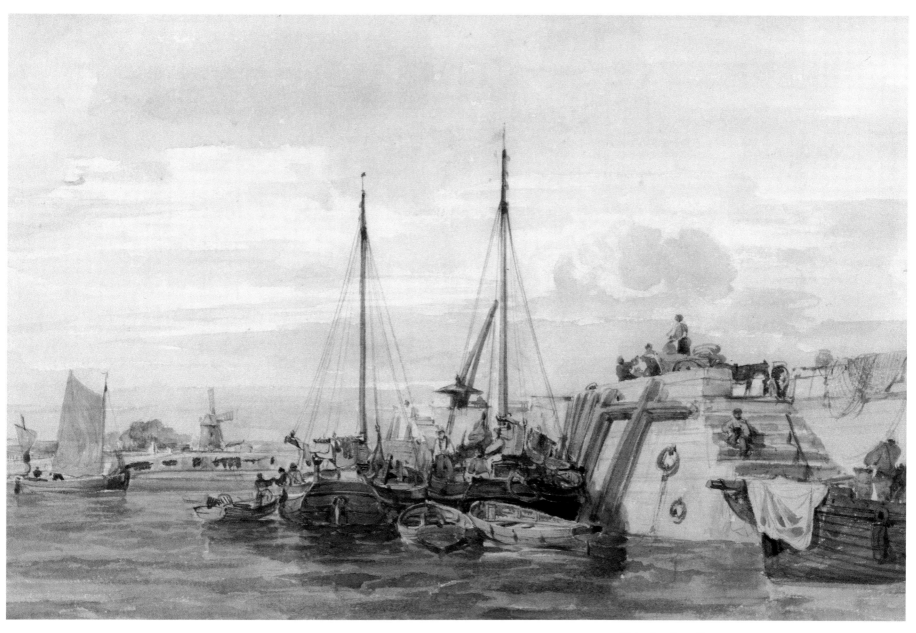

Shipping by a Quay
GEORGE CHAMBERS OWS (1803-40)
Watercolour over graphite
7¾ × 10¾ ins

Seen just under its true size, this work represents the early nineteenth-century watercolour tradition at its purest and most eloquent. Nothing is overstated and yet the washes and details of brushwork say much about the subject and about the art of painting on a smooth sheet of paper.

the English coastline in Hemy's adopted county of Cornwall. He was born in 1841, in Newcastle-upon-Tyne, and when he was eleven, his family emigrated to Australia, where he was to work in the gold mines. But Hemy returned to County Durham a few years later and studied to enter the priesthood. He eventually became a monk, only to abandon the monastic life to take up painting. After a period of art training in Antwerp, Hemy moved to London in 1870 and then on to Falmouth in Cornwall. He was elected ARWS in 1890 and after his elevation to membership, was accepted into the Royal Academy. He died at Falmouth in 1917 after a successful career.

This Diploma work is a classic example of his late style, which makes more than a passing reference to the achievements of the Impressionists. It is free and fresh in handling, full of atmosphere and wind, and is most evocative of changing sunlight emitted through scudding rainclouds. It is painted in a most direct manner, with little sign of under-drawing, onto an off-white paper that is left untouched in the brighter areas of the clouds. This paper colour, particularly above the thatched buildings, is most dexterously employed to give a backlit effect of half-hidden sunlight and Hemy has made clever and extensive use of chinese white to pick out objects struck by the sun's rays.

Let us take as an example of his clever use of body-colour the superbly painted figure of the woman who, clutching her hat against the keen gust of wind, walks towards us, a basket over her other arm. The apron flips up with the breeze and as it folds over and catches the sun, a stroke of white is applied. The backlighting is emphasised by further touches of white on her hat and shoulders, and on the basket handle.

Hemy's vigorous handling, using watercolour and bodycolour almost like an oil painter – which he also was – is particularly forceful in its portrayal of the waves. Yet this vigour is not alone responsible for the vividness with which he has caught the interplay of natural elements in this refreshingly real scene. That goes deeper, with his experience and constant depiction of the Cornish coast over many years at the heart of his ability to convey the essence of the subject. He loved to paint this coast and was enchanted by the lives of Cornish fishing folk. He could identify with the concerns and rewards of their existence, dependent as it was on the sea.

Henry Scott Tuke, another Academician, also spent his later years in the region of Falmouth, where he had lived for a time in his youth. Tuke was born in York in 1858 and trained at the Slade School of Art, going on to paint and study in Belgium, Italy and France. In the Paris of the early 1880s, he would have been aware of the developments in artistic language being made by the Impressionists. Thenceforth, despite over the years making numerous journeys across the globe, Tuke was predominantly based near Newlyn in Cornwall. There he was involved with the Newlyn School of painters, whose primary subject matter was the life of the Cornish coast and its people. Then a fishing village, Newlyn lies just south of England's westernmost town, Penzance, a few miles north-east of Samuel John Birch's village of Lamorna and, beyond that, Land's End.

Tuke was a painter in oils and watercolour paints – the latter his more successful medium – of boats and creeks and of the light and colour of water. He is best known for his paintings of young boys, usually half or totally naked, messing about in or on the water, and it has been observed that this predilection was a somewhat unhealthy one. Some of these pictures were considered scandalous in his lifetime, though today they have lost this edge of controversy and can sometimes seem repetitive, rather than shocking. While Tuke's Diploma work *Green Water* may not convey the formal detachment from his subject of, say, Degas' near contemporary studies of bathers or ballet dancers, we should recognise that he uses the scene as a vehicle for a stunning and luscious painterly artistic performance.

For its impressive exploitation of a range of watercolour techniques *Green Water* has few rivals of its type in the RWS Collection. For comparisons, one calls to mind Sargent's great picture of a *River Bed* discussed in an earlier chapter, and produced at almost the same time, and Arthur Melville's Diploma piece, which we shall look at later on. With what are tranquil and sensuous results, Tuke has painted and scrubbed the paper into submission, particularly in the passages of green water. From the water emerges the shadowy head of a boy, more rubbed away with a sponge or rag than he has actually been painted. This is a remarkable example of the limits towards which pure watercolour may be pushed. On the other hand, the boat itself is painted with extreme economy of languid washes and transparent purple/blue brush-strokes, which allow the paper itself to do most of the work. This is exemplary use of the underlying whiteness of the paper to convey light and the most subtly coloured shadows through pigmented wash. This is a work of pure colour, which surely reveals Tuke's knowledge of the theories of local colour – that there is no black but only reflected light in natural shadows – put into practice by the Impressionists.

To further enjoy Tuke's mastery of his medium, we can turn to the excellent drawing of the oarsman, whose limbs are picked out in chinese white, where the sunlight strikes them. These delicately painted passages contrast admirably with the raw depth of the shaded water of this idyllic Cornish cove. *Green Water*, for all its formal concern with colour, implied by the title, is a nostalgic portrayal of recreation. It is a fitting record of the Edwardian era and was painted only three years before World War I was to shatter such dreams of a life of undisturbed pleasure. Tuke was elected an associate of the Society in 1904, four years after he had achieved similar status at the Academy. He became RWS in 1911, RA in 1914, and died at Swanpool, near Falmouth, in 1929.

Between the wars another fine watercolourist found pleasurable and nostalgic scenes on the Cornish coast. Joseph Edward Southall's Diploma work, painted the year before his election to RWS in 1931, is a view near the mouth of the Fowey estuary, twenty-five miles north east of Falmouth. Born in Birmingham in 1861, Southall began his career as an articled clerk in an architectural practice in the city. It was from this experience that his later interest in architectural mural painting and his sense of craftsmanship may have stemmed. In 1900 he was a founder member of the Society of Painters in Tempera, and he felt that this medium and that of fresco were preferable to oil and watercolour because they demanded more skilled craftsmanship. Southall's interest in mediaevalism and the Pre-Raphaelites is reflected in the subjects and style of his mythological and religious work.

He was also a painter of landscapes and shipping scenes and those made as a result of his numerous visits over the years to Southwold and Fowey are probably his best known works. The many variations of views in the steeply sided estuary of the River Fowey suggest that these were among the most popular works with his patrons. They certainly enjoy great popularity today and watercolours such as *A Cornish Haven*, evoke fashionable feelings of nostalgia for their period.

In this work, a girl walking on her mother's arm turns to salute an elegant schooner plying the waters of the estuary. This gesture of acclamation, together with Southall's own obvious admiration for the vessel that is his central subject, helps to indicate that by 1930 this vision of the great trading ship was already a rarely seen vestige of an era of sail that had passed. Despite its inherent nostalgia, *A Cornish Haven* is stylistically a product of its time, in which decorative arts and crafts were characteristically of the type described as 'Art Deco'. This was also an age in which

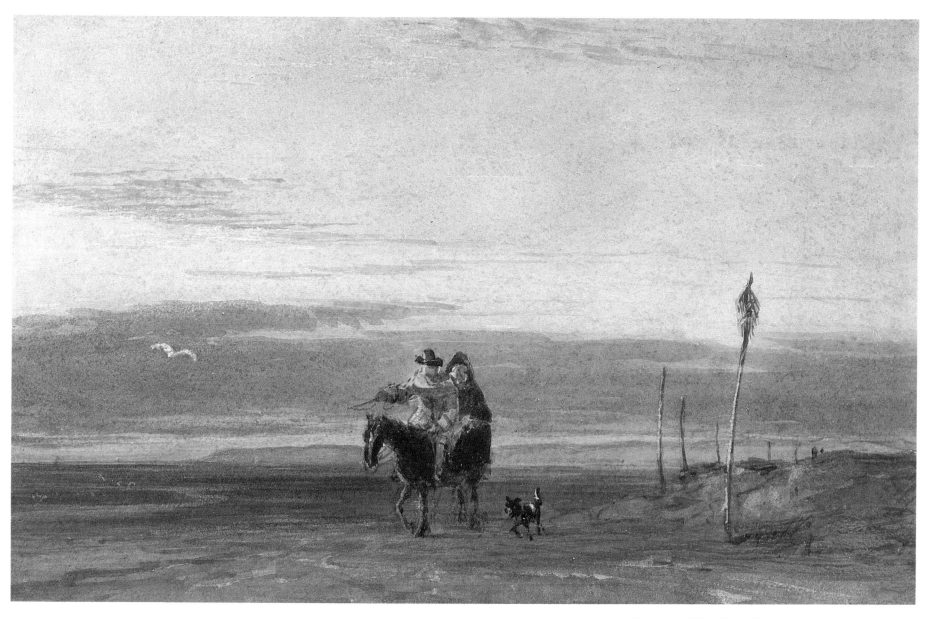

Figures on Horseback Crossing the Sands
DAVID COX OWS (1783-1859)
Watercolour over graphite, with scratching out
5¾ × 8⅞ ins

This full-scale illustration allows us to savour the precise beauty of Cox's manner. Although not as painterly as his late works, this watercolour is testimony to the ability of a great artist to describe much about the nature of the medium in a small area of paper.

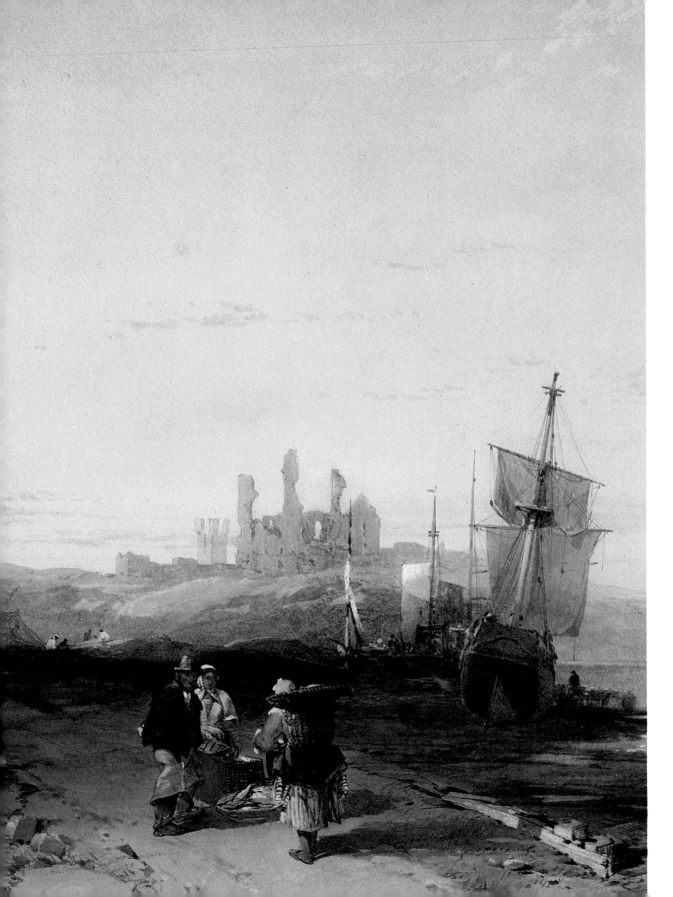

travel posters adorned numerous public sites and illustrations packed magazines, encouraging city dwellers to visit the remoter corners of the country on the expanded railway network. S. R. Badmin's early watercolours and drawings, which we have previously discussed, were born out of this age of burgeoning popular travel and it is possible to draw stylistic comparisons between the two artists' decorative and illustrative work at this period.

The essential flatness of Southall's picture may recall the posters of the time, but it is more properly understood in the light of his practice of fresco and tempera. These mediums, the former the application of paint to wet plaster and the latter a quickly drying admixture of pigment and a binding based on egg, both tend to result in flattish surface images with broad shapes and a generally limited tonal range across an evenly handled surface. While oil and watercolour allow potentially greater intricacy of texture and brushwork and contrasting strength of tone and colour, this watercolour exemplifies how affected Southall was by the use of his preferred mediums. Here he has applied a yellow wash to the paper before adding layers of watercolour and then stippling with a dry brush. The initial wash serves to unify the tonal and colour scheme of the picture in a way that is reminiscent of fresco.

Southall was elected an associate of the RWS in 1925. Twenty years later his death was commemorated by a memorial exhibition organised by Birmingham City Art Gallery, which was also seen at the RWS Galleries and at Bournemouth. No other major exhibition of his work took place until Birmingham marked the revival of interest in one of its finest twentieth-century painters in 1980.

Claude Muncaster was steeped in maritime life and his Diploma work *In South Atlantic* also depicts a sailing ship, the useful commercial life of which had been eclipsed by the age of the steamship. This painting is a record of a four month voyage from Australia to

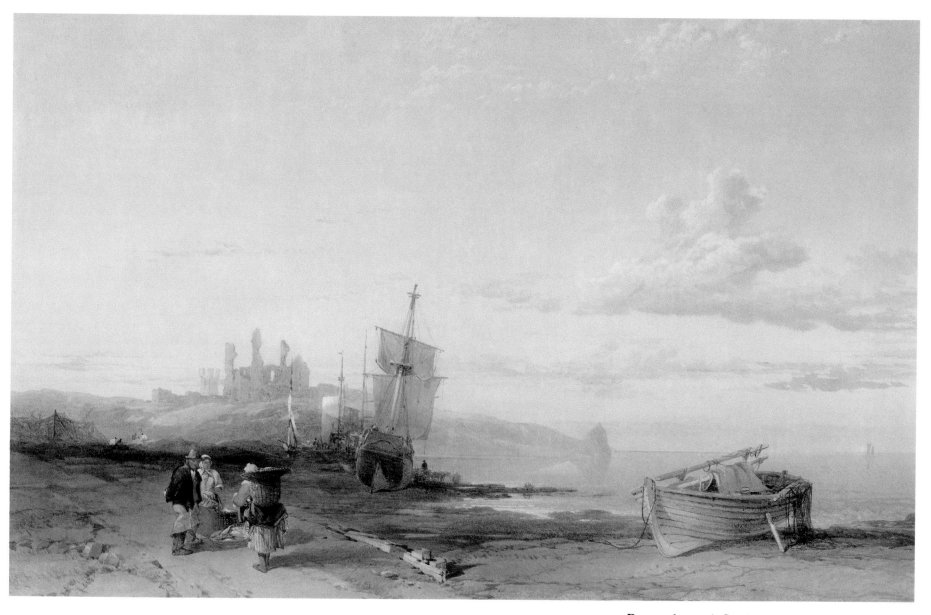

Dunstanborough Castle
THOMAS CHARLES LEESON ROWBOTHAM
(1823-75)
Watercolour, gum and bodycolour over graphite
15½ × 24¼ ins

This reproduction allows us to assimilate the organisation
of Rowbotham's composition and to see how he has used
the light and shade from a setting sun to orchestrate the
picture. While the easily recognisable outline of the castle
is a principal topographical feature, the foreground and
middle distance contain the areas of pictorial interest.

A Coastguard Watch House (*Detail*)
CHARLES NAPIER HEMY RA RWS

This over life-size detail of the most appealing section of the picture reveals Hemy using watercolour and the absence of it to the best advantage. He has allowed the greyish paper to state certain tonal values for the clouds and foreground figure and washing, and from these values he has briskly laid in the paint structure in a most effective way. The motif of the woman gripping her hat against the gale is a particularly pleasing image.

Britain made as a deck hand some two years after Southall had painted his Diploma work. The ship was a four-masted barque called *The Olivebank*. Muncaster had opted to sign on as a crew-man and not as a passenger, because he 'wanted to learn about the blue-water sailor's life at first hand, and for the reason that as an artist I might depict one of the last surviving windjammers which will ever be seen'.

This quotation comes from Muncaster's vivid account of his experiences of the voyage, entitled *Rolling round the Horn*, published in 1933. This book includes photographs taken by the artist from aloft the masts. When Turner had himself tied to a mast in order to observe a storm, he did not have the aid of a camera, only his phenomenal visual memory. Muncaster's Diploma work of 1933, taken from the foremast, is undoubtedly based on photographic material, but its immediacy and accuracy of description of the details of the barque reflect his first-hand experience of a working passage.

Painting with crisp strokes of the brush onto a dry sheet, Muncaster has left many patches of his paper to convey the sparkle of sunlight on cloud, water and sail cloth. The South Atlantic waves have breached the deck and are rendered with the fewest touches of watercolour onto the bare paper. He has scraped the wave crests out of his blue brush-strokes that describe the swirling water. The handling of the sea helps to give a dynamic vividness to the scene and the viewer's involvement is encouraged by the foreshortened perspective and nearness to the picture plane of the sails and rigging. The force of the wind nearly blows the sails through the front of the painting and we can almost feel we are there in the South Seas with the artist.

Claude Muncaster was born in 1903, the son of a painter who was a member of both the Royal Academy and the RWS. He was elected an associate member of the Society in 1931 and a full member in 1936. That his Diploma work dates from his epic voyage, some four years before this last election, perhaps indicates the young man's pride in this venture and the watercolours which resulted from it. He went on to become one of the most admired British marine painters of the century. Muncaster's voyage was of course full of tribulations and he recalled that 'a windjammer really has no practical relation to modern life. However romantic she may seem because of her connection with the past, and the beauty of her form, it is mere sentimentalism to pretend aught else'.

The very different world of modern naval warfare is echoed if not exactly revealed in the Diploma painting

A Coastguard Watch House
CHARLES NAPIER HEMY RA RWS (1841-1917)
Watercolour, gum and bodycolour on off-white paper
13½ × 19⅞ ins

This is a work to relish for its liveliness and atmosphere. Here it looks as fresh and genuinely painterly as it must have done on the day it was being finished in the artist's studio. The reproduction shows how much chinese white has been used in painting the rough sea.

Green Water (*Detail*)
HENRY SCOTT TUKE RA RWS

Around a half life size, this detail both exemplifies the way that Tuke has let the original paper surface do much of the work to make the lights and how excellently he has painted the principal figure, using both watercolour and chinese white to describe the torso and arms. We are also better enabled to appreciate the free, but dextrous handling of the water and boat.

of Sir William Russell Flint. Among amateur water-colourists and many admirers of the art, Flint holds the highest rank in the annals of twentieth-century British watercolour painting. This status is accorded more for his supreme mastery of his medium than his choice of subject matter. The cloying commercialism of his well-known watercolours of half-dressed dusky maidens posed on beaches or in Spanish interiors have given a great artist a very bad name. They were so prolifically produced because the market was sure and Flint was not one to eschew sales for any considera-tion of the integrity of his subject matter.

There is little reason, however, to doubt his integrity as a man. Malcolm Fry, Secretary of the RWS from 1957 to 1982, has recalled how the ever

popular Flint would, on receiving potential pur-chasers at his studio in London's Peel Street, ensure that any sales of watercolours intended for exhibitions with the Society, should entail payment of the regular RWS commission. As a byline, it is worth remarking at this point that the taking of commission on sales at the Society's exhibitions is a relatively recent custom. The resulting funds go towards supporting the ad-ministration and activities of the RWS. If the mem-bers of the early Society had made such provisions, there would not have arisen the necessity to wind it up in 1811.

Although he also painted in oils, Flint was a great ambassador for his preferred medium of watercolour. Almost single-handedly he instilled the art into the

Green Water
HENRY SCOTT TUKE RA RWS (1858-1929)
Watercolour and bodycolour
11⅞ × 18 ins (sight)

In this eloquent example of Edwardian watercolour painting we may observe the extensive use of a sponge in the creation of the textures of the outer areas of the sheet. It is this technique that has produced the mysterious shadowiness of the boy in the water – a quite remarkable image most subtly handled.

In South Atlantic
CLAUDE MUNCASTER RWS (1903-74)
Watercolour over graphite, with scraping out
20 × 13¾ ins

This small-scale illustration binds together the areas of
paint and white paper that Muncaster has used as his
technique of depicting waves, white horses and foam. The
clarity of his painting style is evident.

OPPOSITE PAGE
A Cornish Haven
JOSEPH EDWARD SOUTHALL RWS (1861-1944)
Watercolour over graphite
12 × 9⅝ ins

Southall's meticulous technique is quite adequately
represented in this illustration. We can see how close to
the manner of tempera and fresco, two of his other
favourite mediums, is the overall evenness of the artist's
handling of watercolour in this picture. There is a fresco-
like uniformity to the colour values.

minds of the general public in a manner not seen since the great days of the nineteenth century. Much of this was achieved through extensive publishing of photographic reproductions of his work. As a respected Royal Academician, he also carried the message of the beauty of the watercolour to a captivated and distinguished audience. His prices at exhibitions of the Society were several times higher than those of any of his fellow members and began to come close to the comparatively enormous sums asked by some of his nineteenth-century predecessors, after a general falling off in values for pictures in the early part of this century.

From 1936 to 1956, as President of the RWS through some difficult years, Flint maintained a relatively high profile for a Society which, despite the commission it took, was at times in danger of dying through lack of support. In the immediate postwar period, members were lucky to sell a watercolour for twenty or thirty guineas. The RWS now flourishes, and the current revival of interest in watercolour is due not only to the proper recognition by connoisseurs of the talents of great early members, but also the appreciation by a host of keen amateur painters of such masterly technicians as Sir William Russell Flint. More importantly for the prosperity of the Society's members, the modern or contemporary watercolour is now accorded its proper position in the market place.

Produced in his role as an Official War Artist, Flint's Diploma work is refreshingly unusual in his *oeuvre*. It is not generally known that he was a landscape and architectural painter of consummate skill, for what have been described as his 'breastscapes' dominate the popular conception of his work. If we look at the architectural settings for such pictures as the Spanish confections, we can begin to understand how such a majestic work could have come from the hand of this artist.

Incoming Tide, No 1 Slip, Devonport Dockyard was painted a few days before German bombing raids destroyed the yard in 1941. Devonport is a part of the Plymouth conurbation, an historically important naval port on the South Devon coast. From the natural harbour of Plymouth were launched many of Britain's naval fleets, from medieval times onwards.

The dimensions of the watercolour are large, and the conception one of grandeur. The handling of the brush is breathtaking in its economy and purpose. Where one broad brush-stroke will do, only one brush-stroke is used. When more detailed working is necessary, this is performed without waste. Flint has

117

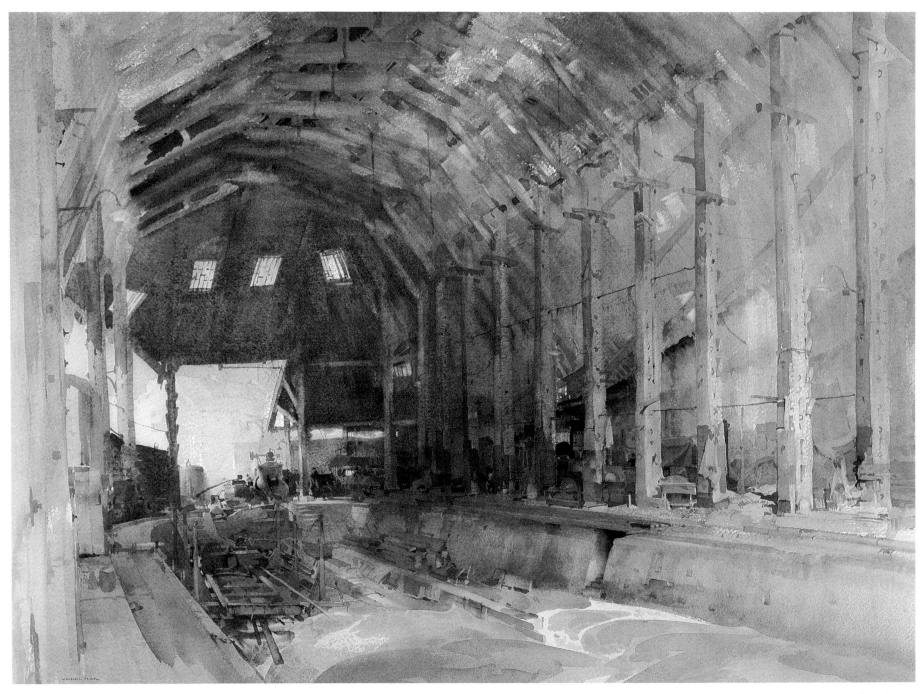

Incoming Tide, No 1 Slip, Devonport Dockyard
SIR WILLIAM RUSSELL FLINT RA PRWS
(1880-1969)
Watercolour over graphite, with scratching out
19¼ × 26 ins (sight)

One of the technically most excellent works in the Collection of the RWS, Flint's Diploma work is also among the most satisfying aesthetic creations by this artist. It is impossible to express in a few words the full grandeur of the conception, but this illustration shows at least how an apparent mess of diametrically opposed brushstrokes can combine to convince us of the veracity of the timber roof.

freely depicted the great timbers of this structure as if they were the piers and vaulting of a cathedral. The great vault is, on close inspection, a seeming mishmash of vigorous sweeps of brown washes, painted wet-in-wet and wet on dry. Standing away from the picture, every timber falls into place and the architectural unity is preserved. The height of the roof is emphasised by angular, dark brush-strokes. Along the right-hand side of the dock and in the middle distance, much greater detail is unfolded and there are some brilliant renditions of figures and machinery, indicated only with the merest dabs of paint.

The receding composition is aided by this variance of brushwork. The eye is led towards the light beyond the shed, not only through perspectival recession, but also along a path from free handling to considered detail and some descriptive scratching out of minute highlights. Of all the works of our century in the RWS Collection, this must be one of the most satisfying. Its monumentality and historical interest place it as a significant work of modern British art. Although regarded as a Diploma work, the Devonport watercolour was presented to the Society many years after Flint's election to membership in 1917. In World War I he had served in the Navy and the Air Force. Born in Edinburgh in 1880, he studied at Heatherleys School of Art in London, and was much involved with printmaking, before turning to watercolour as his principal mode of expression. Some of Flint's drypoints should be included among his finest works, but this war drawing shows where his greatest talents lay.

To conclude this chapter, we turn from Flint's grandiloquent depiction of the architecture of the dockyard, to a more informal and restrained observation of maritime furniture by Michael Whittlesea. His Diploma work is a large study of a beached boat, wrapped up against the likelihood of inclement weather. The wrapping has been effected with the debris of modern seaside life, most conspicuously with a curious array of awnings from promenade kiosks. It seems to be the amusing peculiarity of the subject which has caught the artist's attention and its incongruity is exploited to good effect to produce an intriguing abstract arrangement of shapes and colours. In doing this, Whittlesea is working within the modern artistic tradition of the 'found object'.

To explain the meaning of this term, it is worth referring to the art of Paul Nash, the great English painter in watercolours and oils, whose often surreal work is among the most potent of the first half of this century. Nash would utilise an interesting natural object, found in any setting, but often on the beach, and exploit suggestions of its physical similarity with other objects, or its allusion to a meaning not logically stemming from its own original function. Thus he might, for example, employ a piece of twisted and decayed driftwood to suggest the shape of bones and thus allude to ideas of mortality. Such symbolism is among the most pervasive messages which the 1920s and 1930s Surrealist movement passed on to contemporary painting and sculpture.

It would be wrong to draw a direct parallel here, but while Whittlesea's wrapped boat is a less morbid image than the example quoted above, it does convey associational ideas because of the strange nature of the subject. A nostalgic feeling of summers gone by and lost is expressed by the use of an awning, from a once flourishing souvenir shop, to protect this boat against the winter of a deserted resort. It is a simple image, this found object, but one that is most evocative of times enjoyed in the shabby quietude that is unique to out-of-season seaside towns. There is not, however, any overriding emotive intent in this watercolour, and the 'found object' is seen dispassionately and with a wit characteristic of the artist.

Whittlesea is interested in a wide range of subject matter unrelated to the coast. His restrained sense of humour is evident in much of his work, but a serious aesthetic governs his approach to watercolour. His feeling for design is always present, as befits one who is a successful book-illustrator. Michael Whittlesea was born in London in 1938 and trained at Harrow School of Art, where several members of the modern RWS studied. While increasingly devoting himself to watercolour and oil painting he has also lectured, notably at Berkshire College of Art. He was elected ARWS in 1982 and RWS in 1985.

The sparse use of graphite and watercolour in the *Wrapped Boat* reveals Whittlesea's economy of technique at its best. This economy is refreshing when set beside some of the flights of technical fancy we have previously considered in this chapter. It is, too, most suitable to the uncontrived composition. The flatness of the painted area and harmonious directness of technique add to the strangeness of the subject's presence.

Earlier in this chapter, we found Henry Scott Tuke depicting a scene of recreation on the English coast. But we have not discussed that pioneering pleasure activity of the Victorian era: beach-life. This is because no appropriate nineteenth-century work exists in the RWS Collection, but early members like Samuel Prout were already recording bathing wag-

OVERLEAF
Incoming Tide, No 1 Slip, Devonport Dockyard (*Detail*)
SIR WILLIAM RUSSELL FLINT RA PRWS

This double-spread detail, showing the full width of the watercolour at approximately its true size, gives us ample opportunity to study the brilliant technique typical of all Flint's work, but especially pleasing here. From the breadth of handling at the right of the composition, the eye is led left to the clever brushmarks that represent the figure and machinery beneath the proscenium arch of this performance of a painting.

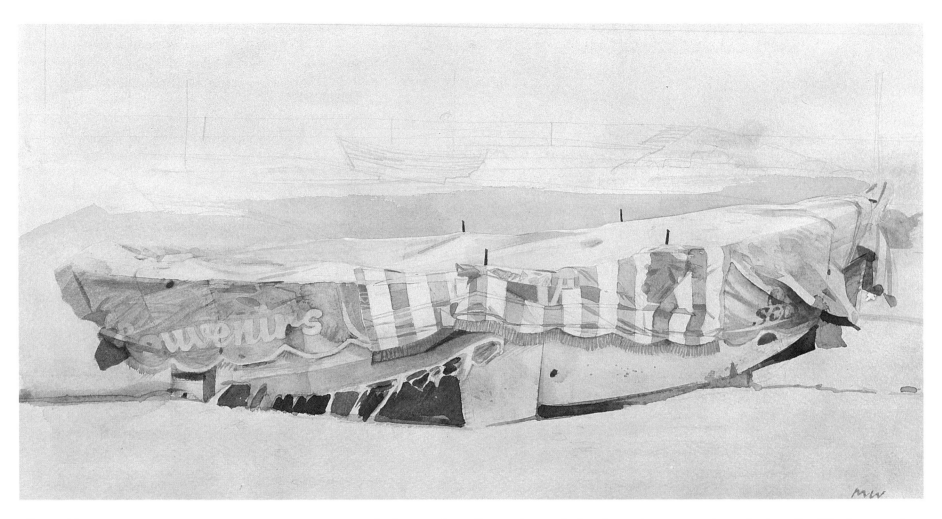

Wrapped Boat
MICHAEL WHITTLESEA RWS (b 1938)
Watercolour and graphite
12³⁄₄ × 23⁷⁄₈ ins (sight)

This is a clever picture, but not in the way that Flint's is. Its cleverness lies in the witty selection of the subject rather than the manner with which the artist has chosen to depict this arresting motif. Whittlesea's wrapped boat is a lovely combination of materials, images and textures, revealed through the descriptive medium of pure watercolour over pencil.

gons and other trappings of recreation on the beach. Queen Victoria herself gave official sanction to bathing and it should be remembered that the popularity of health spas such as Bath and Cheltenham had in the eighteenth century demonstrated a great belief in the therapeutic qualities of water. The Romans had bathed in, as well as drunk, the waters at Bath, and Regency England rekindled both activities as important contributants to health. In those days, however, visitors to the beaches wrapped themselves against the sun. Today, we tend to go to the beach to relax, to take

the sun, to swim and to have fun. We also mess about in boats. Greater stretches of the coast are used for pleasure than for any other purposes. This is not surprising in a relatively affluent age for a country which has to a considerable extent lost its maritime economy, for many reasons and on several levels. The wistful feeling of Michael Whittlesea's Diploma work is a touching note on which to end this chapter of British watercolourists recording subjects central to their nation's maritime tradition.

IN VILLAGE AND TOWN

In the first chapter of this book we alluded to two centuries of encroachment of industrial and urban man on the landscape. The Industrial Revolution brought mines, mills and factories to the land, and with these the housing needed to accommodate the workers. In the Victorian age, great industrial and residential conurbations built up, particularly in those areas of Britain richest in the natural resources which powered and provided for industry.

In the North and North-East, the retrieval of metal ores and coals from the ground was a principal reason for the rapid expansion of cities like Sheffield and Newcastle. In the North-West, Liverpool's docks provided the means for overseas trade in the cloth produced in the water-driven mills of Manchester and the Peak District. The growth of industry also affected smaller communities. Villages became towns as local industry brought an influx of workers and their families into areas where the steady pattern of rural life had only, for many previous centuries, been affected by comparatively gradual agricultural progress. In some instances, hamlets that had barely grown in size since their mention in the Domesday Book could, over the course of fifty years or so, find themselves the nucleus of urban sprawl.

Despite the slow-down of industrial growth in recent years, the pattern continues today and numerous ancient villages have been overwhelmed by piecemeal Victorian and modern construction work. Many of the urban areas of Britain comprise extraordinarily varied mixtures of periods and styles of architecture in a manner hardly equalled by the cities and town of any other country, particularly those that have only become industrialised in the modern age. It might be claimed that this lack of uniformity is partly a result of a deficiency in planning. But as Britain's period of immense industrial expansion spanned some two centuries, longer than that of most other nations, piecemeal development was probably unavoidable.

There have at many stages been serious attempts to plan urban sites in homogeneous and uniform ways, from Sir Christopher Wren's projects for London after the Great Fire of 1666 to the creation of new towns like Stevenage and Milton Keynes in the years since World War II. However, such visions of ideal urban planning have often been thwarted by pragmatic bureaucracy or have been unsuccessful in achieving their aims. The proposals that architects have made to replan unsatisfactory urban centres have, as a rule, been less sympathetically accepted here than in Europe, where, to cite an obvious example, Haussmann remodelled Paris for Napoleon. Wren's planning proposals for the City of London were not effected, although many of his churches were built. John Nash's plans for the West End were only partially completed. It is also most likely that Richard Rogers' radical scheme for the remodelling of the area between London's Leicester Square and Waterloo will remain on the drawing board. Such proposals for sweeping change are anathema to British thought. While this conservatism has left many exciting proposals unrealised, it has also helped to conserve much of what is best in our urban environment. The rich architectural heritage of our cities encourages us to find them enjoyable places in which to live and work.

We begin by turning to a village in Wales. David Cox's *A Welsh Village* of 1828 is probably set in the north of the country, and shows a community apparently unaffected as yet by urban development. Coal or wood fires burn in the houses and the plumes of smoke coming from chimneys give an atmosphere of autumnal chill to the scene.

This is a remarkable example of Cox's watercolour art. It is of characteristically small scale, but in true Coxian style manages to convey all one wishes to know about the subject with great simplicity of presentation. It says as much as pictures many times its size. In describing how well Cox has caught his subject, one could quote Nathaniel Solly's recollection of *A Welsh Village* in his *Memoir of the Life of David Cox* of 1873, which Stephen Wildman reprinted when the watercolour was included in his catalogue of the Cox bicentenary exhibition held in 1983 at Birmingham City Art Gallery and the Victoria and Albert Museum. Solly writes '. . . in a sketch of a village in North Wales, which I have lately seen, an Italian organ-grinder is leading a bear, which is being saluted by the village curs, and gazed at by the wondering natives; the bear is true to Bruin's nature, and the whole is very natural and easy. It impresses you too as being a real scene.'

Cox must have stumbled upon this scene on one of his sketching tours in North Wales. For all his powers of visual imagination, the artist observed, absorbed and recorded in his work many of the unusual sights and events he came upon during his travels. Even his most poetic and thoughtful works, such as *The Welsh Funeral* of 1848, were generally inspired by personal experiences. The scene we witness here is too unlikely to be fictional. The strangeness of these figures of man and bear making their way down a prosaic village street is relished by Cox and he depicts the subject with humour. A characteristically spirited little dog makes its presence known – we can almost hear the sound of yapping – but the lumpen bear, many times its size, chooses to ignore this canine impudence and plods stoically onwards. This comic incident appears to cause considerable mirth in two nearby villagers.

Cox's keen observation and wit are matched by the technical qualities of this watercolour. He is near his best here, with some marvellous passages of subtle tonal washes that are interrupted and modified by occasional stopping and scratching out. One area of paper is left untouched, where a cloud showing over the shoulder of the mountain catches the late afternoon sun. The smokey gloom and fading light are evocatively rendered and the scratched out whiffs of smoke suggest a chill in the air. In this small work we are able to enjoy Cox's brushwork at its most delicate, particularly in the distant street scene, where the tiniest manipulations of the brush convey whole groups of figures and animals. These delightful passages are only possible as a result of the artist's superbly natural control of tone and colour.

Despite its sense of truth to the subject, *A Welsh Village* was in all likelihood painted at Cox's home in Kennington, South London, where he was resident in 1828. It was probably based on sketches made on a trip to Wales three years before, or even on an earlier foray into the country. Such practice was quite common and of course J. M. W. Turner was in the habit of using sketches dating from decades previously for the purpose of painting a finished watercolour.

William Callow also worked in a similar way, but he also made large pencil drawings on the spot which could themselves later be worked up into exhibition watercolours. His large study of *St Mary's Church, Richmond, Yorks, Before its Restoration* may well have been painted as well as drawn before the subject. There is not the high finish of a studio work here, and there is an urgency and freshness to the execution

A Welsh Village (*Detail*)
DAVID COX OWS

This small detail is considerably larger than its original
scale and pays particular attention to the dry-brushed
depiction of the man with his bear, as well as some superb
descriptive passages representing the village cottages.
Note the excitable dog and Cox's use of scratching
out to show the dust being kicked up. The colouristic and
tonal modulations are splendidly effected.

which, for all their boisterous brushwork, many of
Callow's watercolours of the middle and late periods
lack.

The urgency referred to is in keeping with Callow's
choice of this subject. On the reverse of the sheet he
records that he depicted the church 'before its resto-
ration, 1853'. From his early training, Callow was
keenly interested in architecture and a large propor-
tion of his enormous *oeuvre* consists of views of build-
ings in Britain and throughout Europe. His prime
interest was in mediaeval architecture and we may
surmise that he was anxious to record the interior of
this fine church before restorers got their hands on it.
The Victorians favoured various hybrids of Gothic
and other architectural styles, and much of the repair
and renovation of mediaeval churches that took place
at the time has dubious relevance to the integrity of
the original conception. In many instances such
restoration was over-zealous or mechanical and
sometimes destroyed the previous character of
buildings.

Today, with architecture, as with watercolours,
conservation as opposed to restoration, is the byword.
Conserve what remains, but do not restore a work to
how you think it once might have looked, and do not
do anything that cannot be undone. It is remarkable
how a piece of restoration, apparently successful to
contemporary eyes, can so quickly 'date' as the style of
its own time itself dates. It very soon becomes a pro-
duct of its age and not a sympathetic recreation of the
original. Callow loved the picturesque individuality of
mediaeval craftsmanship and would undoubtedly
have been one of those enlightened people who op-
posed wholesale Victorian restoration work, which so
often lacked creative warmth.

The picturesqueness of the line of assorted
fifteenth-century pews in this picture is drawn out by
the steep perspective. This steepness itself adds
weight to the view that Callow was sitting in the central
crossing as he executed his drawing. From a position
close to his subject, his eye acts almost like a wide-
angle camera lens, for example looking way above his
head for a sight of the roof timbers. The darkness of
the rapidly brushed in roof provides a ceiling for the
composition, a counterpoint that helps prevent the
verticality of the Gothic mouldings from soaring up-
wards out of the picture area. In addition to Callow's
compositional awareness, we can enjoy with relish the
fluid descriptiveness of his ever-moving, ever-prob-
ing, brush. The paint is handled with varying propor-
tions of water and gum, but the artist has relied on his
great ability in the medium to alternately wash in
broad areas and pick out detail as the structure of the
study has developed. His masterly manipulation of the
brush probably allowed Callow to have the whole
thing done within a few hours. The immediacy of
execution shines through in this powerful work.

The town of Richmond is situated high above the
River Swale in one of Yorkshire's most beautiful
dales. With its Norman castle dominating views from
the moors and from below in Swaledale itself, the
town was a popular centre for artists visiting the area.
Turner, for instance, depicted the town in a number
of watercolours. Callow was an inveterate traveller
and the RWS is fortunate to own two large albums,
full of pencil and watercolour drawings which trace
some of his journeys throughout Britain and the Con-
tinent. The albums were presented by the artist's
widow, together with a long run of Callow's personal
marked catalogues of the Society's exhibitions. One
album contains around 120 drawings of British
scenes, including ones made on the same 1853 visit to
Yorkshire. The other has twenty-three highly finished

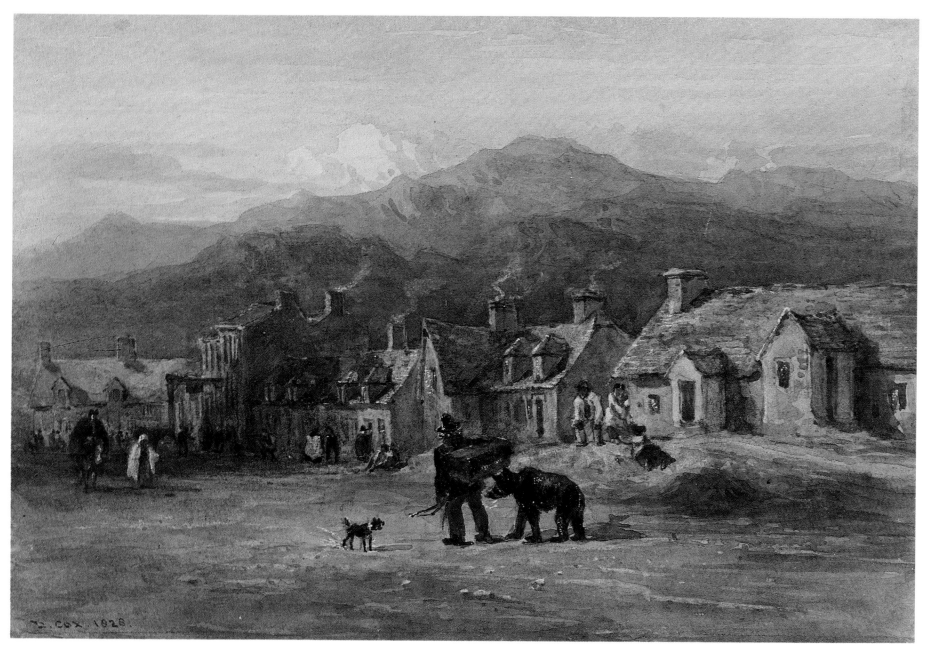

A Welsh Village
DAVID COX OWS (1783-1859)
Watercolour with stopping and scratching out
$6\frac{1}{8} \times 8\frac{7}{8}$ ins

Cox's watercolour is shown here full size and is one of the most interesting images of his mid career. It is not only the subject but the way this is handled that we should note. In this particular illustration, we should perhaps pay attention to a greater freedom of direction in the brushwork than was evident in the admirable watercolour of figures on horseback, discussed earlier. Cox appears to have used stopping out (the application in places of a resist to prevent further watercolour washes being absorbed into the paper) to depict the plumes of smoke.

125

St Mary's Church, Richmond, Yorks, Before its Restoration (*Detail*)
WILLIAM CALLOW RWS

This detail is reproduced at approximately its true size and represents a formidable example of Callow's drawing ability. The strongly recessional perspective of the pews is successfully integrated into the overall design and we see here how well it is juxtaposed with the drawing of the Perpendicular window.

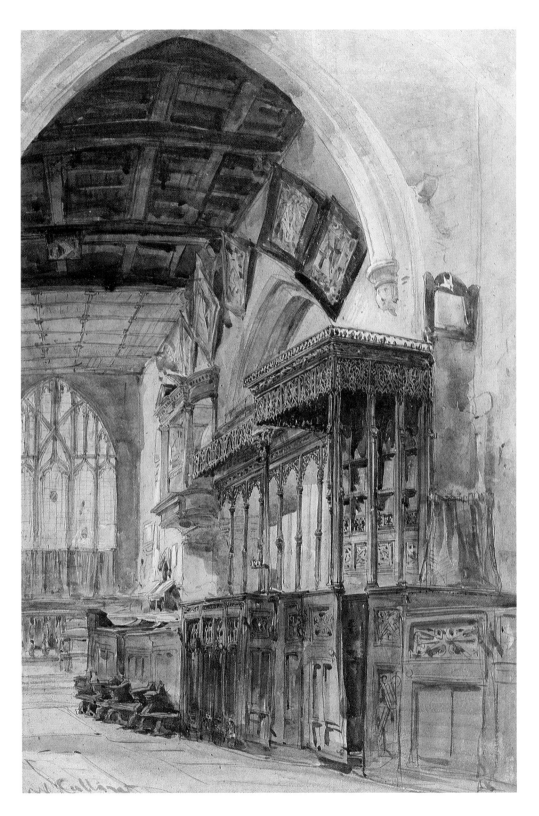

St Mary's Church, Richmond, Yorks, Before its Restoration
WILLIAM CALLOW RWS (1812-1908)
Watercolour and bodycolour over graphite on buff paper
20¼ × 13¼ ins

This is a magnificent example of Callow's swift architectural recording. We may observe the dynamic and very factual perspective, in addition to the easily attained composition, second nature as this must have been to the artist at this stage in his career.

127

graphite studies of Continental towns. Throughout these albums, the attention to architectural detail is fastidious and absorbing, but always with a freedom of line which raises Callow's draughtsmanship above the ordinary. He rejoices in the intricate recording of mediaeval façades – the half-timbered Rows of Chester for example – but this concern for the description of architectural mouldings is complementary to his understanding of the solid form and perspective of buildings. It is little wonder that for Philip Shepherd RWS, one of today's finest watercolourists of architectural subjects, Callow's drawings represent a pinnacle of achievement in this field.

We now turn to a very different viewpoint of the urban scene, that of George John Pinwell in his Diploma work, *A Seat in the Park*. This is essentially a sketch in watercolour and whatever the architectural element of the backcloth, it is only jotted in with graphite. Pinwell's main interest is a weary looking threesome sitting on a park bench. Whether the physical distance between the man, and the woman huddled next to the child whose gaze confronts the onlooker, is symbolic of an emotional distancing, we can only conjecture.

The setting of this watercolour may well be a London park and the people involved could almost be enacting a scene from a Dickensian novel. Such speculation is not entirely redundant as Pinwell was one of the most talented of the Victorian illustrators of the 1860s. Having studied at St Martin's Lane Academy and Heatherleys Art School, he went on to produce work for periodicals and for the Dalziel brothers, who published many of the finest illustrated books of the period. This was a great age for English illustration and many of the most distinguished painters in watercolour and oils started out, or supplemented their incomes, in this way. We have already noted that Birket Foster developed his watercolour art from an early career in black and white illustration and it was characteristic of graphic artists to produce their first designs in watercolour. As photographic colour printing arrived with the twentieth century, books came to include reproductions of drawings in watercolour. This meant that the illustrators were no longer restricted to monochromatic designs and could harness their fine art interests with the practical considerations of their trade. We have already noted how sympathetic watercolour is with the colour printer's own medium. Prominent exponents of coloured book illustrations included Society members like Arthur Rackham, Helen Allingham and Rose Barton.

Pinwell's sketch may be a study for a book illustration, later to be engraved, but it is well worth examining for the freedom of his handling of watercolour. He confronts the subject head-on and with a minimum of artifice or concern for decorative appeal. This is watercolour in the raw, economically used in graphic brushwork to capture the scene. With chinese white, he gives the child a strangely mask-like face and picks out the brim of the man's top hat.

G. J. Pinwell was born in 1842 and elected an associate of the Society in 1869, being made a member in 1870. It was fortuitous for the Society that he was elevated to membership at a young age, for he had only five years to participate in its exhibitions before his untimely death in London in 1875.

Sir Ernest Waterlow's involvement with the RWS was of much greater length and of considerable depth of commitment. Following his first appearance in the associates' list in 1880, it was fourteen years before he was elevated to the members' ranks. But only three years later in 1897, after the death of the President, Gilbert, Waterlow was installed in his place. He remained in the position until 1913, when ill-health forced him to retire, six years before his death. Gilbert had been the first President to be knighted by the monarch and it was during his period of office that Queen Victoria had granted the Society the Royal title it still enjoys today. Waterlow was knighted in 1902, the year before he became an Academician. A knighthood was not to become an automatic entitlement of ensuing Presidents and has been an honour so far conferred on only two of his eight successors in office.

Born in London in 1850, Waterlow studied in Germany and Switzerland and then back in his native city at Cary's Art School and the Royal Academy Schools. Despite his close associations with the RWS, he was by no means a watercolour painter exclusively and many of his landscapes, which depict European as well as British scenes, are in oils. The Diploma work, *Crail, Fife* does show, however, what a fine exponent of his more sensitively natural medium he was.

Crail sits at the mouth of the Firth of Forth, where it enters the North Sea, some eight miles south-east of St Andrews. This delightful little coastal town has not changed much since Waterlow painted it nearly a century ago and much of the interesting architecture we see in the picture remains. Of course the roads are now metalled and the local life Waterlow records is an historical memory.

The horse-drawn hay-waggon, the sheep being driven through the street and the child pushing a wheelbarrow laden with his working implements are all relics of a vanished farming life. It is not just that farming methods have advanced and changed, but that they are either differently integrated with, or driven out of today's town centres, where the car and shopper have pride of place. Even the most rural and agriculturally based of towns cannot any longer survive exclusively on the life of the land, nor should they wish to. As communications and transport have developed in the twentieth century, so our country has 'shrunk' and every town, however small, may presently enjoy the benefits of modern commerce and trade. In the Europe of today a scene such as this can only be encountered in some of the most remote regions. As a traveller enjoys the simplicity and picturesque qualities of unmechanised life, so a work like *Crail* offers today's observers an insight into the lifestyle and customs of our ancestors in a rural town. When Waterlow presented the Society with his Diploma work, the motor car was no longer a gleam in an inventor's eye and had been a reality for a few years. One feels, rightly, that 1890s Crail was, and would remain for some while, untroubled by the impact of this pace-setting machine of the modern age.

In this watercolour of a Scottish subject by a London painter, it is possible to find some affinities with the techniques of contemporary Scottish colourists such as James Paterson and Arthur Melville, both of whom we shall encounter in a later chapter. The 'blotchy' handling of the tree standing to the right of the composition could be compared with Paterson's handling of foliage, as could the confident washes over the foreground, with their added touches of blue in the shadows.

Following the example of the French Impressionists, this latter use of local colour is a not unusual phenomenon in British watercolour painting of the last years of the century. In a sense, Waterlow is the archetypal watercolour technician of his time: building the picture in many layers with fairly broad strokes of pure colour; selecting primary elements such as the figures and buildings for detailed work, while leaving secondary areas more loosely handled; scratching out and touching in with chinese white his highlights in equal degree; and at the end depicting what for a London clientele would be a pleasingly rustic version of urban existence. Waterlow was an appropriate representative of a Society which at the time included artists concerned with figure painting and the expression of serious artistic ideas, but which was largely orientated around the technically proficient portrayal of decorative landscape and genre subjects.

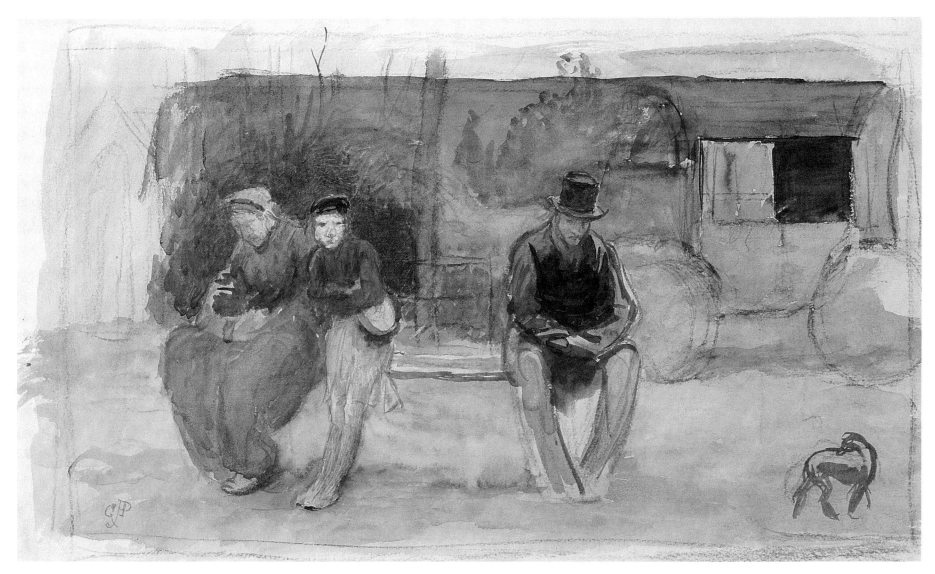

A Seat in the Park
GEORGE PINWELL OWS (1842-75)
Watercolour over graphite
11⅛ × 15⅜ ins

This is an intense study, not so much in regard to its technique but for the obvious seriousness of the subject matter. The work is loosely sketched and painted in and the various modifications to the composition are perfectly evident in this illustration.

In Charles Ginner's Diploma work we find ourselves transported with a jolt to the city, indeed to modern London. The terrace depicted in *Street Scene* is typical of areas of North and West London and is not readily identifiable. It is an example of the kind of housing built in the nineteenth century for middle class families of the new industrial age. London's enormous Victorian housing boom saw the city expand greatly. While widespread areas of working class housing appeared, particularly to the South and East, large sprawls of such terraces, many of them extremely elegant, extended the Georgian city to the North and West. Ginner's terrace consists of houses of no great prestige or size, but for all their narrow frontages they are at least on five floors, including basements, and the families that originally lived here would probably have had domestic staff.

In this century and especially since the World War II, many London houses have been divided into flats, as families could no longer employ servants and found running large houses too inconvenient and costly. The numbers of single people living on their own greatly increased with the breakdown of traditional family life, and this also aided the steady conversion of inner London into a city of flats. Recent rises in living standards among certain sectors of the business community have led to something of an turn around of this phenomenon in recent years, as more and more houses are saved as complete units, particularly dilapidated property new to the housing market and with its Victorian or Georgian internal features untampered with by builders or do-it-yourself enthusiasts.

When built, the stucco façade of Ginner's terrace would probably have been uniformly painted, but here, in the early twentieth century, we see hints of dilapidation and a piecemeal approach to decoration. This terrace is now, in all possibility, beautifully renovated, its stucco work patched up, and its porches and balconies all painted a consistent cream or white. But it is the dichotomy of varied texture and colour over an architecturally homogeneous façade which has so interested Ginner in this subject. His typical style is well shown here, with its flat presentation of isolated shapes edged with black ink over previously laid patches of watercolour. There is little possibility for, or intention to achieve, aerial perspective or subtle nuances such as atmospheric washes in his technique. Every element of the composition is handled with an equal emphasis and attention to detail, and even the clouds are on the same picture plane as the building. Thus, the flatness and repetition inherent in the subject, with the consistency of the architectural mouldings relieved only by the inconsistency produced by decades of human neglect and occasional piecemeal intervention, make this an excellent vehicle for the artist's technique.

Ginner's style has rather flippantly been likened to painterly knitting and to painting by numbers. Such comments, if derogatory, mistake technical procedures for artistic accomplishment, a common-enough fault of many superficial observations on artists' working practices. Ginner developed his idiosyncratic manner as a means to an end. In this instance the end was two-fold. First an interplay of abstract elements of colour and shape, and second a realist's intention to record inner-city decay. The poverty of Britain's city-centre residential districts is a very current concern.

The son of an Anglo-Scottish marriage, Ginner was born in France in 1878 and interestingly worked in an architect's office from 1899 to 1904, when he went to study painting in Paris. He returned to London and joined Sickert's Camden Town Group, which, stylistically influenced by developments in contemporary French art, took upon itself the aim of recording this North London working class area, where the present picture may well be set. It was not until 1938, quite late in his career, that Ginner was elected to associate membership of the RWS and his full membership arrived in 1945, seven years before his death.

Street Scene was chosen to represent the artist in the prestigious 1982 exhibition of British Drawings and Watercolours, which the British Council toured around China to great popular acclaim. The following year this show was the principal exhibition of the Edinburgh International Festival.

In the accompanying catalogue, Andrea Rose summed up the painter's watercolour art. 'All Ginner's work shows his concern to capture the mood of a subject – very often the dilapidated streets of Camden and other poorer areas of London – by deliberate study and sound craftsmanship . . . *Street Scene* is typical of the close observation and meticulous style he brought to his subject matter.'

From urban city sprawl to attractive coastal town, we move from Ginner's claustrophobic London street to Charles Cundall's open, breezy view over *The Old Town, Hastings*, on the Sussex coast. If there is a pessimistic feeling in *Street Scene*, Cundall's Diploma work breathes life and activity, fresh air and open horizons. A resort and fishing town which attracted watercolourists like Cristall and Prout, Hastings remains a genteel and restful haven for the visitor. The inscription on the watercolour is indistinct, but the 1920's may be the time of execution and the optimism of the early years of the decade, between World War I and the General Strike is gently conveyed in this delightful picture. The seaside air can be savoured and Cundall shows himself or a colleague engaged in painting the scene, accompanied by interested onlookers. The impression conveyed is of relaxation and enjoyment. This watercolour could as comfortably have found a place in the preceding chapter, as a fine coastal scene. It is featured here because it is the landside of the town which interests Cundall, and the way in which the buildings cling to their coastal setting reveals more about the make-up of Hastings as an urban community than about its role as a seaside resort.

Cundall has used bodycolour extensively, washing it in an economical fashion much as other artists would wash watercolour, and on the buff paper this creates some fascinating effects. Note, for example, the broad handling of the sea and the unusual green and yellow colourations in these broad sweeps of opaque pigments over a damp paper. Cundall's approach is not in total contrast with Ginner's, for he picks out the details of the town with an even and careful technique, but the overall conception of this atmospheric view is more obviously within the convention of the British watercolour tradition. Turner's use of bodycolour for breadth of effect in his Venetian works comes to mind.

Born in Manchester in 1890, Charles Cundall trained at the Slade, an art school which had a pervasive effect on figurative painting in the early decades of this century. He also studied at the Royal College and in Paris, and served with the Royal Fusiliers during World War I. He was an Official War Artist in World War II, under the aegis of Kenneth (later Lord) Clark, who through his position did much to encourage artists like Graham Sutherland and Henry Moore, as well as RWS members like Russell Flint and Thomas Hennell. Cundall joined the Society as an associate in 1935 and was elected a member in 1941. He contributed much to the RWS exhibitions until his death in 1971, and his work was also a regular attraction at the Royal Academy's Summer shows from the time of his election as an associate Academician in 1937.

Charles Sidney Cheston's Diploma work is another panoramic view, looking down over a broad sweep of urban scenery. In this case, the subject is the inland port of Bristol. The scene is taken from the cliffs of the Avon Gorge, near Isambard Kingdom Brunel's

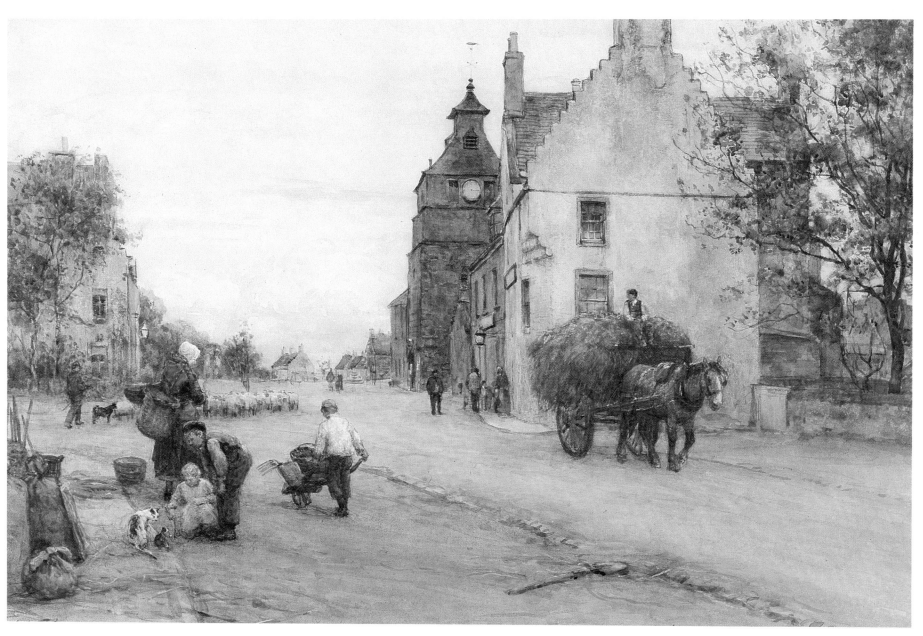

Crail, Fife
SIR ERNEST WATERLOW RA PRWS (1850-1919)
Watercolour and bodycolour over graphite,
with scratching out
13¾ × 20½ ins

One of the principal attractions of this watercolour is its
painterliness, typical as this is of many turn-of-the-century
artists, and particularly the Glasgow painters whom we
shall consider in an ensuing chapter.

Street Scene (*Detail*)
CHARLES GINNER ARA RWS

This detail, slightly over life size, of Ginner's architectural study also picks out the figures which are an essential element of the picture. Although they are not prominently featured, they do show that everyday life goes on, in and around this fairly imposing, but somewhat run-down terrace. In this illustration, we can also examine more closely the artist's individualistic style.

Clifton Suspension Bridge, itself one of the great pioneering achievements of nineteenth-century engineering. On the left of the view, the Georgian terraces of the pleasant residential district of Clifton are stepped up the high river banks. In the middle distance we see Bristol's then still thriving docks area and the Floating Harbour. In the far distance beyond the city, the land rises towards the Mendip Hills of Somerset.

In its near monochromatic treatment, *A Bend in the Avon, Bristol* relies largely on graphite and ink drawing for its structure and broken watercolour washes simply add tonal modulation to the under-drawing. This technique is reminiscent of a much earlier manner. It brings to mind the topographical works of late eighteenth-century draughtsmen and the manner of artists such as John Robert Cozens and Francis Towne. Perhaps it is not too far fetched to make allusion to the watercolours of the more picturesque Italian town of Tivoli, which are amongst the most celebrated works of these great early predecessors of Cheston. The allusion is prompted not only as a result of stylistic and technical similarities, but because Cozen's and Towne's motif of a town on a hillside, falling away to a valley below and with a vista beyond, is exploited by Cheston in like manner to give breadth and movement to the composition.

Bristol's importance as a merchant naval centre from the eighteenth century is reflected by the busy use of the river observable in Cheston's drawing. But as the distant chimneys suggest, it also became a thriving manufacturing city in the nineteenth century and today it remains the largest industrial conurbation in the South West of England. For this Bristol has much to thank its prime position on the Avon, which has provided a passageway for import and export trade as well as power for its factories and mills.

Cheston was born in 1882, but not until his forty-seventh year did he become an associate of the RWS. Achieving membership in 1933, he was later Vice-

President in 1950, and died in 1960. Like Cundall, he had studied at the Slade School and was a close associate of Philip Wilson Steer, the brilliant landscape artist in whose work is absorbed both the influence of Constable and the French Impressionists. If *A Bend in the Avon, Bristol* recalls the eighteenth-century topographical tradition, it also has a freshness of watercolour wash perhaps reflecting his association with Steer.

Leonard Squirrell's Diploma watercolour *The Last Phase : Demolition at Ipswich* alludes in its technique to his precursors in the watercolour tradition. This time, if we were to pick a single most significant inspiration, it would be the art of John Sell Cotman. Like Cheston's work, this picture relies very much on a strong pencil drawing. But here, the outlines are not washed over with broken brushwork, floating over the descriptive graphite marks. Rather they are coloured in with flattish areas of pigment and serve to create shapes which relate to each other in a pattern across the surface of the paper.

One particular value of black and white photographs of paintings is that they give an immediately understandable description of the tonal values employed. Monochrome photographs of works by artists whom we would describe as colourists are often barely recognisable as the originals, not just because of lack of colour, but because the artists have concerned themselves less with creating a register of tonal relationships. The construction of Squirrell's picture, like many of Cotman's greatest early watercolours, is based on the interplay of differently toned and coloured areas and shapes. Also like Cotman, however, he does enjoy rendering the modulations of colour values and the over-life-size detail in this book well illustrates this interest. Nevertheless, another painter might have made more of the bizarre colour patterns of wallpapers and painted plaster of a half-demolished house. Squirrell emphasises the structural skeleton of

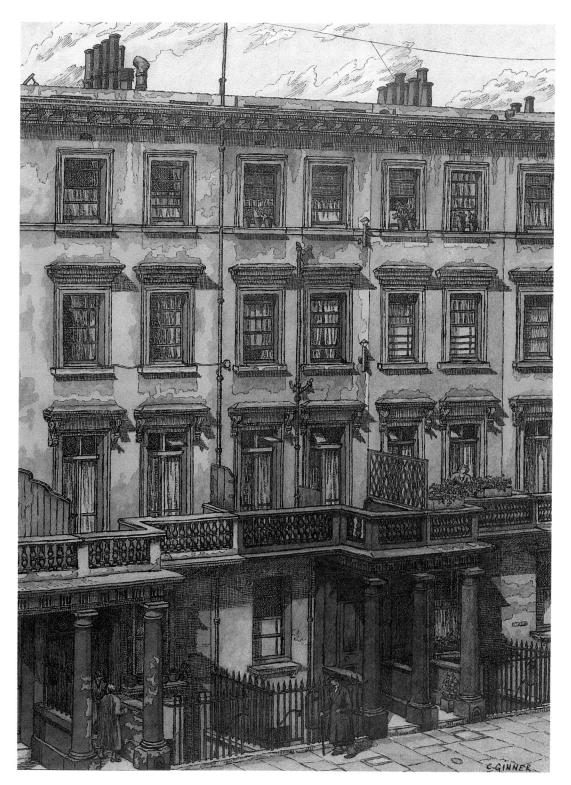

Street Scene
CHARLES GINNER ARA RWS (1878-1952)
Watercolour and pen and ink
14⅝ × 10⅝ ins

Ginner's richly handled terrace is full of interest. He has used his personal handwriting to delineate the architectural elements and to describe the patches of damaged stucco. This manner also creates an abstract pattern across the surface of the sheet.

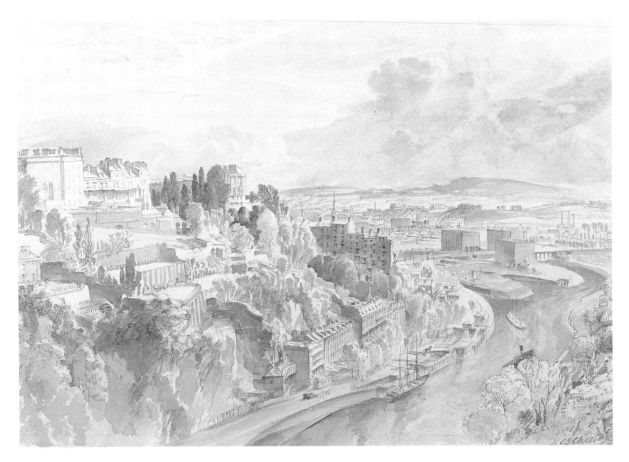

A Bend in the Avon, Bristol
CHARLES CHESTON RWS (1882-1960)
Watercolour and ink over graphite
$10\frac{5}{8} \times 14\frac{7}{8}$ ins

In this illustration we can appreciate the largely monochromatic nature of this work. As an exercise in tonal painting, the picture is most successful in its clear, yet atmospheric description of the panorama.

the building in preference to making capital out of the strangely dislocated revelation of interior decoration that we have all seen during such demolition work.

It should be noted that there is no obvious social comment being made in this picture; indeed its title projects an objective appraisal of the scene. If there is any meaning beyond the artist's aesthetic interest in his subject, it has to be interpreted by the observer. There is certainly no great evidence of such comment in the artist's *oeuvre*. Born in 1893, Squirrell studied at the Ipswich School of Art and at the Slade, where he too was affected by Steer and that influential artist and teacher, Henry Tonks. He was elected ARWS in 1935 and RWS in 1941. Squirrell exhibited regularly with the Society until his death in 1979.

A more recent loss to the RWS has been H. Andrew Freeth, who died in 1986. Best known in his later years as an exceptional portrait painter of the famous, including W. Somerset Maugham and several prominent politicians, Freeth's reputation was established in the 1930s upon the remarkable draughtsmanship apparent in his etchings of figure subjects and land-

scapes. For their truth to the essential linear qualities of this graphic medium, some of these early prints are among the most exceptional works of art produced by a young British artist in this century.

Freeth was born in Birmingham in 1912 and trained at the city's College of Art, from which he won the Prix de Rome at a time when Royal College students were usually the recipients of this honour. Later in life, after being an Official War Artist, he took up watercolour painting seriously, and from his election as ARWS in 1948 and member in 1955, his freely brushed and sometimes quirky depictions of landscape and figure scenes graced the Society's exhibitions for thirty-nine years. Freeth was President of the RWS between 1974 and 1976, having been made ARA in 1955 and a full Academician in 1965.

The watercolour considered here is characteristic of Freeth's figure compositions in watercolour, using a loose, yet controlled, brush technique, overlaid with freely drawn ink outlines. This Diploma work is entitled *Grandma and the Boys in Trafalgar Square*, a subject also for one of his most popular aquatint prints. Selectively dampening the paper, the artist has in his inimitably effortless style used a combination of wet-in-wet and, mainly, wet-on-dry techniques to imbue the picture with a rich texture of pure watercolour. The sketchiness and immediacy of the execution give the work a particular charm and also a sense of reality that is just as convincing as the most 'photographic' portrayal could convey. Nuances of the washes describing the paving show it has recently rained. The wetness of these coloured reflections is made visually convincing by the descriptive application of dabs of paint below the figures and pigeons in the foreground.

In its relation to our present theme, Freeth's watercolour can be appreciated as depicting recreation amid the hubbub of a capital city. Central London contains many landmarks of great touristic attraction, among them this busy square. Many of the city's Georgian squares were designed at one fell swoop and their proportions are a joy to behold. Trafalgar Square, however, has been built up in piecemeal fashion during the last three centuries. Its disassociated elements are as taxing to the eye as they have been for the architects who have struggled to find, in their plans for a new extension to the National Gallery a fitting echo in the Square's north-west corner to the spire of James Gibbs' church of St Martin-in-the-Fields. But Trafalgar Square, with its central homage to Lord Nelson's achievements in the Napoleonic Wars, is a public place of international fame and affection. It is also a daytime centre of attraction for

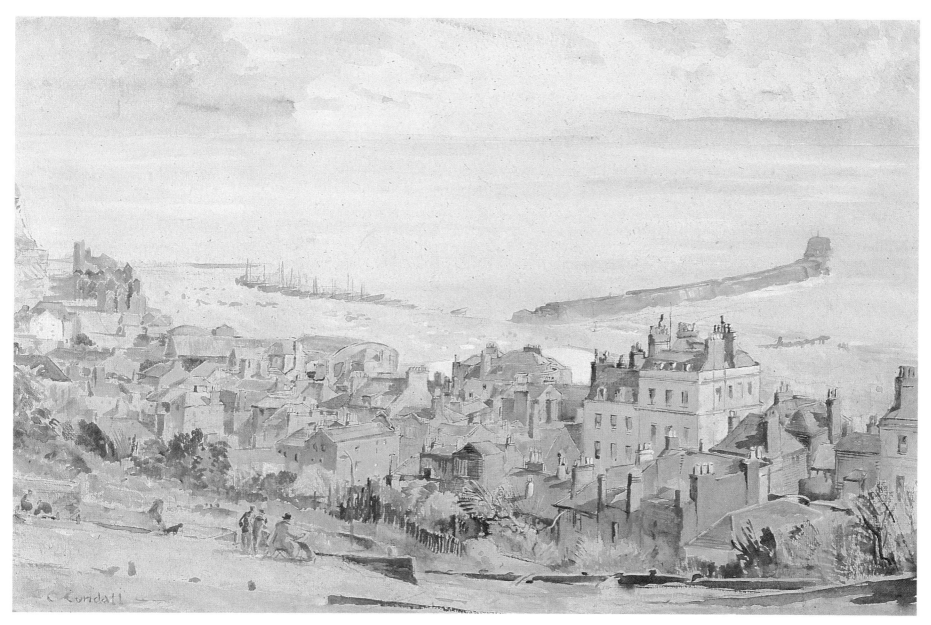

The Old Town, Hastings
CHARLES CUNDALL RA RWS (1890-1971)
Bodycolour and black chalk on buff paper
13 × 19¼ ins

The fine use of bodycolour, or gouache, in this work cannot perhaps be totally appreciated in reproduction, although this illustration does show how Cundall has handled the medium in a variety of ways. For example, we might compare the application of thick bodycolour to highlight some of the buildings with the thinner washes used for the sky. In both instances, the artist is creating the lights on the buff paper.

The Last Phase: Demolition at Ipswich (*Detail*)
LEONARD SQUIRRELL RWS

In this life-size detail of the full width of Squirrell's work, we have the opportunity to take in the rhythms of rich patterning which form the principal pictorial interest. On the right-hand page we might particularly note the complex of half-destroyed rooms set next to a long and relatively unrelieved area of internal wall, with the jagged and angled roofing timbers above set off against these rectangular shapes. In the foreground the artist has dragged his brush across the rough paper, thus creating an interesting texture.

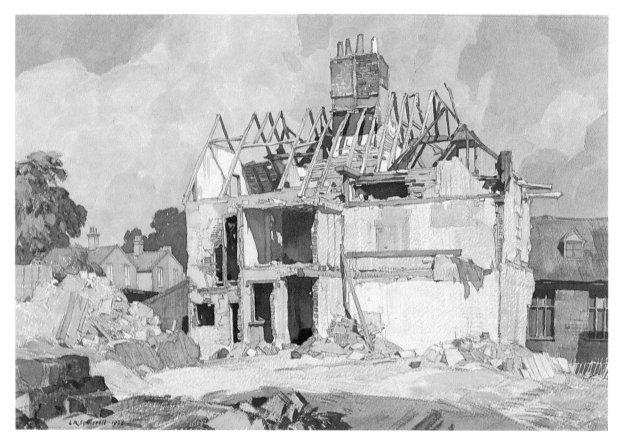

The Last Phase: Demolition at Ipswich
LEONARD SQUIRRELL RWS (1893-1979)
Watercolour, bodycolour and graphite
10⅝ × 15⅜ ins

This illustration of the whole of the composition reveals how the shapes Squirrell has delineated relate to each other over the entire picture area. The influence of his fellow East Anglian watercolourist, John Sell Cotman, is quite evident in the way Squirrell constructs the design, as it is in his handling of the medium.

London's pigeon population, who may hold a lowly place in the hearts of residents, but are well looked after by visitors, including Grandma and the boys.

From London we travel back to where we started in this chapter, the Welsh mountains, and Jane Carpanini's *Backyards, Llanberis*. Jane and her husband David, a painter and printmaker, have their home in this town in the foothills of Wales' highest and grandest mountain, Snowdon. Made in 1978, exactly 150 years after David Cox's *Welsh Village*, Carpanini's painting of her urban environment is very obviously contemporary in style and subject. But still there is a timelessly rugged quality to the terraces which cling to the hillsides in this often inhospitable climate.

However far communications, science and welfare have taken urban development over the passage of time between the production of these two watercolours, as a rule the urban scene is still moulded by the natural environment in which it exists. Thus, in Cheston's Bristol, we can see the influence of the river; in Cundall's Hastings the effect of the proximity to the sea. In Jane Carpanini's Llanberis, the ruggedness of the surrounding landscape is only hinted at in the distant vista, but the solid and matter-of-fact architecture emphasises the harshness of the setting. So too does her unromantically straightforward technique. She paints in a manner that is disarmingly close to how we believe we look at the world. Disarming, because her style is so uncontrived that, like early nineteenth-century collectors of Cox's watercolours, we observers are confronted by the reality of the portrayal of the scene. Although we have not been there at her shoulder when she painted this work, we are convinced by its verisimilitude, and pleased by our unexpected involvement in a domestic scene.

It is the family washing hanging on the line that is central to the artist's composition and her dry-brush technique most attractively captures the late afternoon light on the fabrics. The effects of sunlight are nicely understated and not used in gratuitous contrast to the darker passages of shadow. Indeed the tonal changes through the picture are very subtly handled, notably in the right foreground details.

Carpanini was born in 1949 and her art training took place at Luton and Brighton. She has had one-woman exhibitions organised by the Welsh Arts Council and the National Museum of Wales. Elected ARWS in 1978, she became a member in 1983, in which year the office of Honorary Treasurer was entrusted to her.

Current members of the RWS who regularly portray cities, towns and villages include such notable exponents as Dennis Roxby Bott, Dennis Flanders and Charlotte Halliday. It is a pleasure, however, to end this chapter with Jane Carpanini's Diploma work. She is a young artist prepared to confront seemingly unprepossessing and humble corners of contemporary towns and discover in them an aesthetic satisfaction that many artists of lesser stature would find difficult to recognise or emulate.

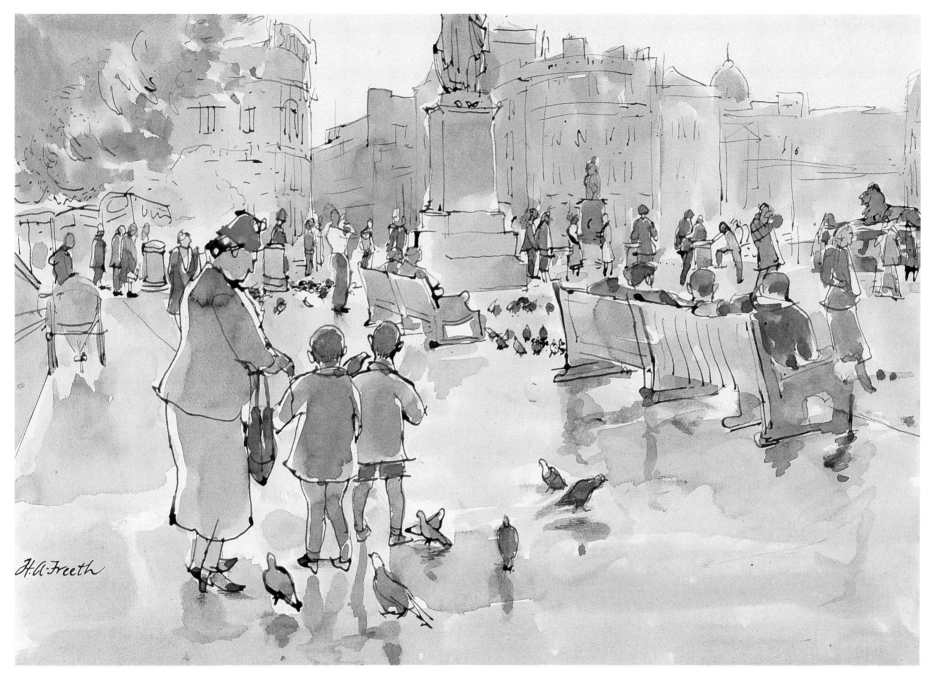

Grandma and the Boys in Trafalgar Square
H. ANDREW FREETH RA RWS (1912-86)
Watercolour and pen and ink
$10\frac{3}{8} \times 13\frac{7}{8}$ ins

In this reproduction we may easily appreciate the freedom of Freeth's mid and late-period technique. There is apparently no initial pencil design and the linear construction is largely applied after the watercolour dabs and washes, with a pen and brown ink.

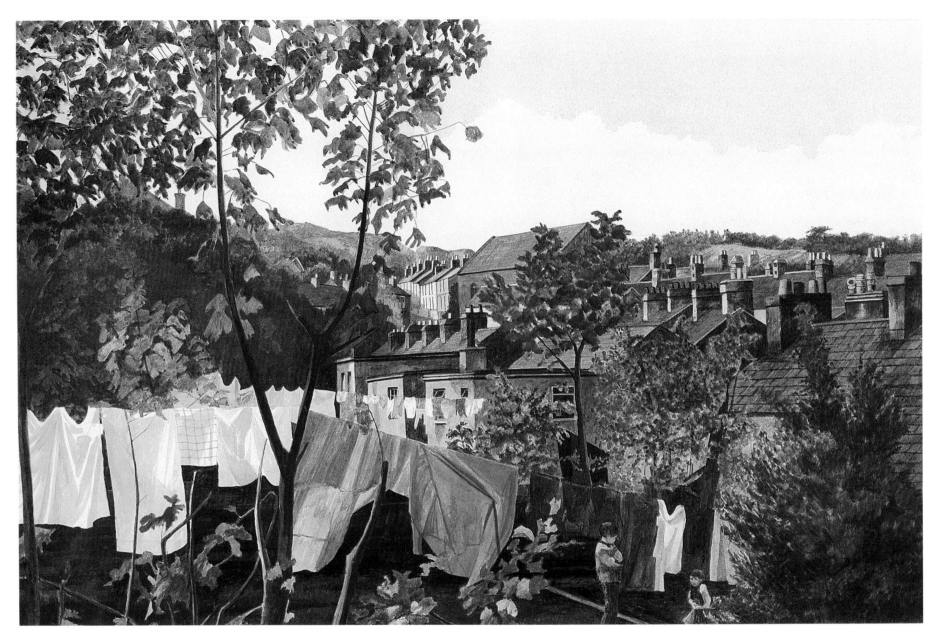

Backyards, Llanberis
JANE CARPANINI RWS (b 1949)
Watercolour over graphite
18 × 24¾ ins

Carpanini lets the brilliance of the white paper do much of
the work in this otherwise dark watercolour. The washing
and other colourful elements of the design are directly
contrasted with the deep overall tonality of this urban
Welsh scene.

140

THE WORKING LIFE

We have delighted in the watercolourists' revelations of the environment in which we and our ancestors have lived. We have seen how the fundamental topographical and figurative tradition of the art form has been preserved and often rekindled over the years. Because of obvious restrictions of space, it has only been possible to survey relatively few subject themes in this book. If, however, we could stretch our imaginations to conceive of the whole body of watercolours recording the varied face of Britain over a period of some 250 years, the resulting archive of available information may be described as a document truly national in its scope.

Many of the pictures we have seen and enjoyed, whether set in the countryside, on waterways, by the coast or in the town, have revealed the hand of man at work. Be it through agriculture, industry, or building work, our habitable surroundings have been changed and changed again by mankind's endeavours to progress, to feed itself and to earn a living. This has all been achieved by labour. In some of the watercolours that have been discussed we have noted the presence of labouring figures. But these people are not the only ones productively going about their business in the scene, for the painter himself is also doing a job of work.

We describe pictures as 'works' and they are indeed the produce of work. In producing a painting, the professional artist is carrying out his trade. He also undertakes a considerable amount of mental and physical effort that does not begin or end during the time it takes to produce the finished painting. The identification of the artist with workers in other trades is an ethos which arose in nineteenth-century thought and of course the great watercolourists of the early years of that century can be closely associated with the Romantic movement that itself made such a conception possible. A romantic, with a small 'r', view of the painter dallying in his art solely to express his emotional reaction to subject matter is, however, liable to lead to a misconception of professional artistic practice. Just like any other worker, the painter has to pay his way through life and any idea that most successful or great artists in history have not to some extent been commercially minded would be erroneous.

From the Italian Renaissance to the Moderns, artists have had to haggle over the just price for commissions, and from Leonardo to Russell Flint they have created more than one, and sometimes multiple versions of successful compositions. The painter pursues a trade and it is often a nine-to-five one, like any other job. There have been relatively few serious artists who have been able to produce good art only as the inspiration strikes or the whim takes them.

And of course being a painter is not just a matter of applying brush to paper or canvas. Besides all the artistic preparatory work involved, there is the proper preparation of materials – such as stretching watercolour paper – and probably some fieldwork to be done. After the event there is the mounting and framing, something many professional artists undertake themselves, and then the often complex and arduous journey that ends on the walls of a gallery. Even after all this there is of course no guaranteed sale to reward the painter for his labour and expense. Thus there is surely a natural empathy for the artist with those who toil in other professions and jobs, intellectual or manual.

In this chapter we shall concentrate on depictions of people at work, in a wide range of jobs, from a shepherd to circus artistes, from a stonebreaker to a greengrocer. First, however, let us go closer into a watercolour already described in an earlier chapter. This is William Havell's *Distant View of Eton*, which, despite its title, the reader may recall, features Windsor Castle. The detail reproduced here concentrates on the right foreground and the river bank. Two figures walk away along the river path, leaving behind a stooping man at work beside a large coil of rope. His labour is in fact the mending of eel traps. We can guess that he has arrived with his dog, shed his blue coat and taken some twine or osiers from his basket to rebind the end of one of his traps.

Such eel traps provided interestingly picturesque additions to depictions of riverbank scenery. We have already seen that such subjects have been popular with watercolourists and a number of artists of Havell's period also featured traps in their pictures. DeWint and Turner of Oxford, both artists fascinated by the minutiae of river life, produced watercolours entitled *Eel traps*. Havell seems more interested in the process of work involved in their maintenance, together with the paraphernalia associated with the man's activities, than in the interesting shapes of the partially obscured traps.

Another artist we have come across previously is W. H. Hunt, colloquially known as 'Birds Nest' Hunt. The work under consideration here dates from before the period of the still lifes that resulted in this nickname and could not be further removed in image or sentiment from the delightful *Jug with Rose* we examined in detail earlier on. *The Stonebreaker*, another Hunt from the Parsons Bequest, is dated 1833 and is a most interesting example of the artist's figure work of the time.

Five years before, Hunt had painted a watercolour of a labourer holding a hod with two bricks, but no other equally serious portrait of adult labour is recorded in Sir John Witt's admittedly incomplete catalogue of his *oeuvre*. Several of his figure pieces feature children carrying out jobs of work, but these are usually to be read as rather contrived pictures of the child playing the grown-up, rather than as observation or critique of child labour. Watercolours intended for the latter purpose would not have been much appreciated or even understood by the art-buying public and nor indeed were such straightforward statements about honest manual labour as *The Stonebreaker* exactly common fare at the time.

The man is elderly, wearied perhaps, but unbowed by his work. He is observed with a touch of sympathy by Hunt, who has not however sentimentalised his subject. The simple pose and upright stance enhance the dignity of the man and of the manual task itself, and the whole is seen with poignant objectivity. This striking watercolour has a little niche for itself in the history of nineteenth-century British art. Two Pre-Raphaelite painters, John Brett and Henry Wallis both chose the subject of the stonebreaker for important oil paintings, following the example laid down by Landseer and Hunt himself. In both pictures, painted some two and a half decades after the Hunt watercolour, the subject was the vehicle for comment on the harmful impact on working people of the harsh labours it was felt were unjustly imposed on them by society.

Stonebreakers were employed under the much criticised Poor Laws system and were a common enough sight in rural areas, breaking stones for road repair. In the middle of the century, they had come to be understood by socially conscious sections of the

Distant View of Eton (Winchester Tower, Windsor Castle) (*Detail*)
WILLIAM HAVELL OWS

Here we can study the artist's portrayal of a man at work on his eel traps. Considerably larger than life size, this detail reveals Havell's extensive use of scratching out. While it has suffered to some extent from surface rubbing over the years, due to the artist's uneven laying down of the sheet onto a grey mounting card, the picture's textural interest is in large part owed to often minute scrapings of the paper and the addition of chinese white highlighting.

The Stonebreaker
WILLIAM HENRY HUNT OWS (1790-1864)
Watercolour over graphite, with scratching out
13¾ × 9½ ins

Although rather faded and consequently warm in colour, it is unlikely that this harsh subject would have been portrayed in lush pastoral hues. This illustration allows us to appreciate the full dignity of the stonebreaker and to observe the dexterity of Hunt's middle period dry-brush manner at its best.

public as symbolic victims of the despised Laws. As critiques of human injustice, as well as for their artistic qualities, these two paintings by Brett and Wallis are regarded as crucial expressions of the shared social conscience which was an important element of the Pre-Raphaelite ideal. Such empathy with the conditions of labour had not previously featured highly in British art.

While we have already remarked that Hunt's intricate still life style was a precursor of Pre-Raphaelitism, it is interesting here to note that he had also treated a famous Pre-Raphaelite subject with a sympathetic eye befitting the political concepts of his successors. It is unlikely that Hunt's *Stonebreaker* was known to either Pre-Raphaelite. Wallis, whose picture in the Birmingham City Art Gallery is one of the most moving of its age, may however have seen in Paris a picture of a similar subject by the great French realist painter, Gustave Courbet. Wallis was himself a member of the RWS, joining as an associate in 1878, twenty years after his stonebreaker picture was first exhibited.

The present watercolour has been considerably affected by exposure to light. Losing its fugitive blues, the effect on the picture's colour range has been to make it very warm, with browns, yellows and reds dominant. This fact nonetheless does not mar our enjoyment of Hunt's fine watercolour technique. Unlike in the later still lifes, this is a manner of pure watercolour brushed in not with freedom, but certainly with a looser touch than the almost stippled technique employed later in the *Jug with Rose*. There is quite extensive scratching out, adding texture to the man's skin, hat, coat and gaiters, highlighting the long handle of his hammer and picking out wisps of his white hair. Despite the fading it is unlikely that the landscape setting was ever more than a simple backdrop, for it is the man and his labour which are the artist's concern.

It may appear almost paradoxical to refer again to Samuel Palmer's lyrical *Shady Quiet* in the context of a chapter based on the theme of labour, but work of a kind is in fact going on. *Shady Quiet* concerns this chapter's theme inasmuch as it postulates a view of work diametrically opposed to that portrayed in *The Stonebreaker*.

Like Palmer's shepherd, the stonebreaker is involved in a task that utilises natural resources for the ultimate benefit of mankind, but in his case at such a cost to his own well-being that it is barely justifiable. His harsh job is in contrast to the fundamental message of Palmer's art, which demonstrates how the toil of man could be in harmony with his surroundings, providing a satisfying quality of life through direct contact with the essential beauty of nature. The ploughmen of his early visionary paintings, made in the Shoreham Valley of Kent, carry out a labour of love for the landscape and are so deeply rooted in their agricultural habitat that they can be understood as being at one with nature. So too is this shepherd absorbed in the life of the land. Unlike the stonebreaker, however, his job of work is surely not destructive to him or to nature. The stonebreaker is given a mere backdrop of a landscape by Hunt, whereas the shepherd is surrounded by luscious vistas of the landscape. This difference is surely indicative of the relative abilities of the two men's toil to allow them to enjoy their surroundings.

As his flock seeks shade from the sun, under the spreading branches, so too can the shepherd relax and enjoy the beauty of this English day. But by his presence he is fulfilling his duties and exemplifying Palmer's belief in a harmonious junction between toil and the land. We can see that it is the woman bearing a pitcher on her head who is doing the physical work at the moment, presumably bringing water to replenish the goblet from which the child drinks. The sheep dog is alert to her imminent arrival.

It is worth lingering over this detailed illustration for a few moments longer, to enjoy the idiosyncratic and intense technique of Palmer. Like all great painters – a word used here to describe artists who manipulate paint for aesthetic effect – he makes every brushmark work and count towards the overall meaning of the picture. The strange, calligraphic quality of these marks is fitting to Palmer's personalised view of nature and natural form. There were other painters and printmakers of his Shoreham circle who developed similarly individual, graphic handling, but few whose approach is so natural and honest in every detail as this artist's.

Dwell for a while on the lovingly treated motifs, such as the carefully rendered figure group and the characteristically 'blotchy' handling of the sheep. Palmer wished to convey the sanctity of his subject through an almost icon-like preciousness of technique. Although it does not easily reproduce in illustration, there is some use of gold leaf, for example on the rim of the man's hat and the goblet he proffers to the child, as well as in the foliage of the trees.

Doing his intriguing job in Sidney Curnow Vosper's strange and intense Diploma work is a man described in the picture's title as *The Weaver*. This title may well have been allocated in recent times, for the

Shady Quiet (*Detail*)
SAMUEL PALMER RWS

Over twice life size, this detail of Palmer's watercolour depicts the work element of a profoundly considered portrayal of human involvement in the natural world. It also presents the opportunity to study closely the delightful foreground figure group and of course the artist's wholly individualistic technique.

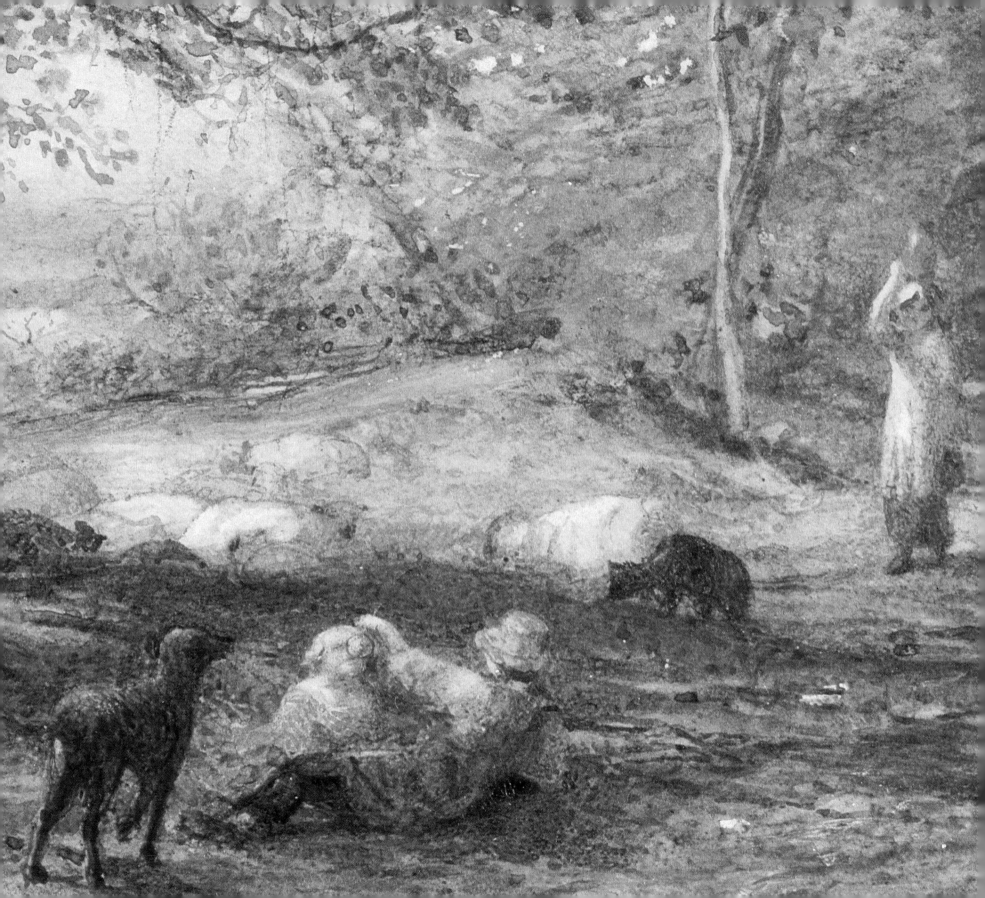

The Weaver
SIDNEY CURNOW VOSPER RWS (1866-1942)
Watercolour and bodycolour, with stopping and
scratching out
11⅞ × 10⅜ ins

Vosper's worker is in fact a rope-maker, in isolated and
darkened surroundings. This rather mysterious painting
invites our close attention and the compositional and
technical emphasis on the various vessels, as opposed to
the man himself, is to be noted.

process depicted would appear to be rope-making.
From an assorted collection of vessels placed on the
floor, strands of hemp or flax are pulled upwards
through an implement which the rope-maker rotates
to get the threads to bind together in a stronger,
thicker strand. He walks backwards and forwards be-
side the wall, lodging the twine onto hooks as he goes.
A second process will then weave these strands
together into a sturdy rope.

Wearing the clogs traditional to this kind of trade,
the man looks towards the bowls, pans and baskets
which prevent the balls of twine from moving around
too much as they unravel, thus keeping the strands
free from tangle. Vosper's splendidly precise handling
of these keenly observed vessels means that they are
the most highly finished elements of the picture. He
has taken great pleasure in the assortment of forms
and colours. The slight variations of angle at which
they sit is carefully recorded and the interrelationship
of shapes is most satisfyingly described.

Vosper has used tiny dabs of chinese white to
heighten the clogs, but otherwise the depiction is
achieved with watercolour and occasional use of
scratching out – the threads for example – and stop-
ping out for lights on the bowls. It is his consummate
technique with a thin brush which has enabled the
artist to convey the differing characters and textures of
these vessels. This area of the floor is where the
lamplight, for it cannot be sunlight, falls most brightly
and the darker and less important areas of the
watercolour are appropriately brushed in with a
broader and less defined technique.

This picture was described above as strange and
intense. The steep perspective, with the vanishing
point way over to the upper right and the well captured
flatness of the artificial light are two contributants to
the peculiar feeling the artist gives to his subject.
Perhaps it also appears odd that the, to us, interest-
ingly attired rope-maker at his labour is paid less

attention than the inanimate receptacles that Vosper has so lovingly portrayed. However, the results are most effective. The artist must have been pleased with his own labours, for at least one other version of this picture exists.

Vosper's career spanned a fair proportion of the late nineteenth century and much of the first half of the twentieth, until his death in 1942. Born in 1866, he started work in an architect's office, but went to Paris in 1888 to study painting. He later lived in Brittany, where he depicted the lives of local people, often in nocturnal genre pictures, and it may well be there that his Diploma work is set. After a time in London, he returned to France during World War I to serve in the Red Cross. Vosper was elected an associate of the RWS in 1906 and reached membership in 1914, which may be the date of this Diploma watercolour.

Laura Knight's workers in her Diploma piece are in the entertainment industry. They are circus performers getting ready in *The Girls' Dressing Wagon*. Knight liked to paint her many watercolour studies of circus scenery directly from the subject and the rapid execution of this fairly sizeable picture might suggest that it is no exception to this preference. One imagines a horse-drawn waggon, in which the painter, familiar to her subjects, has been accorded space to work behind the scenes, to paint the backstage of this nomadic life. Many of her more finished exhibition pictures in oil and watercolour portray the performances on the other side of the curtain, or rather, in this case, in the ring.

After World War I, Knight travelled widely painting scenes in the lives of gypsies, circus entertainers and dancers. She was especially interested in women at work and her World War II paintings of women engaged in the manufacture of armaments reveal her crusading interest in female contributions in the

The Weaver (*Detail*)
SIDNEY CURNOW VOSPER RWS

This almost surprisingly beautiful rendition of an odd assortment of containers for the rope-maker's strands of flax or hemp is illustrated considerably larger than its original size. Vosper's painstaking, but never slavish handling, holds up admirably under such scrutiny. The interest the artist has taken in these details of his work means that the jauntily arranged composition of vessels could be a picture in its own right. Note the scratching out of the strands of rope.

The Girls' Dressing Wagon (*Detail*)
DAME LAURA KNIGHT RA RWS

Slightly under life size, this detail of making-up activity in the dressing wagon shows quite clearly the artist's economical but telling employment of watercolour and chalk. Knight has allowed the paper itself to create the principal areas of light, contrasting as they do with the dark recesses of the wagon, and on top of these she has briskly drawn and painted the necessary outlines of figures and their clothing.

The Girls' Dressing Wagon
DAME LAURA KNIGHT RA RWS (1877-1970)
Watercolour and chalk
20½ × 13½ ins

Knight's rapid execution of this picture belies the thoughtfulness of the composition. It is an attractive and objective study of a subject the artist knew well and painted very often.

149

work-place. Knight was born in 1877 and studied art in Nottingham, where the Castle Museum now houses a fine collection of her pictures. She was made ARWS in 1909. Following her commission to paint non-combat army activity in 1916, she became ARA in 1927, RWS the following year and an Academician in 1936.

Knight's Diploma work is painted with gusto in a dry-brush technique, as befits an artist working on the spot. Elements of the subject are simplified in a way that reveals her involvement with the Modern movement. But her interest in the abstract shapes and colours of the scene does not override consideration of the individual actions of the women preparing themselves for the performance to come. Each figure is well judged and characterised; even the motions of the sketched-in clown at the back are clearly described. This expressive and enjoyable watercolour was selected to represent the artist in the British Council Exhibition that toured China in 1982.

From women to men at work – boatbuilding in fact – in Sidney Lee's Diploma work. This painting could have easily fitted into our earlier chapter about artists' portrayals of sea and coastal life. The construction of sea-going ships and boats was, until fairly recent times, one of the most important and successful of Britain's manufacturing industries. It was also essential to the development of the nation's mercantile base and a provider of mass employment. This picture is about labour in more ways than one, for taking the form of a working drawing rather than a finished painting, it reveals the artist's own struggle to develop the composition to some kind of satisfactory conclusion. Lee shows no mercy for his materials as he creases and rubs the paper, blotches oil paint onto watercolour and continually manoeuvres elements of his design. There is nothing novel about such constant reworking of the composition while the picture-making is in progress; indeed this was a common practice of the Renaissance masters.

Because this picture so interestingly shows the artist's working processes a double-page detail has been reproduced which enables us to examine the technical development of the work. Generally painted in bodycolour of varying thicknesses, but with extensive use of black ink outlines and pencil, *Boatbuilding* is far removed from the nominal conception of the necessary purity of the ingredients of a watercolour that it is hoped has already been dispelled in this book. There is indeed here an unusual addition to the recipe: dabs of oil paint which, with similar applications of bodycolour, are used to enrich the texture of surfaces,

such as the walls of the buildings.

In this picture, Lee has not been aiming for representational 'truth' to the outward appearance of the world: notice for example the stylised and bright mauve plume of smoke. Nor has he sought topographical accuracy. The scene could be in any coastal boatbuilding yard and it is in fact the activity which interests him. Lee is therefore quite prepared to manipulate his subject as he progresses with the work to produce the composition he wants. We can spot that he has, for example, removed two figures originally standing on the wooden scaffold, this side of the skeletal hull. When through time, the original uncorrected passages become visible to the naked eye, these are known as *pentimenti*. More commonly occuring in mediums where reworking of this kind is feasible, *pentimenti* are rarely to be seen in watercolours except when, as here, opaque paints have been used. Other examples appear to the bottom right of the same boat, where a red paint has been overlaid, and elsewhere in the picture.

Other instances of the artist changing his mind are the pencilled-in but uncoloured outline of a building behind the roof tops to the left, and an almost indecipherable passage at the far right end of the main building, on which the chimney stacks have been led a merry dance around the roof slates in the search for their proper positioning within the composition. The picture is by no means fully resolved, but as perhaps a study for a more finished work, it provides an educative insight into the artist's working methods. Much of the feeling of industry going on results directly from the vigour of these methods.

Born in 1866, Sidney Lee trained at the Manchester School of Art and then in Paris. His travels throughout Europe brought him into contact with contemporary developments in art, and Modernism was influential upon his work. Having been elected an Academician in 1930, he became ARWS in 1942 and RWS in 1945, four years before his death.

Our next two subjects both feature a woman at work. Robert Sargent Austin's wife was probably the model for his excellent, subtly painted Diploma work *Dressmaking*. Austin's immense natural talent as a draughtsman is manifest in this work, and it was as one of the most brilliant young engravers of our century that he started his career and is most renowned today.

Born in 1895, Austin studied under Sir Frank Short at the Royal College of Art. His abilities as a designer and engraver later led him to be employed by the Bank of England as its principal designer of

banknotes. From 1962 to 1970 he was President of the Royal Society of Painter-Etchers and Engravers. Fittingly, his immediate successor at the Bank as artist-designer, Harry Eccleston, also attained the office of President of the Painter-Etchers. Eccleston like Austin, under whom he studied at the Royal College, is also a fine painter in watercolour and a distinguished member of the RWS. Now retired from his position at the Bank, he was responsible for the design of the current series of British banknotes. In a sense he can be described as the country's most widely known printmaker, as Austin was before him.

Although he started his career as a watercolourist relatively slowly, Austin became ARWS in 1930, and a full member of the Society four years after. Later in life his attention turned more and more from engraving to painting, as the fine precision demanded by his intricate engraving style grew to be beyond his powers of manual dexterity. He was the only holder of both the Painter-Etchers and RWS Presidency, the latter office lasting from 1957 to his death in 1973.

Dressmaking is a quiet and unassuming picture, whose sophisticated composition and subtle use of a very restricted colour scale impress and reward one the more it is studied. The almost abstract tonal design, with its cut-off elements such as the lefthand window, and with the steeply raked floorboards, puts one in mind of the paintings and pastels of the French artist Edgar Degas, whose revolutionary compositions had considerable influence on English figure painters.

Despite the obviously intimate presence of the painter in Degas's well known domestic scenes, such as the pastels of women bathing, the observer is rarely provoked to feel there is any great sense of attachment to his models or the vicissitudes of their lives. These great works in fact carry a sense of total emotional detachment and the figure, who usually is portrayed acting as though the artist is not present, is treated as a formal component of the overall compositional scheme. Austin's model, her feet almost gauchely pointed inwards, is absorbed in her task and touchingly unaware of the artist's presence. Her face is hidden by hair and the consequent anonymity emphasises the objectivity of the portrayal. Even if she is the artist's wife, this is a business rather than a domestic scene, perhaps a workshop rather than a family house. The simplicity of the young woman's clothes, contrasting with the finery of what may be a ballgown, on which she is working, serves to reinforce the sense of honest work being done.

The attractive surface textures, which with slight modulations of colour and tone serve to animate the

Boatbuilding
SIDNEY LEE RWS (1866-1949)
Bodycolour over graphite, with touches of oil paint
12½ × 17⅛ ins

In this reproduction we are offered the opportunity to assimilate the overall composition of Lee's much altered Diploma work. Whether it is a truly finished work is a matter for conjecture and we might consider this matter further when examining the following detail.

flat picture plane that Austin presents, are made up of many small, dry brush-strokes on a slightly damp wash. There are a very few traces of chinese white here and there in the picture, but no real reliance on anything but the artist's confident handling of the watercolour brush. Despite the use of a narrow colour scale of greys, browns and mauves, Austin's watercolour is by no means grey in its character. Nor is Lionel Bulmer's *Study for Greengrocer*, his Diploma picture, in which the controlled employment of shades of grey watercolour provide an extremely broad range of what one might call 'tonal colour' across the surface of the paper.

Like Austin, Bulmer is interested in the interplay of shapes across a flat picture plane. As have some of history's best practitioners of monochrome media, be it in drawing or printmaking, he makes black and grey describe colour with considerable effect. By saying this, it is meant that some artists are able to suggest the individual colour values of objects through the varied character of tone itself. Rembrandt did so in his etch-

ings, and so did Turner and Girtin in some of their youthful wash drawings. It is in the context of the work of the early draughtsmen and watercolourists that Bulmer's Diploma work may be viewed, despite taking into account the modernity of the stylistic influences on his art.

This pen and wash drawing was produced in 1954, at a time when the painters of the somewhat disparingly named 'Kitchen Sink School' were combining an interest in abstraction with the wish to represent the fabric of humdrum everyday life. Bulmer was alive to these preoccupations and the resigned boredom of his greengrocer is symptomatic of a time when post-war depression and rationing still haunted day-to-day existence for a significant proportion of the population of Britain.

Bulmer's touch is very light and the careful delicacy of his technique avoids the stolidness of some of the productions of the 'Kitchen Sink' painters. Whereas that laudable artist, William Scott, concentrated his attention on the bulky presence of pots and pans,

OVERLEAF
Boatbuilding (*Detail*)
SIDNEY LEE RWS

This detail encompasses the full width of 'Boatbuilding' and represents it approximately twice life size. Although in a reproduction it is difficult fully to understand the full range of Lee's experiments with the varied mediums he has used, we are certainly able to see how this experimental attitude has extended to a number of elements of the composition, such as, for example, the positions of the boatbuilders.

Dressmaking (*Detail*)
ROBERT AUSTIN AR PRWS

In this near-life-size detail of the dressmaker, we are able to examine more closely Austin's fine draughtsmanship and technique.

Dressmaking
ROBERT AUSTIN RA PRWS (1895-1973)
Watercolour and bodycolour
15 × 18 ins

The tonal changes over the picture area and the extremely subtle colour range are particular pleasures that we can appreciate in this illustration. The use of the paper's natural whiteness for the lights is both a discreet and harmonising influence on the composition.

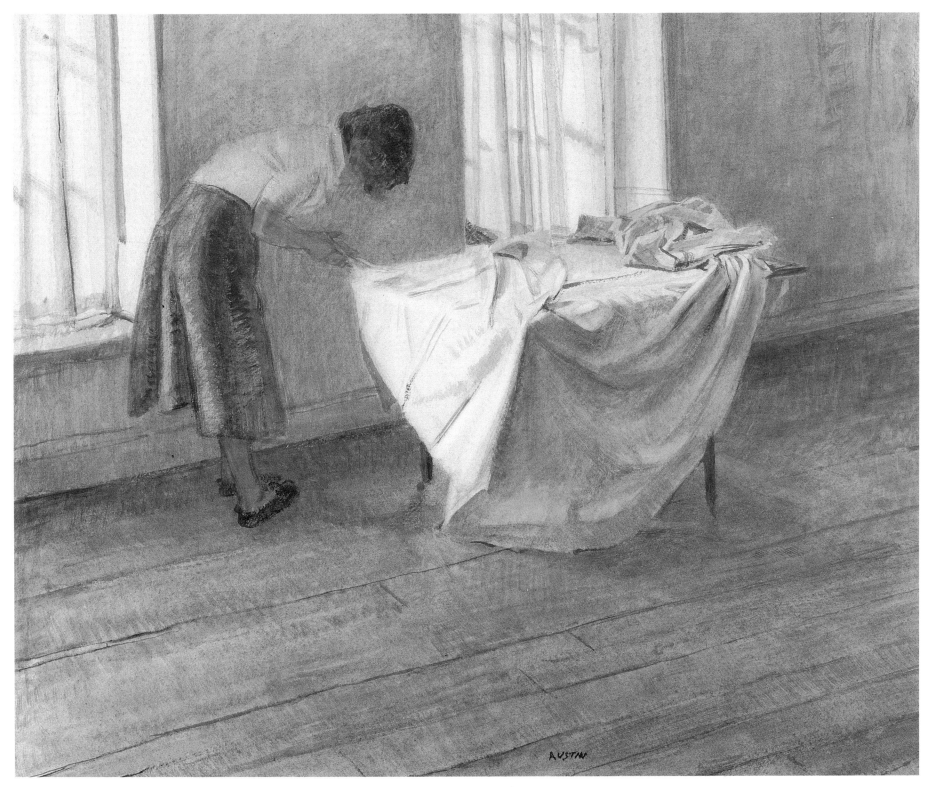

abstracting them in a manner that would have been inconceivable for Sidney Vosper, Bulmer, by comparison, flits across the surfaces of objects, describing them in neat and sensitive pen lines as he goes. Within this essentially formal study of the shapes and tones of things, we are confronted by a human being, who, unlike Austin's dressmaker, stares straight at the viewer. She is awaiting custom for her shop and, arms folded, maintains a formidable presence within the picture.

Bulmer was born in London in 1919, but not elected an associate of the Society until his fortieth year. Although made a member in 1974, his watercolours have only irregularly been seen at RWS exhibitions – an unfortunate fact when such a brilliantly talented artist is concerned.

The last painter to be featured in this chapter is most certainly a Society man. The doyen of the RWS at the age of ninety-eight, Roland Batchelor's contribution as artist and as long-serving Trustee has been magnificent. Described by Patricia Jarrett in her biography as the modern Rowlandson, Batchelor is among the best loved contemporary exponents of the art of watercolour. What he shares with Thomas Rowlandson is the ability to invent or comment upon characters, without actually descending to the level of caricature. The freshness of his watercolour technique, together with his picture-making ability, is always present in even his wittiest and most comically inspired compositions.

Born in 1889, Batchelor did not come to the Society until 1957, when he was elected an associate. Adrian Bury, that distinguished Laureate of the RWS, has written how at this time '. . . the Society needed a figure artist who could improvise on human character with scholarly knowledge of form and feature and not in a slick, facile or pseudo-infantile manner'. Bury was right, for Batchelor has over three decades made a substantial contribution to the spring and autumn exhibitions. Such has been the character of this contribution that in 1987 the RWS paid tribute to the artist with a retrospective exhibition of over one hundred of his watercolours and drawings.

In the same article in the volume of the Old Water-Colour Society's Club for 1966, the year in which the artist was made a full member, Adrian Bury goes on to write that 'Roland Batchelor is not a funny man with a cliché, a servile, automatic pen, but an acute commentator on the *Comedie Humaine*. The French words are not inappropriate, for much of his work has been done in France, his second home.'

Batchelor was indeed in France as a boy before World War I, during which he also fought in that country. He went on to study at Putney Art School under the pen draughtsman, George Morrow, and later with those fine exponents of line, Harry Watson and William Robbins. This important training for his future style was largely undertaken in the evenings, after a day's work as an officer in the Customs section of the Civil Service.

Batchelor's style and subject matter rely on a quick-witted appreciation of human activity that he has come across on his many travels with the pen and brush, in Britain and France. As he once wrote in *The Artist* magazine, the initial studies, rapidly produced on the spot, require 'absolute concentration, quick observation and a realisation of what is happening to the body . . .' This comprehension of the poise and movement of people is what gives to a 'Batchelor' its special human interest. His Diploma work, *Normandy Cattle Market*, depicts a subject not chosen for any notable comic element. This picture is amusing only by dint of the postures and physical characteristics of the participants. They are fulfilling their working life, and Batchelor does not make light of their activity. But they are seen with an unjaundiced wryness that is amusing but sympathetic.

Batchelor's inimitable technique of seemingly cavalier brushwork over dry paper, or dryish washes, is well shown here. On top of the pigments, he rapidly draws ink outlines, reworking these over the spread of the picture to obtain a suitably balanced overall effect. Such rapidity should not be mistaken as slap-handedness. If the result appears effortless, this fact is a compliment to the accumulated aesthetic and technical experience of the artist, which enables him to produce a finished work devoid of clumsiness or apparent indecision. As we noted earlier, the final execution of the painting is only one factor in the artistic process. Indeed a number of attempts may have been discarded before the realisation of the initial conception is achieved. No genuinely individual work of art can be resolved in a totally mechanical fashion and the way Batchelor builds up the marks on his sheet of paper evinces the progressive interplay of graphic and painterly touches that are the hallmark of many of the most inspired creative artists. It is worth noting how he reworks and enforces his black pen marks, drawing out characterising features of his subjects. Look, for example, at the heavily outlined footwear of the two foremost farmers and at the sturdy hind-quarters of the cow to the right of the picture, its gaze turned towards us and the intrigued dog. Each of these elements has been considered and reconsidered as the watercolour has progressed, with pen and brush strokes added and modified accordingly.

We referred above to the Pre-Raphaelite concept of the place of work within society. While Henry Wallis was painting his *Stonebreaker*, Ford Maddox Brown, one of the principal mentors of the young members of the Brotherhood, was involved in his magnum opus, *Work*. Set in Heath Street, Hampstead, this painting allies conceptions of the value of both manual and intellectual work by depicting the toil of road-menders in the presence of the great Victorian writer and theoretician, Thomas Carlyle.

The physically taxing task of mending roads makes us think once again of W. H. Hunt's watercolour of the stonebreaker and its anticipation of a prevalent mid-century concern for the rigours of such labour. This was not uniquely a consideration among the British, for in an admittedly less moralising and more painterly manner, the great French artist Edouard Manet depicted Parisian road-menders in a picture that in 1987 became one of the most expensive works of art ever sold at auction. For all its luscious beauty, this Manet is still a portrayal of people at work and its desirability shows how able a modern audience is to accept a once unpalatable theme, provided quality is paramount. Because of the lessons of Modernism and formal abstraction, we no longer tend to see subject matter as the overriding concern of art. Therefore we do not undergo the crises of conscience of the nineteenth-century public about possibly subversive issues being conveyed in pictures, in the way that Hunt's patrons might have felt about a work such as *The Stonebreaker*. But, like it or not, any art form which intends to convey serious ideas leads itself into sensitive areas of thought and belief, and conditions of work are inevitably prone to contention.

It may be that Wallis' *Stonebreaker* was intended as a pendant to an equally remarkable and less contentious painting of the death by suicide of the poet Chatterton. If so, again the message here is of the equation of intellectual and manual labour, and the rigours both activities can cause for the human frame. We should too bear in mind that the painter usually sees himself as a worker on both levels and is often keen to remind his viewers of this self assessment.

Wherever a job of work is being performed, it may be of interest to the observant artist. In his Diploma work, Roland Batchelor found industrious activity in the north-west corner of the European continent. In our concluding chapter we will follow him overseas to find out what good travellers British watercolourists have been.

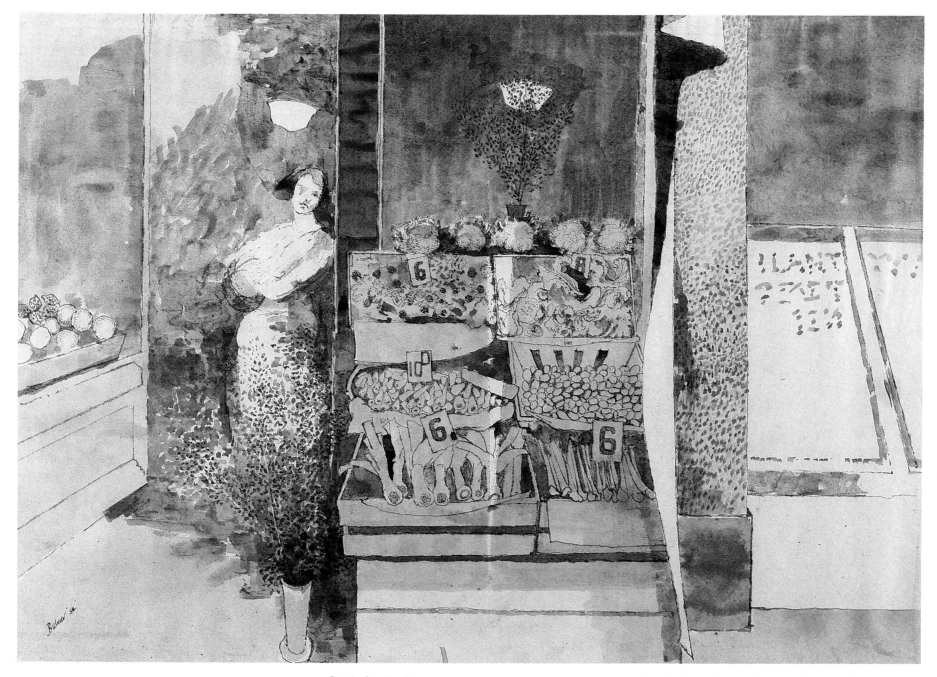

Study for the Greengrocer
LIONEL BULMER RWS (b 1919)
Watercolour, pen and ink and wash
10⅞ × 15½ ins

A work which relies totally on tonal values. Even this most 'grey' of watercolours benefits, however, from colour reproduction. Even in monochromatic works there are always slight colour effects due to paper or paint characteristics, which the artist will have taken into account in his production of the work.

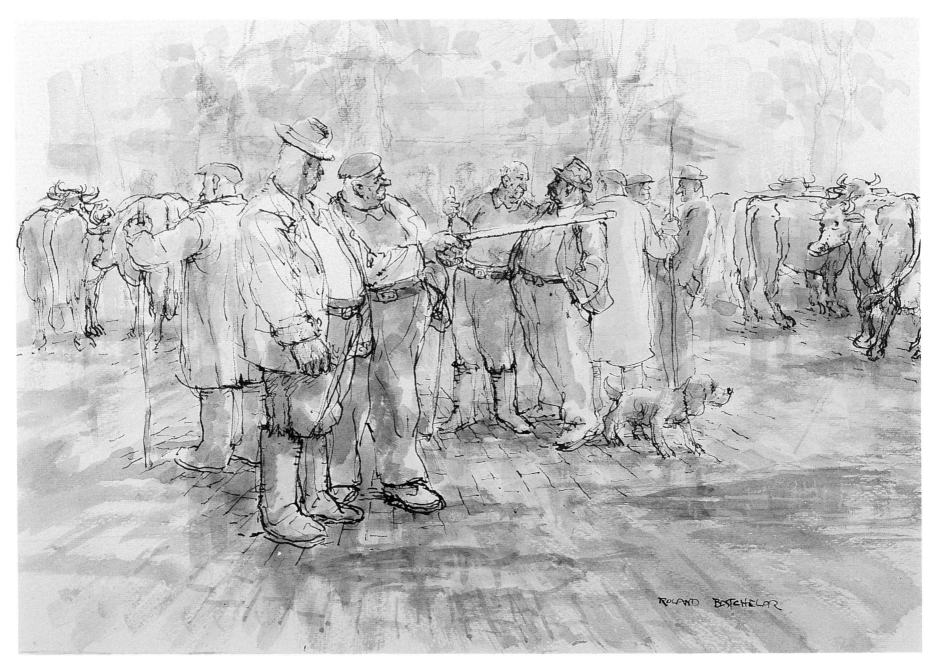

Normandy Cattle Market
ROLAND BATCHELOR RWS (b 1889)
Watercolour, bodycolour and pen and ink over graphite
8⅞ × 12⅞ ins

Batchelor's splendid portrayal of French farmers at work on market day is a fine example of his ability to capture inimitable characteristics and manners. It also displays fine use of the medium and emphasises that although he may at times be humorous, Batchelor should be better known as a modern master of the watercolour art.

TRAVELLERS ABROAD

In Chapter One some mention was made of the influence that the examples of the Italian and Dutch seventeenth-century masters had on the way British artists perceived and portrayed their native landscape. We also discussed the Grand Tour and the increasing accessibility to collections of the great art of the past that came about in the eighteenth century. But as the next century dawned, there were a number of occurrences and factors which led to something of a dearth of masterpieces available for study.

In general, only artists fortunate enough to gain admission to private houses were able to view collections of art. But even this was not entirely satisfactory as the principal available access to major artworks of the past. In the early years of the century Britain as yet had no National Gallery and London's only considerable collection open to the public was that housed in the Dulwich Picture Gallery. In our modern era, with new museums continually opening to complement and add to the great range of collections established during Victoria's reign, Dulwich remains one of our most inspiring galleries and a unique historical record of the collecting and connoisseurship of its period.

Since the commencement of the war with France, Britons had been unable to travel to the Continent to visit the great European collections. Previously untravelled young artists of the generation of Turner and Girtin were particularly deprived. When the Treaty of Amiens was signed just before the Academy's 1802 Summer Exhibition, a number of these took the opportunity of this temporary cessation of hostilities with Napoleon to cross borders previously closed by the wars and especially to go to Paris to see the magnificent collection of treasures the Emperor had amassed over the past decade. In the Louvre was presented an exhibition, the quality and range of which probably has rarely been paralleled. Only once before had such an important collection of paintings been amassed in Northern Europe – that of Charles I of England, whose holdings were largely dispersed under the Commonwealth by his Puritan successors. From this collection came a number of the works of art gathered by Napoleon on the triumphal swath he had cut through Europe. Artists such as Benjamin West, John Flaxman and Henry Fuseli took the chance offered, and 1802 was also the year of Turner's first visit to the Continent. His studies of pictures in the Louvre

exhibition had a profound influence on the development of Turner's mature style.

It was a good thing that these artists took advantage of their freedom to travel, for with the breakdown of the Treaty, it was only after the defeat of Napoleon at Waterloo in 1815 that they were again accorded ready access to Europe. From this time onwards, it became a common practice of British watercolourists to travel on the Continent in search of topographical and figurative material for pictures to be exhibited in London.

Since John White's travels with Raleigh, British artists had seen journeys overseas as providing usefully exotic subjects and John Robert Cozens and Francis Towne had, in the late eighteenth century, established the watercolourist-draughtsman as an important and useful foreign traveller. As the decades unfolded after the Napoleonic Wars, such journeys with the pencil and brush became more widely common practice and more far flung in their range.

One of the treasures of the RWS Collection is a pencil drawing of the 1830 exhibition of the Society of Painters in Water Colours by John Frederick Lewis. This is not the kind of work for which Lewis is best known, for in 1840 he travelled to the Middle East, basing himself in Egypt for ten years. Exhorted by the Society to submit a watercolour for exhibition in its Pall Mall Gallery, he sent to the 1851 show the *Hhareem*, which created a sensation in London and resulted in his immediate return. Lewis was elected President of the Society in 1855, but resigned his office and his membership three years later to apply for the Academy as an oil painter. Not only was membership of the two bodies still disallowed, but Lewis probably also recognised the greater status and commercial potential of working in the medium of oil, which still existed at this time. It was upon his experiences in Egypt that most of his subsequent work was based. The point of this anecdote is to illustrate how exotic foreign subject matter had become very fashionable for the British audience by the mid-century, and this fact will be echoed by the chronological passage we are about to make through the art of those watercolourists who risked life, limb and discomfort to record scenes in other lands.

Let us return first to the Napoleonic Wars and to a rare watercolour artist who actually depicted the com-

bat. John Augustus Atkinson was born in London, probably in 1775. He was already out of the country when hostilities began, having been taken to St Petersburg at the age of nine and staying there until 1801. He was patronised by the Empress Catherine and the Emperor Paul, but returned to London after Paul's assassination. Atkinson was elected to the Society in 1808 and exhibited with it until its transformation into the Oil and Water Colour Society in 1812.

A painter of genre and landscape subjects, Atkinson is however best remembered for his war scenes, of which the watercolour of *British Cavalry on the Field of Waterloo* is a fine example. This is a scene taken in the last decisive battle of the wars with France and whatever its accuracy of military detail, it shows a convincing understanding of battlefield conditions. These wars did not provide subject matter for many distinguished British artists, whose contribution to the recording or ennobling of events is minimal by comparison with the pictures by such of Napoleon's painters of Imperial splendour as Jacques Louis David and Baron Gros, as well as less official artists like Théodore Géricault. British painters mostly stayed at home and at a distance could only reflect reports of the wars in their works; David Wilkie's *Chelsea Pensioners Reading the Waterloo Dispatch* being a prime and popularly admired example. Not until later in the century did the State send artists to record war in any numbers. Later in this chapter, we shall come across Thomas Hennell, posted to Iceland as one of the great team of Official Artists intended to create during World War II one of the most extensive archives of human combat ever attempted.

As Atkinson's endeavours were unusual for his time, the apparent veracity of the present work is likewise to be appreciated. Watchful of the enemy, or startled by gunfire or explosion, a cavalryman turns his eyes toward something unseen by us to the left of the picture space. So too does the startled horse being attended by a dismounted soldier, who is adjusting his charge's saddle before following his comrades down through the smoke of battle. The interesting juxtaposition of the shapes of two horses and riders in the centre of the picture, the one distant and pale, the other nearer and strongly coloured, reveals Atkinson as an artist able to express formal as well as descriptive

British Cavalry on the Field of Waterloo
JOHN AUGUSTUS ATKINSON OWS
(c 1775-after 1833)
Watercolour and gum over graphite
10¼ × 17½ ins

This is a superbly executed picture by an underrated artist. Atkinson's handling of watercolour is reminiscent of Girtin's and he cannot be considered an original spirit in terms of technique, but the adventurous and intriguing subject matter of this and other war drawings place him above the role of jobbing military artist.

concerns. A mysteriously Napoleon-like sketched-in figure, a dog by his side, seems to watch the manoeuvre from his position in front of a windmill. It is perhaps difficult to determine whether the graphite drawing of this right hand area of the composition is preparatory to an unachieved watercolour fill-in, or if the work is in fact finished and the haziness of this passage an intentional device to create aerial perspective and emphasise the smoky atmosphere. This is one of a series of watercolours of the battle produced by Atkinson and the windmill is a fabled feature of the field. But quite why this Napoleonic figure is present and seemingly unnoticed by the British soldiers is somewhat mysterious.

Although it has suffered slightly from fading, this watercolour retains its original pigments to a sufficient degree for us to experience early nineteenth-century watercolour brushwork at something like its best. This is an artist who has fully absorbed the example of Girtin and over the graphite outline he is drawing powerfully with a loaded brush. Its technical qualities make this work a most adequate exposition of the early nineteenth-century watercolour. The sense of unease embodied in the subject and the dramatic composition show it to be a significant example of the medium's potential to express weighty concerns. This is not an heroic depiction of war, but a record of a minor though frightening incident captured with sympathy for the lot of the participants. Atkinson's understanding of equine anatomy is also good and his

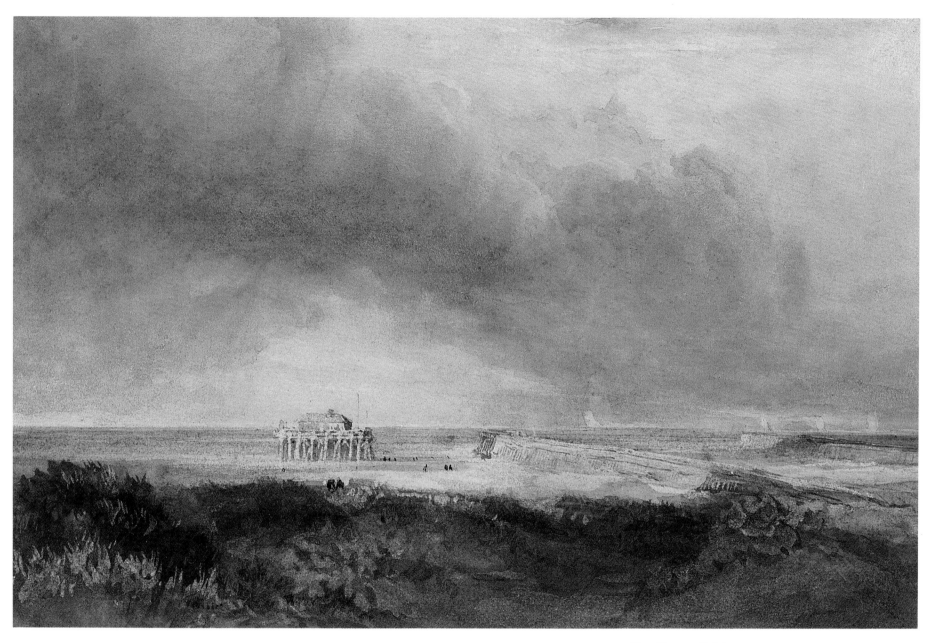

Fort Rouge, Calais
DAVID COX OWS (1783-1859)
Watercolour over graphite, with scratching out
7⅞ × 11¾ ins

The swirling clouds in Cox's watercolour are superbly
described. The dextrous handling of watercolour to depict
the sky contrasts with the dense, gummy areas of the
foreground, the principal role of which is to throw into
recession the middle distance sands, fort and pier.

161

appreciation of how the horses tackle the inhospitable conditions helps us to believe in the reality of the scene.

Not until 1826, eleven years after Napoleon's domination of Europe was ended by Wellington, did David Cox first venture into Europe. His last Continental visit was in 1832, when he travelled to the coast of north France, taking in the seaside towns of Boulogne, Dieppe and Calais. Several finished watercolours ensued from this trip, among them at least two versions of *Fort Rouge, Calais*, the one illustrated here having been donated to the RWS under the terms of the 1980 McKewan Bequest. While he found the picturesque coastal scenery of northern France useful material for exhibition watercolours, it has to be said that Cox did not gain as much inspiration from his overseas travels as many other artists and was fairly insular by nature. Maybe, through force of circumstance, he set foot overseas too late in his career for its direction to be greatly influenced by such new experiences.

Nonetheless, some fine drawings of Paris were produced on this trip, as were a number of pictures of the northern beaches. Turner had also painted the Calais forts, like Cox seeing the setting as a suitable vehicle for conveying broad atmospheric effects. In the breezy watercolour of *Fort Rouge, Calais*, a threatening bank of cloud seems to corkscrew diagonally across the sky. The seventeenth-century fort is bathed in sunlight and it is the changing effects of the weather and the natural movement within the scene that have interested the artist just as much as the topography of the view.

Cox has stopped out extensively in the foreground, to pick out some vegetation against the dark undergrowth of the dunes, and scratching out describes the structure of the fort. But his technical genius is reserved for the cloudscape, so effectively real and painted with the most delicate nuances of tone and colour. This watercolour has much of what is most characteristic in Cox's art – the great atmospheric sky and the sense of changeable weather are personal hallmarks and the whole is brought together with technical skills that leave the paper marked and scraped but with most appealing textures.

Unlike his contemporary, Samuel Prout was an inveterate traveller overseas, whose appetite for picturesque European architecture was only matched in his century by a few British artists, among them William Callow. The great fund of drawings Prout built up over thirty-eight years of visits abroad from 1819 onwards, served as the basis for the topographical

lithographs and engravings in at least a dozen of the numerous books, many of them works of instruction, produced during his lifetime with illustrations after his work. The British public were hungry for foreign travelogues and a good many artists scoured Europe and later more distant lands to accumulate visual material for such publications.

Being comparable to prints in their scale and in their use of paper as support, watercolours proved suitable for translation by professional engravers. For the skilled engraver, the coloured as well as the tonal rendition of a subject in watercolour was most helpful in the attempt to achieve a successful result in the prevalently monochromatic medium of print. This was because having a notion of the colour value of, say a tree, or the wall of a building, could give the creative printmaker greater and more subtle information about the true tonal nuances of the subject than a monochrome drawing in sepia or graphite. Watercolours thus allowed the engraver to use his abilities to convey the sense of colour through varying tonal arrangements of lines, or through the complex technique of aquatint. In other words the engraver used his own creative abilities to interpret a colour drawing, rather than slavishly reproduce an existing tonal representation made by the artist.

The writer has not established whether Prout's delightful and jewel-like little watercolour of *Lucerne* was ever engraved for publication. It is known that the artist made his only recorded visit to the Alps in the late summer of 1824. Drawings made on this tour were the basis for a series of engravings that illustrated Thomas Roscoe's 1830 edition of the *Landscape Annual*, a publication that took the reader through a succession of European countries. The watercolour may not have been intended for this book, as Roscoe's text leads the armchair traveller through Switzerland and Italy without stopping at Lucerne. But it is a work of the type and size used by the engravers for the *Annual*. As in several of the reproduced watercolours, Prout contrasts the hazily painted distant scene with the more graphic architectural foreground, where the brushwork is nudged into greater clarity of structure by broken pen outlines.

Prout based such watercolours on factual pencil studies made before the subject. But he regularly combined different elements of his on-the-spot records to create caprices, with the intention of revealing more about the character of his scenery than merely topographical records of particular views might allow. Thus, this Lucerne may be an amalgam of landscape, 'lakescape' and townscape that could

not be seen all at once, but conveyed what Prout felt to be the essential appeal of this fine mediaeval town and its dramatic Alpine setting. To take such liberties with the factual was not considered reprehensible, and has been a common practice of artists of all periods.

Among Samuel Prout's contemporaries, Turner was one of the most prolific distorters of natural geography for artistic ends. For a travelogue, with a limited number of visual representations, some artist's licence is quite justifiable. Much more sensible, surely, to attempt to capture the total reality and character of a place in one illustration than depict only one or two isolated aspects in the equivalent of photographic form. Besides, the job of the wordsmiths of the travel books was to convey a multitude of impressions, while the artist's task was to sum these up in a few general ones. We all know how misleading the one or two very particular photographs reproduced in a modern tourist guide or holiday brochure can be.

Lucerne is one of five watercolours by Prout which the Parsons Bequest brought to the Society's collection, which previously had no representation of the artist. Of these five, there are three, including the present work, which are of the highest quality. Prout's watercolours are sometimes described as dull or worse, their sometimes repetitive subject matter being duplicated in a methodical and uninspired manner. But when care in execution and inspiration from his subject combine to produce an attractive image, he is one of the finest watercolourists of his time. His work is perhaps at its best when the brushwork is carried out with verve. Here the marks are agitated and the tonal and colouristic juxtapositions create a lively movement of light, shade and shapes across the surface of the paper.

The most impressive of Miss Parsons' group of Prouts is the grand watercolour of *The Doge's Palace and the Grand Canal, Venice*, unquestionably one of his major works. Not only is it a significant early nineteenth-century statement of the monumentality which watercolour can achieve, but unlike many of his other exhibition machines, it could not be described as drab, with every area of the sheet being enlivened with well-controlled variations of rich light and colour effects.

Prout went to the city on the same 1824 journey and when soon afterwards he exhibited Venetian views in London, these were greeted with acclaim. They were rare and unusual, for Turner and Bonington had yet to show their interpretations of this supremely picturesque meeting of architecture and water – a subject well known to British collectors through the

Lucerne
SAMUEL PROUT OWS (1783-1852)
Watercolour and bodycolour
10½ × 8 ins

This pleasingly unponderous work is a relatively intimate example of Prout's *oeuvre*. The details of figures and the vista through to the lake are very attractively handled and might lead us to the possibly uncharitable thought that this important architectural watercolourist was often at his best painting nature and human life.

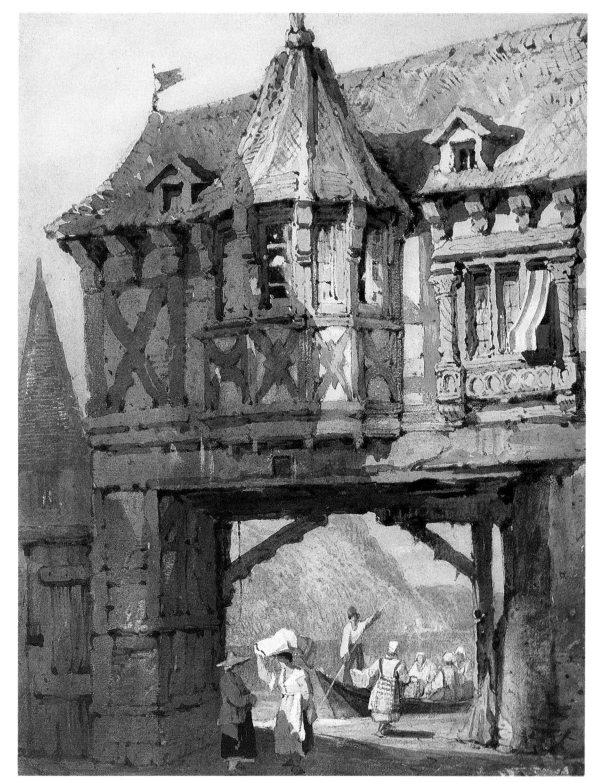

paintings of Canaletto, Bellotto and the Guardis. It was on Prout's recommendation that Bonington travelled to Venice in 1826. However capricious in his composition of architectural elements Prout may sometimes have been, John Ruskin praised his architectural accuracy in a letter to the artist of 1849. He wrote, 'I, who in many cases like the sketches better than the places, pursued my walk through Venice with intense pleasure: especially because you have been so scrupulous and fondly *faithful*: and so often rendered the character of particular features, of which, I believe, few persons except myself could understand the precision.' Always a persuasive writer, if on occasion verbose and self-contradictory, Ruskin here lends weight to the justification of Prout's caprices given above.

When Ruskin organised a posthumous London exhibition of the artist's on-the-spot drawings, at the Fine Art Society in 1879, together with a display of W. H. Hunt's watercolours, Prout was still considered one of the greatest exponents of the watercolour tradition. Works of the quality of that presently being discussed could at the time fetch as much at auction sale as the extraordinary sum of £1,000. To understand this price today, one would have to multiply it by something like fifty times, depending on what criteria of inflation are taken into account. The late nineteenth century saw a boom in art values and works by living painters like Burne Jones or Sir John Everett Millais commanded much higher sums still. Only in the 1980s have contemporary artists once again come to achieve comparable prices.

When it arrived in the RWS Collection, this watercolour was paired with a view of the Piazzetta San Marco. Both works were presented in their Victorian gold coloured mounts and fine carved gilt frames. Together they are conceivably the most important contribution to the Collection other than the members'

own Diploma works. The present picture's companion is very close to an engraving with which Prout illustrated Roscoe's *The Tourist in Italy*, his *Landscape Annual* for 1831. Possibly because of the fame of their subjects, both views are more topographically accurate than some of the artist's more modestly scaled *capricci*. Even Canaletto, that exemplar of artifice in the construction of his Venetian scenes, tended to depict the area of St Mark's Cathedral with topographical veracity.

There is much incident to enjoy and enthuse about in *The Doge's Palace*, and the reader is invited to explore in detail this rich painting. Take pleasure in the range of human activity; the statuesque traders, the architectural detail, the glorious colouring of the vista with the distant church of the Salute. Above all, make note of the remarkable draughtsmanship which is at the core of Prout's best work, and for which he has been insufficiently recognised in the modern age. Until recent years there has existed a tendency to place so much emphasis on the importance of painterly form, as for this to be at the expense of appreciation of sound drawing.

Samuel Prout was born in Plymouth in 1783 and first worked for the antiquary John Britton, producing drawings for engravings on British tours. His early proximity to a great naval port may have led to his later predilection for overseas travel. Joining the Society as a member in 1819, following his first contribution to exhibitions in 1815, he became 'Painter in Water-Colours in Ordinary to his Majesty' George IV in 1829. Prout suffered life-long ill-health and in 1836 decided he should leave London for the Hastings air. Previously he had been a resident of the South London suburbs of Brixton and Camberwell. In the latter parish Robert Browning grew up and Ruskin's family home was situated on Denmark Hill. David Cox was for a time living in a house in Foxley Road, not half a mile away. The artistic identity of the suburb was reinforced later in the century, when a generation imbued with the Ruskinian principals was to found there the Camberwell School of Arts and Crafts.

Roscoe's *Landscape Annual* for 1832 followed two successive years of illustrations after Prout with a series of engravings from drawings by James Duffield Harding. The year's subject was also *The Tourist in Italy* and the edition in the Society's library was donated by William Callow, whose watercolour of

The Doge's Palace and the Grand Canal, Venice
(*Detail*)
SAMUEL PROUT OWS

This under-life-size detail shows the bustle of human activity which animates Prout's watercolour. As always with this artist, the figures are somewhat statuesque, but in this grand work such a quality is certainly to the picture's advantage. The lone man to the left, set before the distant church of the Salute, is a memorable image and a counterpoint to the silhouetted figure at the very edge of the picture area.

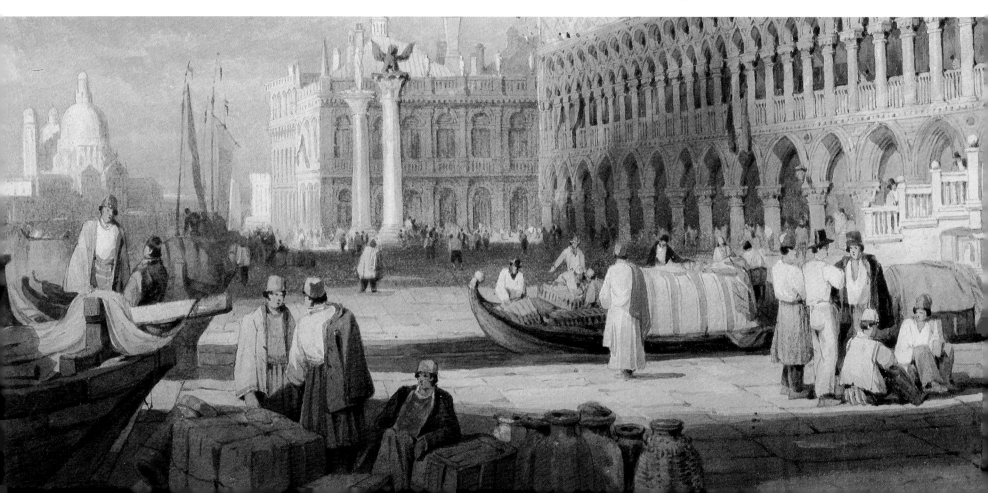

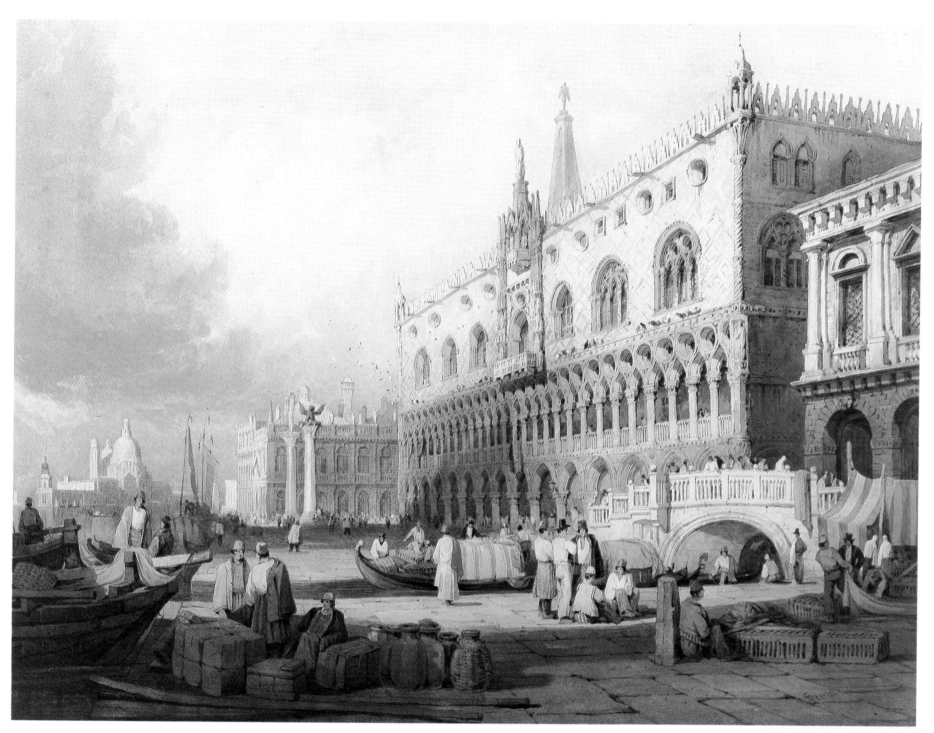

The Doge's Palace and the Grand Canal, Venice
SAMUEL PROUT OWS (1783-1852)
Watercolour
17⅛ × 22¼ ins

Prout's magnificent and stately Venetian watercolour may here be seen in its true glory. This is one of the artist's masterpieces and a fine example of the unity of good draughtsmanship and painterly technique, not so very long after Girtin and Turner had pushed the watercolour medium into the nineteenth century and the realms of high art. Note Prout's apparently effortless composing of the scene.

Verona
JAMES DUFFIELD HARDING OWS (1797-1863)
Bodycolour and graphite on buff paper
14⅝ × 20 ins

Approximately one third of its real dimensions, this taut
and extremely fine drawing may be fully appreciated on
this scale. It has the grandeur of conception and technique
to stand up to an appraisal from 'some distance'. Although
we understand this may have been intended as a drawing
for the engraver or lithographer, it is entirely satisfying as
a picture in its own right.

Frankfurt we shall consider shortly. The drawing by Harding illustrated here was given in 1928 by another member, Robert W. Allan. It is pleasing and appropriate that many of the works representing members who died before, or in Harding's case just after, the inception of the 'Diploma Gallery', were bequeathed by their colleagues in the Society. This fact bolsters the idea that this is a unique museum collection, chosen by artists rather than by its curators.

Harding's drawing of *Verona* was made on site and is dated 5 September 1845. It is the kind of architectural record that Prout also made for later transformation into finished watercolours or engravings. It is consummately drawn in graphite, with the addition of white heightening of the riverside buildings. This effect superbly enriches the drawing and clarifies the architectural structure by emphasising the sun-facing surfaces. It also may have served Harding's purposes by enhancing the tonal range of these architectural passages for a future lithograph, a medium for which this graphite and chinese white technique is a ready blue-print. The buff paper used by the artist allows him to work from a middle tone to light and to dark, creating a richness of effect in the most economical fashion possible. Lithographers of the time also worked on this principle.

Among the nineteenth-century drawing masters, Harding surpassed even Prout in his production of a corpus of illustrated instruction books. It has been claimed that he had a greater influence on amateurs than any other practitioner of art teaching in the history of British painting. He most evidently had the skills to impart knowledge from an early age, for as a precocious thirteen-year-old he first had a work accepted for the Royal Academy Summer Exhibition. With such raw natural ability at such a tender age, Harding may be placed alongside other young geniuses such as Palmer and Millais.

The lucid and economical quality of the draughtsmanship of this piece is admirable and it is hardly surprising that Ruskin, that preacher of the crucial importance of drawing, was for a time a dedicated follower of this popular teacher. Partly under Harding's tutelage, Ruskin himself became a fine exponent of the architectural drawing and his Italian subjects number among the most informed and perceptive records of their kind produced in their period. Ruskin too was in Italy in 1845, and encouraged by Prout's work, Verona was to become one of his most beloved cities. Following his 1869 visit, he published the characteristically moralising work *Verona and its Rivers*. Of the city's bridges, the puritanical Ruskin

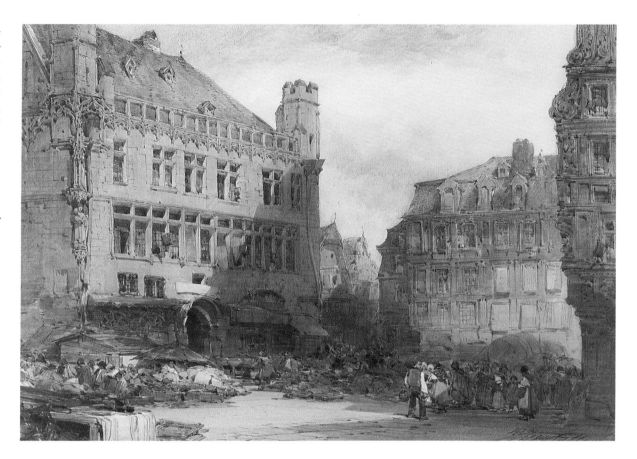

was particularly entranced by the Ponte della Pietra that we see here in Harding's view, not only for its architectural qualities, but because it was across this structure that the Goths supposedly arrived many centuries before to quell Roman vice and corruption.

Of all Victorian art critics and theoreticians it was principally Ruskin who in his writings set out the seminal considerations of the meaning of art in his age. The stature of the man and of his didactic pronouncements on the high seriousness of the visual arts should not obstruct our appreciation of his own technical and aesthetic accomplishments in drawing; nor should it influence overmuch our enjoyment of the practical achievements of jobbing artists like Harding. As befits a drawing made directly before the subject, where time is of the essence and light and weather conditions variable, *Verona* is economically handled. It is sparse where the need arises. The river is barely suggested by hints of reflections in the water and although these are sufficient within the context of the composition, it must also have been in the artist's mind that his memory and other experiences of Italian

Market Place, Frankfurt
WILLIAM CALLOW RWS (1812-1908)
Watercolour over graphite
13⅛ × 19 ins

This illustration of the full picture is simply intended to convey the overall composition. We may observe here the way in which Callow has so animated the market activity, just allowing a few figures at the right of the scene to stabilise the composition and show us the costume of the traders. Above this blur the mediaeval architecture of Frankfurt rises majestically.

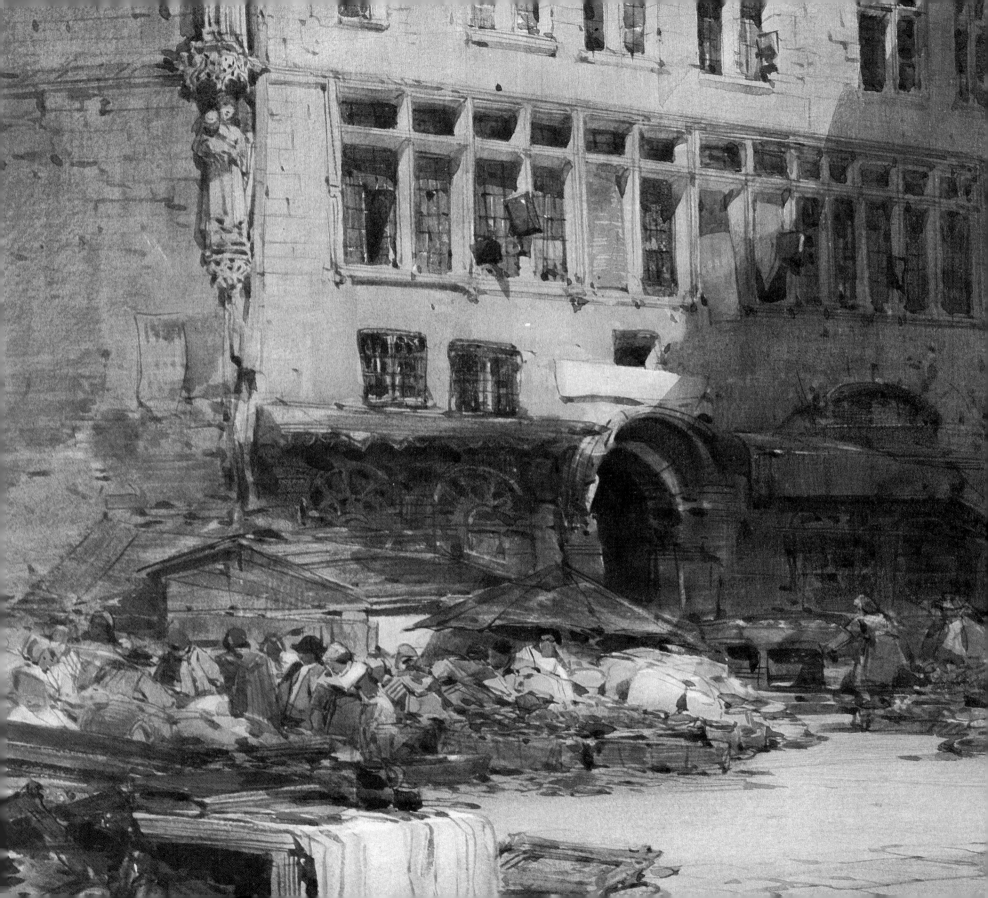

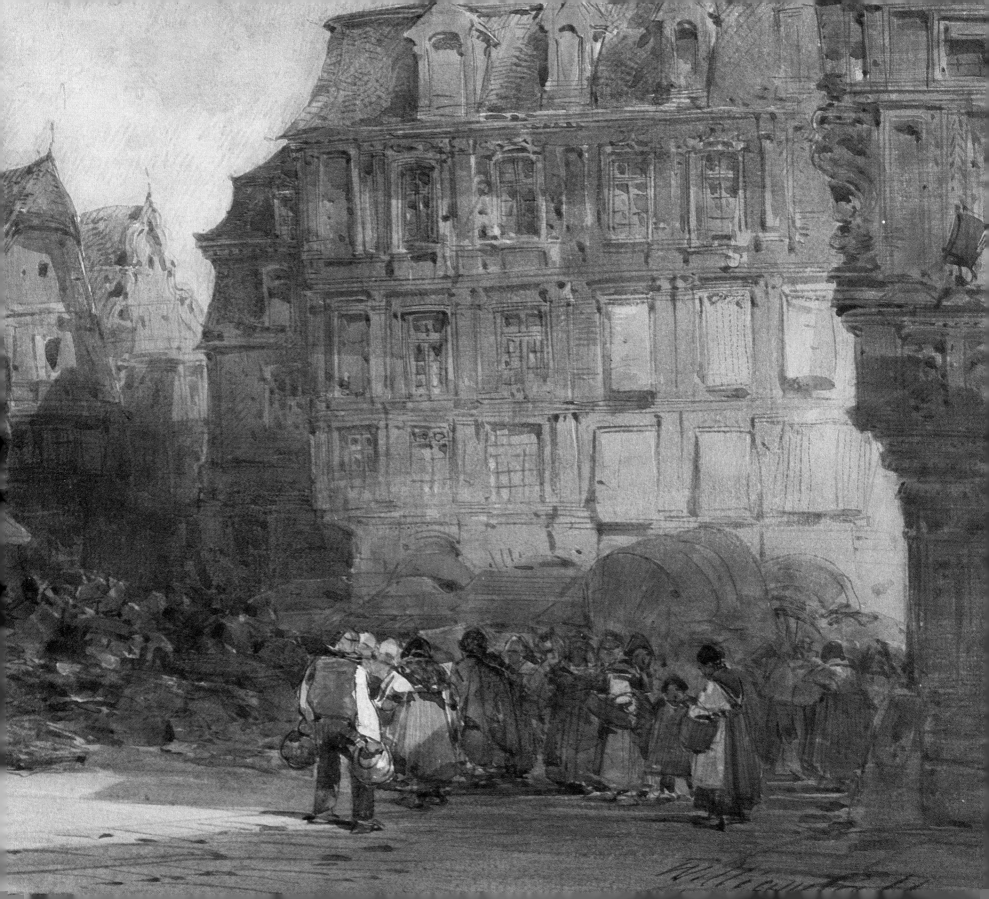

Market Place, Frankfurt (*Detail*)
WILLIAM CALLOW RWS

Now, rather over life size, we see the full glory of Callow's brushwork and his vigorous description of the market. The size of his brushmarks does not necessarily alter from one passage to another; rather it is their change of direction, colour and, above all, vigour that enables him to instil such dynamic vitality to this work.

rivers would serve him well enough when translating the drawing into a lithographic representation of the scene, if this was the intention. On the other hand, the description is rich where necessary. Harding wanted topographical accuracy in the architectural vista and it is given to few artists to have the extraordinary visual memory of Turner, who in any case took great liberties with his architectural subjects in turning sketchbook notes into finished pictures.

Born in 1797 in Deptford, East London, Harding became a pupil of Prout and was later briefly apprenticed to an engraver, Charles Pye. His first Italian journey was made in 1824, having been elected AOWS in his twenty-third year and a member of the Society in 1821.

For the last time, we return to that versatile artist and mainstay of the Society through the nineteenth century, William Callow. *Market Place, Frankfurt* is a watercolour of 1861 and almost certainly the artist's Diploma work, presented at the inception of the scheme. It is a virtuoso example of Callow's middle period, in which his abilities as an architectural draughtsman are wonderfully juxtaposed with his energetic use of the brush to convey movement and life.

The grandeur of Frankfurt's mediaeval buildings, proudly rising above the hubbub of market day, provides a telling image of the permanence of fine architecture and the ephemeral but essential presence of human activity. This is not to say that Callow was here moralising about mortality, but he must certainly have felt architecture to be one of the few lasting and tangible achievements of transitory humanity. In his watercolours, figures are usually incorporated as adjuncts to the general scene. They tend to populate their surroundings either as fixtures, rather in the manner of Prout's mannequins or, as in this work, they give a general sense of activity and bustle. Neither of these artists wished to single out the characteristics of people in a manner similar to that of

Turner, whose figures' individual actions so often give a life-enhancing warmth and feeling of mortal permanence to his watercolours. It is hardly Callow's fault that his apparent faith in the permanence of fine ancient architecture was to be negated by World War II bombing raids and battles. Although he lived eight years into this century, Callow was a watercolour artist born in the Romantic period whose creative impulses successfully matched his longevity right through the Victorian age.

The contrast between Prout's statuesquely rendered figures and the animated dry brush-strokes which capture Callow's market traders could hardly be greater. With the exception of a few people who stand to the right of the picture, the description of the market scene is a nearly abstract blur of light, shade and colour that sweeps horizontally across the middle distance, from which rise the vertically delineated buildings. The Gothic mouldings which embellish these are drawn at first with graphite line, in the manner of the album studies referred to in a previous chapter, and then given emphasis of shading with broken strokes of a fine brush laden with umber watercolour.

The actual process of watercolour technique employed by Callow was not dissimilar to that of many of his contemporaries. Prout, Bonington, Boys and others would similarly build up architectural passages with selective applications of a wettish brush over previously dried washes that implanted the correct fundamental tone and colour. Where Callow departs from his predecessors is in the chopping brushwork that broadly describes the market scene.

There are a number of prolific nineteenth-century watercolourists whose obvious facility in their mature art has been described as prone to the creation of pot-boilers; the repetition of a successful subject when the genuinely creative impulse has been superseded by commercial considerations. As contemporary taste has turned towards the acceptance of watercolour as the significant art form the progenitors of the Society always felt it should be, these 'pot-boiling' phases of artists' careers are in a state of continual re-evaluation. Middle and late career Callow is an example, as are the later watercolours of Varley, Cotman and Palmer. In the light of such similarly belated recognition, Callow is not in bad company. The fact that experienced artists could reiterate versions of a subject does not by nature belittle the achievement of each individual work of art, nor indeed should it obscure the sheer professionalism and craftsmanship which enabled them to produce what are generally such

convincingly 'original' repetitions. It is the care and creative energy bestowed on the particular work that determine its quality.

Alfred Downing Fripp was a much travelled watercolourist whose *oeuvre* was dominated by Italian subjects after his first visit to the country in 1850. Born in Bristol in 1822, he was a grandson and follower of the marine artist Nicholas Pocock, whose *View of the Menai Straits* is illustrated at the beginning of this book. Fripp was elected to the Society as associate in 1844 and his membership followed two years later. A prominent figure in the Society's affairs, he became Secretary from 1870 until his death in 1895.

Fripp's work submitted as his Diploma piece is characteristically of an Italian scene, *Sta Rocco, Olevano*. Inscribed *Rome*, it may well date from his 1850 visit. It is plausible that this picture was in part conceived directly before the subject. Undoubtedly the painting of the dazzling light, so strong that it visibly flattens objects and almost obliterates deep shadow, is such a faithful visual transcription of the Mediterranean sun that the observer can imagine standing in the artist's place on this bare hillside. Any reader who has painted a watercolour away from shade in such bright light will know how glaringly white is the paper surface and how the tendency can be to strengthen and deepen colour to give it some impact. However, a truer rendition would be one such as Fripp's, where the brilliance of a high sun reflected from the stone surfaces overrides the resonance of colours. The many reflecting surfaces are another reason for the presence of intense light in the shadows. Relatively few pictures executed entirely in the studio tend to convey such heightened effects of dazzling sunlight.

Fripp painted in an era in which the Pre-Raphaelites taught artists to use bright palettes, after nearly three centuries of dark paintings and reliance on the method of chiaroscuro – the modulation of tones between light and dark. Passing was the era of the Claude glass, a tinted mirror that artists used to reflect the scene before them and which played down the vagaries of natural light in the attempt to emulate the tonal harmony of the landscapes of Claude Lorraine. With its harshly real lighting, *Sta Rocco, Olevano* has an opposing effect and is a strikingly convincing and light-hued rendition of the subject.

If the reader has struggled with a sheet of white paper in the difficult circumstances mentioned above, he or she may be able to learn something from Fripp's approach to the problem. The artist has used a pale grey paper, which establishes the consistent middle

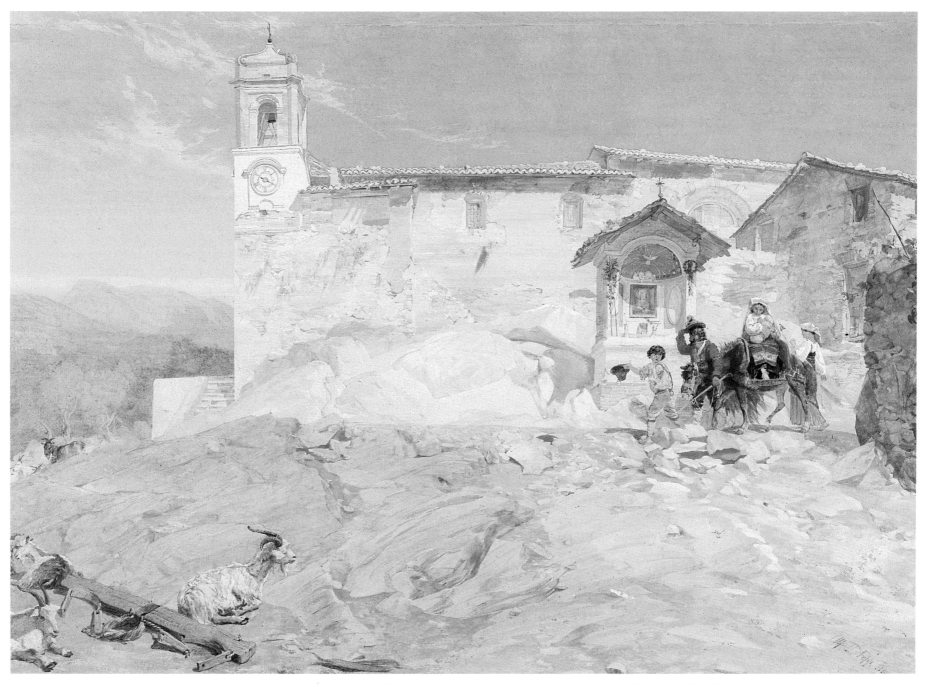

Sta Rocco, Olevano
ALFRED DOWNING FRIPP RWS (1822-95)
Bodycolour and watercolour over graphite on grey paper
15³⁄₈ × 21¹⁄₈ ins

The extraordinarily detailed bodycolour construction of this picture might not be fully appreciated in this illustration. We may, however, get an idea of the painting's make-up from studying the shrine and figures. Above all we should take account of the radiant colours and light effects that Fripp has created.

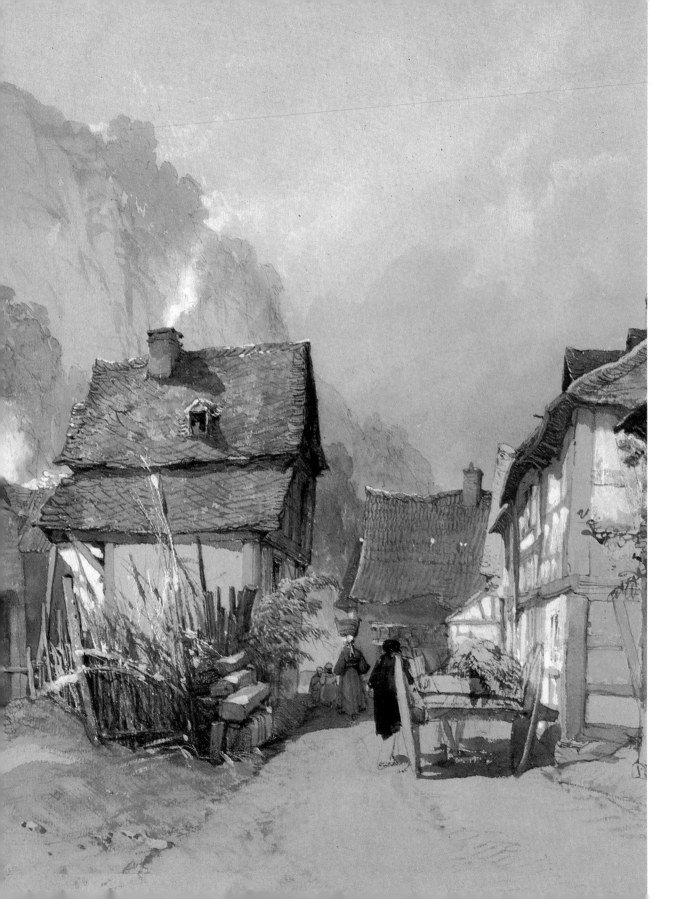

The Village of Saÿn on the Pretsoh Bach, Rhine (*Detail*)
THOMAS MILES RICHARDSON JR RWS

Slightly under its real size, this detail picks out the marvellously captured man with his cart, as well as the excellent drawing of the buildings and sticks to the left of the illustration. We might note the way Richardson draws his bodycolour lights out of the neutral tone of the paper.

tone of the picture. In places, the paper surface is left untouched to describe areas like the foreground rocks. From this middle tone, he has worked the lights up, and the areas of shade down. In places water-colour has been used for the shadows, but the predominant medium is bodycolour, with which Fripp has painted the sky, buildings and the figure group for example, and extensive application of chinese white describes the highlights.

The uncomplicated composition might add to the belief that the painting was at least started on the spot. Such a feeling is enhanced by the fact that during the progress of the work Fripp felt the need to give more space around the bell tower by adding a half-inch strip of paper to the top of the sheet. A line showing where this strip joins the main sheet is visible in the illustration. This slight alteration could indicate a lack of the preplanning that one might associate with an entirely studio-conceived composition.

Although the painter's primary wish has perhaps been to capture the Mediterranean light striking the picturesque walls of this much altered and rambling church, this is still very much a Victorian subject picture. A family pass by an elaborate shrine to the Virgin Mary. The boy and a man, who may be his father, doff their hats in reverence, while sitting on the mule that the man leads is a woman clutching a baby. An intended Christian message is suggested, but this is unclear and speculative. It could be that the boy is a guide and if so the central couple might be seen to recall the Holy Family on the flight into Egypt, even if only as an art historical reference on the part of the artist.

Having so far only observed Thomas Miles Richardson Jr at work in England, it is a pleasure to find him at his absolute best in a Continental subject from the Parsons Bequest, *In the Village of Säyn, on the Pretsoh Bach, Rhine*, dated 1841. If Richardson's view of Norham Castle reminded us of the sunset water-colours of Turner, this work recalls some of the Alpine drawings in bodycolour by the master. In his

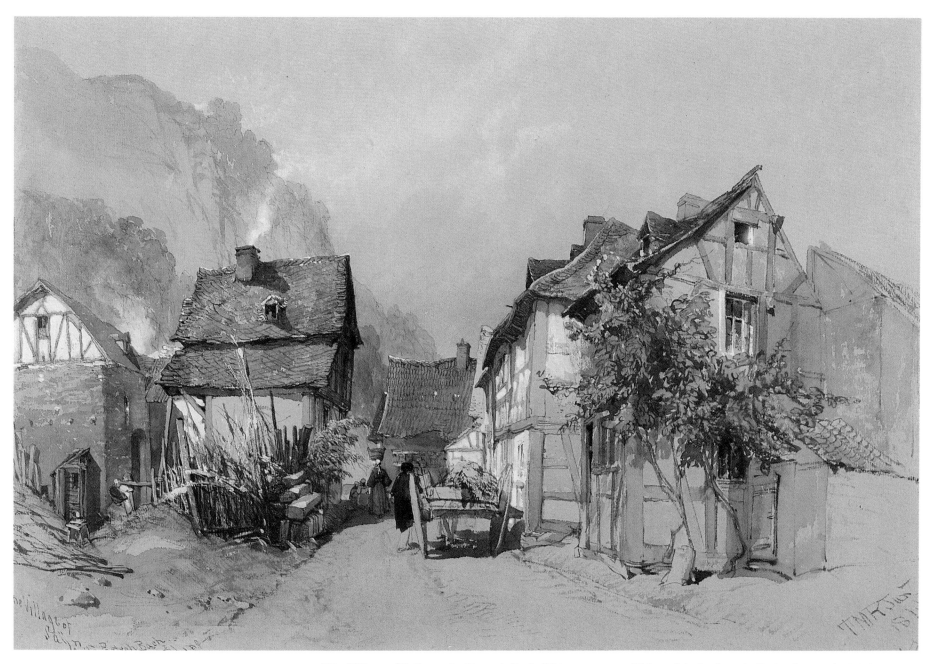

The Village of Saÿn on the Pretsoh Bach, Rhine
THOMAS MILES RICHARDSON JR RWS
(1813-90)
Watercolour and bodycolour over graphite on buff paper
10¼ × 14¾ ins

This work is the finest by Richardson in the RWS Collection. The beguilingly picturesque village and the lure of the distant mountains have brought out Richardson at his skilful best. However, this is not a superficial work and the interplay of shapes and linear elements is particularly pleasing.

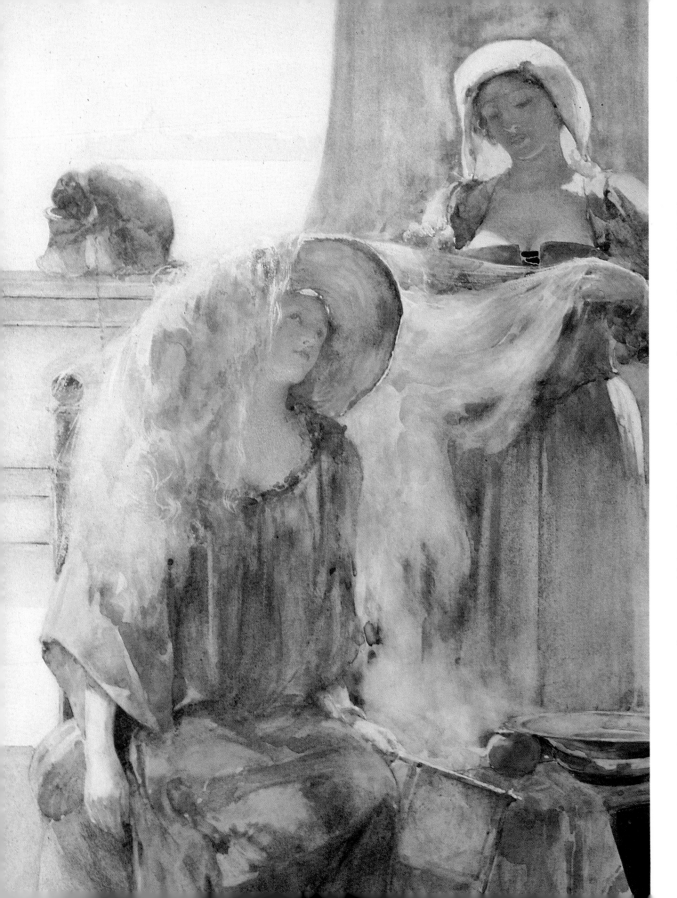

Venetian Gold (*Detail*)
JOHN REINHARD WEGUELIN RWS

This half-size detail reveals much of the beauty of Weguelin's brilliant technique in this work. The painting of the hair of the central figure, much of it in bodycolour, and the depiction of the chained monkey in pure watercolour, are both examples of considerable technical facility and sophistication.

younger years, Richardson soon became at ease with his medium and his natural stylistic facility helped lead to a penchant for eclecticism. This is not to say that he wilfully modified his style according to his subject or the dictates of fashion, but unlike an artist such as Samuel Palmer he displays a lack of interest in ploughing an individual furrow. This absence of an individualistic creative manner means that, for all his ability, he does not stand out as a major or influential force in the progress of nineteenth-century watercolour painting.

Richardson was only in his twenty-eighth year when he so beautifully captured this Rhine village scene. It is a consummate work in which the economy of handling and versatility of description make it worthy of being placed alongside some of Turner's own Rhine drawings. Like Turner before him, and Fripp a few years later on, he has used a tinted paper, in this case of buff colour, from which to lower and heighten tonal and colour values. A large surface of paper is left exposed and only where necessary to the finished design has Richardson touched the sheet with his brush.

The attractive lines and angles of the half-timbered houses are sharply delineated with a reed pen, and the plasterwork gently washed in with watercolour or emphasised with chinese white. The blurred blue and grey watercolour washes of the distant hills form an atmospheric backdrop. Contrasting with this misty distance is the sunlit clarity of the foreground scene, with the cart casting a strong shadow on the track. Richardson employs that good old device for conveying aerial atmosphere, which David Cox similarly used in his *Welsh Village*, namely painting in plumes of chimney smoke.

In this work the skill and economy of Richardson's drawing with the brush and pen belie his relative youth. What he has done is to subject only essential features of the composition to close scrutiny and thereby throw these passages into direct relief against the blandness of the untreated areas of paper. In the compacted passages of graphic activity, he has

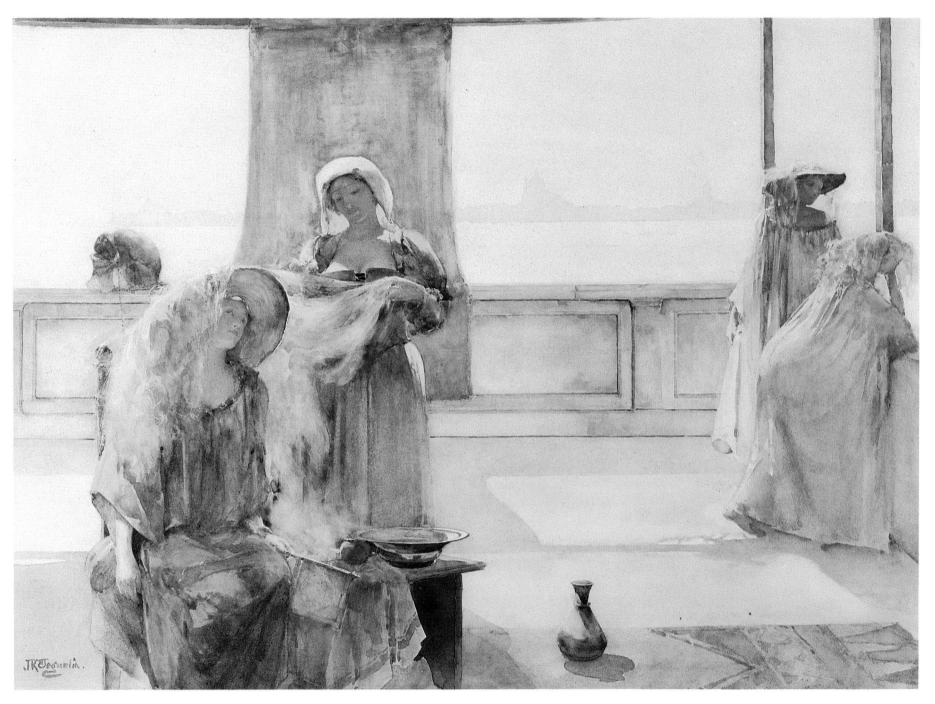

Venetian Gold
JOHN REINHARD WEGUELIN RWS (1849-1927)
Watercolour and gum and bodycolour
21 × 28½ ins

The transparent washes and extraordinary technical manipulation of this work make it one of the most individual, as well as one of the finest Diploma works that the RWS owns. This small illustration of the composition helps us to place the accompanying detail in perspective.

wielded a sensitive and descriptive brush. Note, for example, the lovely tonal drawing of the foliage of the trees and the densely packed thicket of cut branches on the left of the village track. This is a superbly observed and well constructed watercolour and a good example of a British artist finding inspiration in a picturesque yet fairly simple Continental subject.

From Prout onwards, Venice has been one of the most popular of European cities for painters and equally for British tourists. Since eighteenth-century English noblemen started to corner the market in the Venetian scenes of Canaletto and his contemporaries, the city has held a special place in the affections of travellers from Britain. Even today, with the great freedom of travel afforded the populations of continental Europe, the principal foreign language heard in Venice is English, albeit sometimes with an American accent. This is hardly surprising when we consider that the British more or less invented trans-frontier tourism and that a Venetian visit has for a long while been a high priority for travellers from this country. This bejewelled North Italian city is also still a favourite place for artists. Surely the Grand Canal must have been represented in British art as many times as almost any other subject.

A rather unusual portrait of the city is the pale silhouettes of San Giorgio Maggiore and the Rendentore across the water in John Reinhard Weguelin's Diploma work *Venetian Gold*. This mysteriously beautiful watercolour is something of a revelation from this relatively little known painter. Born in Sussex, the son of a clergyman, he was educated in Birmingham, going on to become an underwriter at Lloyds of London. He changed course however, and went to study at the Slade School under the academic and classical artist, and for twelve years President of the Royal Academy, Sir Edward John Poynter. Weguelin also came under the influence of the classicising subjects of Alma Tadema and the inspiration of both painters can be felt in this large watercolour.

By this late in the nineteenth century, watercolour had achieved such an acceptably high status in the hierarchy of artistic mediums to be practiced consistently by prominent Academicians and oil painters like Poynter and Alma Tadema. Also the rule barring membership of the RWS to Academicians had now been revoked and these and many other artists were active in both institutions. In 1893 however, the forty-four-year-old Weguelin decided to abandon oil painting and concentrate on watercolour alone. This decision was justified by his almost immediate success in being elected ARWS the following year. His mem-

bership followed in 1897, allowing him thirty years of full participation in the Society's activities until his death in 1927.

The influence of Alma Tadema's paintings of ancient Roman life is evident in the figure composition and handling of *Venetian Gold*, as well as in its classicising style. The watercolour of *Pandora* illustrated in the Introduction features only a single figure, but Alma Tadema's Roman genre pictures most characteristically consist of groups of languid, classically draped figures lounging on marble balconies. The sense of repose in even these works could not be greater than in Weguelin's more contemporary subject. The air of luxurious idleness is almost stifling, the light brilliant and beautifully captured, the whole a wistful evocation of a strange and enigmatic scene.

What exactly is going on here? A lady is having her full and golden head of hair dressed. The elaboration of the ritual, which seems to involve pulling the hair through a hat-brim, then styling it beneath a net, adds to the sense of languor and sensuous indolence which almost overwhelm the observer. It has indeed been suggest that this may be the balcony of a high-class house of ill-repute. However, any reticence we might have about the luxuriant mood of the picture is more than counterbalanced by the artist's exceptional handling.

Using pure watercolour and bodycolour as it suited the desired light effect, Weguelin's manner ranges from broad washes in the sky and loose brushwork for the drapery and hair, to a miniaturist's precision in the shaded faces. The handling of the central figure's golden mane is so fancifully airy as it catches the light, that it blends in with the rising steam.

The backlighting of the scene gives the artist the opportunity to exploit the effects of the sun shining through a variety of coloured textiles. Again we see the brilliant white light of the Mediterranean, but whereas it was harsh and glaring in Fripp's watercolour, here it is softer, dreamier. The reflections of light from stone and rock coloured and lightened the shadows in *Sta Rocco*, and in Weguelin's picture the reflected light principally comes from the sea and sky and gives a blue cast to the areas of shade. Even the striking pink drape, a device included to stabilise the composition and emphasise contrast between foreground and distant elements, throws a blue shadow. An interesting and less obvious artist's device to note is the relative strength of the shadow cast by the bottle. This serves to ensure that the vessel is well seated on the rug beneath and not floating in undefined space, but it is also a fact that a small painted shadow usually

has to be stronger than larger areas of shade to give it equality of emphasis within the total picture area.

It is possible to argue on a number of grounds that *Venetian Gold* is not a fully resolved picture. In formal terms there is the question of the somewhat obtrusive but compositionally necessary pink drape, as well as some slightly awkward figure drawing. In terms of the subject theme it has to be said that the meaning and not just the nature of the activity is something of an enigma. The last criticism can be answered satisfactorily if we treat the watercolour as a purely decorative concept. This is not to overlook the conveyed sense of languor and ennui, but to suggest that the sensuous quality of the subject was Weguelin's primary motive in creating what is a delightful pattern of colour and light. One of the most ravishing and enjoyable works in the RWS Collection, *Venetian Gold* exists for our pleasurable appreciation of ephemeral beauty.

In its Diploma Collection, the RWS holds an Arthur Rackham watercolour produced for a book illustration and known as *A Bargain with the Devil*. It is one of those well-loved, but rather threatening Rackhams with which we are so familiar. The great illustrator was, however, a noted painter of landscapes and town scenes in watercolour. Also in the Collection is a watercolour of the *Abbaye d'Ardennes, Caen*, an intriguingly composed and attractive view of a corner of the mediaeval Normandy town. The British have of course had close familial ties with the Normans for almost a thousand years and in times of peace the northern French province has long been a happy hunting ground for tourists from this country. Caen was devastated during the 1944 Allied push into France, although parts of its great Romanesque abbeys survived and have been reconstructed during the post-war period.

Rackham has arranged an unusual and inventive composition from the patterns of light and shade created amid the archways of the courtyard. Painted with some speed in near monochrome washes, with outlines struck in with pen, and quite possibly made on site, this work reveals another side of Rackham's inventive and quirky vision. It likewise reveals a relatively unknown aspect of the picture-making skills of a consummate graphic artist. This relatively unpicturesque vista is in complete contrast to the townscapes of artists like Prout and Callow, who would have preferred the detailed consideration of architectural elements to be paramount in their drawings. Rackham wilfully eschews the topographical tradition by concentrating on the interesting perspective of the shadowed arches he has come across on entering the

176

Abbaye d'Ardennes, Caen
ARTHUR RACKHAM RWS (1867-1939)
Watercolour and bodycolour
12⅜ × 9 ins

To those who know only Rackham's illustrative work, this fine topographical watercolour will seem somewhat out of the ordinary. In fact he was a fine landscape artist and here we see him depicting an ancient architectural subject with the compositional instincts of a true illustrator.

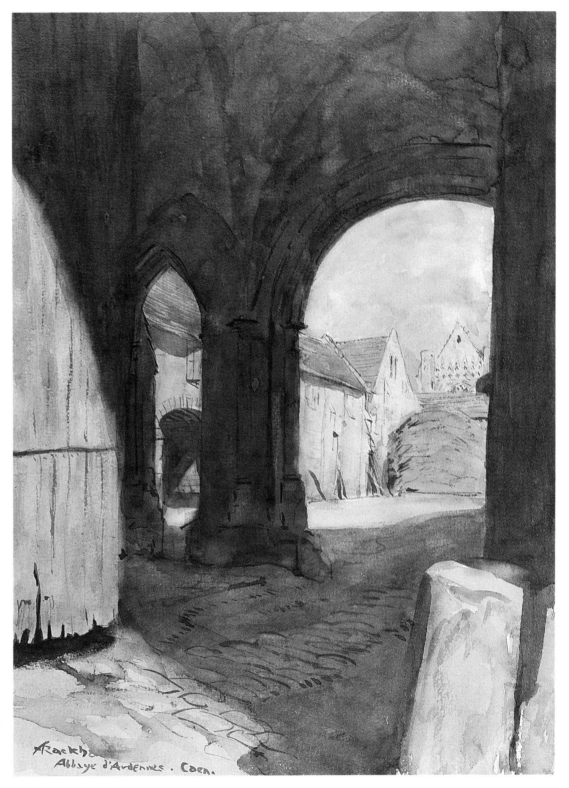

abbey precincts. In this instance he provides no acknowledgement of the style or function of the church itself, but in a very modern way he employs the structure of its buildings to create a semi-abstract composition.

Rackham was born in London in 1867. During his childhood his family emigrated to Australia. Arthur returned to Britain in his youth and was able to study at Lambeth School of Art. In his mature years his reputation as an illustrator went before him, and having worked for periodicals for many years, his attention turned in the 1890s to books. His popular fame was sealed by his edition of *Grimms' Fairy Tales*, issued in 1900. Rackham was elected an associate of the Society two years later and his name was added to the roll of members in 1908.

Caen is just about as close to home as the British can be in Europe, but the three artists we are about to consider were far more adventurous and travelled beyond Europe for their subjects. We have already suggested what an impact on public, critics and artists alike J. F. Lewis's *Hhareem* had when it was his sole contribution to the 1851 exhibition. Lewis was not the first British painter to travel to the Middle East, but his example did pave the way for many others to follow his quest for exotic subject matter and the brilliant light and colours that the Arab world provided.

By the time he reached his twenties, Arthur Melville was already a seasoned traveller. Born in Forfarshire in 1858, he studied at the Royal Scottish Academy Schools and later in Paris. In 1881, after three years in the city, Melville embarked on an adventurous journey eastwards, travelling from Egypt and the Gulf on to India. He did not return to his native Scotland until 1884. Melville's powerful style had by this time matured and the pictures of far-off lands that he exhibited so impressed artists and critics that he was soon heralded as a leader of the emerging Glasgow School. Coloquially known as the 'Glasgow

Arabs Returning from Burning a Village
ARTHUR MELVILLE RWS (1858-1904)
Watercolour and gum over graphite
22⅝ × 18½ ins

Melville's expressive freedom can barely be appreciated in this small-scale illustration which reveals the composition of the work. However, the brush-strokes of one of his most extremely abstract paintings begin to make sense here and create an unforgettably evocative image.

Boys', these bold and expressionistic colourists were among the more progressive British painters of their period. In recent years they have begun to recover the interest of the art world that their work so deserves.

Two years after his return from the East, Melville was elected an associate of the Royal Scottish Academy. He soon moved south to London and in 1888 he joined the RWS as an associate, becoming a member in 1899. His broad handling of watercolour was a revelation to his contemporaries. Many of his most celebrated works – for example the dramatically atmospheric bull-fight pictures – were carried out with a freedom comparable to the methods being developed by the most avant-garde European artists of the day, from the Post-Impressionists to the young Picasso.

Melville seems to us a very modern artist, but in his period it is very easy to mistake freedom of technique for the concerted attempt to break down preconceived ideas of representational picture-making then taking place in France. Even his most 'abstract' works, such as the bull-fight series, with their clouds of dust and wonderful crowd scenes, do however have their origin in nineteenth-century values of pictorial representation. They are free descriptions of a very recognisable visual reality.

Nonetheless, in his least conventionally figurative works, like the Diploma piece that was painted at the very end of the century, we come across an artistic vision well in tune with contemporary developments. Pictures by Melville like *Arabs returning from burning a Village* often baffled exhibition visitors by the apparently casual attention to detail, let alone the perhaps unsettling choice of subject. Kandinsky, that great pioneer of non-figurative art, was soon to treat landscape in a similarly detached, painterly and indeed symbolic way. Melville's approach to the production of his more extremely 'modern' watercolours makes him almost a precursor of the American Abstract Ex-

pressionist painters of the 1940s and 1950s.

In 1924 Melville was accorded the honour of being featured with Peter DeWint in the first volume of the Old Water-Colour Society's Club. This club was founded the previous year under the aegis of the RWS to be a central forum for appreciation and study of the art form. Its annual volumes have over the years built up the principal reference source for the history of watercolour painting in Britain. In that first volume, Romilly Fedden admirably describes the artist's methods and his extensive description is well worth quoting:

'So complete was Melville's mastery of technique that he deceived his critics. The public were under the impression that these works were brought to a conclusion by a genius if you will, but through somewhat haphazard, slapdash methods. Melville in reality was the most exact of craftsmen. He worked at high pressure yet with infinite patience. No picture was ever hurried over and finished up in time for exhibition. He could never let a picture leave his studio until all traces of labour had vanished from it. His method was pure watercolour, but applied on *prepared* paper. This paper was impregnated with chinese white, saturated again and again, and finally rinsed, leaving a prepared surface. He worked often wet, sponging out superfluous detail, running in those marvellous browns and blues and reds that he knew so well how to blend and simplify. He would at times work with his strained paper brimming with water flat upon the studio floor. When the paper dried he would add those rich, full, dark blobs of colour here and there which stand out almost as stencils on the blended, softened ground, yet give the just relief and emphasis exactly where they are needed. When we look at a Melville watercolour, we are at once impressed by what in painting we understand as *quality* – beautiful paint, beautifully handled, the perfect juxtaposition of

The Mosque
HENRY SILKSTONE HOPWOOD RWS (1860-1914)
Watercolour and bodycolour
21⅜ ×15 ins

This illustration allows us to appreciate Hopwood's very broad technique and the blocking in of simple shapes of watercolour and bodycolour. The vista through the archway is well observed and the areas of shadow enliven the scene and create recession in this flat picture.

Punta Brava, Tenerife (*Detail*)
JAMES PATERSON RWS

Rather over life size, this illustration enables us to examine in detail the much worked painterly structure of Paterson's picture. In particular our attention might be brought to the cacti, the leaves of which have been swiftly dragged out of the washes with a rag.

the lost and found edge, that *matt* texture which is exclusively the property of watercolour and which at the same time can be transparent and sparkling.'

This enthusiastic pen-picture of Melville's technique applies so well to his Diploma work that it could almost have been written about this painting. Fedden's description of the artist working on a soaked and floor-bound sheet of paper is what puts one in mind of the Abstract Expressionists and the result we see reproduced here is evidence of the appropriateness of this connexion.

Melville's *Arabs* is scarcely a portrayal of people; the foreground horseman or horsemen hardly exist after Melville's emphatic sponging out. The broken brushwork over the prepared base is pure abstract patterning. The ruddy hillside, down which ride the last band of horsemen, is dominated by a majestic cloud of smoke, sitting centrally, both symbolically and compositionally speaking as a keynote to the picture. Unrestricted as it is by conventions of topographical and pictorial reality, this Diploma work is one of Melville's most remarkably experimental pictures. Art historians often benefit from the technical evaluation of pictures made by conservators, who are so involved with the precise methods of artists. It is thus worth noting that Michael Warnes, who conserved this picture and has probably looked after as many Melvilles as any member of his profession, regards *Arabs* as among the painter's most exceptional performances.

It can only be an exercise in speculation to prophesy to what extremes of modernity Melville would have taken his art had he lived beyond his forty-sixth year. But like Girtin, who of course had a much shorter lifespan in which to convey his genius, Melville was an influential artist who had much to offer his followers and admirers. His period of RWS membership was very brief and contrasts with the less dynamic but certainly most substantial contribution to the Society's exhibitions made by Henry Silkstone Hopwood, who also died too young at the age of fifty-four.

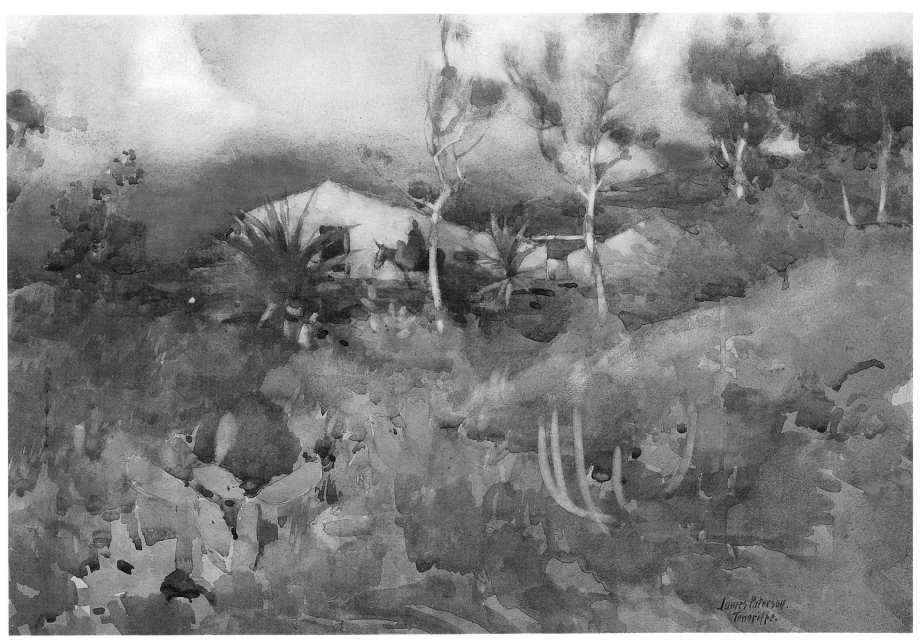

Punta Brava, Tenerife
JAMES PATERSON RWS (1854-1932)
Watercolour
14½ × 20¾ ins

Paterson's freely handled and exotic composition can be much enjoyed and studied in this illustration. Like Melville and other Scottish painters of the time, he developed an expressionistic style eminently suited to the depiction of semi-tropical vegetation and the light of a hot and colourful climate.

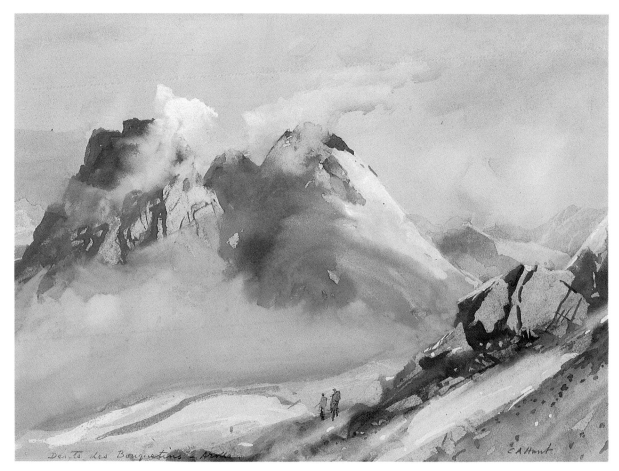

Dents des Bouquetins, Arolla
CECIL ARTHUR HUNT (1873-1965)
Bodycolour over graphite
10½ × 14¼ ins

This illustration allows us to appreciate the varying and skilful application of bodycolour. The swirling cloud is an impressive tour de force, characteristic of the artist.

Born in Leicestershire in 1860, Hopwood went on to take up a business career, during which he attended evening classes at the Manchester School of Art. His travels were extensive, encompassing Australia, then Antwerp and Paris, in which cities he pursued his artistic training, and later North Africa and Japan. Hopwood also spent much time in the area around Montreuil in France, the scenery of which was the subject for many of his watercolours . He was elected an associate of the RWS in 1896 and his full membership arrived in 1908, six years before his death.

Hopwood's Diploma work, known simply as *The Mosque*, depicts a group of Arab men descending a staircase from what may be a café at Biskra. Without the freedom of Melville's powerful handling, this work nevertheless reveals Hopwood to be most expressive in his painterly abilities. Working wet-in-wet and wet-on-dry, the artist has vigorously brushed in the figures that are really a series of abstracted shapes, within the simple, centrally orientated composition. Discreet in its colour range, the painting relies on the

bold uncomplicated forms of the bulkily-clad figures to pull together the composition. Their recession from daylight into shade and out beyond to sunlight provides the only three-dimensional aspect of the otherwise flattened picture plain.

Like Melville, Hopwood has attacked the paper with brush and sponge, allowing a variety of effects to emerge from his handling. For instance, the brown robe of the figure standing to the right of the foreground is washed in over some prepared surface that causes the pigment to diverge into tiny rivulets, thus utilising the rough paper surface to enhance the texture of the painting. Most of the whites we observe are sponged out of previously dark areas of paint and sometimes heightened with chinese white.

By the early years of the century, when Hopwood painted *The Mosque*, the portrayal of oriental subjects had long been considered attractive by collectors of watercolours. James Paterson, another Glasgow painter, who was influenced by Melville, travelled as far afield as Hopwood and his Diploma work is of *Punta Brava, Tenerife*. On Melville's technique, we read Romilly Fedden describing the artist's ability to achieve 'the perfect juxtaposition of the lost and found edge'. Paterson's approach also involves the search for this elusive quality of painterly technique.

In *Punta Brava*, the trees are set against the moody sky as blurs of paint, sponged and brushed wet-in-wet. Complementary sharp edges are made to emphasise the central vista of the buildings and also the figure on a mule and the middle-ground plants. With sweeping but controlled strokes of a rag, Paterson also finds an appropriately hard shape for the image of a cactus plant in the right foreground. Other cacti to the left are painted dry and stand out well against the atmospheric and watery distant view. The relatively luminous middle-ground is thrown into relief against the deep blue hills and drifting clouds in the distance. The composition itself is a satisfying admixture of painterly passages, which through differentiation of emphasis allows the eye to concentrate on the centrally placed principal subject.

Even in this richly coloured work is evident the sometimes gloomy palette Paterson used to depict his native country. Nonetheless he is a powerful user of the colourist's brush and an estimable member of the Glasgow School. He trained at the city's art school, and later in Paris, returning to live and paint in Scotland, from which base he made forays to various mainly European countries. Paterson was brought into the Society as an associate in 1898 and became RWS ten years afterwards. Also a member of the

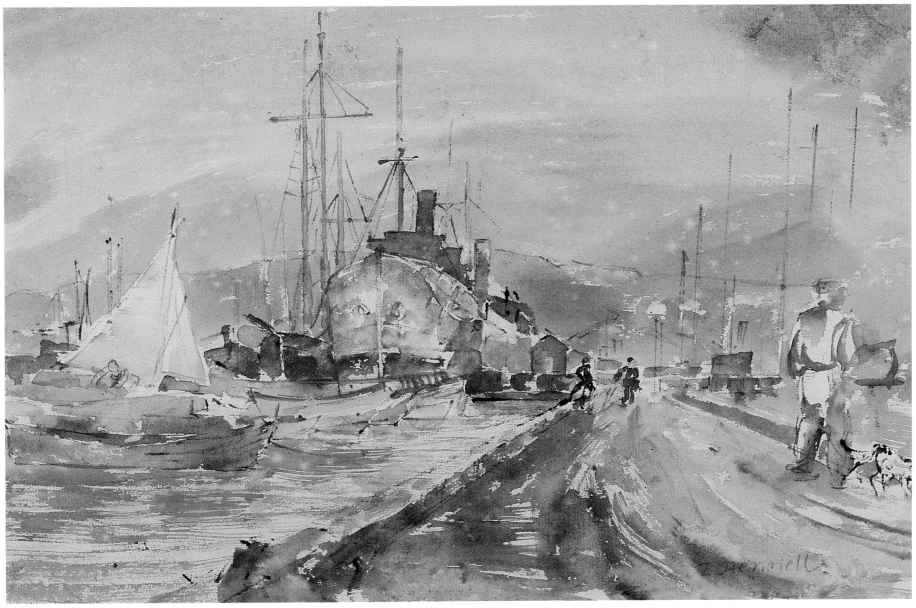

Reykjavik Harbour
THOMAS HENNELL RWS (1903-45)
Watercolour over graphite on buff paper
12⅜ × 18¾ ins

We can almost feel the damp and chill in this illustration
of Hennell's Diploma work. The rapid brush work and
freely handled washes can clearly be seen, as can the spots
of real rain in a washed sky.

Royal Scottish Academy, he was to be President of the Royal Scottish Society of Painters in Water-Colours from 1923.

In his inimitable article on the career of Cecil Arthur Hunt, published in the 1963 volume of the Old Water-Colour Society's Club, Adrian Bury described Hunt's technical methods and his predilection for mountainous scenery thus: 'I have been conscious of a visionary who tries to expand his technique by his imagination rather than limit his imagination to a rigid technical system. His love of mountain form has stimulated a poetic mind to interpret artistically what are the most steadfast and awe-inspiring of natural phenomena.' Of several works by Hunt in the Society's possession, the Parsons Bequest picture of *Dents des Bouquetins, Arolla* is perhaps the most remarkable for its technical verve and understanding of its subject.

The subject in question is a group of Alpine peaks – literally translated as The Ibex Horns. They are clothed in drifting cloud and set in the middle distance beyond a glacier and a rocky mountainside foreground, from which two walkers observe the spectacular scene. The presence of these figures emphasises the scale of the scenery and they also serve a purpose noted much earlier in this book, when we saw Varley and Copley Fielding providing a human witness to lead the observer into the scene. Cecil Hunt was born in Torquay in 1873, and elected ARWS in 1919, six years before his elevation to membership. He exhibited regularly with the Society until his death in 1965.

For much of his long life, Hunt produced views of Alpine scenery. It is the mysterious and forbidding grandeur of the mountains which he so successfully expresses in the present work. The swirling grey-blue cloud is captured by broad washes of bodycolour, dominantly consisting of chinese white, which is itself the medium used to depict the brightest areas of cloud and snow. The paint is applied in varying degrees of wetness, over a graphite structure that tightly holds together the composition. There have been few artists since Turner who have so effectively exploited the potential expressiveness of bodycolour used as the principal medium in a picture. C. A. Hunt's technical mastery of the medium allows him to represent an impressive variety of weather effects by skilful manipulation of paints of varying consistency.

The artist working in pure watercolour almost by definition has less opportunity to alter the substance and texture of his picture to suit his subject. Although he may apply more gum here and there, he essentially achieves his effects by soaking pigment-bearing water into the texture of the paper. Bodycolour adds an extra dimension: that of tangible opacity. In the present instance Hunt's particular skill lies in the way he alternately thins and thickens the paint, applying it vigorously or precisely, to achieve effects of contrasting areas of swirling and static cloud. In other words he manages to give pictorial form to movement, or the lack of it, through the manner of his handling of paint. The broad swirl of cloud around the peaks of the crisply painted *Dents des Bouquetins* is really the subject of this work.

Alpine scenes had become a stock in trade of British watercolourists long before Hunt made his pilgrimages to the European mountains. From Turner's 1819 journey through the Alps to Italy, rapture before the dramatic spectacle of such scenery had been a constant inspiration of many artists. We have to remember that it was the British who pioneered mountaineering and winter sports as suitable pursuits for the adventurous middle and upper classes. Today's numerous British visitors to the ski slopes and mountain peaks keep alive a long-standing national affection for the Alps.

Despite the grandeur of our Scottish and Welsh mountains, truly Alpine-like scenery does not exist within our shores. One of the primary motives of foreign travel is to experience landscapes and places unlike anything to be found in one's native land. It was very much in this spirit that the first Alpine visitors made their brave and pioneering treks. Although conditions were much improved in Hunt's day and are still further in the 1980s, the high mountains are dangerous places and it is their awesome beauty and an element of risk which together constitute for many a thrilling attraction. Hunt appreciated the majesty of the mountains and sought to convey this in his work, often pointing out the swiftly changeable weather conditions which can make them so hazardous.

With our next picture, we again move away from Europe and to a country not normally on the itinerary of the travelling watercolourist – Iceland. The reason for Thomas Hennell's choice of *Reykjavik Harbour* for a subject is a simple one: he was there as Official War Artist, under the direction of Kenneth Clark's War Artists Advisory Committee. In this capacity, Hennell also took part in the 1944 invasion of France, recording battle scenes in Normandy. He worked too in Holland and India but in 1945 met his death at the hands of Indonesian terrorists in Burma.

A good traveller, he should be equally remembered as one of the most talented exponents of watercolour in this century. While war artists like Russell Flint, Graham Sutherland, Henry Moore and John Piper have long received great acclaim for the effectiveness of their drawings produced at this time of national crisis, Hennell's reputation has lagged way behind these major figures who survived him. But now, long overdue credit is confirming his status as a significant figure. That he was sadly unable to build on his wartime career was one reason for the lack of public awareness of his work in the post-war years. Recent reassessment of the work of World War II artists and a great revival of interest in twentieth-century figurative painting have at last placed people like Hennell in the upper ranks.

Thomas Barclay Hennell was born in 1903 and studied at the Regent Street College where the teaching of A. S. Hartrick, an RWS member who had himself been directly influenced by Paul Gauguin and the Pont Aven painters, had a great impact on his art. He was elected as an associate in 1938 and a member of the Society in 1942. The Diploma work illustrated here was painted the following year during his despatch to Iceland. It shows a British warship at anchor in the capital's harbour, but the principal interest of the watercolour is in the rendition of a seemingly cold, wet and grey day.

There can be little doubt that this painting was executed on the spot. Not only do the freshness and vigour of the handling indicate a wish rapidly to lay down on paper the subject and atmospheric conditions, but we also find that the weather has been physically involved with the production of the picture. In Hennell's superbly washed sky are evident several light spots that must surely have be been created by raindrops. These serve to provide an additional dimension of reality to what is already a work of great integrity and immediacy. We can almost feel as well as see the climatic conditions under which he was working.

Over a summary graphite under-drawing, Hennell has laid in his colour with a dynamically wielded wet

Arabs Returning from Burning a Village (*Detail*)
ARTHUR MELVILLE RWS

Here we see part of Melville's Diploma work, reproduced at its actual size. We can now study the full force of the artist's dramatic brush technique and see how formless the various elements of the picture become when observed so closely.

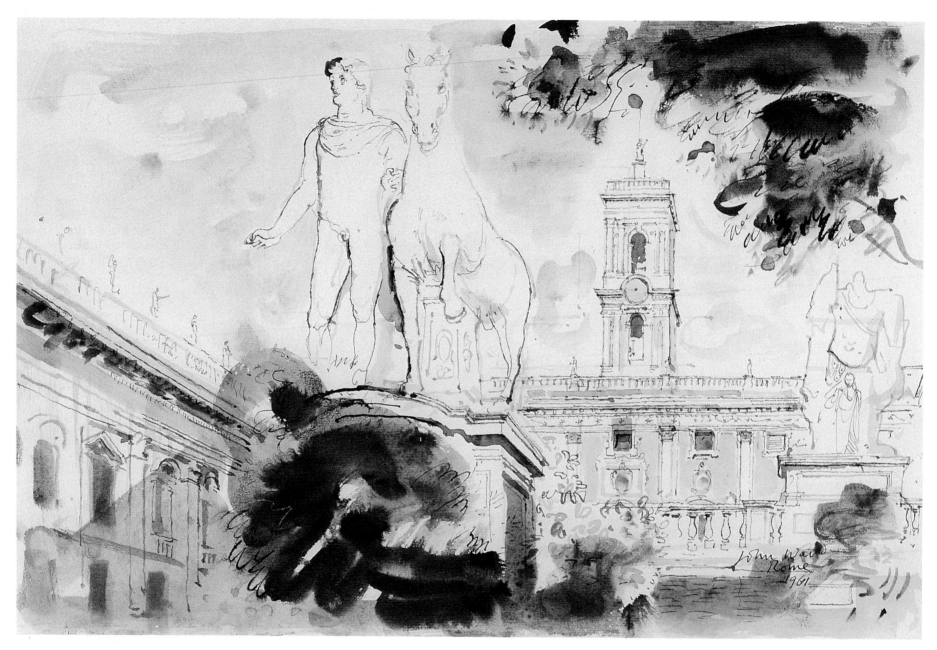

Rome
JOHN WARD RA RWS (b 1917)
Watercolour and pen and ink
12¾ × 18⅞ ins

Here we see the contrasting handling of areas of Ward's
picture. Very different use of ink is made to sweep in the
dense foreground foliage from the fine sensitive line that
describes the sculpture. This is more than simply a wash
drawing.

brush. The sky area was previously dampened – presumably by the artist and not the weather – and into this Hennell works his broad washes, not so much wet-in-wet, but 'wet-in-damp'. Other passages are similarly handled, but the broken brushwork that may clearly be seen in the foreground arises from the speedy dragging of a wet brush across dry textured paper. In fact the surface pattern of this buff sheet is not itself very pronounced. There is perhaps a lesson to be learned here by those amateur watercolourists who use rough-surfaced paper in the belief that it is the only support capable of giving anything but a smooth finish. Rough paper can dominate and control the feeling of a watercolour. No artist should allow his expression to be dictated by his materials; good painters make their mediums work for them. In this case Hennell has chosen a paper whose colour provides a suitable base for his washes and, when left untouched, gives the keynote to the colour scheme. His paper is likewise sufficiently smooth to allow the application of sweeping washes and rutted enough to break up a swiftly dragged brush-stroke. It is a pleasure to study the dramatic activity of Hennell's brushwork.

We finish our travels abroad with a visit to sunnier climes. We return again to that mecca for British artists through the centuries, Italy, and a view of a Roman piazza by John Ward. Like his nineteenth-century predecessors, Ward loves to travel in search of topographical subject matter. Also like many of them he has a particular affection for Italy and his stays in Venice, as mentor and painting companion for such distinguished amateur watercolourists as the Prince of Wales and Lord Thorneycroft, have been newsworthy enough to extend his already considerable status as one of Britain's leading painters to an unusually wide audience. He is justifiably acclaimed too for his portraits in oil and watercolour of leading national figures.

John Ward was born in Herefordshire in 1917 and studied art there and later at the Royal College, where he came under the influence of Gilbert Spencer. He served in the Royal Engineers from 1939 to 1946 and went on to work as an illustrator for *Vogue* magazine between 1948 and 1952. In 1959 he illustrated *Cider with Rosie* for Laurie Lee. But he had already for some years been turning his main focus of interest from illustration work to painting and his election to associateship of the RWS had come about in 1952. Owing to a long absence from the Society's exhibitions, full membership did not arrive until 1986, by which time he was well established as one of the finest post-war painters in watercolour. Recognition by the Royal Academy was given in the meantime and he was elected ARA in 1956 and RA in 1965.

Ward's career as an illustrative artist is reflected in this Diploma work, in which graphic qualities of line and simplified form describe a topographical subject. The ability he has to selectively emphasise important areas of the scene is also a hallmark of the fine illustrator. Ward sets off his fine pen drawing of the principal buildings and statuary with dashing blurs of wet-in-wet and wet-in-dry brushwork. In particular we should remark on the charged and seemingly impulsive strokes of dark brown watercolour or ink representing foliage, which throw these passages into pictorial relief and give emphasis to the delicacy of his line work.

John Ward's drawing provides a fitting note on which to end this chapter. Back in the land which is the cradle of our modern European artistic heritage, this contemporary painter finds as much inspiration in the wealth of Italy's art and culture as did Prout or Harding. And there, in 1961, he had just as much to say about this heritage in the language of modern art as his forebears did within the stylistic confines of their own age. And, like Prout and Harding, Ward is a fine draughtsman, admirably capturing the outlines of sculptural and architectural forms. The sensitive quality of his drawing is the essence of this watercolour's success. If we feel that Prout's drawing and watercolour technique is at times mechanical in effect as well as conception, this is not a criticism that can easily be levelled at Ward. He is of an age in which the opening up of international frontiers of contemporary artistic influence has allowed ready access to and appreciation of the work of such great modern draughtsmen as Picasso and Matisse. In the freedom of his line John Ward has assimilated such influence, without slavishly imitating the manner of any other artist.

And so we leave the travellers. We live in an age when air-travel can carry us to the farthest corners of the planet in a matter of hours. Artists like Ward now make extensive use of this facility to travel and paint. No longer do they have to suffer the ordeal of weeks of horse-drawn journeys over rough roads in search of subjects with which they will later enthral the London audience.

POSTSCRIPT

Notwithstanding the relative comfort of contemporary transport, painters still make a significant aesthetic and financial commitment by presenting themselves before any subject at home or abroad, with brush in hand and exhibition in mind. They have to buy materials, they have to pay for travel and framing expenses and, when any picture is sold, they have to yield commission to the gallery and pay tax on this to the Government. When you next look at a modern watercolour in a commercial gallery show, remember that for every hundred pounds worth of work on exhibition, it is quite likely the painter will carry around fifty pounds to his bank from those pictures he is lucky enough to sell. After all this, he then has to pay his income tax.

It is therefore hardly a surprise to learn that at least one observer has reckoned that only around one hundred professional artists practicing in Britain today receive a comfortable living from their creative production alone. One hopes that the current buoyancy of the market may help to alleviate the financial pressure on many watercolourists that enforces them to rely on other income besides the sale of work. Teaching is, of course, a most necessary element of the fabric of artistic life, but there are many respected teachers who would dearly love to be able to devote more time and energy to the pursuit of their own creative development. The better supported contemporary painters are, the more substantial will be the artistic heritage of the future.

Samuel Prout made a fair living out of his overseas excursions. Let us hope that younger members of the Royal Society of Painters in Water Colours, such as Gregory Alexander (whose Diploma work set in Kenya was illustrated in the Introduction), will be accorded similar financial stability to further their talents to the benefit of their careers and of the future of our national art of watercolour.

INDEX OF MEMBERS AND WORKS

Index of associates, members and Honorary members of the Royal Society of Painters in Water-Colours, together with works by them in the Collection of the Society as at July 1987 and the page numbers of illustrations in this book.

The artists are listed alphabetically. Immediately following the Christian name is the title of Royal Academician and Presidency of the Society where appropriate. This is followed by the dates of birth and death, and then, in brackets, by the dates of election respectively to associateship and full membership of the Society. When an artist has only been elected an associate (or fellow exhibitor) or only a member, this is recognised by the elimination of the other category of membership by a dash (-). In the case of Presidents a third date is given for first election to this office. In the case of Honorary members (indicated immediately after the Christian name) just one date of election is usually given.

Election to associateship, membership or Presidency does not necessarily imply that this membership was held until the death of the artist. Notwithstanding this fact, it may otherwise be assumed that those artists living after the granting of the Royal title in 1881 should be described as ARWS (associates) or RWS (members). Artists who died before 1881 should be described as AOWS (associates) or OWS (members)

Following the artists' election dates are the titles and inventory numbers of works by them in the permanent Collection of the Society. Those works that have a number including the letters 'PB' are part of the Parsons Bequest, 1979 and 1986. Otherwise, the drawings are Diploma works or gifts from other sources and this can be checked with the RWS.

Following the inventory number the **bold** type indicates the page reference of the work in this book, if the work is illustrated. Following this is the name of the person or organisation who have adopted the picture for conservation.

ARA	associate Academician of the Royal Academy of Arts
b	born
c	circa
fl	flourished, ie. is known to have been alive at this time
(Hon)	Honorary member
(Hon1967)	Honorary member also elected to associateship or membership and date of election to Honorary membership
Jr	junior
(p99)	page number of illustration in this book
PB	Parsons Bequest
POWS	President of the Society of Painters in Water Colours (Old Water Colour Society)
PRA	President of the Royal Academy of Arts
PRWS	President of the Royal Society of Painters in Water-Colours
RA	Royal Academician
RWSX0999	Royal Society of Painters in Water-Colours inventory number

Clark, Jean Manson b1902 [1965,1972]
Our Village, February RWSC0066
Clark, John Cosmo, RA 1897-1967 [1950, 1952]
Cafe in Provence RWSC0065
Clark, Norman Alexander b1913 [1953,1960]
London to Brighton Car Run RWSC0067
Clausen, Sir George, RA 1852-1944 [1889,1898]
A Sunny Orchard RWSC0069
Girl and Flowerpot RWSC0068 **(p66,67)**
Adopted by Tom Caldwell Galleries
Clausen, Katherine 1886-1936 [1931,-]
Clennel, Luke 1781-1840 [1812,1812]
Coates, Thomas J b1941 [1983,1985]
French Farmhouse and Dovecote RWSC0096
Coke, Dorothy J 1897-1979 [1935,1942]
Longage, Near Folkestone RWSC0070
Collingwood, William 1819-1903 [1855,1884]
Mountain Scene RWSC0071
Connard, Philip, RA 1875-1958 [1932,1934]
Barges at Gravesend RWSC0072
Buildings, Water and Swans RWSC0073
Cooper, Mario (Hon) b1905 [1978]
Cotman, John Sell 1782-1842 [1825,-]
Cowern, Raymond Teague, RA 1913-1986 [1940,1947]
A House in the Paragon, Bristol RWSC0075
Cowles. Geoffrey Clement 1897-1981 [1962,1974]
Seated Nude RWSC0076
Cowper, Frank Cadogan, RA 1877-1958 [1904-1911]
Portrait of J W North RWSC0077
Cox, David 1783-1859 [1812,1812]
Ffestiniog RWSC0079
Figures on Horseback Crossing the Sands RWSPBC19 **(p109)** Adopted by a Friend
Fort Rouge, Calais RWSC0081 **(p161)**
A Welsh Village RWSC0078 **(p124,125)**
Adopted by Diners Club International
Cox, David, Jr 1809-1885 [1848,-]
Cramp, Elizabeth Frances b1929 [1970,1976]
Window RWSC0080
Cramp, Jonathan David b1930 [1974,1978]
Pembrokeshire Landscape RWSC0083
Crane, Walter 1845-1915 [1888,1902]
The Fountain of Life RWSC0084 Adopted by Amanda Sebestyen
Crawford and Balcarres, Earl of (Hon) 1900-1975 [1938]
Criddle, Mary Ann 1805-1880 [1849,-]
Cristall, Joshua, POWS 1767-1847 [-,1804,1816]
Delphi RWSC0088
Jason and Medea RWSC0086
Landscape RWSC0090
Self Portrait (oil painting) RWSC400
Sepia Landscape RWSC0089
The Basket Girl RWSC0085 **(p53)**
The Peaks of Snowdon RWSC0087
Crocket, Henry Edgar 1870-1926 [1905,1913]
Tilford Bridge RWSC0091
Cundall, Charles Ernest, RA 1890-1971 [1935,1941]
The Old Town, Hastings RWSC0092 **(p135)**
Adopted by Roy Graf

Dalby, Claire b1944 [1973,1977]
Narcissi RWSD0398
Danby, Thomas 1818-1886 [1867,1870]
Landscape RWSD0097
Daniels, Alfred b1924 [1972,1978]
Davidson, Charles 1824-1902 [1855,1858]
Davis, Louis ?-1942? [1898,-]
Dawber, Sir Edward Guy, RA (Hon)

c1860-1938 [1938]
Dawson, Nelson 1859-1941 [1921,1941]
Deacon, Charles Ernest (Hon) flc1934-1964 [1958]
Deane, William Wood 1825-1873 [1870,-]
De Grey, Roger, PRA (Hon) b1918 [1985]
Delamotte, William Alfred 1775-1863 [1806,-]
Dent, Reginald Stanley G b1909 [1983,1986]
Andalusia RWSD0110
DeWint, Peter 1784-1849 [1810,1811]
Cannock Chase RWSD0109 Adopted by Diners Club International
The Thames at Windsor RWSD0099 **(p76,77)**
Adopted by Diners Club International
Dinkel, Ernest Michael 1894-1983 [1939, 1957]
Boat in Eoligarry Harbour RWSD0100
Dobson, William Charles Thomas, RA 1817-1898 [1870,1875]
Dodd, Francis, RA 1874-1949 [1923,1929]
Turner Road, SE3 RWSD0101
Dodgson, George Haydock 1811-1880 [1848,1852]
Scene From 'As You Like It' RWSD0102
Dollman, John Charles 1851-1934 [1906,1934]
The Ravagers RWSD0103
Dorrell, Edmund 1778-1857 [1809,1809]
Doyle, John b1928 [1977,1983]
Fortified Church of Beaurain RWSD0104
Dring, William, RA b1904 [1942,1957]
The Gareloch RWSD0105
Du Maurier, George Louis Palmella Busson 1831-1896 [1881,-]
Love the Debt RWSD0106
Duncan, Edward 1803-1882 [1848,1849]
Rescuing the Flock RWSPBD22
The Approaching Wreck RWSD0107 **(p104-5)**
The Old Gull Light RWSD0108
Duncan, Walter fl1869-1906 [1874,-]
Dunkley, Keith b1942 [1968,1978]

Eccleston, Harry Norman b1923 [1964,1975]
Putting Green RWSE0111
Eldridge, Mildred Elsie b1909 [1942,1956]
Studies of Blue Tits RWSPBE24
Study of Grey Squirrel RWSPBE91
Emslie, Alfred Edward 1848-1917 [1888,-]
Seated Arab with Black Boy Holding a Vessel RWSE0113
Essex, Richard Hamilton 1802-1855 [1823,-]
Evans, Samuel Thomas George 1829-1904 [1858,1890]
Evans, William, 'of Bristol' 1809-1858 [1845,-]
The Old Bridge RWSE0112 **(p72-3,81)**
Adopted by the Woolwich Equitable Building Society
Evans, William, 'of Eton' 1798-1877 [1828,1830]
Eyton, Anthony, ARA b1923 [1985,-]

Fairclough, Wilfred b1907 [1961,1967]
Trees RWSF0114
Field, Walter 1837-1901 [1880,-]
Watering Place, Shiplake RWSF0115
Fielding, Anthony Vandyke Copley, POWS 1787-1855 [1810,1812,1831]
In the Highlands RWSPBF25 **(p34,35)**
Adopted by Diners Club International
Snowdon RWSPBF26
Fielding, Mary Anne fl1821-1835 [-,1821]
Fielding, Thales 1793-1837 [1829,-]
Finch, Francis Oliver 1802-1862 [1822,1827]
Classical Landscape RWSF0116
Findlay, Sheila Anne Macfarlane b1928

[1969,1982]
Still Life A RWSF0117
Still Life B RWSF0118
Flanders, Dennis b1915 [1970,1976]
Fleetwood Walker, Bernard, RA 1893-1965 [1940,1945]
Sally RWSF0119
Flint, Francis Russell 1915-1977 [1955,1968]
Wet Sands at Polzeath RWSF0120
Sudbury Hall RWSF0389
Flint, Robert Purves 1883-1947 [1932,1937]
The Bridge, Albi RWSF0121
Koog Aan de Zaan RWSF0122
Landscape RWSF0124
Flint, Sir William Russell, RA PRWS 1880-1969 [1914,1917,1936]
Incoming Tide, No. 1 Slip, Devenport Dockyard RWSF0124 **(p118,120-1)** Adopted by David Mussett Ltd
Forbes, Elizabeth Adela Stanhope 1859-1912 [1899,-]
Foster, Mary 1853-1885? [1884,-]
Foster, Myles Birket 1825-1899 [1860,1862]
The Artist's Palette RWSF0130
The Green Lane RWSF0125 **(p58)** Adopted by The Lyndhurst Settlement
Freebairn, Robert 1765-1808 [1805,-]
Freeth, Hubert Andrew, RA 1912-1986 [1948,1955]
Grandma and the Boys in Trafalgar Square RWSF0126 **(p139)**
Fripp, Alfred Downing 1822-1895 [1844,1846]
Sta Rocco, Olevano RWSF0127 **(p171)**
Adopted by Abbott and Holder
Fripp, Charles Edwin 1854-1906 [1891,-]
Fripp, George Arthur 1813-1896 [1841,1845]
Namur RWSF0128
Fry, Arthur Malcolm (Hon1959) b1909 [-,1977]
Weald of Kent RWSF0129

Gaa, Christa b1937 [1986,-]
Still Life with Pottery Duck RWSG0419
Gamble, Tom b1924 [1987,-]
Whitechapel Pavement RWSG0436
Gaskell, W J C 1906-1966 [1955,1961]
Gastineau, Henry 1791-1876 [1821,1823]
Moonlight – Landscape with a Water Mill RWSG0131
Gere, Charles March, RA 1869-1957 [1921,1926]
A Drink at the Pool RWSG0132
Gilbert, Sir John, RA PRWS 1817-1897 [1852,1854,1871]
Joan of Arc RWSG0133
The Hanging Committee of the Water Colour Society, 1870 RWSG0134 **(p15)** Adopted by the Friends of the Royal Society of Painters in Water-Colours
The Presentation of an Album Containing Sketches by Members of the R W Society Accepted by Her Majesty as a Souvenir on the Occasion of her Golden Jubilee, 1887 RWSG0135 **(p17)**
Gillies, Margaret 1803-1887 [1852,-]
Gilpin, William Sawrey POWS 1762-1843 [-,1804,1804]
Farmyard Scene with a Donkey RWSG0151
View near Wormholt Scrubs from the Paddington Canal RWSG0136 Adopted by The Royal Borough of Chelsea and Kensington District Fine Art Society
Ginger, Phyllis Ethel b1907 [1952,1958]
St Marylebone Parish Church RWSG0137
Robert Austin RWSG0138
Ginner, Charles, ARA 1878-1952 [1938,1945]
Street Scene RWSG0139 **(p132,133)**
Gladstone, William Ewart (Hon) 1809-1898

[1873]
Glennie, Arthur 1803-1890 [1837,1858]
Landscape at Paestum RWSPBG28
Glindoni, Henry Gillard 1852-1913 [1883,-]
Glover, John POWS 1767-1849 [-,1804,1807]
Caernarvon Castle RWSPBG29
Sepia Landscape A (attributed) RWSG0140
Sepia Landscape B (attributed) RWSG0141
Gluck, David b1939 [1985,-]
Oak Tree, River Medway, Fordcombe RWSG0418
Goodall, Edward Angelo 1819-1908 [1858,1864]
A Smithy at Seville RWSG0142
Goodall, Walter 1830-1889 [1853,1861]
Goodwin, Albert 1845-1932 [1871,1881]
Glastonbury RWSG0144 **(p41)** Adopted by Chris Beetles Limited
The Afterglow, Venice RWSG0143
Gorell, Baron Ronald (Hon) 1884-1963 [1939]
Gouldsmith, Harriett 1787-1863 [-,1813]
Granger Taylor, Mrs E ?-c1958 [1936,-]
Gray, Ronald 1868-1951 [1934,1941]
Blakeney RWSG0146
Blakeney Quay RWSG0147
High Ham RWSG0148
Ted RWSG0145
Plus a collection of other works by the artist
Greensmith, John b1932 [1976,1983]
Playing in the Snow RWSG0405
Self Portrait RWSG0423
Greenwood, Ernest, PRWS b1913 [1962,1972,1976]
Spring RWSG0149
Gregory, Charles 1850-1920 [1882,1883]
Dolwyddelan RWSG0150
Gross, Anthony, RA 1905-1984 [1948,-]

Haag, Carl 1820-1915 [1850,1853]
Street Musicians of Cairo RWSH0152
Hackney, Alfred b1926 [1964,1972]
Hackney, Thomas Arthur b1925 [1951,1957]
Church Tower RWSH0153
Flintstone RWSH0154
Hale, William Matthew 1837-1929 [1871,1881]
Ben Eagh, Loch Maree RWSH0155
Loch Maree RWSH0156
Hall, Arthur Henderson 1906-1983 [1958,1970]
View of Perth RWSH0157
Supper in the Garden RWSH0158
Hall, Oliver, RA 1869-1957 [1916,1919]
Study of Avignon RWSH0159
Halliday, Charlotte b1935 [1971,1976]
London Terrace RWSH0421
Hamilton Holden, Douglas 1919-1972 [1953,1961]
Hardie, Martin (Hon) 1875-1952 [1943]
The Seine at Chantemesle RWSH0161
Harding, James Duffield 1797-1863 [1820,1821]
Verona RWSH0162 **(p166)**
Old Farm Building, South Brent RWSH0163
Hardwick, John Jessop 1831-1917 [1882,-]
Flowers RWSH0164
Hardy, Heywood 1842-1933 [1885,-]
Harper, Jean b1921 [1960,1966]
Mother and Child RWSH0165
Harris, Josephine b1931 [1967,1974]
The V & A from the RCA RWSH0166
Harrison, George Henry 1816-1846 [1845,-]
Sunlight and Shadow RWSH0167
Harrison, Maria ?-1904 [1847,-]
Hartrick, Archibald Standish 1864-1950 [1910,1920]
Clevedon RWSH0170

Italian Landscape RWSN0262
North, John William, ARA 1842-1924 [1871,1883]

Oakley, Octavius 1800-1867 [1842,1844]
O'Connor, John b1913 [1974,1982]
East Suffolk Storm RWSO0264
Oliver, Kenneth H b1923 [1956,1974]
The Walk RWSO0265

Palmer, Arnold (Hon) 1886-1973 [1957]
Palmer, Samuel 1805-1881 [1843,1854]
Shady Quiet RWSP0266 **(p26-7,145)**
Adopted by Diners Club International
Parker, John 1839-1915 [1876,1881]
Basil Bradley RWSP0267
Parsons, Alfred William, RA PRWS 1847-1920 [1899,1905,1913]
The Garden RWSP0268
Paterson, James 1854-1932 [1898,1908]
Glen Esth, Forfarshire RWSP0270 Adopted by Mrs Anne Paterson Wallace
Punta Brava, Tenerife RWSP0269 **(p180,181)**
Adopted by Mrs Anne Paterson Wallace
Payne, Henry A 1868-1940 [1912,1920]
Distant View RWSP0271
Payne, William c1760-c1830 [1809,1813]
The River Path RWSP0272
Pemberton, Muriel Alice b1909 [1959,1974]
Vase of Flowers A RWSP0273
Vase of Flowers B RWSP0274
Perrin, Brian Hubert b1932 [1959,-]
Phillip, Colin Bent 1855-1932 [1886,1898]
The Firth of Lorn RWSP0275
Phillips, Patrick 1907-1976 [1968,1975]
Chenonceaux RWSP0276
Phillott, Constance 1842-1931 [1882,-]
Philp, Harry (Hon) ?-1962 [1957]
Pilsbury, Wilmot 1840-1908 [1881,1908]
The Never Failing Brook, the Busy Mill RWSP0277 **(p91)** Adopted by the Woolwich Equitable Building Society
Pinwell, George John 1842-1875 [1869,1870]
A Seat in the Park RWSP0278 **(p129)**
Piper, John (Hon) b1903 [1980]
Pitchforth, Roland Vivian, RA 1895-1982 [1957,1958]
Kent Marshes RWSP0279 **(p48)**
Ramsgate Harbour RWSP0392
Pocock, Nicholas 1740-1821 [-,1804]
View of the Menai Straits from outside Bangor RWSP0280 **(p28)** Adopted by Diners Club International
Powell, Sir Francis 1833-1914 [1867,1876]
Squrr Dubh, Loch Coruisk RWSP0281
Poynter, Sir Edward John, PRA 1836-1919 [1883,1883]
Nude Study RWSP0430
Studies of Legs, Venus RWSP0431
Price, William Lake 1810-1891 [1837,-]
Procktor, Patrick (Hon1981) b1936 [-,1981]
On the Equator RWSP0417
Prout, Margaret Fisher ARA 1875-1963 [1938,1945]
The White Horse RWSP0282
Prout, Samuel 1783-1852 [-,1819]
Ratisbon RWSPBP61
In the Cathedral Porch RWSPBP62 Adopted by Mr and Mrs W H Statham
Lucerne RWSPBP63 **(p163)** Adopted by James Ford Smith
The Doge's Palace and the Grand Canal, Venice RWSPBP59 **(p164,165)** Adopted by Diners Club International
The Piazzetta San Marco and the Doge's Palace, Venice RWSPBP60 Adopted by Winsor and

Newton
Pugin, Augustus Charles de 1762-1832 [1807,1812]
Pyne, George 1800-1884 [1827,-]
Pyne, William Henry 1769-1843 [-,1804]

Rackham, Arthur 1867-1939 [1902,1908]
A Bargain with the Devil RWSR0284 Adopted by Diners Club International
Abbaye d'Ardennes, Caen RWSR0285 **(p177)**
Radford, Edward 1831-1920 [1875,-]
Ramsay, The Lady Patricia 1886-1974 [1940,1957]
Jungle Shrine RWSR0286
Rayner, Nancy 1827-1855 [1850,-]
Rayner, Samuel A flc1821-c1872 [1845,-]
The Book RWSR0287
Read, Samuel 1816-1883 [1857,1880]
The Rathaus, Marburg RWSR0288
Redpath, Anne, ARA 1895-1965 [1962,-]
Reinagle, Richard Ramsay, RA POWS 1775-1862 [1806,1806,1808]
Eagle RWSR0289
Remfry, David b1942 [1983,1987]
Richardson, Sir Albert E, PRA (Hon) 1880-1964 [1953]
Richardson, Thomas Miles, Jr 1813-1890 [1843,1851]
Lock at Windsor RWSPBR67 **(p82,83)** Adopted by Diners Club International
Norham Castle RWSPBR65
Norham Castle, Evening RWSPBR64 **(p85)** Adopted by the Friends of the Royal Society of Painters in Water-Colours
The Village of Säyn on the Pretsoh Bach, Rhine RWSPBR66 **(p172,173)** Adopted by R A Le Bas
Richter, Henry James 1772-1857 [-,1813]
Rigaud, Stephen Francis Dutilh 1777-1861 [-,1804]
The Genius of Painting Contemplating the Rainbow RWSR0290 **(p12)** Adopted by Diners Club International
Rigby, Cuthbert 1850-1935 [1877,-]
Riviere, Henry Parsons 1811-1888 [1852,-]
Rizvi, Jacqueline Lesley b1944 [1983,1986]
Still Life with Porcelain on a White Cloth RWSR0388 **(p69)**
Roberts, John Vivian b1923 [1958,1983]
The Young Bill Ward RWSR0301
Robertson, Charles 1844-c1891 [1885,1891]
Robins, William Palmer 1882-1959 [1948,1955]
Robinson, Frederick Cayley, ARA 1862-1927 [1911,1918]
St Christopher RWSR0291 Adopted by Solomon and Peres Ltd
Robson, George Fennel, POWS 1788-1833 [-,1813]
Sheep Drinking at a Pool RWSR0298
Roget, John Lewis (Hon) ?-1909? [1905]
A collection of drawings
Rooke, Thomas Matthews 1842-1942 [1891,1903]
Church Interior RWSR0293
Rue des Bonnetiers, Rouen RWSR0292 Adopted by The Friends of the Royal Society of Painters in Water-Colours
Rosenberg, George Frederick 1825-1869 [1847,-]
Rowntree, Kenneth [1943,-]
Rushbury, Sir Henry, RA 1889-1968 [1922,1926]
The Piazza, Verona RWSR0294
Ruskin, John (Hon) 1819-1900 [1873]
Russell, Sir Walter Westley, RA 1867-1949

[1921,1930]
The Boatyard RWSR0296
The Farmyard RWSR0295
The Ferry RWSR0299 Adopted by Diners Club International
Rutherston, Albert Daniel 1881-1953 [1934,1941]
Etruria RWSR0297

Sargent, John Singer, RA 1856-1925 [1904,1908]
River Bed RWSS0302 **(p87,88-9)** Adopted by Diners Club International
Schwabe, Randolph 1885-1948 [1938,1942]
Moat Farm, Alphamstone RWSS0303
Schwarz, Hans b1922 [1982,1983]
Quantocks, Somerset RWSS0346
Self Portrait 1 RWSS0437
Self Portrait 2 RWSS0438
Susan Hawker RWSS0439
Scott, Mary fl1823-1859 [-,1823]
Scott, William Henry Stothard, 'of Brighton' 1783-1850 [1811,-]
Scott Moore, Elizabeth b1904 [1966,1975]
Corsican Harbour RWSS0304
Man Seated at a Table RWSS0409
October Morning, Conway Castle RWSS0305
Seago, Edward Brian 1910-1974 [1957,1959]
Green's Farm RWSS0306 **(p45)** Adopted by Diners Club International
Seddon, Richard Harding b1915 [1972,1977]
The Martello Tower, Aldeburgh, Early Morning RWSS0408
Seebohm, Baron Frederic (Hon) b1909 [1987]
Segonzac, Andre Dunoyer de (Hon) 1884-1974 [1960]
Selby, William b1933 [1987,-]
Seward, Prudence Eaton b1926 [1967,1977]
Sharp, Paul S [1956,1960]
Fields in Hampshire RWSS0307
Surrey Landscape RWSS0308
Sharpe, Eliza c1796-1874 [-,1829]
Sharpe, Louisa 1798-1843 [-,1829]
Shaw, John Byam Liston 1872-1919 [1913,-]
Shaw, Margaret 1917-1983 [1962,1974]
The Window RWSS0309
Victorian Interior RWSS0397
Shaw, Nevil b1915 [1976,1983]
After the Football Game RWSS0310
Shelley, Samuel 1750-1808 [-,1804]
Love's Complaint to Time and (verso) sheet of studies RWSS0347
Shepherd, Philip Desmond b1927 [1977,1982]
Early Morning, Campo S Degola, Venice RWSS0407
Sheppard, Maurice Raymond, PRWS b1947 [1974,1977,1984]
Rest, Going Home from Work, Prescelly RWSS0311 **(p49)** Adopted by Diners Club International
The Visitor at St Martin's Park (Carel Weight) RWSS0421
Shepperson, Claude Allin, ARA 1867-1921 [1910,-]
The New Lodgers, a Fantasy RWSS0312
Shields, Frederick James 1833-1911 [1865,-]
Sillince, William Augustus 1906-1974 [1949,1958]
Lancing College RWSS0313
Thorn Trees RWSS0314
Simon, Lucien Jeanne (Hon) 1861-1945 [1921]
Sims, Charles, RA 1873-1928 [1911,1914]
The Little Archer RWSS0315
Skilton, Charles (Hon) b1921 [1973]
Slater, Joseph Edward b1902 [1965,1974]
Great Glen, Leicestershire RWSS0316

Smallfield, Frederick 1829-1915 [1860,-]
Smith, Arthur Reginald c1872-1934 [1917,1925]
Smith, David Murray c1865-1952 [1916,1933]
The Ross-shire Highlands RWSS0317
Smith, Erik 1914-1972 [1960,1971]
Smith, John 'Warwick', POWS 1749-1831 [1805,1806,1814]
The Copper Works on the Parys Mountain, Anglesey RWSS0318 **(p33)**
Smith, Stan b1929 [1987]
Smith, William Collingwood 1815-1887 [1843,1849]
Woodland Stream RWSS0319
Smythe, Lionel Percy, RA 1839-1918 [1892,1894]
Child in a Red Dress RWSS0321
La Tricotreuse RWSS0320
Smythe, Minnie fl1896-1955 [1901,1937]
Gorse RWSS0322
Sorrell, Alan 1904-1974 [1937,1942]
The Resurrection RWSS0323
Sorrell, Elizabeth b1916 [1958,1966]
Windswept Leaves RWSS0324
Sorrell, Richard b1948 [1975,1978]
Seascape with Rocks RWSS0325
Southall, Joseph Edward 1861-1944 [1925,1931]
A Cornish Haven RWSS0326 **(p117)** Adopted by Diners Club International
A Welsh Cliff RWSS0327
Spencer, Gilbert, RA 1893-1979 [1943,1949]
Oak Tree, Wellsham le Willows RWSS0328
Sproule, Sara b1914 [1968,1983]
Squirell, Leonard Russell 1893-1979 [1935,1941]
Hills near Settle, Yorkshire RWSS0340
Houghton Mill, Cambridgeshire, RWSPBS77
The Last Phase: Demolition at Ipswich RWSS0329 **(p136-7,138)**
Stephanoff, James c1787-1874 [-,1819]
The Crown of Laurels RWSS0059
Stevens, Francis 1781-1823 [1806,1809]
Stokes, Charles Adrian Scott, RA 1854-1935 [1920,1926]
The Durance at Sisteron, France RWSS0341
Stokes, Marianne 1855-1927 [1923,-]
Stone, Frank, RA 1800-1859 [1833,1842]
Sullivan, Edmund Joseph 1869-1933 [1903,1929]
Swan, Alice Macallan 1864-1939 [1903,1929]
Lady with Butterfly RWSS0342
The Birthday Gift RWSS0343
Swan, John Macallan, RA 1847-1910 [1896,1899]
Orchard RWSS0345
The Captive Maldonada RWSS0344

Tayler, John Frederick, POWS 1802-1889 [1831,1834,1858]
Goats RWSPBT53
The Huntsman RWST0348
Tayler, Norman 1843-1915 [1878,-]
Taylor, Jane b1925 [1985,-]
Thomson, John Leslie 1851-1929 [1910,1912]
A Summer's Sea RWST0349
Thorneycroft, Baron George Edward Peter (Hon) b1909 [1982]
Thurston, John 1774-1822 [1806]
Todd, Arthur Ralph Middleton, ARA 1891-1966 [1929,1937]
Mr Brown RWST0350
Topham, Francis William 1808-1877 [1848,1848]
Maiden with Cupid and Lyre RWST0351
Young Girls with Chicks by a Croft RWSPBT93

Tuke, Henry Scott, RA 1858-1929 [1904,1911]
Green Water RWST0352 **(p114,115)** Adopted by Diners Club International
Sailing Boat in a Harbour RWST0420
Turner, Katharine fl1900-1955 [1914,-]
Turner, William, 'of Oxford' 1789-1862 [1808,1808]
Cherwell Waterlilies RWST0353 **(p78,79)** Adopted by Sotheby's

Uwins, Thomas, RA 1782-1857 [1809,1810]

Varley, Cornelius 1781-1873 [-,1804]
Varley, John 1778-1842 [-,1804]
Bamburgh Castle RWSPBV82 **(p97,99)** Adopted by Brian and Barbara Wilson
Cader Idris, North Wales RWSV0359 **(p30,31)** Adopted by Diners Club International
Moel Hebog near Beddgelert, North Wales RWSV0358 Adopted by Diners Club International
Vernon Cryer, Joan b1911 [1970,1976]
Goats at Salina Bay, Malta RWSV0361
Vosper, Sidney Curnow 1866-1942 [1906,1914]
The Weaver RWSV0362 **(p146,147)**
Wainwright, William John 1855-1931 [1883,1905]
David Cox RWSV0363
Waite, Robert Thorne 1842-1935 [1876,1884]
Landscape with Goats RWSW0364 **(p38,39)** Adopted by Diners Club International
Wales, HRH The Prince of (Hon) b1948 [1982]
Walker, Frederick, ARA 1840-1875 [1864,1866]
Man and Child RWSW0367
Pencil Sketch RWSW0368
Sketch for A Friend in Need A RWSW0365
Sketch for A Friend in Need B RWSW0366
Walker, William 1780-1863 [1820,-]
Walker, William Eyre 1847-1930 [1880,1896]
Gypsy Encampment RWSW0369
Wallace, Sir Richard (Hon) 1819-1890 [1873]
Wallis, Henry 1830-1916 [1878,1880]
Walton, Edward Arthur (Hon) 1860-1922 [1917]
Ward, John, RA b1917 [1952,1986]
A City Walk RWSW0370
Rome RWSW0371 **(p186)** Adopted by Count John Manassei
Ward, Thomas William b1918 [1950,1957]
Hulks at Bideford RWSW0372
The Butterwick RWSW0373
Waterlow, Sir Ernest Albert, RA PRWS 1850-1919 [1880,1894,1897]
Crail, Fife RWSW0374 **(p131)** Adopted by Haden plc
Watson, Harry 1871-1936 [1915,1920]
The Chalk Pit RWSW0375
Watson, John Dawson 1832-1892 [1865,1870]
Watson, Thomas J 1847-1912 [1880,-]
Weber, Otto 1832-1888 [1876,-]
Webster, Norman b1924 [1966,1975]
Weguelin, John Reinhard 1849-1927 [1894,1897]
Venetian Gold RWSW0376 **(p174,175)** Adopted by Diners Club International
Weight, Carel, RA (Hon) b1908 [1985]
Wells, William Frederick, POWS 1762-1836 [-,1804,1806]
West, Joseph Walter 1860-1933 [1901,1904]
The Patroness RWSW0377
Westall, William, ARA 1781-1850 [1810,1812]
Whaite, Henry Clarence 1828-1912

[1872,1882]
View of Wales (Storm on Snowdon) RWSW0378
Wheatley, Grace 1884-1970 [1945,1952]
The Delinquent RWSW0379
Wheatley, Jenny b1959 [1984,1987]
Wheatley, John, ARA 1892-1955 [1943,1947]
The New Bridge, Froggatt RWSW0380
Wheeler, Sir Charles, PRA (Hon) 1892-1974 [1957]
Whichelo, C John M c1784-1865 [1823,-]
White, Ethelbert 1891-1972 [1933,1939]
Catbush Farm RWSW0381
The Lock, Jacobswell, Guildford RWSW0382
Whittaker, James William 1828-1876 [1862,1864]
Whittlesea, Michael b1938 [1982,1985]
Wrapped Boat RWSW0387 **(p122)**
Wild, Charles 1781-1835 [1809,1821]
Wilkinson, Norman (Hon) 1878-1971 [1955]
Williams, Joan b1922 [1971,1982]
Landscape RWSW0383
Williams, Penry 1798-1885 [1828,1833]
Willis, Henry Brittan 1810-1884 [1862,1863]
Highland Cattle RWSW0384
Wilton, Andrew (Hon) b1942 [1986]
Wood, William Thomas 1877-1958 [1913,1918]
Showery Weather, Cornwall RWSW0385
Worth, Leslie Charles b1923 [1958,1967]
Evening Sky at Epsom RWSW0386
Garden Geometry RWSW0394
Whit Sunday RWSW0396
Wright, John Massey 1777-1866 [1824,1824]
Wright, John William 1802-1848 [1831,1841]
Wyeth, Andrew Newell (Hon) b1917 [1986]

Artists who have not been members of the Society and who are represented in the Collection.

Bell, Sir Charles 1744-1842
A Castle by a Lake RWSPBB03
Bennett, Newton 1854-1914
Wilton House RWSB0030
Bigham, C
Cote d'Azur, from Italy RWSPBB05
Birby, Margaret
Autumn Roses RWSPBB06
Boden, Samuel Standige 1826-1896
Thatched Cottages RWSB0050
Boxall, Sir William, RA 1800-1879
Brighton Downs (after Fielding) RWSPBB07
Brown, May
The Thames at Nine Elms RWSPBB08
Cannell, Edward Ashton b1927
Sunlight, Water, Ireland RWSC0093
Carmichael, James Wilson 1800-1868
The Town of Staithes, Yorkshire RWSPBC12
Cattermole, Charles 1832-1900
A Cavalier RWSPBC15
Cheston, Evelyn 1875-1929
Figure sketches RWSC0412
Sketch of Langham Mill RWSC0413
Collins, William, RA 1788-1847
Hastings RWSPBC16
Cooper, Thomas Sidney, RA 1803-1902
Highland Figures with Cattle, Sheep and Goats RWSPBC92
Cotman, John Sell, Follower of
The Ruined Abbey RWSC0074
Cox, David, Follower of
A Country Cottage RWSPBC18

Dayes, Edward, Follower of
St Michael's Mount RWSPBD20
De Loutherbourg, Philip James, RA, Follower of
Llyn Ogwen RWSPBD35
Derby, William 1786-1847
Portrait of a Man RWSPBD21
DeWint, Peter, Follower of
Southgate RWSD0098
Dicksee, Sir Francis Bernard, PRA 1853-1928
Night Fisherman RWSD0403

Edridge, Henry, ARA 1769-1821
Beauvais RWSPBE23

Foweracker, A Moulton fl1898-1912
Moonlight, Malaga, Spain RWSPBF27

Hughes, Arthur 1832-1915
William Callow RWSH0197

Jagger, David fl1917-1940
The Cloud RWSPBJ36
Joy, William 1803-1867
Sailing Boats in a Calm RWSPBJ37 **(p101)**

Landau, Dorothy fl1903-1927
Robert Weir Allan RWSL0223
Langmaid, Rowland fl1924-1930
Yachts off the Coast RWSPBL38
La Trobe Bateman, E
Flower Study A RWSPBL39
Flower Study B RWSPBL40
Flower Study C RWSPBL41
La Trobe Bateman, F W
Snowdonia RWSPBL42
La Trobe Bateman, L D
Big Ben RWSPBL43
Lawrence, Alfred Kingsley, RA 1893-1979
Robert Anning Bell RWSL0224
Leitch, William Leighton 1804-1883
Italian Washerwomen RWSPBL44
Newark Castle on the Clyde RWSPBL45
Leman, Robert 1799-1863
Landscape with a Rocky Stream RWSPBL80
Lessieux, Ernest-Louis 1848-1925
Monastery of the Annunciata RWSPBL49
Palermo from across the Bay RWSPBL48
Rough Sea in the Old Port, Menton RWSPBL46
Seascape RWSPBL50
Sunset RWSPBL47

Mole, John Henry 1814-1886
Beach Scene RWSPBM51 Adopted by Diners Club International
Montague, Alfred fl1880-1888
River Landscape RWSPBM52
Murray, Alexander Henry Hallam 1854-1934
Garth House, Wales RWSPBM55
Murray, Charles Fairfax 1849-1919
Study for a composition RWSJ0216

Nasmyth, Jane? 1788-1866 (and others, including B R Haydon)
Album of watercolours and drawings RWSPBN56
Norris, Hugh L c1863-1942
Staverton Bridge, Devon RWSN0263

Parsons, Lydia D
Sunshine, Alhambra, Spain RWSPBP57
Parsons, Mary
Alpine View RWSPBP58
Pyne, James Baker 1800-1870
Old Hamp Rock, Swanage RWSP0311

Roberts, David, RA 1796-1864
Cathedral Shrine RWSPBR68
Roberts, David, Follower of
The Chapel RWSPBR69
Romney, George 1734-1802
Compositional study of figures RWSR0300
Rowbotham, Thomas Charles Leeson 1823-1875
Cliveden Reach, Thames RWSPBR71 **(p86)** Adopted by Diners Club International
Dunstanborough Castle RWSPBR73 **(p110,111)** Adopted by Winsor and Newton
Highland Landscape RWSPBR72
The Windmill RWSPBR70
Ryan, E
Boats Moored by Warehouses RWSPBR74

Shepherd, George flc1800-1830
Ramsgate Harbour RWSPBS75
Shepherd, Thomas Hosmer flc1827-c1832
Windsor Castle RWSPBS76
Stanfield, Clarkson, RA 1793-1867
Figures by a Canal in a Busy Continental Town RWSPBS91 Adopted by the Mark Hammond Trust
Stanfield, George Clarkson 1828-1878
Church at Minnegaff RWSPBS78

Tucker, Edward flc1849-c1873
In the Highlands RWSPBT79

Unattributed
East Anglian Street Scene RWSU0241
F La Trobe Bateman as a Child RWSPBU87
Gathering Seaweed RWSU0355
Horse Teams Ploughing RWSU0356
Landscape with Cornfield RWSU0442
Mode Wheel on the Irwell, Manchester RWSPBU81
Near Maidstone RWSU0357
Normandy Coastline RWSPBU17
Peter DeWint at Work RWSU0354
Portrait of an Unknown Man RWSU0398

Varley, John, Follower of
A Mosque in a Landscape, with Figures by a Road RWSV0360
Figures in a Landscape RWSPBV83

Wade, Robert Albert William b1930
St Pauls from Bankside RWSW0440
Westall, Richard, RA 1765-1836
Portrait of a Boy RWSPBW84
Wimperis, Edmund Morison 1835-1900
Near Muker, Swaledale RWSPBW85
The Spring RWSPBW86
Wyld, William 1806-1889 (attributed to)
The Grand Canal, Venice, from Santa Maria Della Salute RWSPBW90